THE PAPER MUSEUM OF CASSIANO DAL POZZO

SERIES A ~ PART TWO
EARLY CHRISTIAN
AND MEDIEVAL ANTIQUITIES

VOLUME TWO
OTHER MOSAICS, PAINTINGS, SARCOPHAGI
AND SMALL OBJECTS

THE PAPER MUSEUM OF CASSIANO DAL POZZO

A CATALOGUE RAISONNÉ

Drawings and Prints
in the Royal Library at Windsor Castle,
the British Museum, the Institut de France
and other Collections

General Editors
Francis Haskell and Jennifer Montagu

Assistant General Editor
Henrietta McBurney

Series Editors
Series A ~ Antiquities and Architecture
Amanda Claridge
Series B ~ Natural History
David Freedberg

Patrons and Sponsors
Accademia dei Lincei
Académie des Inscriptions et Belles-Lettres
British Academy
Getty Grant Program
Monument Trust
Ing. C. Olivetti & C
Royal Collection Trust

SERIES A ~ ANTIQUITIES AND ARCHITECTURE

PART TWO

EARLY CHRISTIAN AND MEDIEVAL ANTIQUITIES

VOLUME TWO

OTHER MOSAICS, PAINTINGS, SARCOPHAGI AND SMALL OBJECTS

by John Osborne
and Amanda Claridge

with contributions by
Cecilia Bartoli and Eileen Kinghan

HARVEY MILLER PUBLISHERS

HARVEY MILLER PUBLISHERS
Knightsbridge House, 197 Knightsbridge, London SW7 1RB
An Imprint of G+B Arts International

British Library Cataloguing in Publication Data
A catalogue record for this book is available
from the British Library

ISBN 1872501672

*This work is published with the assistance of
The Getty Grant Program*

*The production of this volume has been supported by
Banca Nazionale del Lavoro*

Monochrome and colour origination by Neue Schwitter AG, Basel, Switzerland
Printed by Clifford Press Ltd., Coventry
Manufactured in Great Britain

CONTENTS

THE CATALOGUE RAISONNÉ

SERIES A PART II ~ VOLUME TWO

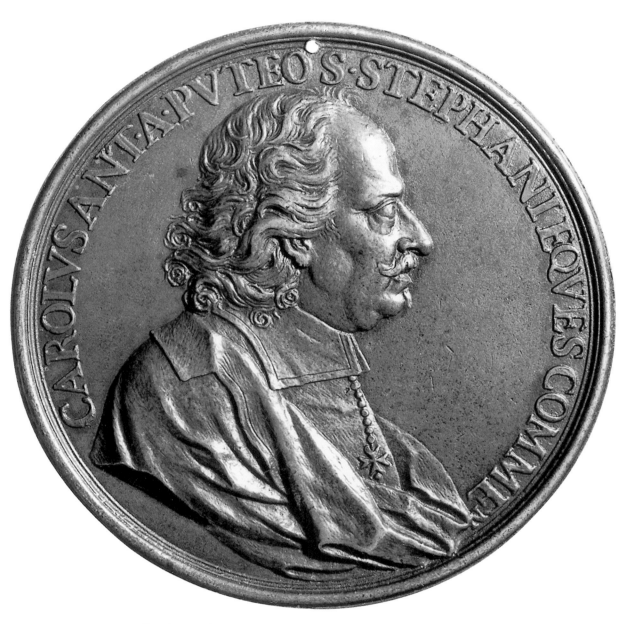

Frontispiece. Gasparo Morone Mola, *Portrait of Carlo Antonio dal Pozzo*,
obverse of medal. Cambridge, Fitzwilliam Museum

PREFACE

by Amanda Claridge

For general introductions to the dal Pozzo collections, the composition of the 'Mosaici Antichi' album and the division of its contents in the present Catalogue, the reader is referred to the prefatory chapters of Volume One.

AS IN VOLUME ONE, all the drawings in this volume, with the exception of two (**297, 304**) from the dispersed Stirling-Maxwell sculpture album, are to be found in the *Mosaici Antichi* album in the Royal Library at Windsor. There they constitute 61 folios (56 in a block, the other five interleaved elsewhere) in the midst of the drawings of church mosaics and wallpaintings which are catalogued in the first volume. In comparison with the latter, which date from the 1630s and 1640s and were mainly produced by one artist, Antonio Eclissi, the drawings in Volume Two differ in almost every possible respect. Not only do they cover many more kinds of material, they also range widely in drawing technique and the variety of hands (see below pp. 14–16), and clearly reflect a diversity of sources. Their differing types of mount and 'Pozzo' numbering (see Volume One, pp. 35–8), or lack of same, divide them into three main groups, tabled in Concordance E (p. 317). The twelve with burnished inlay and double ink framing lines (type A: see Concordance E.1), many of the twenty-one with no burnished inlay or framing lines (mount type B) but no numbering (Concordance E.2),[1] and a few of those with type B mounts and low numbers (the first four in Concordance E.3), can be dated—and were presumably collected—within Cassiano's lifetime (1588–1657).[2] The remaining ninety drawings tabled in Concordance E.3, however, whose numbering runs in an intermittent sequence from *558* to *1228*, can be identified fairly confidently as accessions made by Carlo Antonio dal Pozzo from the 1660s to the late 1680s.[3] On their evidence the *Mosaici Antichi* album was essentially Carlo Antonio's creation and it is interesting to pursue the nature of his involvement in more detail. The additions made in the 1670s and 1680s continue to include some significant examples of mosaics and paintings, but consist mainly of small objects, either from the catacombs or relating to Christian rites: decorative discs, statuettes, medallions, gold-glass, gems, ivories, plaques, pins and clasps. Much of the selection is in keeping with, even slightly in advance of, contemporary antiquarian studies, which were beginning to credit certain categories of small artefact with a value as primary evidence, not merely as accessories to the written sources. A more 'archaeological' quality is manifest in the drawings too, for example in the finer

copies of paintings and mosaics (**180–82**), which seek to reproduce accurately the condition and style as well as the formal content of their models, and the drawings of gold-glass (**249–82**), recorded in every fragmentary detail.

On Cassiano's death in 1657 Carlo Antonio (1606–89) was awarded the *commenda* in the Order of S. Stefano and also inherited various other lucrative privileges which had been granted by Urban VIII. By 1661 his annual income was estimated at 10,000 scudi and he ran two four-horse carriages as well as a large household.[4] Six of his thirteen children married well, into the Carpegna, Rondanini, Sampieri, Patriarca, Ferretti and Olgiati families, and Carlo Antonio himself became a noted figure in local politics and charitable works. He probably had more money to spend on the collections than ever before. Among his particular interests, it seems, were papal coins, medals, gems and the collection of portraits of illustrious men and women, royalty, cardinals and popes, but he also greatly expanded the library and the picture gallery,[5] and in the course of time added hundreds of new drawings to the Paper Museum.[6] In a letter of 27 February 1666 he lamented the fact that artists skilled in drawing antiquities were hard to find or he would be adding more than he was.[7] It was not his intention to publish (which he recognized was beyond his talents, not to mention the expense); rather, in modern parlance, he saw himself as an 'enabler': the archives were to continue to be of service to interested specialists. And indeed his subsequent accessions bear witness to his continuing contact with leading collectors and scholars and his efforts to keep the Paper Museum up to date with new discoveries and developments.[8]

In the case of the drawings of Christian antiquities in the *Mosaici Antichi* album, Carlo Antonio's motivation could well have been personal and highly informed. An abiding interest in the Roman Church as an institution is attested by two volumes of prints he collected.[9] It was an interest shared by the dal Pozzo brothers' early patron Cardinal Francesco Barberini, who outlived Cassiano by more than twenty years and with whom Carlo Antonio remained in close touch. Several late accessions catalogued here have a matching drawing in the Barberini library (see **182, 187–92, 193, 283**). The Barberini connection not only introduced Carlo Antonio to most of the antiquaries attracted to Rome in the heyday of Urban VIII, such as Holstenius, Menestrier, Suarès, Agostini and Allacci, but also those of the next generation, most notably Fabretti, Ciampini, Bellori and Bartoli, whose activities dominated the Roman antiquarian scene in the last quarter of the century (for short biographies of all these figures, see pp. 305–11). Their published works indicate that Fabretti and Bartoli knew the dal Pozzo drawings well;[10] Ciampini used the drawings that Carlo Antonio had collected of the medieval paintings in S. Andrea cata Barbara and the St Thomas oratory in S. Giovanni in Laterano (see **180** and **182**), praising their accuracy. In his turn, during the 1670s and 80s Carlo Antonio accessioned drawings of gold-glass in Fabretti's collection,[11] various objects in Ciampini's[12] and substantial parts of Bellori's.[13] To judge by the other drawings of gold glass he also had an entrée to Cardinal Flavio Chigi's *casino* on the Quirinal[14]

10

and Cardinal Gaspare Carpegna's *palazzo* near Piazza Navona.[15] Carpegna's museum also housed the small disc **286** and perhaps the ivories **245–8**. Further contacts are probably concealed among the objects we have not been able to identify. Towards the end of his life Carlo Antonio could also have met the young Filippo Buonarroti and Francesco Bianchini, who both arrived in Rome in 1684, one to join Carpegna's household, the other that of Cardinal Pietro Ottoboni (see p. 307f.). Bianchini certainly knew and used the dal Pozzo drawings, both in *La Storia Universale* of 1697 (when they were still in the dal Pozzo house in Via dei Chiavari) and later in his edition of *Anastasius* (see **176**), when they had passed to the Palazzo Albani, and where his nephew Giuseppe subsequently took a detailed inventory of the whole *Mosaici Antichi* album (see pp. 19–41).

Folio arrangements

As in Volume One, the sequence in which the drawings appear in the catalogue is not the same as the one in which they appear in the album. The album sequence can be followed in the Concordance D (pp. 314–6) and the Bianchini inventory, Appendices I–II (pp. 27–41), from which it will be seen that although the drawings often appear in thematic groups, there is no particular sense of an overall order. The thirty-one large drawings on single folios (nineteen wall mosaics and paintings, seven sarcophagi, three bas-reliefs, three ivories and the two 'instruments of martyrdom') are distributed more or less at random. Sarcophagi, for example, appear in one batch of four folios (*Mosaici Antichi* II, fols 34–7), another of six (II, fols 72–7), (and there are another two on a composite folio, II, fol. 28), but the separation does not apparently signify an alternative relationship with any of the neighbouring drawings. Paintings and mosaics are not particularly coherent either, with the two drawings of the apse of S. Andrea cata Barbara widely separated (I, fol. 94, II, fol. 64) and distant also from the mural in the same church (II, fol. 61). In this catalogue, therefore, the order has been changed, but only to bring readily associated material together. It still preserves any evident groupings within each category. Thirty smaller drawings mounted on fifteen folios in related pairs, the pairs often making up larger sets, are all in the correct order in the album sequence and are integrated in the catalogued sequence accordingly: a set of six wallpaintings in Rome (**187–92**), two mosaics at Ravenna (**195–6**), two illuminations from the Roman Vergil (**204–5**) and fourteen illuminations from an Exultet roll (**206–19**), the four sides of a sarcophagus at Tolentino (**230–33**).

The remaining seventy-seven drawings are mounted on fifteen folios (see Figs 1.1–2.6). Eleven are clearly studied compositions of related subject matter and/or type of object:

- an association of images of St Peter or both Saints Peter and Paul(*Mosaici Antichi* II, fol. 31; Fig. 1.3)

- four small ivories (II, fol. 45; Fig. 1.5)

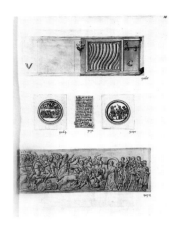

Fig. 1.1. **227**, **284**, **174**, **285**, **228**

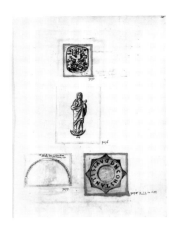

Fig. 1.2. **290**, **296**, **172**, **175**

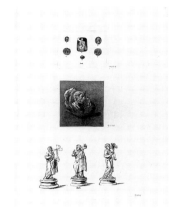

Fig. 1.3. **291**, **283**, **295**

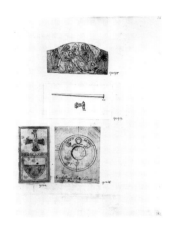

Fig. 1.4. **198–201**, **299**

Fig. 1.5. **245–8**

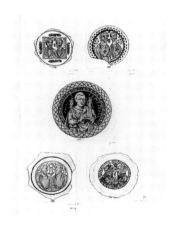

Fig. 1.6. **249–53**

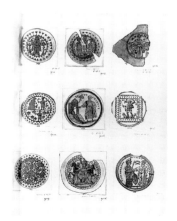

Fig. 1.7. **254–62**

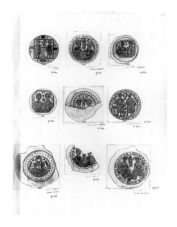

Fig. 1.8. **263–71**

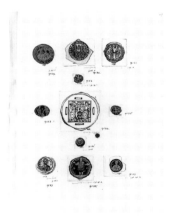

Fig. 1.9. **272–82**

Figs 1.1–1.9. Composite folios: *Mosaici Antichi II*, fols 28, 30–31, 44–9

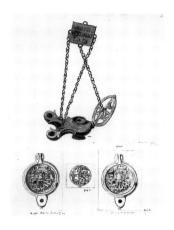

Fig. 2.1. **292–4, 286**

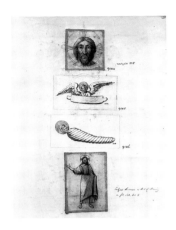

Fig. 2.2. **183–6**

Fig. 2.3. **167–70**

Fig. 2.4. **287–9**

Fig. 2.5. **173, 298, 240**

Fig. 2.6. **234–6**

Figs 2.1–2.6. Composite folios: *Mosaici Antichi II*, fols 50–51, 62–3, 71, 74

- thirty-four drawings of gold-glass (II, fols 46-9; Figs 1.6–1.9)
- three drawings of lamps, two decorated with the Good Shepherd and biblical scenes, between which is mounted a disc with the same imagery (II, fol. 50; Fig. 2.1)
- details from paintings in S. Urbano alla Caffarella including a head of Christ, combined with a similar image of Christ from another church (II, fol. 51; Fig. 2.2)
- copies of mosaics taken from a Ciaconio codex (II, fol. 62; Fig. 2.3)
- five discs or medallions (II, fol. 63; Fig. 2.4)
- all four sides of a sarcophagus from Tortona (II, fol. 74; Fig. 2.6).

The other four composite folios seem to be genuine miscellanies and have consequently lost their group identity here:

- two sarcophagi, an inscription and two sides of a medallion (II, fol. 28; Fig. 1.1)
- a gem, a statuette, a sketch of the inscription on the triumphal arch of S. Paolo fuori le mura and a brickstamp of Constans (II, fol. 30; Fig. 1.2)
- a coat of arms, a possibly heraldic device, a little clasp and what may be a painting of the Lamentation (II, fol. 44; Fig. 1.4)
- a sketch of a church apse, a statuette of St Hilaria and a bas-relief probably interpreted as the 'Adoration of the Magi' (II, fol. 71; Fig. 2.5).

Notes on artists and individual hands

Drawing styles and techniques range from red and black chalk to pen and ink and variously tinted washes, to elaborately detailed water- and body-colouring. Only sixteen of the earlier drawings are attributed, a set of four to ANTONIO ECLISSI (fl. 1630–44) (163–6), the characteristics of whose style and techniques have been described in Volume One (pp. 63–6), another four to VINCENZO LEONARDI, and eight, or possibly nine, rather less confidently to PIETRO TESTA.

300–303 VINCENZO LEONARDI (fl. 1621–46), a little-known but accomplished artist who was also responsible for many of the natural history drawings commissioned by Cassiano,[16] is cited as a member of the entourage accompanying the papal legation to France in 1625. While in France he executed drawings of antiquities as well as of natural history subjects, and appears to have continued to do so after his return to Rome. His drawings are characterized by a concern to convey the three-dimensional form of the object, whether it be natural or man-made (see especially **302** and **303**). He does this partly through building up layers of watercolour and bodycolour (usually over black chalk underdrawing), then heightening with white and often with gum to achieve a solid, almost tactile effect. Sometimes, however, he uses less pigment, allowing either the white of the paper or paler watercolour to act as the highlights (see, for example, **302**). Depending on the texture of the object, he may use a series of minute or longer brush strokes (see **302** and **303** respectively), or stippling, sometimes combined with longer strokes (see **300** and **301**).

225–9, 237–9, ?240 PIETRO TESTA (1612–50, see below p. 311) was possibly the most prolific of the artists who executed drawings after the Antique for Cassiano, the latter describing him as *'buon pittore, et eccellente disegnatore delle cose antiche'* ('a good painter and an excellent draughtsman of antiquities').[17] Blunt, on the basis of Baldinucci's statement that the dal Pozzo collection included five large albums of Testa's drawings (see Volume One, p. 34 and n. 4), attributed to the artist a group of over 600 drawings amongst the volumes of the Paper Museum at Windsor;[18] Turner revised this list to a total of just over 500 drawings.[19] Blunt, however, acknowledges that the drawings demonstrating the style he attributes to Testa— pen and brown ink, with brown or grey wash, using a 'fine but sensitive pen line' (or as Turner describes it 'a characteristically elegant touch') 'lack the lively expressiveness of Testa's independent drawings, no doubt because the process of copying from an ancient model exercised a restraining influence on his style'. On account of this difficulty of certain identification (also acknowledged by Turner, and by Cropper 1988), the group of drawings of sarcophagi and reliefs given to Testa here are described as 'Attributed to', rather than by, Testa.

Although unidentified, there are several other distinctive hands:

222–4: three drawings of sarcophagi with consecutive low 'Pozzo' numbers (*29–31*) are characterized by a use of dark brown wash combined with finely detailed penwork, the latter especially noticeable in the heads. The hand is one familiar from a substantial number of drawings in the *Bassi Rilievi*, which Turner cautiously suggested might be that of Bernardino Capitelli (1590–1639).[20] However, as Ingo Herklotz pointed out,[21] it is unlikely that Capitelli was in Rome during the appropriate period (1630s).

171, 230–33: a sheet of catacomb paintings copied from the manuscripts of Ciaconio, and four drawings of a sarcophagus at Tolentino share a similar use of pen and ink and lightly coloured washes, and a lack of 'Pozzo' numbers. The watermark (Hills 6) on **171** provides a date of *c.* 1639. The same hand may also be found on a set of copies of illustrations from the Calendar of AD 354.[22]

181–2, 194: drawings of murals, two in the Lateran bearing 'Pozzo' numbers *977* and *979*, and a third of an unidentified mural with 'Pozzo' number *578*, are characterized by the same type of carefully modelled figure and backgrounds densely filled in with bodycolour or watercolour. The 'Pozzo' numbering gives a possible date of 1670 to early 1680s.

167–70, 178, 180, 187–92: variously mosaics copied from Ciaconio manuscripts, the apse and wallpaintings in S. Andrea cata Barbara, and other church paintings from a Barberini codex. A very accomplished hand, using a vivid palette over black chalk underdrawing and demonstrating a close interest in the condition and style of the original. Again, the 'Pozzo' numbers (*900–904, 957, 965, 1166* respectively) suggest a date in the early 1680s.

249–76, 278–82: the series of drawings of gold-glass are amongst the most

accomplished examples of archaeological draughtsmanship in the Paper Museum, both in terms of technique and their faithfulness to the original objects, which they reproduce at actual size, using gold-powder and watercolour over pen and ink or black chalk or graphite. They capture remarkably accurately not only the shape, condition and colour but also the style of the original. It is possible that the artist is the same as that of the preceding group.

NOTES

1. **171**, **204–5**, **228**, **230–33**, **302–3** are broadly dateable to around 1630–40; **172–3** were apparently cut from a yet older notebook. However, it is most uncertain what chronological weight, if any, can be placed on the absence of a number *per se*. One of the unnumbered drawings (**179**) can hardly have been acquired before 1675.

2. The number *9* appears on one in a set of four (**163–6**) which can be attributed with confidence to Antonio Eclissi (fl. 1630–44) and while it is topographically unlikely to be the *9* missing from the *1–55* sequence (see Volume One, p. 55f.) it could be a remnant of another such earlier series. Similarly, the drawing numbered *324* (**227**), of a sarcophagus, should probably be associated with the sarcophagus numbered *323* (**226**), by the same hand, which has a type A mount (in Concordance E.1). The hand is attributed to Pietro Testa (1612–50), who has also been credited with the drawing of a relief (**237**), which is numbered *268*. However, the placing of the number in that instance suggests Carlo Antonio dal Pozzo's inventory, as does the numbering *350–51* on two unmounted drawings attributed to Vincenzo Leonardi (fl. 1621–46) (**300–301**, Concordance E.4). Whether this means that Carlo Antonio began collecting on his own behalf, keeping his own inventory, in the 1630s or earlier, or simply that the drawings in question were acquired some time after they were produced is not certain. For the time being we have no timescale for the first 500 numbers in Carlo Antonio's inventory (always assuming it started from 1).

3. For an outline of the basic chronology see Volume One, p. 37f.

4. Lumbroso 1874, p. 147 (= 1875, p. 19); cf. Sparti 1992, p. 62.

5. The documentary evidence for Carlo Antonio's collecting interests is assembled and discussed by Sparti 1990 and Sparti 1992, pp. 51–63. Various scholarly works were dedicated to him in the course of his life and his collection of papal coins was celebrated in 1679 in the preface to G. Du Molinet's *Historia summorum Pontificum*, p. Xr (Sparti 1992, p. 54).

6. See Volume One, p. 38.

7. Replying to an enquiry from Angelico Aprosio as to the fate of the drawings collections after Cassiano's death: '…*si continuerebbe a raccorne degli altri ancora quando si trovassero le mani atte al disegno di queste cose antiche, ma la carestie e le continue molestie che si provano distolgono da queste curiose applicationi. Che siano per stamparsi, oltre che in me non vi sono talenti simili per illustrazione di materie antiche, ne si richiederebbe spesa più che regia nell'intaglio di quello che in disegno fedelissimo s'è nello spazio di molti e molt'anni raccolto. Restano però communicabili a quelli che di notitie sì fatte si dilettano*' (Lumbroso 1874, p. 167f.).

8. See also A.I. *Ancient Mosaics and Wallpaintings*, where over half the drawings are additions made by Carlo Antonio in the later 17th century.

9. British Library, King's Library, pressmarks 134 g. 10–11, labelled *Popish Ceremonies*, vols 1 and 2 respectively (Griffiths 1989, p. 5f., nos III–IV). The first contains a miscellany of church processions, tombs, altarpieces, coronations, the second has 172 folios of views, elevations, ground plans, altars and other interior features of Roman churches, arranged topographically, including 49 folios relating to the Vatican and St Peter's, and 45 of S. Maria Maggiore.

10. Fabretti 1683, addendum to p. 379D, illustrates a sarcophagus relief in the Vatican from a drawing *'ex Museo Nob. V.D. Commend. Caroli Ant. à Puteo'*. Bartoli based many of his engravings of ancient paintings and mosaics (see A.I), and illustrations from the Vatican Vergil (A.VI), on dal Pozzo drawings.

11. **253, 261–2, 273–4.**

12. A series of drawings of five lamps, two keys and a pin in the British Museum (Franks 437–8, 441–2, 452, 454) bear Carlo Antonio's numbers *1370–71, 1373–79* and annotations identifying them as *'di Mons. C(i)ampini'*.

13. Here possibly only **292–3, 295** but there are at least another forty items in other albums (see Bailey 1992 and A.V).

14. See pp. 199, 308 and **251, 257, 259–60, 264, 266, 268, 276.**

15. See pp. 199, 308 and **249–50, 252, 254–6, 258, 263, 265, 267, 269–72, 275, 277–82.**

16. See B.I, *Citrus Fruit*, pp. 38, 57–9.

17. Letter to Antonio Maria Salvini, 12 April 1653 (?), Florence, Biblioteca Marucelliana, MS A 257.258, fols 39v–40 (Solinas/Nicolò 1988, p. lxxiii).

18. Blunt 1971, pp. 121–3.

19. Turner 1992.

20. Turner 1993, p. 29f.

21. Herklotz 1993, p. 573.

22. In the *Nettuno* album RL 11363–11374, to be published in A.VI.

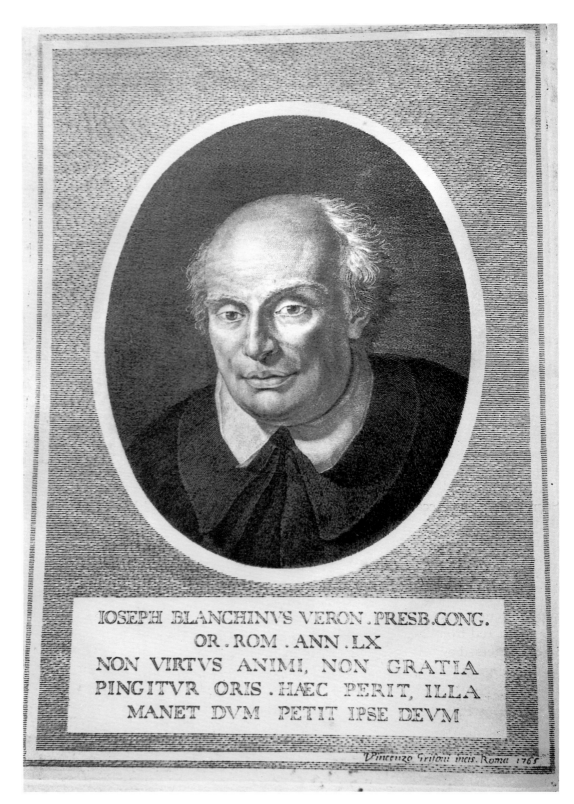

IOSEPH BLANCHINVS VERON.PRESB.CONG.
OR.ROM.ANN.LX
NON VIRTVS ANIMI, NON GRATIA
PINGITVR ORIS.HAEC PERIT, ILLA
MANET DVM PETIT IPSE DEVM

Vincenzo Grifoni incis. Roma 1765

Fig. 3. Vincenzo Grifoni, *Portrait of Giuseppe Bianchini.*
Engraving from F. Bianchini, *Josephi Blanchini presbyter congregationis
Oratorii romani. Elogium historicum*, Rome, 1765

THE BIANCHINI INVENTORY: *MOSAICI ANTICHI* AS A SOURCE FOR AN EIGHTEENTH-CENTURY MUSEUM

by Cecilia Bartoli

THE Museo Cristiano—the Museum of the Christian Church—was officially opened in the Vatican Library in 1757 by Pope Benedict XIV (Lambertini, 1740–58), with his encyclical *Ad Optimarum Artium*. Conceived of as both a collection of monuments and a statement about Christianity, the new Museum was welcomed warmly by the scholars and intellectuals who had encouraged the pope to sponsor it.[1] Scipione Maffei (1675–1755), whose Etruscan collection had already championed the cause of periods considered 'minor' in comparison with Classical art, had dedicated his *Museum Veronense* of 1749 to Benedict XIV, acclaiming the idea of founding a 'Christian Museum' as a major contribution to the development of ecclesiastical studies.[2] Giovanni Gaetano Bottari too, in the latest edition of Bosio's *Roma Sotterranea* published in three volumes in 1737, 1746 and 1754 respectively, had stressed the value of the Museum in preventing the dispersal of the artistic heritage.

But more than anyone else, it was Giuseppe Bianchini (1704–64; see p. 307) who had laboured to bring the Museo Cristiano lambertiniano into being [Fig. 3]. As Secretary of the Accademia di Storia Ecclesiastica, which had been founded by Benedict XIV in the Oratory of the Chiesa Nuova [Fig. 4], he devoted his life to completing and publishing the great works of his uncle, Francesco Bianchini (1662–1729), in particular the *Historia Ecclesiastica*, which set out to 'prove' the history of the Church through its material remains. In 1703 Francesco Bianchini had been nominated *commissario* of antiquities by Clement XI (Albani, 1700–21), with the creation of a 'Museo Ecclesiastico' amongst his tasks. A range of material was gathered from the papal gardens, monasteries and churches in the city, only to be dispersed again by 1716.[3]

Giuseppe Bianchini's notes and papers (preserved in the Biblioteca Vallicelliana in Rome), afford valuable insights into the debate which preceded the creation of the Museo Cristiano and also the phases by which the *Historia Ecclesiastica* was prepared for the press, since the two projects were by no means unrelated. The notes consist mainly of a collection of ideas and lists of antiquities, including Early Christian reliefs, church glass, medallions, and inscriptions, together with information on where works suitable for the Museum could be found: mostly works

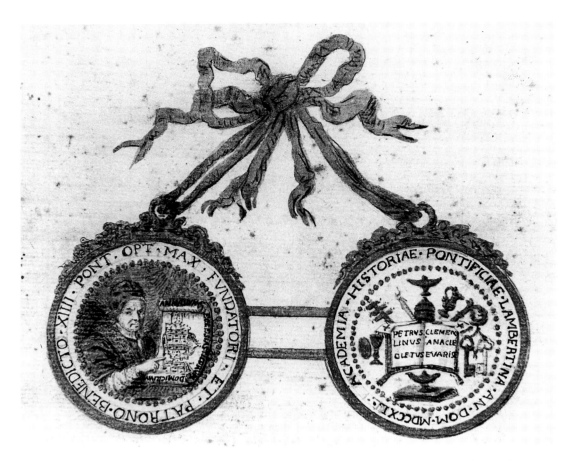

Fig. 4. Giuseppe Bianchini, *Design for a medal commemorating the foundation of the 'Accademia Ecclesiastica'*
On the obverse is Benedict XIV pointing to a picture of the Chiesa Nuova, seat of the new Academy.
On the reverse is the Academy's emblem. Pen and brown ink and watercolour. Rome, Biblioteca Vallicelliana
MS U39, fol. 7

neglected and in a state of decay. He also reports on one person in particular who could be called upon to restore the works to be put on display and from whom to buy others: the famous dealer and restorer, Bartolomeo Cavaceppi (1717–99).[4] It was in the course of research on Cavaceppi that the two versions of the document published here came to light (Appendices I and II).[5] They consist of two fascicles with gilt edges, one composed of three sheets for the Latin version [Fig. 5], and one of four for the Italian, both in excellent state of preservation.

The first page is headed: 'In a codex, which is now in the Library of the House of their Excellencies Albani and previously belonged to Cavaliere Cassiano dal Pozzo, are preserved the drawings of the following Christian Antiquities made by the artist almost always from the originals, which still exist today, in painting, or in sculpture, or in mosaic'. The drawings are then listed by folio, in the order they appeared in the codex, with a brief description and—at least in the case of the mosaics and paintings in Roman churches—an attempt to locate the original. The two versions are not identical. The Latin version is more accurate in listing the drawings and the numeration of the folios.[6] The Italian is less detailed in the descriptions but in many cases adds a reference to a publication where the subject

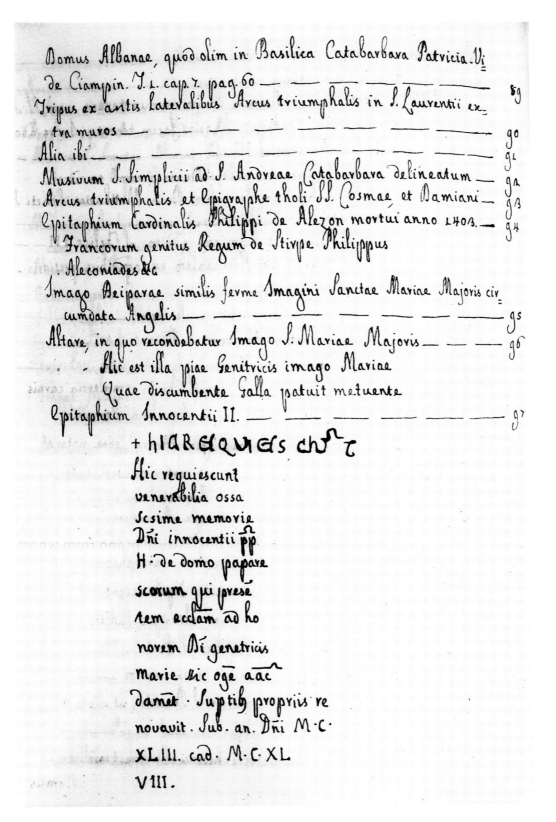

Domus Albanae, quod olim in Basilica Catabarbara Patricia. Vi
de Ciampin. T. i. cap. v. pag. 60 _____ 89
Tripus ex antis lateralibus Arcus triumphalis in S. Laurentii ex=
tra muros _____ 90
Alia ibi _____ 91
Musivum S. Simplicii ad S. Andreae Catabarbara delineatum __ 92
Arcus triumphalis et Epigraphe tholi SS. Cosmae et Damiani__ 93
Epitaphium Cardinalis Philippi de Alezon mortui anno 1403. __ 94
 Francorum genitus Regum de Stirpe Philippus
 Aleconiades &c
Imago Beiparae similis ferme Imagini Sanctae Mariae Majoris cir=
 cumdata Angelis _____ 95
Altare, in quo recondebatur Imago S. Mariae Majoris___ ___ ___ 96
 - Hic est illa piae Genitricis imago Mariae
 Quae discumbente Galla patuit metuente
Epitaphium Innocentii II. ___ ___ ___ ___ ___ ___ ___ 97

 + hIARЄIQUЄIS chr̄τ
 Hic requiescunt
 venerabilia ossa
 Scsime memorie
 Dn̄i innocentii p̄p
 H· de domo papare
 scorum qui prese̅
 tem ecc̄lam ad ho
 norem Dī genetricis
 Marie hic og̅e aac̄
 damet · Suptib propriis re
 novavit. Sub· an· Dn̄i M·C·
 XLIII. cad· M·C·XL
 VIII.

Fig. 5. A page from the Latin version of the Bianchini inventory (Appendix I). The inscription at fol. 97 is not transcribed in the Italian version. Rome, Biblioteca Vallicelliana, MS T9, fol. 214v

is reproduced. For example right at the beginning of the document we find, in the Latin version, a detailed list of folios 1–6 with the description of the subjects of the drawings, while in the Italian we move straight from folio 1 to 6 with the phrase, 'drawings of the other mosaics follow'. There is a reference, however, to volume 2 of the *Vetera Monimenta* of Monsignor (Giovanni) Ciampini in which the mosaics in question are published. Ciampini is the author to whom Bianchini makes most frequent reference, though on occasion he cites others such as Alemanni (1625), Bartoli/Bellori (*Antiche Lucerne*, 1691), Boldetti (1720), Buonarroti (1716), Du Cange (*De imp. Const.*, 1678) Wilthemius (1659), Aringhi (*Roma Subterranea*, 1651), the Abbot 'Cajetano' (Costantino Caetani, see **22**), the Abbot 'Patrizio' and 'padre Papebrochio'.[7] A modern authority was clearly of an importance equal to the original work of art and it is worth noting that Bianchini uses those same sources when selecting the sarcophagi, glass, inscriptions and bas-reliefs to be included in the Museo Cristiano.

What did Bianchini find so significant in the dal Pozzo codex that prompted him to make a detailed inventory of its contents, and when and why did he make it? The most probable date is in the early 1740s when he was working on the *Museo Cristiano* project, some time before 1746, since he refers to the gold-glass disc on fol. 140 (here no. **251**) as being in the Chigi Casino rather than the Vatican. If so, some of the information—the general scope and some of the specific items—could well have been of practical interest straight away, but the specific context in which the document is now to be found suggests a further function. While broadly associated with Bianchini's editorial notes for the four-part *Demonstratio Historiae Ecclesiasticae*[8] and the assemblage of material for the creation of the 'Vatican Museum of Christianity' [Fig. 6], it is preceded by drafts of a proposal which Bianchini evidently worked on sometime between 1758 and his death (aged only 60) in 1764. The proposal was to be addressed to Benedict XIV's successor Clement XIII (1758–69) and concerns a *Museo Dipinto*—a 'Picture' (or 'Painted') Museum:

> In the Pontificate of Clement XIII, Bianchini undertakes to complete an entire History which would embellish the Pontifical Picture Gallery, giving the passing Popes the image of the Church throughout the centuries at a glance. Benedict XIV started the Christian Museum, and Clement XIII would entertain the idea of continuing it for all the centuries. Painted on large canvases, it could even be placed in the Papal Palace on the Quirinal. (fol. 141v)[9]

He goes on to explain its content and purpose:

> It is proposed to paint in the Vatican a History of the Church according to its true nature ... whence the Painted Museum would gradually lead to the creation of a Real Museum, which would greatly benefit the Church ... Such a work would be of much help to Painters, Sculptors, Architects, and antiquaries since they could then see the characteristics of each century as they

Fig. 6. Giuseppe Bianchini, *Various proposals for the naming and location of the Museo Cristiano.* Rome, Biblioteca Vallicelliana, MS T9, fol. 143

CI MELIARCHIVM LAMBERTINVM

seu

VETERVM

COLLECTIO MONIMENTORVM

pertinentium ad Ecclesiae Catholicae gesta,

dogmata, ritus, mores, ac disciplinam disposita in Museo Christiano

BENEDICTO XIV. PONT. MAX. SAPIENTISSIMI

juxta seriem Chronologicam

ad fidem Temporum et Gestorum.

Colligite fragmenta, ne pereant.

Fig. 7. Engraving, Pl. II from Antonio Giuseppe Barbazza, *Demonstratio Historiae Ecclesiasticae,* Rome 1752

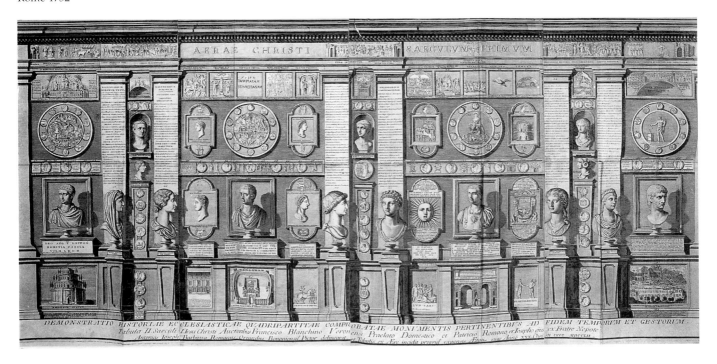

really were, in their original colours. He who wants to paint a Saint will find him as he would have been in early times, as he is found in the oldest pictures. Who a Council, how the bishops were seated. Who Holy images, how they were always depicted clothed. In the Picture Museum there will be all the greatest rarities of Europe from the coming of Christ down to the present day. Of the Popes, their early images taken from the earliest paintings. Of the Bishops, the many series in the diptychs. For every century, the proper forms of stone-cut lettering. Once such a gallery of pictures was set up the studious young could then copy from it. (fol. 142v)[10]

He had also been concerned to find an artist to do the paintings:

Padre Antonio Barbazza would paint a century in panels according to the design for only 231 scudi = 20 [?] but when that century is accepted, for the others of my History he would like 400 scudi per century. [And again] For the first century the painter will settle for 200 scudi, to cover the basic expenses for paint, canvas and his own food. But when that is done and meets with papal approval he wants 400 scudi for each of the other centuries. (fol. 145v)[11]

and he had worked out the timing:

He [Barbazza] would employ many [assistants] in order to finish a century every three months, whence he would undertake to the Holy Father to produce in four and a half years all 18 centuries, that is, down to Your Holiness's own Pontificate. Lest it should be feared that, through the fault of the Author (i.e. Padre Bianchini), the work to be painted will not be in hand before the painting of the first century begins, Bianchini is ready to show anyone who would do him the honour of visiting his studio in the Chiesa Nuova that he already has many centuries prepared, that is, nine or ten, and in a year or two will have finished, if it is decided to have them painted. A small explanatory book will be produced for the painted panels, as was done for the plates engraved in Rome [or in copper]. (fol. 142v)[12]

It seems we are presented with a novel consideration in the history of the Museo Cristiano. The statues, busts, bas-reliefs and liturgical glass were to be accompanied by paintings, by *'pitture sacre'*—church paintings, selected perhaps on the basis of the very same list of dal Pozzo drawings. The possibility is intriguing not only in connection with the Museo Cristiano in particular but more generally for the analysis of Bianchini's museological approach. As far as we know the *'Museo Dipinto'* was destined to remain purely an idea; it was never realized, or rather, it was only realized on paper. We actually have the engravings which Giuseppe Bianchini commissioned for the text begun by his uncle Francesco, the *Demonstratio Historiae Ecclesiasticae* [Fig. 7]. They were done by the same Antonio Barbazza

proposed for the paintings and illustrate exactly what the notes in Bianchini's papers suggest:

> The architectural setting all in Parian marble. The busts also in Parian. The pictures as themselves. The mosaics in little pieces of stone. In sum, everything as if it were real. (fol. 144v)[13]

Thus the aims of Giuseppe Bianchini and Cassiano dal Pozzo were closely connected. Both were working towards the creation of a museum based on documentary evidence. Cassiano had made his Museum on Paper. Bianchini then took up the Paper Museum as the starting point for his 'real' Museum, made of statues, bas-reliefs, glass and inscriptions and perhaps even large paintings.

NOTES

1. For the history of the Museo Cristiano see: Kanzler 1903, pp. vii–viii; Le Grelle 1910; Pastor *Papi* 16 (1933), pp. 162–5; *DBI* viii, s.v. 'Benedetto XIV' p. 401 [M. Rosa]; Ruysschaert 1975, pp. 307–33; Morello 1979 and 1981; *Vatican Collections* cat. 1983, pp. 14–25, 94–7; Pietrangeli 1985, pp. 29–38, and 1993 pp. 37–47.

2. From the beginning of the 18th century, Italy witnessed the growth of several movements which sought to express political, institutional, cultural or religious independence by the revival of epochs or genres considered minor in relation to the dominant Classicism of the age. One was the Etruscan Academy at Cortona, which was founded in 1726 by Onofrio Baldelli and the Venuti brothers. This academy was the first concrete expression of the nascent interest in Etruscan antiquities, and it also gave shape to the idea of the public museum— an idea which emerged in Rome only a few years later, first with the opening of the Capitoline Museums and then that in the Vatican. The subject is a very large and complex one and deserves much further study, but see Dal Pane 1959; Venturi 1969; Assunto 1973; Pavan 1977; Haskell 1981, pp. 11–17; Concina 1983; Cristofani 1983; Barocchi 1985.

3. Hülsen 1890; Pietrangeli 1985, p. 29f. or 1993, p. 37.

4. On Cavaceppi's restorations for the Museo Cristiano see Morello 1979; G. Daltrop, in *Vatican Collections* cat. 1983, p. 30f.; Pietrangeli 1985, p. 33 or 1993, p. 50f., n. 15; Bartoli 1994.

5. Rome, Biblioteca Vallicelliana MS T9: a composite codex, in paper, measuring 270 × 200 mm, containing three tomes (nos 27–9). Our documents occupy 14 sides in tome 28, and bear both an original numbering in ink from 59 to 69, and modern pencil numbering from 200 to 213 (205v, 212v–213v are blank).

6. The folios are still in the same order as that recorded by Bianchini, but the numbers he gives and the modern numbering differ from each other. In Bianchini's day there were two consecutive pairs of folios numbered 56 and 57, with the result that from that point onwards the numbering he gives is two behind the modern numbering in *Mosaici Antichi I* (since the earlier duplication has been corrected). In *Mosaici Antichi II* the modern numbering is completely different anyway, because the sequence starts from 1 again. See also Volume One, p. 53f. and here, Appendix II, pp. 33–41.

7. Daniel van Papenbroeck, co-author of the *Acta Sanctorum*, and *Chronico-historicus ad Catalogum Romanorum Pontificum, a Sancto Petro usque ad ... Innocentium XI*, with N. Heinschen and L. Possini, 1685.

8. Giuseppe Bianchini makes specific reference to the *Mosaici Antichi* volume in the *Demonstratio Historiae Ecclesiasticae* III, p. 471, in connection with a drawing of the apse mosaic of S. Pudenziana (here either **142** or **176**): '*delineari diligenter curavit Eques Cassianus a Puteo ad fidem prototypi, & compegit cum ceteris sacrae antiquitatis monumentis in pretiosa volumina, quibus hodie nobilitatur Emorum Principum S.R.E. Cardd. Alexandri et Francisci Albanorum insignis Bibliotheca'.*

9. '*Sotto il Pontificato di Clemente XIII s'impegna il Bianchini di dar finita per la pittura tutta la Storia la quale abbellirebbe la Galleria Pontificia e metterebbe in un'occhiata ai Papi passeggiando la faccia della Chiesa di tutti i secoli. Benedetto XIIII avrebbe incominciato il Museo Cristiano e Clemente XIII lasciarebbe l'idea della continuazione di esso per tutti i secoli. Facendosi in quadri grandi potrebbesi mettere ancora nel Palazzo Apostolico del Quirinale'.*

10. '*Si progetta la pittura nel Vaticano d'una Istoria Ecclesiastica al naturale...onde il Museo Dipinto farebbe a poco a poco formare nel Vaticano il Museo Reale, che alla Chiesa sarebbe tanto proficuo ... Tale opera servirà molto ai Pittori, Scultori, Architetti, antiquari, perchè vedranno le fattezze al naturale d'ogni secolo coi nativi suoi colori. Chi vorrà dipingere un Santo lo troverà come anticamente si è trovato nelle più antiche pitture. Chi un Concilio, come si sedevano i Vescovi. Chi le Sacre immagini come si dipingevano sempre vestiti. Si avrà tal Museo dipinto quanto v'ha di più raro in Europa dalla venuta di Cristo a dii nostri. Dei Papi le antiche immagini prese dalle più antiche pit-*

ture. Dei Vescovi molte serie nei dittici. D'ogni secolo i veri caratteri lapidari. Fatta una tal Galleria di quadri, si potrebbe dalla gioventù studiosa copiare'.

11. '*Il P. Antonio Barbazza farebbe in quadri un secolo a tenor del disegno, per soli scudi 231=20 ma quando esso secolo incontri, vuole per li altri secoli della mia Historia scudi 400 per ciascun secolo... Per il primo secolo il pittore si contenta di scudi 200, buttando fuori le mere spese dè colori, telari, e la sua sola cibaria. Ma quando sarà fatto ed incontri la pontificia approvazione dimanda 400 scudi d'ogn'uno degli altri secoli'.*

12. '*Terrebbe molti al travaglio, per dare ogni trimestre un secolo, onde s'impegnarebbe col Santo Padre di dare in 4 anni e mezzo finiti tutti li XVIII cioè fino al Pontificato della Santità Sua: Perchè non si tema che l'opera da dipingersi per via dell'Autore (cioè del P. Bianchini) non si avessi prima d'incominciarvi a dipingere il primo secolo è pronto il Bianchini di far vedere a quelli tanti quali che vorranno onorare il suo studio in Chiesa Nuova essere già in ordine per molti secoli, cioè per nove, o dieci e in un anno o due l'avrà affatto compiuta se si risolvano di farla dipingere. Si farà per le tavole dipinte un libretto di spiegazione come si è fatto delle tavole incise in Roma [rame?]'* The latter refers to the *Breve dichiarazione delle sei tavole incise in rame*... (Rome 1753) in which Bianchini provided a commentary on the six plates engraved by Antonio Giuseppe Barbazza for the *Demonstratio Historiae Ecclesiasticae* of 1752, saying where each work of art came from and where it would be displayed in the Museum [see Fig. 7].

13. '*L'architettura tutta di marmo pario. Li busti parimente di marmo pario. Le pitture come sono. Li musaici a pietrelle. In somma tutto se fosse reale'.*

APPENDIX I

Latin version of the Bianchini inventory
(Rome, Biblioteca Vallicelliana, MS T9 tom. 28)

Antiquae Imagines, pictura, sculptura aut musivis operibus efformatae in Basilicis ac Titulis Urbis, in Sacris Coemeteris suburbanis, aliisque locis veterum Christianorum, quas ex Autographis delineandas curavit Eques Cassianus de Puteo. Codex nunc extat in Museo Bibliothecae Domesticae Excellentissimae Domus Albanae.

Imagines Virginis Deiparae inter Sanctas Praxedem, et Pudentianam, quae visitur musivi operis in Cappella Sancti Zenonis ad Titulum Sanctae Praxedis fol.1

Eiusdem Cappellae imagines occurrunt folio 3 et sequentibus

Imago Xpi Domini in tholo eiusdem Cappellae musivo expressi in orbe medio à quatuor Angelis suffulto 2

Imagines in Cappella ad S. Zenonis in Tit. S. Praxedis exhibentes Sanctas Praxedem, Pudentianam, et Agnetem supra stantes, infra vero Agnum supra montem inter quatuor cervos sitientes, et infra Sanctam Theodoram cum tribus aliis Sanctis Virginibus 3

Imagines ejusdem Cappellae adversae exhibentes Sanctos Ioannem Andream, et Iacobum supra, infra vero Xpum Dominum inter duos Sanctos, quorum dexter Diaconu, seu Clericus, sinister Monachus 4

Imagines Sanctorum Apostolorum Petri, et Pauli, et Sedis Pontificalis sub corona in eadem Cappella 5

Imagines Sanctae Mariae Virginis, et Sancti Ioannis Apostolis in eadem Cappella, et infra Xpi Domini quatuor Sanctis stipati, duabus quoque figuris (Monachorum ut videtur) ante ipsum procumbentibus, et Altari ejusdem Cappellae 6

Imagines Deiparae Virginis Xpum Dominum gestantis inter duos Sanctos casula ornatos ex veteri pictura: infra mulier genuflexo ornans 7

Imagines eedem quae folio 1 ex Sanctae Praxedis Oratorio S. Zenonis 8

Imagines Xpi Domini inter duas arbores palmarum, cui astant hinc, inde Sancti Petrus, et Paulus, et Sancti Ioannes Baptista, et Ioannes Evangelista, ille cum orbiculo, in quo Agnus Dei, iste cum Calice ex pictura 9

Imago Urbani V ex veteri pictura, Cappellam a se dedicatam gestantis 10

Imagines Imperatoris Palaeologi et Uxoris ac filii, quales in Costantinopoli Christiana 11

Visitatio Dieparae ex veteri pictura 12

Imagines Xpi Domini Sanctis inter Sanctos Petrum, et Paulum, Stephanum, et Laurentium, Sixtum Papam et Lucinam ex veteri Musivo, aut pictura, fortasse ad Sanctam Lucinam existentem (nam S. Lucina praefert
Ecclesiam 13

Imagines Musivi in tholo S. Caeciliae à Paschali I constructi 14

Imagines ex veteri pictura Deiparae Virginis puerum Iesum sinu gestantis inter Sanctum Antonium Abbatem et Sanctum ... duobus Monachis infra genu adorantibus 15

Annunciatio Deiparae Virginis. Ibi etiam imago Imperatoris coronati Vexillum cum Aquila, et Scutum cum Aquila gestantis, fortasse ad Altare Basilicae Vaticanae 16

Musivum Arcus Sanctae Mariae Transtiberim parte dimidia, ubi Isaias 17

APPENDIX II

Italian version of the Bianchini inventory
(Rome, Biblioteca Vallicelliana, MS T9, tom. 28)

In un Codice, che ora si conserva nella
Biblioteca dell'Eccellentissima Casa
Albani, e che fu già del Sig.r Cavaliere
Cassiano del Pozzo, si conservano
i disegni delle infrascritte
Antichità Cristiane
formati dal pittore quasi sempre su li originali,
che esistono anche al presente, ò in Pitture
ò in Sculture, ò in Mosaici.

RL inv./ Cat.nos		no. on verso	actual folio no.
8928 **133**	Imagine del Musaico rappresentante la Bma Vergine con il bambino Giesù, e con le Sante Vergini Prassede, e Pudenziana, che sta nella Cappella di S. Zenone in Santa Prassede, fatto da S. Paschale primo Papa, e pu= blicato da Monsignor Ciampini nel Tomo secondo de Mo saici, intitolato Vetera Monimenta cap. 26 ——— fol.1	(-)	1
8929-33 **130–2,135–6**	Sieguono l'altre figure de Musaici della medesima Cappella sino al ——— fol. 6	(3,2,4,5,6)	2–6
8934 **153**	Imagine di antica pittura rappresentante la Beatissima Vergine con il Bambino e con due Santi vestiti di abito Sa= cerdotale, e à piedi una donna in atto di orare in ginocchio, non sò ove sia l'originale ——— fol. 7	(6)	7
8935 **134**	Disegno replicato della Immagine del foglio 1 ——— fol. 8	(7)	8
8936 **119**	Figura di una pittura antica di qualche Tribuna rappresen= tante Nostro Signore Giesù Christo trà due Alberi di palma con à fianco S. Pietro, e S. Paolo, e più discosti S. Giò. Battista e S. Giò Evangelista ——— 9	(8)	9
8937 **154**	Imagine di Urbano Quinto tratta d'antica pittura in atto di te= nere il modello della Cappella da se ornata per riporvi le tes= te de Santi Apostoli Pietro, e Paolo. Credo che l'originale fosse in SS. Giò, e Paolo: Vedi infra al foglio 116 ——— 10	(9)	10
8938 **202**	Imagine, che rappresenta l'Imp.re Michele, e la Imp.e Teodora Comnena sua moglie con il figliolo Costantino Porfirogenito stampata dal Sig.r Du Cange nella dissertazione de Inferioris Evi numis= matibus alla Tavola VI ——— 11	(10)	11
8939 157	La Visitazione della Beatissima Vergine ricopiata da pittura an= tica ——— 12	(-)	12

RL inv./ Cat.nos		no. on verso	actual folio no.
8940 71	Imagine del Salvatore, che stà in piedi trà i Santi Pietro, e Paolo, Stefano, e Lorenzo, Sisto Papa Secondo, e Lucina l'ultima de quali tiene il modello della Chiesa, e indica essere stata nel= la Tribuna del titolo di S. Lorenzo in Lucina ———— 13	(-)	13
8941 6	Figure della Tribuna di S. Cecilia: Mosaico fatto da S. Paschale Papa Primo, e stampato da Monsignor Ciampini nel Tomo secondo Tab. LII pag. 160 ———— 14	(13)	14
8942 102	Immagine della Santissima Vergine con il Bambino, con le fi= gure de Santi Antonio Abbate, e e con due Mo- nachi à piedi inginocchiati che orano: forse era in S. Andrea detto Catabarbara, ove oggi è la Chiesa di S. Antonio Abbate ——— 15	(14)	15
8943 101	Immagine della Vergine nostra Signora annunziata dall'Archang= elo Gabrielle, e vi si vede ancora in piedi la Imagine di un Santo vestito con manto Imperiale, e con la Corona Imperia= le, che tiene il Vessillo con l'Aquila e lo Scudo similmen= te con l'Aquila. Pur essere, che il Santo sia S. Maurizio, e che la pittura originale di questa copia fosse nel suo Alta= re nella Basilica di S. Pietro, ove si benedice l'Imperatore dai Sig.ri Cardinali, e si unge avanti che sia coronato dal Pa pa all'Altare Maggiore, come narrano Romano, e Veggio, antichi Can.ci di S. Pietro, e con essi tutti i moderni, che descri vono le antiche memorie della Basilica ———— 16	(15)	16
8944–5 **98–9**	Arco di Mosaico in S. Maria in Trastevere diviso in due pag. — 17 e 18	**(16,17)**	17-18
8946 100	Musaico della Tribuna della medesima Basilica ove sono effigi= ati li SS. Papi Calisto, Cornelio, Giulio, Innocenzo primo, e S. Calepodio Prete ———— 19	(18)	19
8947 **116**	Il Capo del Salvatore cavato da una Pittura antica ———— 20	(19)	20
8948 **114**	Immagine di S. Giò. Battista da una pittura antica ———— 21	(20)	21
8949 **8**	La metà dell'Arco di Musaico nel titolo di S. Clemente ———— 22	(21)	22
8950 21	Pittura antica, che rappresenta un Santo in atto di fare elemosina à poveri. Può essere che fosse nel Titolo di Pammachio, ò sia de Santi Giò, e Paolo ———— 23	(22)	23
8951–2 **31, 30**	Prospetto delle Pareti esteriori, e dell'interiore del Portico di S. Lorenzo fuori le mura, ove sono le Pitture, che appresso sieguono dal numero 50: sino al 77 ———— 24	(23)	24
8953 77	Parte dell'Arco Trionfale Musaico di S. Maria Maggiore fatta da Sisto III ———— 25	(24)	25
77	Adorazione dei Magi ———— 25	(24)	25
8954–5 **78–9**	Strage degli Innocenti ———— 26	(25)	26
8956 **80**	Presentazione al Tempio ———— 27	(26)	27
8957 81	Altare, e Sede Pontificale nel mezzo dell'Arco fatta à Musa co, e descritta da Monsig.r Ciampini T. I p. ... ———— 28	(27)	28
8958 82	Pittura modernamente fatta in uno de riquadri della Nave Maggiore della Basilica Liberiana, ove era caduto il pez= zo di Musaico, et accompagnava gli altri di S. Sisto Terzo———— 29	(28)	29

RL inv./ Cat.nos		no. on verso	actual folio no.
8959 **158** 8960 **139**	Disegni, o sbozzi di due pitture, ò Musaici antichi. Nel primo la Bma Vergine presenta il Bambino Giesù all'Adorazio= ne di un Pontefice, e de Ministri. Nel secondo pare figu= rata una parte dell'Arco di Musaico di S. Prassede, ò di S. Cecilia, ove si esprime la Gierusalemme nuova dell'Apo= calisse fatta di pietre preziose ——————— 30	(29)	30
8961–4 **126–7** **140-1**	Arco trionfale di Musaico di S. Prassede, ò di S. Cecilia, ove so= no li ventiquattro Seniori dell'Apocalissi delin.o da Monsig.r Ciam= pini Tomo 2o Vet. Monim. cap. 78 ——————— 31 e 32	(-, 29)	31-32
8965 **86**	Musaico di S. Maria Nuova nella tribuna, ò sia di S. Frances= ca Romana descritto, e delineato da Monsig.r Ciampini To= mo 2o cap. 28 tavola LIII ——————— 33	(30)	33
8966 **177**	Musaico della Tribuna di S. Pietro in Vaticano fatto da Inno= cenzo III da Mons.r Ciampini stampato nel Tom. de edif. à Const. M. constr. ——————— 34	(31)	34
8967 **128**	Musaico della Tribuna di S. Prassede fatto da S. Paschale I. stamp. da Mons.r Ciampini Tom. 2. cap. 25, 26, 27 ——————— 35	(32)	35
8968 **129**	La facciata esteriore della Cappella di S. Zenone fatta nel medesimo Titolo di S. Prassede dallo stesso Pontefice S. Paschale I. Ciamp. Tom. 2. cap. 25 et 26 et 27 ——————— 36	(33)	36
8969 **11**	Pianta dell'Altar Maggiore, Presbiterio, e Coro di S. Clemente stampata da Monsig.r Ciampini Vet. Mon. Tomo I cap. 2 ——————— 37	(34)	37
8970 **10**	Amboni per leggere l'Epistola, e l'Evangelio, che si veggono nel medesimo Titolo di S. Clemente, e furono stampati da Mons.r Ciampini nel suddetto Tomo p.$ Veterum Monimentorum cap. 2 ——————— fol. 38	(35)	38
8971 **13**	Trè Iscrizzioni di carattere Latino di forma Gotica, che for= mano l'Epitafio di un tale Nicolò Seniore Dottor di Legge——————— 39	(36)	39
8972 **83**	Imagine di Mosaico del Salvatore in piedi, che si vede con= servata nella Tribuna di S. Maria in Monticelli ——————— 40	(37)	40
8973 **150**	Mosaico fatto da S. Felice Quarto nella Tribuna del Titolo de SS. Cosma, e Damiano, stampato da Monsig.r Ciampini Vet. Mon. Tomo 2o pag. 60 ——————— 41	(37)	41
8974 **85**	La metà dell'Arco trionfale di Musaico nell'istessa Chiesa, ove sono due Santi Evangelisti Giovanni, e Luca L'altra metà dell'Arco stà al foglio 44 ——————— 42 L'altra metà dell'Arco stà al foglio 44	(38)	42
8975 **194**	Immagine del Musaico di S. Paolo I Papa il di cui ritratto si vede con ornamento quadrato in testa segno d'essere egli allora vivo. Lo rappresenta in atto di adorare genuflesso à piedi della Bma Vergine il suo Divino Figliuolo, assisten= dogli li SS. Apostoli Pietro, e Paolo ——————— 43	(39)	43
8976 **84–85**	L'altra metà dell'Arco Trionfale da SS. Cosma, e Damiano con i Santi Evangelisti Matteo e Marco. Vedi sopra fol. 42– ——————— 44	(40)	44

RL inv./ Cat.nos		no. on verso		actual folio no.
8977 27	Musaico di Pelagio II nell'Arco trionfale nella Basilica di S. Loren= zo fuori le Mura stampato da Monsig.^r Ciampini Vet. Mon. To= mo 2° pag. 102 ———————————————————	45	(41)	45
8978 147	Pittura antica nella Cappella interiore sopra la Tribuna del Titolo di S. Pudenziana, in cui è rappresentato S. Urbano I Pa= pa con i SS. Tiburzio, e Valeriano, precedendo l'Angelo da es= si veduto à preghiere di S. Cecilia ———————————	46	(42)	46
8979 70	Pittura, che stà nel Deposito del Cardinale Guglielmo Nipote d'In= nocenzo IV, in S. Lorenzo fuori le Mura, ove non si vede ancora il ritratto d'Innocenzo IV che adora Christo Sig.^r Nostro ————— fol. 47		(43)	47
8980 9	Musaico della Tribuna del Titolo di S. Clemente ———————	48	(44)	48
8981 22	Pittura antica della Cappella secreta de Pontefici nel Palazzo La= teranense che oggi resta nella Penitenzieria vicina al Musaico del Triclinio Leoniano: nella quale due Pontefici prostrati à pi= edi della B. Vergine adorano il Bambino Giesù nel di Lei seno: e sono Callisto II, e Anastasio III. stampata dall'Abbate Gaetani, e da altri ———————————————————	49	(45)	49
8982–9018 28–9, 32–3, 35, 38–69	Pitture, che rappresentano i fatti di S. Lorenzo nel Portico della di lui Basilica fuori le Mura, in una delle quali al foglio 70 si legge. Hoc opus fecit fieri Dnus Matthaeus Scti Al= berti pro anima sua. Sono dal foglio 50 sino al 77 —————	77	(47-75)	50-79*
9019 14	Musaico della Tribuna de SS. Cosma e Damiano replicato———	78	(76)	80
9020 137	La metà dell'Arco Trionfale di S. Prassede, ove si rappresenta la visione della Santa Città nell'ultimo Capitolo dell'Apo= calissi descritta———————————————————	79	(77)	81
9021 138	L'altra metà dell'Arco med.^{mo} ———————————————	80	(78)	82
9022 124	La metà dell'Arco prossimo dentro l'istesso Titolo, in cui sono espressi li 24 Seniori dell'Apocalisse ———————————	81	(79)	83
9023 144	Pitture della Cappella interiore sopra la Tribuna di Sta Pras= sede: quelle sotto la volta al fol. ——————————————	82	(80)	84
9024 143	Le altre à fianco ove S. Paolo battezza i Soldati in Casa di S. Pudente suo Ospite, e le di lui figliuole———————————	83	(81)	85
9025 123	Pittura antica forse d'un' Oratorio del titolo di S. Eusebio, in cui Nro Signore Giesù Christo è rappresentato trà i Santi Eusebio, Stefano, Lorenzo, e altri Santi ———————————	84	(81)	86
9026 152	Capo del Salvatore ricopiato dal Musaico della Basilica di San Paolo ——————————————————————————	85	(82)	87
9027 145	Un altra pittura del portico di S. Lorenzo fuori le mura——— fol. 86		(83)	88
9028 146	Musaico del titolo di S. Prassede come sopra fol.1 —————	87	(84)	89
9029 148	Le medesime Sante Prassede, e Pudenziana e S.Pietro ———	88	(85)	90
9030 1	Lavoro Egizio di pietre rimesse, che rappresenta la favola d'Ilo, e va= rj Sacrificj Egizziani istoriati in un lembo che rappresenta una coltre, e si vede nel Palazzo delli Eccmi Albani, fù stampa= to da Monsig.r Ciampini Vet. Monim. Tomo primo cap.7 pag. 70 ———	89	(86)	91

* prior to the most recent numeration the numbers 57–56 were duplicated

RL inv./ Cat.nos		no. on verso	actual folio no.

9031 **2**	Tripode ricopiato da un'antico in S. Lorenzo fuori le mura nelle muraglie, che sostentano l'Arco trionfale ———————— 90	(87)	92
9032 **3**	Un'altro dalla parte opposta———————————— 91	(88)	93
9033 **179**	Musaico fatto da S. Simplicio Papa nella Chiesa di S. Andrea Cata Barbara vicino à Santa Maria Maggiore, che fù dis= trutto nel fabricare il Monastero della Chiesa di S. Antonio, Ciamp. Tomo primo pag. 243 ———————— 92	(89)	94
9034 **15**	Arco di Musaico, ed Iscrizzione del Mosaico di S. Felice IV nel= la Chiesa de SS. Cosma, e Damiano ———————— 93	(90)	95
9035 I **111**	Iscrizzione Sepolcrale del Sig.r Cardinale d'Alenzon morto nell' anno 1403. Francorum genitus Regum de Stirpe Philippus Aleconiades &c ————————————— 94	(91)	96
			Volume II
9036 **151**	Immagine della Bma Vergine attorniata d'Angeli, simile à quel= la di S. Maria Maggiore ————————————— 95	(92)	1
9037 **88**	Altare in cui stava la Immagine di S. Maria Maggiore, ò pu= re quella di S. Maria in Porticu ———————— 97	(93)	2
9038 **97**	Epitafio di Innocenzo II di Casa Papareschi l'anno 1148——— 98	(94)	3
9039 **110** 9040 **113**	Sepolcro del Card. Piccolomini in S. Maria in Trastevere con le pitture, che lo adornano——————————— 99 et 100	(95,96)	4–5
9041 **108** 9042–4 **103,105,107**	Alcune copie di parte de Musaici esprimenti la Vita della SS.ma Vergine, ò in Santa Maria Maggiore, ò in Santa Maria in Trastevere- ————————————— 101–102	(97–99)	6–8
9045–6 **91–2**	Immagini delle Sante Vergini, che stanno nella facciata di Santa Maria in Trastevere ———————— 103	(100)	9
9047–8 **95–6**	Due Santi prostrati avanti la B. Vergine ———————— 104	(101)	10
9049–50 **93–4** 9051–2 **89**	Altre Immagini delle Sante Vergini della facciata di S. Mar= ia in Trastevere ———————————— 105 et 106	(102,103)	11-12
9053 **87**	Disegno non compito del Musaico nella Tribuna di Santa Maria Nuova, ò sia Santa Francesca Romana nel Foro Bovario stampato da Monsig.r Ciampini Vet. Mon. Tom. 2. pag. 161 Tab.53— 107	(104)	13
9054 **75**	Disegno d'un semestre del Calendario ricopiato da libro antico —— 108	(105)	14
9055 **76**	L'altro semestre ————————————— 109	(106)	15
9056 **118**	Arco Trionfale da S. Leone Magno ornato di Mosaici nella Basilica di S. Paolo fuori le mura Ciamp. Tom.1 pag.230 ——— 110	(107)	16
9057 7	Arco Trionfale di Mosaico del Titolo di S. Clemente ——— 111	(108)	17
9058 **142**	Tribuna di Mosaico di S. Pudenziana ———————— 112	(109)	18
9059 **18**	Pittura della facciata, e portico di S. Lorenzo extra muros, ò de SS. Giò. e Paolo ———————————— 113	(110)	19
9060 **19**	Pittura antica del Martirio di S.Pammachio ———————— 114	(111)	20

RL inv./ Cat.nos		no. on verso	actual folio no.
9061 **20**	Pittura antica del Martirio de SS. Gio. e Paolo ——————— 115	(112)	21
9062 **17**	Altra Pittura dell'approvazione dell'Ordine de Gesuati fat= ta da Urbano V. l'anno 1367 ——————— 116	(113)	22
	Queste trè pitture credo che fossero, e le due prime ancora siano nel Titolo de SS. Giovanni, e Paolo, e può essere che vi fosse quella di Urbano V. notata sopra al foglio 10. ———		
9063 **197**	Disegno antico in cui è scritto. Grazia di curazione fatta per la beata Camilla ——————— 117	(114)	23
9064–6 **34, 36–7**	Residuo di pitture del portico di S. Lorenzo extra muros —118 e 119.120	(115) (116,117)	24 25,26
9067 **171**	Pitture de Cemeterj di S. Felicita, e d'altri Santi Via Ardea= tina——————— 121	(118)	27
9068 **227**	Iscrizzione del Cemeterio ad Ursum Pileatum, che sta nel por= tico di S. Bibiana ——————— 122	(119)	28
9073–4 **204–5**	Pitture assai rozze di alcune Deità de' Gentili ——————— 123	(120)	29
9075–8 **172, 175, 290, 296**	Alcune antichità Christiane ——————— 124	(121)	30
9081 **295**	Immagine di S. Pietro Apostolo cavata da una statuetta di bronzo antica, che fu stampata da Pietro Santi Bartoli nelle Lucerne Christiane con le note del Bellori ——————— 125	(122)	31
9082 **300**	Catene di ferro antiche, con le manette ——————— 126	(123)	32
9083 **301**	Istromenti del Martirio, pettini di ferro, securi &c. ——————— 127	(124)	33
9084 **225**	Sarcofago de Cristiani ove è scolpita la Nascita del Sal= vatore——————— 128	(-)	34
9085 **224**	Altro con la figura della Samaritana ——————— 129	(125)	35
9086 **223**	Altro con la Istoria di Giona Profeta ——————— 130	(126)	36
9087 **222**	Altro con li trè Fanciulli della fornace di Babilonia ——————— 131	(127)	37
9088–9 **187–8**	Pittura del Ristoramento della Chiesa di S. Silvestro, che for= se doveva essere nella Tribuna antica di S. Silvestro in Capite ——————— 132	(128)	38
9090–91 **189–90**	Pittura della B.a Vergine in mezzo ad altre Sante Vergini, forse cavata dall'Oratorio dell'istesso Titolo, ove resta la Tavola di marmo antica con i nomi delle Sante Vergini delle quali vi erano le reliquie, e si celebrava la festa ——————— 133	(129)	39
9092–3 **191–2**	Altre immagini di Santi, e Sante ——————— 134	(130)	40
9094–5 **195–6**	Disegno della Tribuna del Musaico di Ravenna stampato da Monsig.r Ciampini nel Tomo secondo ——————— 135	(131)	41
9096 **181**	Pittura del Martirio di S. Sebastiano ——————— 136	(132)	42

RL inv./ Cat.nos		no. on verso		actual folio no.
9097 **182**	Pittura di Giovanni Papa Duodecimo, stampata dal Sig.^r Card. Rasponi nel Tomo della Basilica Lateranense con la iscriz= ione del di Lui nome come stava nella suddetta Basilica, e ristampata da Monsig.^r Ciampini senza il nome del Papa —— 137		(133)	43
9101 **198**	Pittura, che si dice ricopiata dalla Chiesa di S. Lorenzo nel Cas= tello detto Monte di Giove ———————————— 138		(134)	44
9102–5 **245–8**	Immagini di Giove, di Pane etc. ricopiate da figurine antiche d'avorio———————————————————— 139		(135)	45
9106–10 **249–53**	Immagini de Santi, e de Personaggi Christiani ricavate da vetri antichi ritrovati ne Cemeteri de SS. Martiri. La prima mi pa= re che riferisca Minuzio Felice, l'auttore del Dialogo intito= lato Octavius. Stà nel Museo Ghigi del Casino ———— 140		(136)	46
9111–28 **254–71**	Seguono l'altre stampate da Monsig.^r Fabretti in parte, e dal Sig.^r Senatore Bonarroti, e dal Sig.^r Canonico Boldetti —— 141–142		(137–138)	47, 48
9129–39 **272–282**	Altre, in una delle quali è CALLISTUS. stampate similmen= te dal Sig.^r Senatore Bonarroti, e dal Sig.^r Canonico Boldetti —— 143		(139)	49
9140–43 **286, 292–4**	Lucerne de Christiani stampate da Pietro Santi Bartoli ———— 144		(140)	50
9146A **186**	Immagine del Salvatore in piedi, che resta di Musaico antico nella Tribuna di S. Maria in Monticelli ————————— 145		(141)	51
9144–6 **183–5**	Ivi è ancora la Immagine della deposizione di Christo Sig.^r Nos tro nel sepolcro fasciato con gli aromi ad uso de Giudei, ed Egiz.¹ ————————————————————— 145		(141)	51
9147–60 **206–19**	Figure ricopiate da un volume di pergameno, in cui è scritto l'In= no del Cereo Pasquale Exultet, che mostrano le funzioni, che si fanno nel benedirlo, e i misteri, che per quelle si rappresenta= no. Mi pare di aver veduto l'originale nella Catedrale di Sa= lerno, e che il Pontefice rappresentato in queste funzioni sia San Gregorio VII ———————————— 146 sino al 153		(142–148)	52-58
9161 **244**	Dittica rotonda di legno con Immagini Sacre, e caratteri Illirici. L'originale fu donato alla S. M. di Clemente XI, e ne fu fatta la spiegazione dal Sig.^r Abbate Patrizio, il quale interpretà nelle lettere parte del Tropario della Messa Greca detta di S. Giaco= mo, che oggi dì ancora si recita, prova della Invocazione de San ti sempre ritenta dalla Chiesa ———————————— 154		(149)	59
9162–3 **302–3**	Disegno di un pezzo di calamita armato ———————— 155		(150)	60
9164 **180**	Pittura antica che rappresenta la Predicazione, e il Martirio de SS. Apostoli Pietro, e Paolo in Roma, e stava nella Chiesa antica di S. Andrea in Cata Barbara, ove oggi è il Monastero di S. Antonio Abbate vicino a S. Maria Maggiore stampata da Monsig.^r Ciampini Vet. Mon. Tomo 1 cap. 7 ——————— 156		(151)	61
9165–8 **167–70**	Imagini di S. Leone Terzo, e di Carlo Magno ricavate dalli Mu= saici del Triclinio Leoniano, e di S. Susanna, e stampati dall'Ale= manni nel libro de Parietinis Lateranensibus ————— 157		(152)	62
9169–71 **287–9**	Laminette antiche con il nome, e resurrezzione del Salvatore —— 158		(153)	63

RL inv./ Cat.nos			no. on verso	actual folio no.
9172 178	Musaico fatto da S. Simplicio Papa nella Chiesa di S. Andrea in Cata Barbara, stampato da Monsig.^r Ciampini Vet. Mon. Tomo I cap. 27	159	(154)	64
9173 237	Basso rilievo antico della Beata Vergine che tiene il Bambino Giesù	160	(155)	65
9174 238	Altro basso rilievo della Madre, che tiene il figliuolo fasciato, che suppongo rappresenti la Beata Vergine con il Bambino, come sopra	161	(156)	66
9175 239	Basso rilievo di Cristo Sig.^r Nostro, che sana il cieco nato	162	(157)	67
9176 193	Pianta d'antica Chiesa, ed Immagine della Beata Vergine (forse stà à S. Martino de Monti)	163	(158)	68
9177 241	Dittica Consulare di Flavio Anastasio Console Ordinario Stampa= ta dal P. Wilthemio nel Dittico Leodiense	164	(159)	69
9178 243	Immagini Greche di Nostro Signore Giesù Christo, della B. Ver= gine, e d'altri Santi	165	(160)	70
9179–81 173, 240, 298	Adorazione de Magi presa dall'antico, è di S. Ilaria	166	(161)	71
9182–3 230–1	Sarcofagi di Catervio, e Severina con le loro Iscrizzioni	167	(162)	72
9184–5 232–3	Sarcofago con l'Adorazione de Magi	168	(163)	73
9186–8 234–6	Sarcofago di P. Elio Sabino con la favola di Fetonte	169	(164)	74
9189 229	Sarcofago di Cristiani con la Istoria della sommersione di Fa= raone	170	(165)	75
9190 226	Sarcofago de Cristiani con il Buon Pastore	171	(166)	76
9191 220	Sarcofago del Cemeterio Vaticano con l'ingresso del Signore il dì delle Palme in Gierusalemme stampato dall'Aringhio	172	(167)	77
9192–5 163–6	Musaico antico, che rappresenta il Salvatore sedente sopra il globo, e li XII Apostoli fatto da Ricimere nella Diaconia di S. Agata, e stampato da Monsig.r Ciampini Tomo I. cap. 28 173 sino al 176		(168-171)	78-81
9196 176	Musaico della Tribuna di S. Pudenziana	177	(172)	82
9197–8 121–2	Arco Trionfale di qualche Chiesa, nel quale si vede l'Agnel= lo del Signore, li quattro Evangelisti, e due altri Santi, ed una Santa	178	(173)	83
9200 16	Pittura antica del Signore, e degli Apostoli	179	(174)	84
9201–2 155–6	Urbano Quinto, che tiene le Immagini de SS. Apostoli Pietro e Paolo: e forse era nel Titolo, ò Monastero de SS. Giò. e Paolo. Vedi sopra fol. 116	180	(175)	85
9203–4 160–1	Due altre pitture del portico di S. Lorenzo extra muros	181	(176)	86

RL inv./ Cat.nos		no. on verso	actual folio no.
9205–6 **25–6**	Pitture della Cappella, ò sia Oratorio di S. Nicolò accanto al Triclinio Leoniano, che rapresentano li Papi S. Leone Magno Gelasio Secondo, Pasquale Secondo, e Urbano Secondo stampa= to dall' Abbate Costantino Cajetano nella Vita di Gelasio Se= condo, e dal Padre Papebrochio nel Propileo di Maggio, con il Catalogo de Sommi Pontefici———————————— 182	(177)	87
9207–8 **117, 72**	Due Musaici, l'uno della Tribuna de SS. Nereo, et Achilleo, l' altro di un'altra Tribuna, ma non so di qual Chiesa ———— 183	(178)	88
9209–10 **104, 106**	La Nascita del Salvatore, e la Presentazione al Tempio ricopiata (per quanto mi pare) dal Musaico di Nicolò IV in S. Maria Maggiore ————————————————————— 184	(179)	89
9211 **125**	La metà dell'Arco di Musaico con li 24 Seniori in S. Prassede- 185	(180)	90
9212 **12**	Pianta della Chiesa Titolare di S. Clemente ———————— 186	(181)	91
9213–14 **23–4**	Altre quattro Immagini dell'Oratorio di S. Nicolò vicino al Tricli nio Leoniano, che sono di S. Gregorio Magno, di Alessandro Se= condo, Gregorio Settimo, e Vittore Terzo ——————— 187	(182)	92
9215 **149**	Pittura di S. Benedetto, e di due Santi fatta da Benedetto Primo Papa in S. Sebastiano in Palatio detto in Pallara ———— 188	(183)	93
9216 **115**	Pittura di S. Michele Archangelo, di cui non sò ove sia l'ori= ginale—————————————————————— 189	(184)	94
9217 **73**	La metà del Calendario Ecclesiastico da Gennaro à Giugno ——— 190	(185)	95
9218 **5**	La metà dell'Arco di Musaico di S. Cecilia con i Seniori della Apocalisse———————————————————— 191	(186)	96
9219 **74**	L'altra metà del Calendario dal mese di Luglio &c.————— 192	(187)	97
9220 **120**	Pittura, che rappresenta la Beata Vergine, ed altri Santi ——— 193	(188)	98
9221 **4**	L'altra metà dell'Arco di S. Cecilia con i Seniori dell'Apoca= lissi—————————————————————— 194	(189)	99
missing	Diverse Miniature in pergameno tagliate da un libro delle fun= zioni Pontificali, nelle quali li ritratti di due Pontefici Inno= cenzo Terzo e Alessandro Quarto più volte si ravvisano, e sono incollate su li fogli di questo libro dal foglio 195 sino al 197, che è l'ultimo del Tomo.		missing

CATALOGUE

Acknowledgements
The authors are most grateful to the following people for their help in the preparation of this
volume of the Catalogue: Donald Bailey, Maria Giulia Barberini, Lucos Cozza,
Martin Henig, Ingo Herklotz, Mark Lewis S.J., Paolo Liverani, Marlia Mundell Mango,
Raimondo Moncada, Giovanni Morello, Cornelius Schuddeboom, Saskia Sombogaart,
Lucina Vattuone and David Wright.

CONTENTS OF CATALOGUE

The items catalogued in Volume One, 'Mosaics and Wallpaintings in Roman Churches'
are numbered **1–162**

Volume Two

NOTES FOR THE READER

The following notes are intended to clarify the meaning of key terms,
headings and typographical conventions used in the Catalogue.

CATALOGUE NUMBER: each Catalogue entry has a unique number composed of
the SERIES letter (A = Antiquities and Architecture, B = Natural History); the PART
number in roman numerals, and the ENTRY number, e.g. A. II. 32. Cross-references
to entries within a Part are indicated by the **bold** entry number only. References to
entries in other Parts of the Catalogue Raisonné are to the full Catalogue number.
A list of all planned Parts in the Series appears on p. 6.

PROVENANCE: unless otherwise stated, the provenance for the drawings in this
volume is: dal Pozzo, Albani, George III and by descent to Her Majesty The Queen.
The abbreviation RL signifies the Royal Library; SMS stands for Stirling-Maxwell
Sculpture album.

DRAWING SHEET: size, in millimetres (height followed by width); condition and
Watermark. For discussion and types of watermarks see pp. 293–304.

NUMBERING: Pozzo numbers, where relevant, in *italic*, others in roman type. The
position of Pozzo numbers is given only when it is not in the lower right-hand
corner (the most common position).

ANNOTATION: position, medium and transcription of annotation. For colour
annotations see Volume One, p. 64 and Fig. 19.

VERSO: Information is given only when the verso of a sheet has an image or an
annotation. Some drawings on versos are catalogued separately.

MOUNT SHEET: size, in millimetres (height followed by width); condition and
Watermark. Types A and B correspond to the method of mounting: see Volume One,
p. 35.

BIANCHINI: inventory from the 1740s. See pp. 27–41. I = Latin version, II = Italian
version.

LITERATURE: this pertains to the drawing only. Full details of titles cited in
abbreviated form in the Catalogue will be found in the Bibliography.

OBJECT DRAWN: information regarding the subject of the drawing is given,
including museum location and references as relevant.

ENGRAVINGS: made after the catalogued drawing.

The diagram opposite is a key to the terms used in the Catalogue to describe the
drawings and their mounts

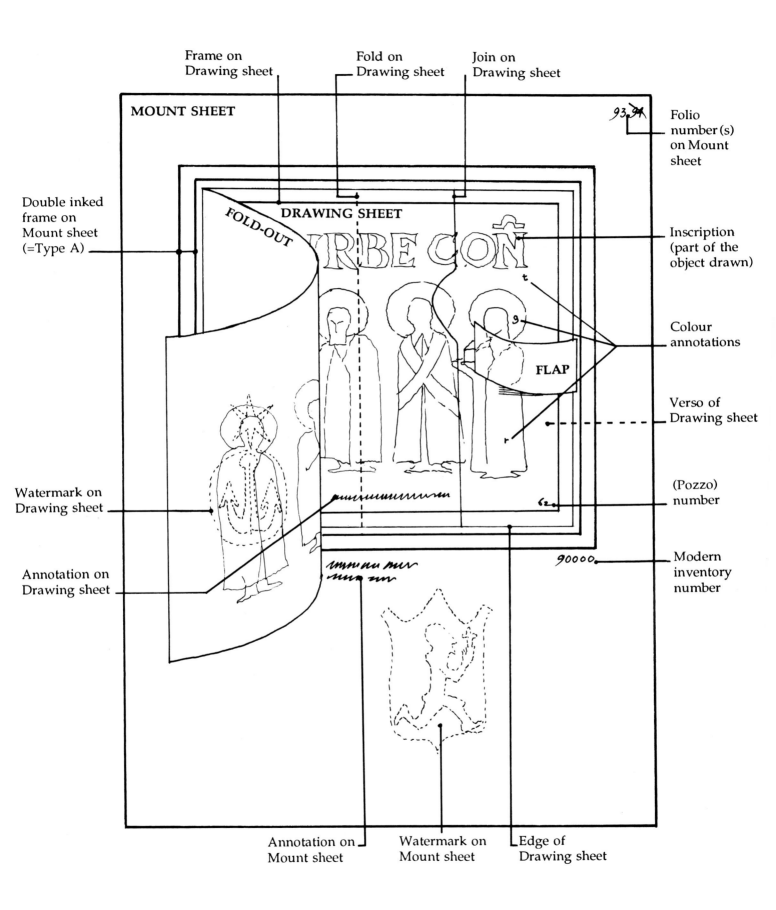

Frame on
Drawing sheet

Fold on
Drawing sheet

Join on
Drawing sheet

MOUNT SHEET

93.94

Folio
number(s)
on Mount
sheet

Double inked
frame on
Mount sheet
(=Type A)

FOLD-OUT

DRAWING SHEET

RBE CON

Inscription
(part of the
object drawn)

FLAP

Colour
annotations

Verso of
Drawing sheet

Watermark on
Drawing sheet

(Pozzo)
number

Annotation on
Drawing sheet

90000

Modern
inventory
number

Annotation on
Mount sheet

Watermark on
Mount sheet

Edge of
Drawing sheet

MOSAICS AND PAINTINGS
COPIED FROM CIACONIO MANUSCRIPTS [163–171]

Alonso Chacón, better known as Alfonso Ciaconio (1530–99), was born near Granada in Spain. He entered the Dominican order, becoming a doctor of theology in 1566. The following year Pope Pius V called him to Rome to be a *penitenziere* at St Peter's. Over the next three decades he devoted himself to historical studies, assembling a substantial library and a museum of antiquities and fossils in his house on the Pincian hill. In 1576 he published a commentary on Trajan's Column and the Dacian Wars, with plates by Girolamo Muziano, which went into five editions in the sixteenth and seventeenth centuries (Ciaconio *Historia*), but his most famous work was an account of the lives and deeds of the popes down to his own day: *Vitae et gesta Summorum Pontificum a Christo Domino usque ad Clementem VIII*, published posthumously in Rome by his nephew in 1601. The library and other papers were dispersed after his death, many being purchased by Francesco Peña, an Aragonese jurist, who left them to the Vatican in 1612. Two codices (BAV, Vat. lat. 5407, 5408) include copies of saints and popes taken from mosaics and wallpaintings in Roman churches. A third (BAV, Vat. lat. 5409) contains drawings of Early Christian sarcophagi (see p. 147) and numerous catacomb paintings: the seven chambers and some of the sculptures in the catacomb of Giordani, some of those in the catacombs of Priscilla nearby, and other catacombs (S. Valentino, Domitilla—'*coemeterium Zephirini papae*'), and the subterranean levels of S. Nicola in Carcere, together with a copy of the memorandum concerning this last which Ciaconio prepared in 1591 for Cardinal Federico Borromeo of Milan (BAV, Vat. lat. 5409, fols 67–71). Other related material is to be found in the Biblioteca Angelica (MS 1564), in the Biblioteca Oliveriano at Pesaro (MS 59), and among the Bosio–Aringhi papers in the Biblioteca Vallicelliana (MS G6).

Ciaconio's manuscripts were much consulted and copied in the late sixteenth and early seventeenth century. Copies made for Cardinal Borromeo survive in the Biblioteca Ambrosiana in Milan. Francesco Barberini also engaged Claude Menestrier on the task in 1629: in a letter to Peiresc that year, Menestrier said he had been employed for some time making drawings of the manuscript of S. Climax and 'other books in the Vatican where there are figures taken from ancient mosaics and paintings and the early church' (Tamizey de Larroque *Lettres*, V, p. 566; Herklotz 1992b, p. 47 and n. 41).

Of the dal Pozzo drawings which derive from Ciaconio, a set of four (**163–6**) copy figures from the apse mosaic of S. Agata dei Goti in BAV, Vat. lat. 5407 and are apparently the work of Antonio Eclissi, thus probably dating from the 1630s. Another set of four (**167–70**) by a different hand all mounted on one folio and with high Carlo Antonio inventory numbers indicating acquisitions of about 1680, were copied from the Ciaconio codex in the Biblioteca Angelica. A ninth (**171**), dated by its watermark to about 1639, is taken from the catacomb drawings now in the Biblioteca Vallicelliana.

LITERATURE: Recio Veganzones 1968, 1974;
DBI xxiv, pp. 352–6 [S. Grassi Fiorentino]

S. Agata dei Goti [163–166]

In the fifth-century mosaic which formerly decorated the apse of the Roman church of S. Agata dei Goti on the Viminal hill (S. Agata in Suburra) the centre was occupied by Christ seated on the orb of the world, flanked by twelve standing apostles, six on either side, all of whom were named in inscriptions (Cecchelli 1924b). The mosaic perished when the apse vault collapsed in 1589. An inscription, read and recorded before that date by Ugonio, named the patron as Flavius Ricimer, the Arian Goth who served as *magister militum* and the power behind the throne to a series of puppet emperors before his death in AD 472.

Christ and all twelve apostles were drawn as a series of separate images in a Ciaconio codex, now in the Vatican Library (Vat. Lat. 5407, pp. 44–72; Waetzoldt 1964, nos 1–13), of which there is a second copy in the Biblioteca Ambrosiana at Milan (F221, inf. 3, fols 1–12, 15–16; Waetzoldt 1964, nos 14–26).

The dal Pozzo set, whose draughtsmanship and technique suggest the hand of Antonio Eclissi (see Volume One, p. 63f.), are perhaps to be associated with the interest taken in the church by Cardinal Antonio Barberini in 1633 and 1636, attested by several inscriptions (Forcella *Iscrizioni* X, nos 578–82). They are clearly based on the Vatican Ciaconio set, following the same order and copying the figures very closely but forming them into groups, presumably in an attempt to recreate the original composition. Ciampini later did the same, also using the drawings in Ciaconio's codex, and reassembled the whole company (*Vet. mon.* I, p. 271., pl. LXXVII).

Comp. fig. 163, 166: Anonymous, *Apse mosaic, S. Agata dei Goti*, engraving, Ciampini, *Vet. mon.* I, pl. LXXVII

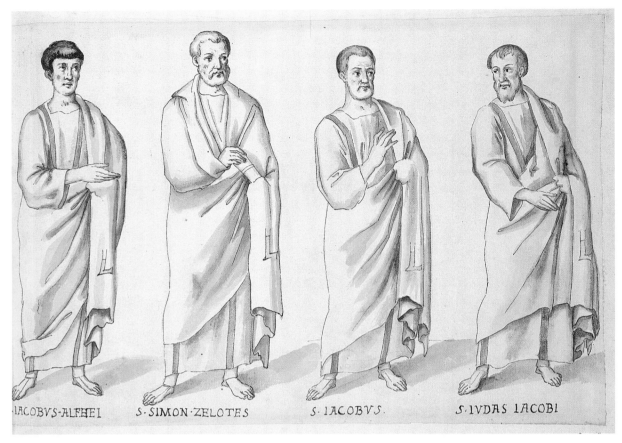

S·IACOBVS·ALFHEI S·SIMON·ZELOTES S·IACOBVS· S·IVDAS IACOBI

163

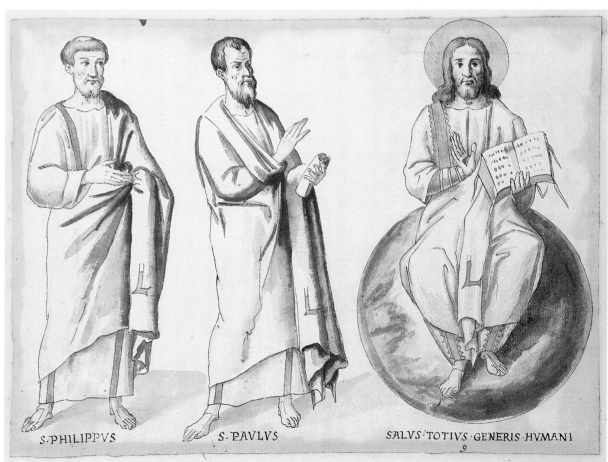

S·PHILIPPVS S·PAVLVS SALVS·TOTIVS·GENERIS·HVMANI

9

164

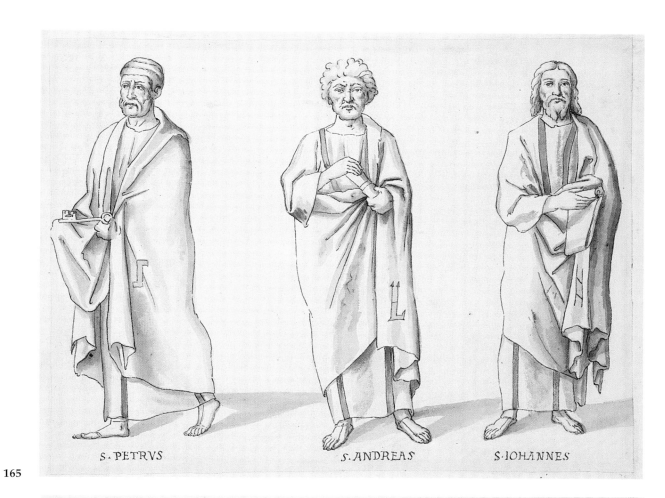

S. PETRVS S. ANDREAS S. IOHANNES

165

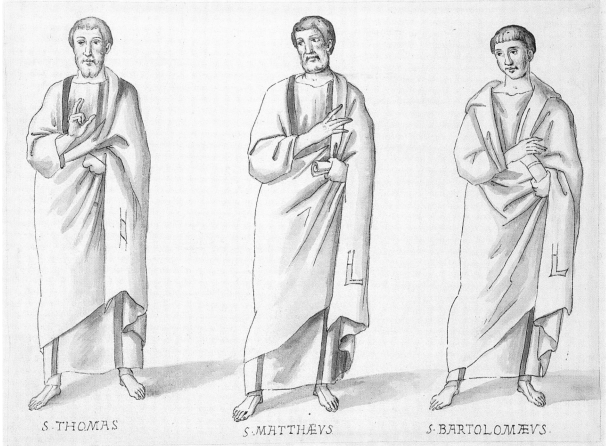

S. THOMAS S. MATTHÆVS S. BARTOLOMÆVS

166

163. BAV, Vat. lat. 5407: four apostles from the apse mosaic of S. Agata dei Goti, Rome

ANTONIO ECLISSI (fl. 1630–44)

Windsor, RL 9193

Watercolour, pen and ink and dark brown wash, over traces of black chalk

271 × 391 mm. *Watermark*: Figure *16*

MOUNT SHEET: type B

BIANCHINI: fol. 174 [see **164**]

The drawing copies the images of the first four apostles from the left-hand side of the apse: James the Less ('S. IACOBUS ALFHEI'), Simon ('S. SIMON ZELOTES'), James ('S. IACOBUS'), and Judas ('S. IUDAS IACOBI').

LITERATURE: Waetzoldt 1964, no. 28

OBJECT DRAWN: BAV, Vat. lat. 5407, pp. 46, 48, 50, 52 respectively. Waetzoldt 1964, nos 1–4, figs 1–4

OTHER DRAWINGS: Milan, Biblioteca Ambrosiana, F221, inf. 3, fols 15, 16, 3, 4 respectively

164. BAV, Vat. lat. 5407: two apostles and Christ from the apse mosaic of S. Agata dei Goti, Rome

ANTONIO ECLISSI (fl. 1630–44)

Windsor, RL 9192

Watercolour, with gold powder in gum arabic, pen and ink and dark brown wash, over black chalk

268 × 351 mm. Stained and brittle. *Watermark*: Coat of Arms 5

NUMBERING: [beneath image of Christ] *9*

MOUNT SHEET: type B

BIANCHINI fol. 173, I and II: Early mosaic which represents the Saviour seated on the globe and the Twelve Apostles (I: with their names) commissioned by Fl. Ricimere in the Diaconia of S. Agata in Suburra, and printed by Monsignor Ciampini Volume I, chap. 28.

The drawing depicts the central section of the mosaic, with the figure of Christ seated on a large orb, beneath which is the inscription 'SALUS TOTIUS GENERIS HUMANI' ('the salvation of the entire human race'). To the left are Saints Philip ('S. PHILIPPUS') and Paul ('S. PAULUS').

LITERATURE: Waetzoldt 1964, no. 27

OBJECT DRAWN: BAV, Vat. lat. 5407, pp. 54, 56, 58 respectively. Waetzoldt 1964, nos 5–7, figs 5–7

OTHER DRAWINGS: Milan, Biblioteca Ambrosiana, F221 inf. 3, fols 5, 6, 1 respectively

165. BAV, Vat. lat. 5407: three apostles from the apse mosaic of S. Agata dei Goti, Rome

ANTONIO ECLISSI (fl. 1630–44)

Windsor, RL 9194

Watercolour, and pen and ink, over traces of black chalk

265 × 345 mm. *Watermark*: Figure 17

MOUNT SHEET: type B. *Watermark*: Anchor 14

BIANCHINI: fol. 175 [see **164**]

The drawing depicts the three apostles who stood immediately to the right of Christ: Peter ('S. PETRUS'), Andrew ('S. ANDREAS') and John ('S. IOHANNES').

LITERATURE: Waetzoldt 1964, no. 29

OBJECT DRAWN: BAV, Vat. lat. 5407, pp. 62, 64, 66 respectively. Waetzoldt 1964, nos 8–10, figs 8–10

OTHER DRAWINGS: Milan, Biblioteca Ambrosiana, F221, inf. 3, fols 2, 7, 8 respectively

166. BAV, Vat. lat. 5407: three apostles from the apse mosaic of S. Agata dei Goti, Rome

ANTONIO ECLISSI (fl. 1630–44)

Windsor, RL 9195

Watercolour, and pen and ink, over traces of black chalk

268 × 351 mm

MOUNT SHEET: type B. *Watermark*: Hills 9

BIANCHINI fol. 176 [see **164**]

The drawing depicts the three apostles at the far right of the apse: Thomas ('S. THOMAS'), Matthew ('S. MATTHAEUS') and Bartholomew ('S. BARTOLOMAEUS').

LITERATURE: Waetzoldt 1964, no. 30

OBJECT DRAWN: BAV, Vat. lat. 5407, pp. 68, 70, 72 respectively. Waetzoldt 1964, nos 11–13, figs 11–13

OTHER DRAWINGS: Milan, Biblioteca Ambrosiana, F221, inf. 3, fols 9–11 respectively

167. Biblioteca Angelica, MS 1564: three saints from mosaics in Rome

SEVENTEENTH-CENTURY ITALIAN

Windsor, RL 9165

Watercolour and bodycolour, and pen and ink, over black chalk

105 × 180 mm

NUMBERING: [below the two figures at left] *900*
 [below figure at right] 901

ANNOTATION: [between figures at right, brown ink] *H alibi*

MOUNT SHEET: type B. Also bears **168–70**.
Watermark: Fleur de Lys 70 (cut)

BIANCHINI fol. 157 [not mentioned]

In Ciaconio's manuscript, probably taken from originals by Philips van Winghe (Schudde-boom 1996, p. 101f.), the three figures are identified by captions, the two on the left as *Ex musivo absidis S. Andreae in Exquiliis anno 468* 'From the mosaic in the apse of S. Andrea (cata Barbara) on the Esquiline, the year 468' (where they stood to the right of St Peter, see **178**), and that at the right, holding a crown, as *Ex musivo S. Venantii anno 638* 'From the mosaic of S. Venanzio (in the Lateran Baptistery), the year 638'. He is one of the four Dalmatian martyrs depicted in the mosaic, all almost identical in pose, dressed in *chlamys* with *tablion*, but the shoulder ornament and drapery folds are closest to the figure labelled Telius (compare Matthiae 1967, pl. 105).

For van Winghe, Ciaconio and the later copyist the principal interest lay in the nature and arrangement of the clothing, which is distinctly different in each case. The note placed between the two saints at the left: '*H alibi*' (elsewhere H), is also part of the Ciaconio manuscript and refers to the *gammadia*, i.e. the decorations resembling Greek letters which appear on the saints' garments.

The 'Pozzo' numbers *900* and *901* belong to Carlo Antonio's inventory and indicate acquisitions in the early 1680s, at the same time as the other three drawings which are mounted on the same folio (see **168–70**). The hand can be compared with **178**, **180**, **187–92**.

LITERATURE: unpublished

OBJECT DRAWN: Rome, Biblioteca Angelica, MS 1564, fol. 44. Recio Veganzones 1974, pp. 318–21, fig. 4

OTHER DRAWINGS: S. Venanzio figure: [Peiresc—Menestrier] BAV, Vat. lat. 10545, fol. 47. Waetzoldt 1964, no. 272, fig. 149

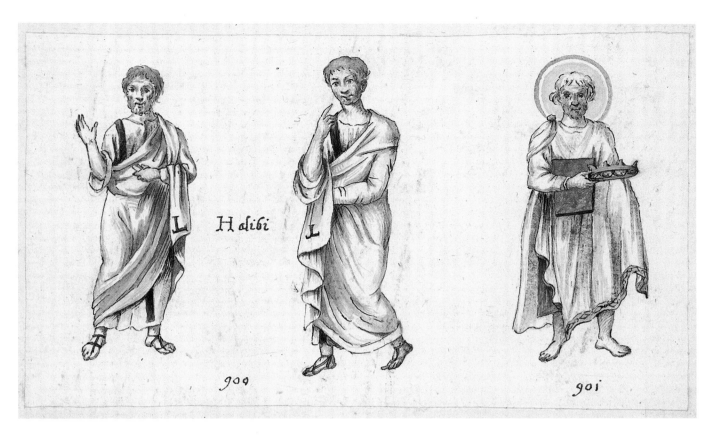

167

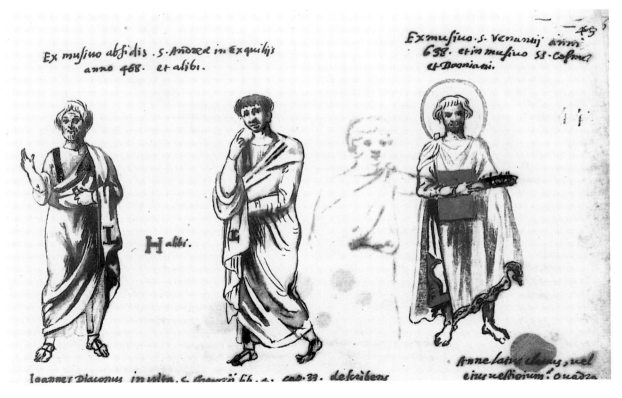

Comp. fig. 167: Anonymous, *Three saints from apse mosaics in S. Andrea on the Esquiline and S. Venanzio.*
Rome, Biblioteca Angelica, MS 1564, fol. 44 (top)

168. Biblioteca Angelica, MS 1564: St Peter, Pope Leo III and Charlemagne, from the *Triclinium* of Leo III in the Lateran Palace, Rome

SEVENTEENTH-CENTURY ITALIAN

Windsor, RL 9166

Watercolour and bodycolour, and pen and ink, over black chalk

185 × 188 mm. *Watermark*: Fleur de Lys 67 (cut)

NUMBERING: [lower centre] *904*

MOUNT SHEET: type B. Also bears **167**, **169–70**.
Watermark: Fleur de Lys 70 (cut)

BIANCHINI fol. 157, I and II: Images of his Holiness Leo III and Charlemagne taken from the Mosaics of the Leonine Triclinium and of S. Susanna and printed by Alemanni (II:) in the book *de Parietinis Lateranensibus*.

Built and decorated early in the pontificate of Leo III (795–816), by the later 16th century the *Triclinium* (grand dining-reception hall) was a ruin, with only the south end of the hall still partly intact and only fragments of the mosaics remaining in the apse and on its surrounding arch. On the left side of the arch, Christ may have been shown entrusting the Christian Church to Pope Silvester (or to St Peter) and to the first Christian emperor, Constantine. (There is some dispute on this point, since even the earliest copies indicate that the mosaics on this side had already been lost: see Schramm 1928, p. 27; Belting 1976; and Iacobini 1989b.) On the right side, shown in the dal Pozzo drawing, a similar formula was employed, with St Peter, identified by an inscription as 'SCS (i.e. sanctus) PETRUS', investing the contemporary figures of Leo III ('S(an)C(t)ISSIMUS D(ominus) N(oster) LEO P(a)P(a)') and Charlemagne('D(ominus) N(oster) CAROLUS REX') with the symbols of their authority. Leo receives the papal pallium, and Charlemagne either the Constantinian banner (*labarum*) or the standard of the *patricius Romanorum*. Both have their heads framed by square 'haloes', indicating living portraits. (Charlemagne's title of 'rex' should suggest a date before his coronation as Holy Roman Emperor on 25 December 800.)

The mosaics attracted the attention of church historians and antiquaries from the mid 16th century onwards, culminating in an extensive restoration financed by Francesco Barberini in 1624–5 (see Herklotz 1995). Nicolò Alemanni

Comp. fig. 168 (i): Anonymous, *Triclinium of Leo III*, engraving, Alemanni 1625 pl. II

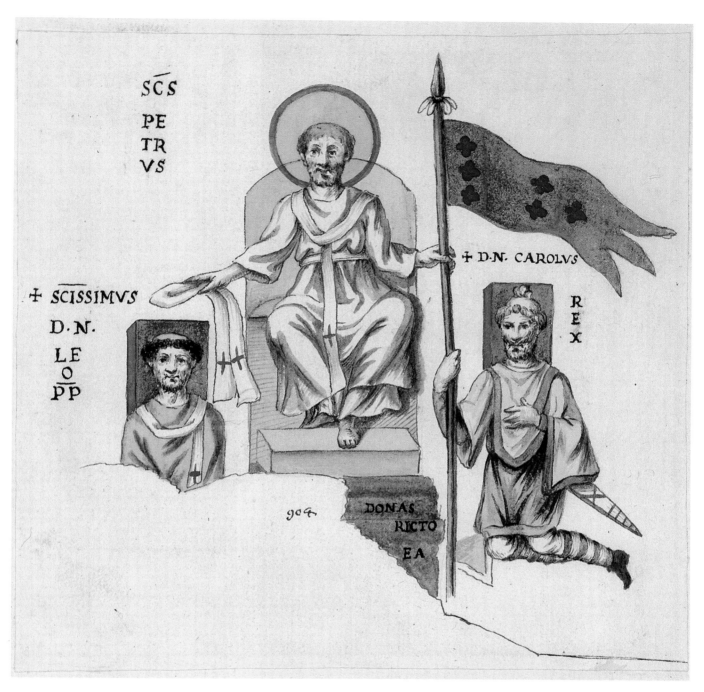

SCS
PE
TR
VS

✝ SCISSIMVS
D·N·
LE
O
PP

✝ D·N· CAROLVS

REX

904

DONAS
RICTO
EA

168

(1625, pp. 42, 55, 80, 130, 145f.) relates how the reconstruction made use of descriptions and drawings among the papers of Onofrio Panvinio and Angelo Massarello which recorded more of the inscriptions and other elements of the design, such as Leo's lower body, which had since fallen away. Drawings in Panvinio and Grimaldi codices in the Barberini collections (BAV, Barb. lat. 2738 and 2733) could be some of those in question (Davis-Weyer 1965, p. 179f.). Another source cited by Alemanni (p. 52) is a drawing of 'Francesco Penna' (i.e. Peña), by which he probably meant one in the Ciaconio codex in the Vatican (Vat. lat. 5407). That is a second copy after an earlier drawing in the Ciaconio codex in the Biblioteca Angelica.

Ciaconio's Biblioteca Angelica drawing, of which the dal Pozzo drawing is a very accurate copy, is itself a copy, likely to have been taken in about 1590 from an original by Philips van Winghe (Schuddeboom 1996, p. 103). A seemingly autograph version was obtained by Peiresc in 1608 as a gift from Philips' brother Hieronymus and survives among Peiresc's papers at Carpentras. Peiresc sent a copy of the latter to Girolamo Aleandro in Rome in 1608, asking him to check the inscription relating to the figure of Charlemagne and later corresponded on the occasion of the Barberini res-

toration (Müntz 1884, p. 6, n. 1). The copy sent to Aleandro could well be that in another Barberini codex (BAV, Barb. lat. 2062) usually associated with the name of Joseph-Marie Suarès. Another copy closely related to and perhaps also taken from Peiresc's van Winghe drawing, in the possession of his friend Pierre-Antoine De Rascas de Bagarris (1562–1620), is attested at second hand by a print published by Jacob Spon at Lyons in 1685 (*Miscellanea*, p. 284, pl. III; Schramm 1928, fig. 4g; Davis-Weyer 1965, fig. 10). According to its numbering the dal Pozzo copy was acquired in the early 1680s.

Most of the copies circulating in the 17th century did so in company with two corresponding images of Leo III and Charlemagne from the apse mosaic of S. Susanna, also descendants of drawings by Philips van Winghe, with their genesis either in those among his papers in Flanders or through the medium of Ciaconio's copies in Rome (see **169-70**).

Although the Leonine *Triclinium* was demolished under Pope Clement XII (1730–40), a reconstructed version of the apse and arch decorations was commissioned soon afterwards by Pope Benedict XIV and completed in 1743. It still exists, opposite the façade of the Lateran basilica, more or less on the site of the original (Schramm 1928, fig. 4c).

LITERATURE: Marriott 1868, p. lii; Waetzoldt 1964, no. 221; Davis-Weyer 1965, p. 185

OBJECT DRAWN: Rome, Biblioteca Angelica, MS 1564, fol. 48v [49v]. Davis-Weyer 1965, pp. 184–7 (with tentative attribution of original to Jean L'Heureux in preference to van Winghe); Recio Veganzones 1974, pp. 326–8, fig. 7; Schuddeboom 1996, p. 103f., fig. 31

OTHER DRAWINGS: [Panvinio] BAV, Barb. lat. 2738, fol. 104 (Ladner *Papstbildnisse* I (1941), pl. XIIIa; Davis–Weyer 1965, fig. 1). [Grimaldi] BAV, Barb. lat. 2733, fols 309v–311 (Schramm 1928, figs

4h–k; Ladner, op. cit., p. 114f., figs 96–8; Davis-Weyer 1965, fig. 2). [Ciaconio, later copy from Biblioteca Angelica] BAV, Vat. lat. 5407, fol. 97 (p. 186) (Schramm 1928, fig. 4e; Davis-Weyer 1965, p. 183, fig. 6). [Van Winghe—Peiresc] Carpentras, Bibliothèque Inguimbertine, MS 1784, fol. 115v (Schuddeboom 1996, p. 102, fig. 30). [Peiresc—Aleandro—Suarès] BAV, Barb. lat. 2062, fol. 61 (Ladner, op. cit., p. 114, fig. 95; Schramm 1928, fig. 4f.; Schuddeboom 1996, p. 103, n. 376). [Miscellany] BAV, Barb. lat. 4423, fol. 12 (Müntz 1888, p. 117)

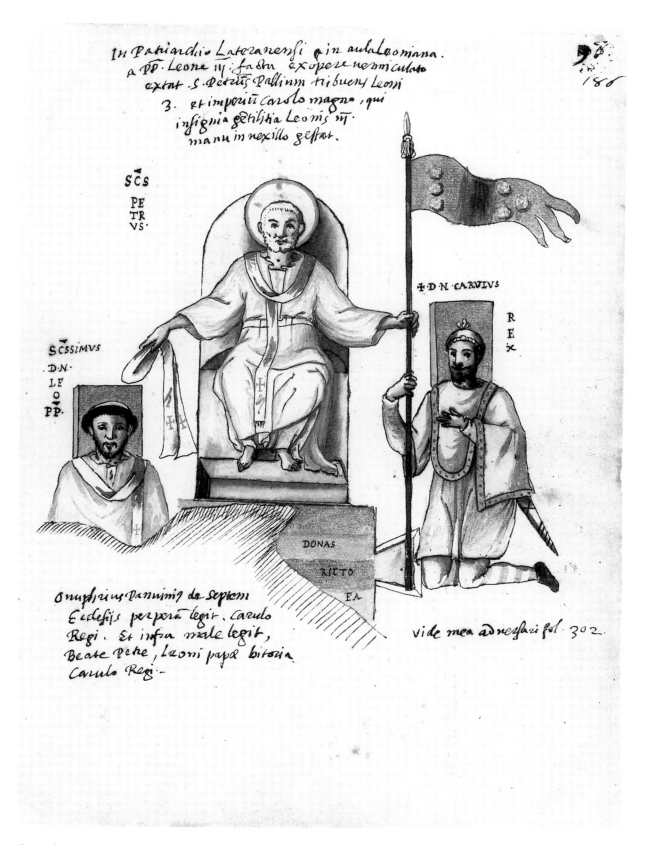

In Patriarchio Lateranensi q̃ in aula Leonina.
a PP. Leone iij. facta exopere vermiculato
extat. S. Petrus Pallium tribuens Leoni
3. et imperiũ Carolo magno, qui
insignia gentilitia Leonis iij.
manu in vexillo gestat.

SCS
PE
TR
VS.

SCSSIMVS
D.N.LE
O
PP.

✠ D N CARVLVS

REX

DONAS
RICTO
EA

Onuphrius Panuinis de septem
Ecclesijs perpera legit. Carulo
Regi. Et infra male legit,
Beate Pere, Leoni papa historia
Carulo Regi:-

vide mea adversari fol. 302.

Comp. fig. 168 (ii): Anonymous, *St Peter, Pope Leo III and Charlemagne, from the Triclinium of Leo III.*
BAV, Vat. lat. 5407, fol. 97

169. Biblioteca Angelica, MS 1564: Pope Leo III, from the apse of S. Susanna, Rome

SEVENTEENTH-CENTURY ITALIAN

Windsor, RL 9167

Watercolour and bodycolour, and pen and ink, over black chalk

152 × 91 mm

NUMBERING: [bottom centre] *902*

MOUNT SHEET: type B. Also bears **167–8**, **170**.
Watermark: Fleur de Lys 70 (cut)

BIANCHINI fol. 157 [see **168**]

This drawing and its companion (**170**) complement the previous drawing (**168**) in depicting the figures of Pope Leo III (795–816) and Charlemagne from the apse mosaic in the church of S. Susanna on the Quirinal hill in Rome, where they appeared in addition to various saints shown flanking a central image of Christ. Leo III, his head enclosed in a square 'halo' indicating a portrait, is holding a model of the church, which he had built and decorated (see *Liber Pontificalis* ii, p. 3; Ladner, *Papstbildnisse* I (1941), pp. 126–8, III (1984), p. 31). The mosaic was destroyed in 1595, when the church was radically restored by Cardinal Rusticucci.

As in the case of **168**, the dal Pozzo drawings reproduce Ciaconio's copies in the codex in the Biblioteca Angelica, not that in the Vatican, and are matched by a series of other copies all ultimately linked to the name of Philips van Winghe, who probably made the prototypes in about 1590 (Schramm 1928, p. 29, figs 5a–e; Ladner, op. cit.; Schuddeboom 1996, p. 103). Davis-Weyer (1965, p. 187f.) considered the apparent quality of the original drawings too amateurish for van Winghe and reasoned instead in favour of Jean L'Heureux. Prints were published by Alemanni in 1625 (p. 10), based on the copy in the Vatican Ciaconio codex (Vat. lat. 5407, fol. 96), and by Spon in 1685 (*Miscellanea*, p. 284, pls I–II; Schramm 1928, fig. 5d; Davis-Weyer 1965, figs 8–9), citing de Bagarris as his source (see **168**).

LITERATURE: Waetzoldt 1964, no. 1063

OBJECT DRAWN: Rome, Biblioteca Angelica, MS 1564, fol. 45 [46]. Davis-Weyer 1965, fig. 4; Recio Veganzones 1974, pp. 321–6, fig. 5

OTHER DRAWINGS: [Van Winghe—Peiresc] Carpentras, Bibliothèque Inguimbertine, MS 1784, fol. 118 (Davis-Weyer 1965, p. 185). [Peiresc—Menestrier] BAV, Vat. lat. 10545, fol. 235 (Schramm 1928, fig. 5a; Ladner, *Papstbildnisse* I (1941), pl. XIIIc; Davis-Weyer 1965, fig. 11). [De Villers] Paris, BN, nouv. acq. lat. 2343, fol. 80 (Schuddeboom 1996, p. 79). [Ciaconio copy of Biblioteca Angelica] BAV, Vat. lat. 5407, fol. 96 (Ladner, op. cit., p. 127, fig. 107; Davis-Weyer 1965, fig. 7). [Ciaconio, Leo III alone, independent source] BAV, Vat. lat. 5407, fol. 74 (p. 140) (Ladner, op. cit., p. 127, fig. 106; Davis-Weyer 1965, fig. 3). [Peiresc—Aleandro—Suarès] BAV, Barb. lat. 2062, fol. 62 (Schramm 1928, fig. 5c; Ladner op. cit., p. 127, fig. 108; Davis-Weyer 1965, p. 185; Schuddeboom 1996, p. 103)

170. Biblioteca Angelica, MS 1564: Charlemagne, from the apse of S. Susanna, Rome

SEVENTEENTH-CENTURY ITALIAN

Windsor, RL 9168

Watercolour and bodycolour, and pen and ink, over traces of black chalk

153 × 91 mm

NUMBERING: [bottom centre] *903*

MOUNT SHEET: type B. Also bears **167–9.**
Watermark: Fleur de Lys 70 (cut)

BIANCHINI fol. 157 [see **168**]

The figure of Charlemagne stood at the far right of the apse mosaic, balancing that of Pope Leo III. The drawing forms a pair with **169,** similarly deriving from Ciaconio's manuscript which is now in the Biblioteca Angelica, rather than that in the Vatican.

LITERATURE: Waetzoldt 1964, no. 1064

OBJECT DRAWN: Rome, Biblioteca Angelica, MS 1564, fol. 47 [48]. Recio Veganzones 1974, pp. 321–6, fig. 6

OTHER DRAWINGS: [Van Winghe—Peiresc] Carpentras, Bibliothèque Inguimbertine, MS 1784, fol. 116, and those listed under **169**

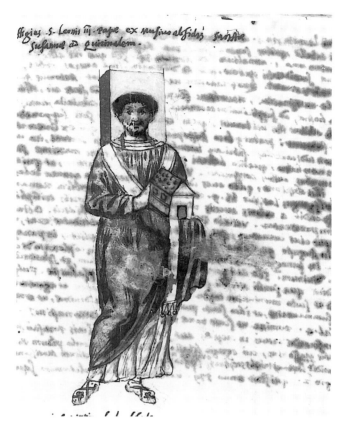

Comp. fig. 169: Anonymous, *Pope Leo III from the apse mosaic of S. Susanna.* Rome, Biblioteca Angelica, MS 1564, fol. 45

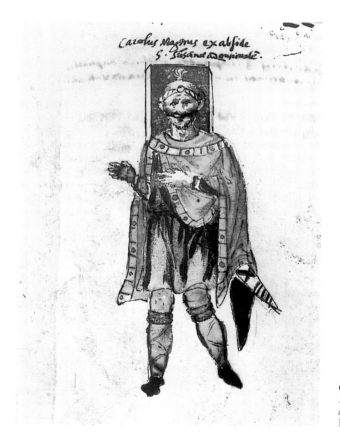

Comp. fig. 170: Anonymous, *Emperor Charlemagne from the apse mosaic of S. Susanna.* Rome, Biblioteca Angelica, MS 1564, fol. 47

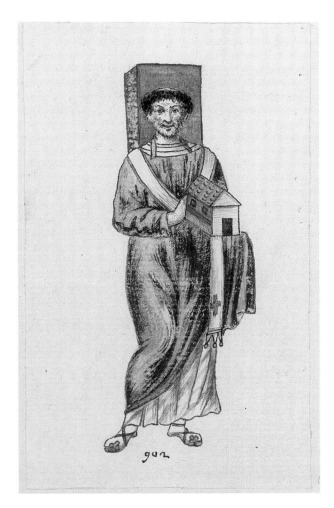

169

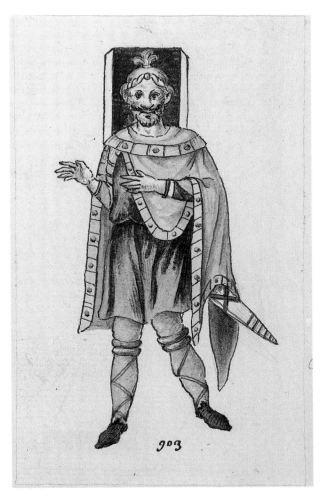

170

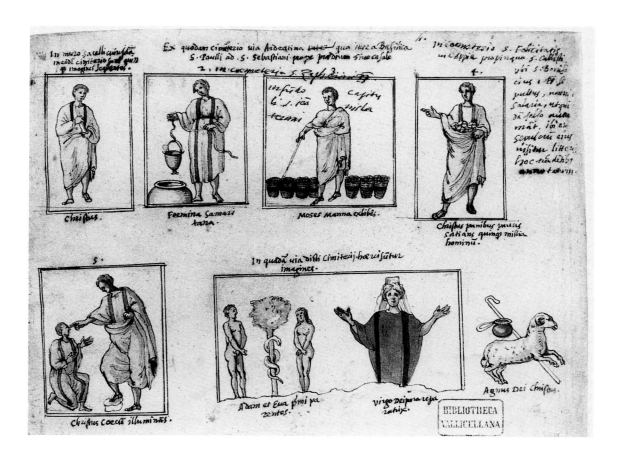

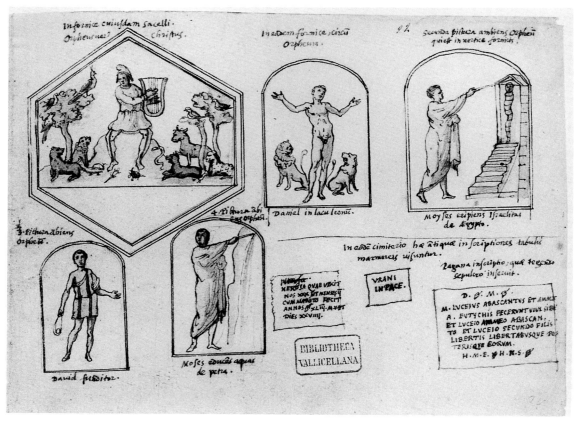

Comp. fig. 171: Anonymous, *Paintings and inscriptions in the Catacomb of Domitilla.*
Rome, Biblioteca Vallicelliana MS G6, fols 4 and 22

171. Biblioteca Vallicelliana, MS G6: paintings and inscriptions in the Catacomb of Domitilla, Rome

SEVENTEENTH-CENTURY ITALIAN *c.* 1639

Windsor, RL 9067

Watercolour and bodycolour, and pen and ink, over graphite

463 × 338 mm. *Watermark*: Hills 6

ANNOTATION: [brown ink] *Ex quodam Cimeterio via Ardentiana* [sic], *qua itur a Basilica S. Pauli ad S. Sebastiani prope Praedium sive casale in cimeteri S. Zefferini PP et Martiris* ('From a certain cemetery on the via Ardeatina, which leads from the basilica of S. Paolo to S. Sebastiano, near the estate or farmhouse in the cemetery of St Zephyrinus pope and martyr')

> *In muro sacelli cuiusdam in eodem cimiterio sunt quinque imagines sequentes* ('On the wall of a certain chamber in the same cemetery are the five following images')
>
> 1. *Christus* ('Christ')
>
> 2. *Foemina Samaritana* ('the Samaritan woman')
>
> 3. *Moises Manna exhibens* ('Moses displaying the manna')
>
> 4. *Christus panibus paucis satians quinque millia hominum* ('Christ satisfying five thousand men with a few loaves of bread')
>
> 5. *Christus Caecum illuminans* ('Christ giving sight to the blind man')
>
> *In coemeterio S. Foelicitatis Via Appia propinquo S. Callisti, ubi S. Bonifacius I PP sepultus non Via Salaria, ut quidam falso autumant, ibi esse Sepulcrum eius visitur licteris* [litteris] *hoc tradentibus annotantur 131* ('In the cemetery of St Felicitas on the via Appia near St Callixtus, where Pope Boniface I is buried (not on the via Salaria as some falsely claim), there his tomb is visited, as recorded by inscriptions of which 131 are noted'[?])
>
> *In quadam via dicti Cimiterii hae visuntur imagines* ('In a certain passage of the aforesaid cemetery these images are seen')
>
> *Adam et Eva primi parentes* ('Adam and Eve, the first parents')
>
> *Virgo Dei paratrix* ('the Virgin bearer of God')
>
> *Agnus Dei Christus* ('Christ the lamb of God')
>
> *In fornice cuiusdam sacelli*
>
> *Orpheus verus Christus*
>
> ('In the vault of a certain chamber Orpheus the true Christ')
>
> *In eadem fornicem circum Orpheum*
>
> *Daniel in lacu leonum*
>
> ('On the same vault around Orpheus: Daniel in the lions' den')
>
> *Secunda pictura ambiens Orpheum qui est in*
>
> *vertice formicis* [fornicis]
>
> *Moises eripiens Israelitas de Aegypto*
>
> ('The second picture around Orpheus in the crown of the vault: Moses leading the Israelites out of Egypt')

David funditor

('David the slinger')

Pictura ambiens Orpheum

Moises educens aquas de petra

('A picture around Orpheus: Moses drawing the waters froma rock')

In eodem cimeterio hae antiquae inscriptiones

tabulis marmoreis visuntur

('In the same cemetery are seen these ancient inscriptions on marble tablets')

Pagana inscriptio, quae tegendo sepulcro

inseruit

('A pagan inscription, installed as the covering for a tomb')

MOUNT SHEET: type B

BIANCHINI fol. 121, I and II: Paintings from the Cemetery of S. Felicia and other Saints (I:) Via Appia and (I and II:) Via Ardeatina.

The whole page, including the annotations, was copied from a sheet (now in two pieces) in a codex in the Biblioteca Vallicelliana in Rome. It is possible that the same copyist produced the dal Pozzo copies of the Tolentino sarcophagus and the Calendar of AD 354 (see below **230–33**). The watermark Hills 6 is also found on **36**, dateable to 1639.

Once owned by Antonio Bosio (see Volume One, p. 45f.), subsequently passing to his editorial heirs Giovanni Severano and Paolo Aringhi, the Vallicelliana codex incorporates material acquired from various sources, but De Rossi (1864, p. 29) identified the handwriting on the original sheet as that of Alfonso Ciaconio. Wilpert judged its drawings among the finest of the many copies of catacomb murals which Ciaconio possessed (Wilpert 1891, p. 41). Schuddeboom (1996, pp. 147–58) suggests that they may have been taken from originals by Philips van Winghe (1560–92, see p. 311 below). Ciaconio's Vatican codex contains drawings of two of the scenes by another hand.

The catacomb in question, located between the via Appia and the via Ardeatina, about 1.5 km beyond the city walls, was discovered in 1591 (Schuddeboom 1996, p. 145). Bosio explored it in December 1593, in company with Ciaconio and others. At first it had no name, but was subsequently believed to be that of St Zephyrinus (pope, 198/9–217), hence the

heading and sub-heading on the drawing. The annotation at the top right indicates that at some stage Ciaconio had associated it with St Felicitas, whereas Bosio later identified it with Zephyrinus' immediate successor St Calixtus (*Roma Sotterranea* pp. 195–283; cf. Aringhi *Roma Subterranea* I, pp. 491–593). Today it is known as the Catacomb of Domitilla.

With the exception of those at the right on the second row, all the figures in the drawing are taken from the paintings in a *cubiculum* of the third century AD, of which Bosio provided a comprehensive account in the *Roma Sotterranea* (pp. 237–49. Cf. Aringhi *Roma Subterranea* I, pp. 544–57; Wilpert 1903, pls 54–5; Nestori 1975, p. 122, no. 31). The figures at the top, numbered 1–5, come from three of the walls; those in the lower half are from the ceiling. The frames reflect (not very accurately; the hexagon should be an octagon), the panels into which the original decorative schemes are divided. The male figure at the top left, labelled on Ciaconio's drawing as Christ, was more plausibly identified by Bosio with a 'martyr' (one of the people buried in the *cubiculum*). Bosio (and all scholars since) would agree with Ciaconio, however, that the Orpheus charming the animals with his lyre, though borrowed directly from the repertory of Classical art, was seen by the Early Christians as a 'type' of Christ. The other subjects represent biblical

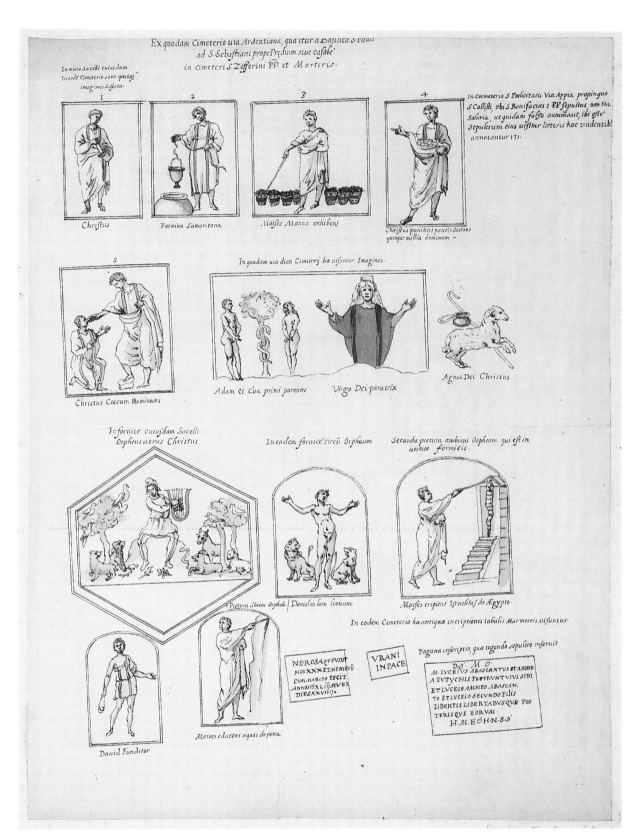

Ex quodam Cimeterio uia Ardentiana, qua itur a Basilica S. Pauli
ad S. Sebastiani prope Prædium siue casale
in Cimeteri S. Zefferini PP. et Martiris.

In muro Sacelli cuiusdam.
In eod⁀e Cimiterio sunt quinq⁀;
imagines seguntes.

1 2 3 4

In Coemeterio S. Foelicitatis Via Appia propinquo
S. Callisti, ubi S. Bonifacius I. PP. sepultus non uia
Salaria, ut quidam falso autument, ibi esse
Sepulcrum eius uisitur litteris hoc tradentib.
annotantur 171.

Christus Foemina Samaritana Moises Manna exhibens Christus panibus paucis Sacians
 quinque millia hominum –

5

In quadam uia dicti Cimiterij hæ uisuntur Imagines.

Christus Coecum Illuminans Adam et Eua primi parentes Virgo Dei paratrix Agnus Dei Christus

In fornice cuiusdam Sacelli In eadem fornice circa Orpheum Secunda pictura ambiens Orpheum qui est in
Orpheus uerus Christus uertico formicis.

Pictura abiens Orphe⁀u Daniel in lacu leonum. Moises eripiens Israelitas de Ægypto.

In eodem Cimeterio hæ antiquæ inscriptiones tabulis Marmoreis uisuntur

David Funditor Moises educens aquas de petra.

NERO SA QVEVRVNT
NOS XXX ET MENSES.j
CVM MARITO FECIT
ANNOS IX.XLIIJ.M.VET
DIES XXVIIJ.

VRANI
IN PACE

Pagana inscriptio, qua tegendo sepulcro inseruit

D⁀ø. M. ⁀ø
M. LVCEIVS ABASCANTVS ET AMME
A EVTYCHIS FECERVNT VIVI SIBI
ET LVCEIO AMMEO ABASCAN
TO ET LVCEIO SECVNDO FILIS
LIBERTIS LIBERTABVSQVE POS
TERISQVE EORVM
H. M. E. Ø. H. N. S. Ø.

171

episodes which were widely popular in Early Christian funerary art: the New Testament miracles of Christ, Multiplying the Loaves, Healing the Blind Man, Raising Lazarus from the dead (which Ciaconio mistook for Moses leading the Israelites out of Egypt), and the story of the Samaritan woman drawing water from the well; the Old Testament stories of Moses and the baskets of manna, Daniel in the Lion's Den, David, slayer of Goliath, with his slingshot, Moses striking the rock and bringing forth water. The Adam and Eve, the woman with her hands raised in prayer and the lamb with the shepherd's staff and milk-pail (the latter two seen by Ciaconio as the Virgin Mary and the Lamb of God respectively) came from one of the passages elsewhere in the catacomb,

as their caption above them states. They do not appear to be those published by Bosio (*Roma Sotterranea* p. 273).

The funerary inscriptions transcribed at the bottom right were reproduced in very similar form in Bosio's *Roma Sotterranea* (pp. 215 and 195). The first records a woman named (Ve)nerosa, who lived for 30 years and two months (*ICUR* III, no. 8585), the second a certain Uranus (*ICUR* III, no. 8599). The pagan inscription of M. Lucceius Abascantus and his wife Ammea Eutychis (*CIL* VI, no. 21525), which, as Ciaconio noted, had been reused to seal a Christian tomb, was removed by Bosio to his villa on the via Flaminia (*Roma Sotterranea*, p. 195).

LITERATURE: Lanciani 1895, p. 191f.

OBJECT DRAWN: [upper half] Rome, Biblioteca Vallicelliana, MS G6, fol. 4; [lower half] ibid., fol. 22. Wilpert 1891, pp. 41–6, pls xix–xx; Schuddeboom 1996, pp. 147–58 (C18–C28), figs 48–9

OTHER DRAWINGS: from Van Winghe: [Peiresc—Menestrier] BAV, Vat. lat. 10545, fols 189–91

(Schuddeboom 1996, figs 70–74). [De Villers] Paris, BN, nouv. acq. lat. 2343, fols 103–103v, 105 (Schuddeboom 1996, figs 63, 65–6)

Different hand: [Ciaconio] BAV, Vat. lat. 5409, fols 27v–28, 30 [42v, 44, 47v]. Milan, Biblioteca Ambrosiana, F228 inf., fols 9, 15–16

172. From an antiquary's notebook?: mosaic inscription on the triumphal arch of S. Paolo fuori le mura, Rome

LATE SIXTEENTH-CENTURY ITALIAN (?)

Windsor, RL 9077

Pen and ink, over black chalk and stylus

83 × 116 mm

ANNOTATION: [brown ink] *nell'arco che separa la tribuna dal volto della chiesa in S. Paolo di mosaico* [in a different brown ink] *1592*

MOUNT SHEET: type B. Also bears **175, 290, 296**. *Watermark*: Figure 13 (cut)

BIANCHINI fol. 124, I and II: Some Christian antiquities.

The 5th-century mosaics on the triumphal arch of St Paul outside the Walls were damaged by fire in 1823, and subsequently replaced. They had earlier suffered some losses (see **118**). This drawing records the dedicatory inscription in Latin verse which ran around the edge of the arch: 'PLACIDIAE PIA MENS OPERIS DECUS H[OMNE PATERNI] GAVDET PONTIFICIS STUDIO SPLENDORE LEONIS'. The penultimate word is wrongly transcribed; it should read SPLENDERE (as in **118**). Morey (1915, p. 2) noted that *1592* at the end of the annotation is

written in a different ink and suggested that is the 'Pozzo' number of the drawing. However, there is no indication that the sequence went this high, and the placement at the top right would be very unusual. More probably, 1592 is the date, and the drawing has been extracted from a late 16th-century antiquary's notebook (perhaps the same one of which several pages are mounted among the dal Pozzo drawings in the British Museum: Ashby 1904, p. 72; *Cassiano* cat. 1993, p. 136, no. 88). See also **173**.

LITERATURE: unpublished

OBJECT DRAWN: destroyed 1823. Mabillon *Iter Italicum*, p. 52; Ciampini *Vet. mon.* I, p. 230, pl. LXVIII; Pietrangeli 1989, p. 50

OTHER DRAWINGS: **118**; BAV, Barb. lat. 4406, fols 139–40 (Waetzoldt 1964, no. 835, fig. 453)

172 (actual size)

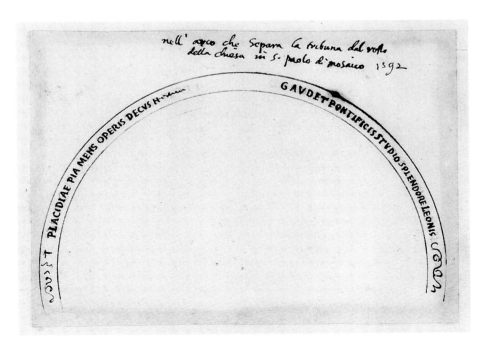

173. From an antiquary's notebook?: sketch of a church apse

LATE SIXTEENTH-CENTURY ITALIAN (?)

Windsor, RL 9179

Watercolour, pen and ink and dark brown wash, over faint traces of black chalk

55 × 81 mm. Heavily foxed

ANNOTATION: [brown ink] *nella volta / di ss. qua*[cut]

MOUNT SHEET: type B. Also bears **240, 298**

BIANCHINI fol. 166 [not mentioned]

The ink and handwriting of the annotation is very similar to **172** and thus the drawing may also derive from a late 16th-century notebook. It shows a church apse in which a single haloed figure stands beneath a large wreath. No such apse survives in Rome but the annotation cut off at the right 'on the vault of ss. qua...' suggests the church of the SS. Quattro Coronati, near the Lateran. The apse of that church currently depicts the glory of all the saints in Paradise, a mural which is signed by the Tuscan painter Giovanni Mennozzi da San Giovanni, and dated 1623. The earlier apse decoration, dating from the restoration of the church in the time of Pope Paschal II (1099–1118), is known only from rather vague descriptions, but also seems to have included a large number of figures (Muñoz 1914, p. 64f.). Possibly the author of the dal Pozzo sketch was only interested in the elements he drew (just as the arch of S. Paolo is reduced to its inscription in **172**), but it is equally possible that, if the drawing was cut from a larger page in a sketchbook, the annotation actually referred to an adjacent image.

LITERATURE: unpublished

OBJECT DRAWN: uncertain

173 (actual size)

174. Inscription set in the façade wall of S. Bibiana, Rome

SEVENTEENTH-CENTURY ITALIAN

Windsor, RL 9071

Pen and ink

83 × 46 mm

NUMBERING: *724*

MOUNT SHEET: type B. Also bears **227–8**, **284–5**.
Watermark: Figure 13

BIANCHINI fol. 122, I and II: Inscription of the Cemetery ad Ursum
Pileatum, which is in the porch of S. Bibiana.

The inscription, probably of the 13th century, marked the road which led to the ancient cemetery on the Viminal hill known by the title *'ad ursum pileatum'* ('at the bear with a hat') and the subsequent church, dedicated to S. Bibiana, built at that site. In it, the cemetery is said to have contained the remains of some 5266 saints and martyrs, and an indulgence was offered to pilgrims making the visit during the week following the feast of All Saints on 1 November. The inscription is now set in the façade wall of S. Bibiana, but Antonio Bosio records having first seen it near the church of S. Eusebio, where it presumably pointed visitors in the right direction. He notes that it was moved to its present location when the street was widened.

Another early copy of the inscription, in which only the first line of the text replicates the original late medieval letter forms, is to be found in the codex which once belonged to Claude Menestrier (d. 1639), containing Peiresc's copies of drawings made by Philips van Winghe in 1589–92 (Schuddeboom 1996, p. 94). A general flowering of interest in St Bibiana, an Early Christian martyr, followed the rediscovery of her remains beneath the high altar in 1624. Pope Urban VIII, who may have had an earlier interest in her cult, restored the church in the years 1624–6, entrusting the task to Bernini. However, the high 'Pozzo' number suggests that **174** was not added to the Paper Museum until the late 1670s, perhaps the last in a larger group, all inscriptions of various kinds, bearing Carlo Antonio's inventory numbers *715–723*, now in the British Museum (Franks volume II, fols 22 and 28, to be published in A.VII of the present catalogue).

LITERATURE: unpublished

OBJECT DRAWN: in S. Bibiana porch. Bosio *Roma Sotterranea*, p. 584f.; Forcella *Iscrizioni* XI (1877), p. 113, no. 228

OTHER DRAWINGS: [Peiresc—Menestrier] BAV, Vat. lat. 10545, fol. 230v

174 (actual size)

175. Brickstamp of the Emperor Constans (AD 337–50)

SEVENTEENTH-CENTURY ITALIAN

Windsor, RL 9078

Pen and ink, and brown wash, over black chalk and stylus; accidental traces of glue

107 × 108 mm. Tinted pink

NUMBERING: [bottom centre] *741*

MOUNT SHEET: type B. Also bears **172, 290, 296**.
Watermark: Figure 13 (cut)

BIANCHINI fol. 124, I: brick/tile DN CONSTANTIS AUG.

The stamp is presumably from Rome and, given its presence in the *Mosaici Antichi*, was perhaps found in the catacombs or during restoration or rebuilding work in one of the Early Christian churches. It is of a rare type, bearing the legend D(omini) N(ostri) CONSTANTIS AVG(usti) set in an eight-pointed star. Constans, younger son of Constantine the Great, was emperor in the West from AD 337 to 350. Only one other example has been recorded (*CIL* XV, no. 1658), now lost(?) but previously in the Bianconi collection in Bologna (Marini 1884, p. 74, no. 147). That cannot be the one in the dal Pozzo drawing, however, since the letters AVG were placed differently (in the centre of the stamp not on the outer band).

According to its 'Pozzo' number, the drawing was acquired sometime between 1674 and 1680, which is about the time that Roman brickstamps began to attract serious scholarly interest. Both Ciampini (*De sacris aedificiis*, p. 30f., pl. VI) and Fabretti (1683, chap. 7, and *Inscript. antiq.*, pp. 496–545) included them in their studies. Another drawing of a brickstamp (of Diocletian, *CIL* XV, no. 1627) is to be found in the dal Pozzo album in the British Museum (Franks 342) and bears the consecutive 'Pozzo' number *742*.

LITERATURE: unpublished

OBJECT DRAWN: not traced

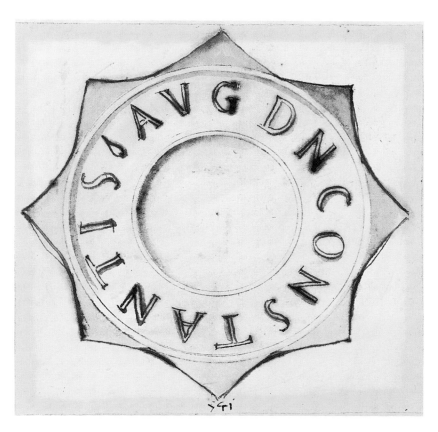

175 (actual size)

176. Apse mosaic of S. Pudenziana, Rome

SEVENTEENTH-CENTURY ITALIAN

Windsor, RL 9196

Watercolour and bodycolour, over red chalk

345 × 506 mm. Irregular shape, flap at bottom centre; old fold down centre

ANNOTATION: [bottom right] *DI. PITTURA*

MOUNT SHEET: type B

BIANCHINI fol. 177, I and II: Mosaic in the Apse of S. Pudenziana.

Like its Eclissi equivalent (see **142**), the drawing has been cut into a semicircle, reflecting the shape of the apse. Waetzoldt believed it to be a preliminary study for the Eclissi version but, in addition to the differences in size and various minor differences of detail, the treatment of the heads is so strikingly dissimilar that it seems improbable that the two copies can be by the same hand. The annotation '*di pittura*' at the bottom right refers to the fact that in the major restoration of 1588 large missing areas of mosaic on the right, and smaller ones on the left, were replaced in paint (in 1831–2 the painted areas were replaced in their turn, in mosaic). On the right-hand side the only original head is St Peter's; on the left only St Paul's and the three further to the left.

17th-century commentators, such as Nicolas Poussin (Nibby 1839, p. 679), and Giovanni Antonio Bruzio (BAV, Vat. lat. 11886, fol. 410) judged the mosaic to be the best of the 'Old School' and several more drawings are known.

Cassiano sent transcriptions of the inscription on the book held by Christ to Jan Gruterus in Amsterdam (Leiden, Bibliotheek der Rijksuniversiteit, codex Papenbrochianus 6, fol. 106) and Joseph-Marie Suarès (see p. 311f.) made a particular study of the fragmentary lettering which is indicated in the drawing on the pages of the book held by St Paul (BAV,

Barb. lat. 3084, unpaginated). The text on the latter is now restored as '*Liber Generationis*' but previously said something quite other. Suarès worked initially on the basis of a detail he had taken either from **176** or from a second coloured drawing very similar to **176** acquired by the Vatican Library with the papers of Gaetano Marini but originally from the Barberini collections. (The Barberini drawing cannot be found at present but reportedly bears the same annotation '*di pittura*' as the dal Pozzo copy.) Having tried to make sense of the transcription in the copy, Suarès checked the original mosaic and concluded that the two right-hand columns of text had recorded the names of the founders of the church, Leopardo and Ilicius or Icilius, and the consular dates for its inception and completion: FUN(data) A / LEOPAR/DO ET IL /ICIO/ VALENT(iniano) AUG(usto) ET... [Eutropio= AD 387 or Neoterio = AD 390] | (perfecta/Honorio Aug. IIII et) EUTY/CIA/NO/COS [=AD 398].

Both Francesco Bianchini and his nephew Giuseppe cite a dal Pozzo drawing of the apse mosaic in their publications, the former in the notes to his edition of Anastasius' *Lives of the Roman Popes* (*Anastasius*, II, p. 122f.), and Giuseppe in his account of the mosaic in the *Demonstratio Historiae Ecclesiasticae* (see above p. 26 at note 8). In neither case is it clear whether the drawing they meant was 142 or 176.

LITERATURE: De Rossi 1867, pp. 58–60; De Rossi *Musaici cristiani*, fasc. xiii, [pp. 26–9]; Waetzoldt 1964, no. 1000, pl. 506; Dempsey 1989, p. 256, fig. 7; Cropper/Dempsey 1996, fig. 76, p. 135

OBJECT DRAWN: extant. [Suarès] BAV, Barb. lat. 3084; Montini 1960, p. 10f.; Oakeshott 1967, pp. 65–7, pls 6, 42–5

OTHER DRAWINGS: **142**. [Ciaconio] BAV, Vat. lat. 5407, p. 81. [Marini] BAV, currently untraceable. [In black chalk] BAV, Barb. lat. 4423, fols 60v–61. Another coloured copy is cited by De Rossi: De Era, *Historia ecclesiae s. Pudentianae*, fol. 361

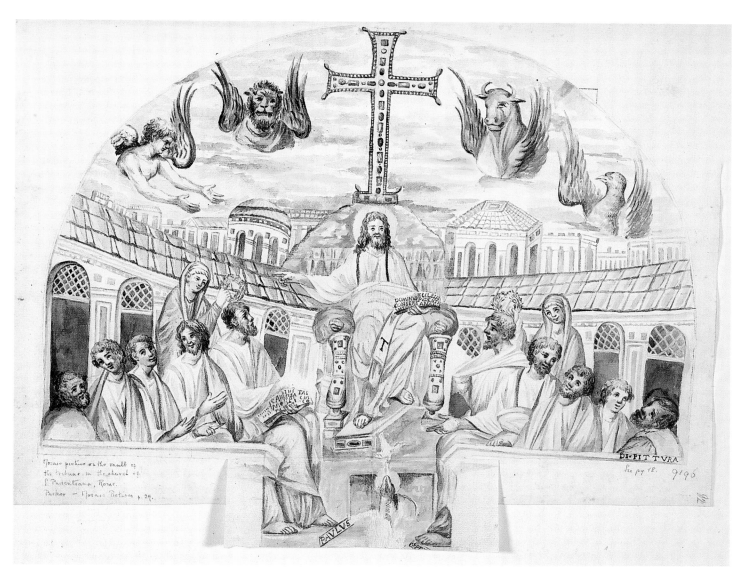

Mosaic picture on the vault of
the tribune in the church of
S. Pudentiana, Rome.
Parker — Mosaic Pictures p. 24.

176

75

177. Apse mosaic of Old St Peter's, Rome

SEVENTEENTH-CENTURY ITALIAN

Windsor, RL 8966

Watercolour and bodycolour, with gold powder in gum arabic, and pen and ink, over black chalk

548 × 774 mm. Old folds across and down centre.
Watermark: Figure 18

NUMBERING: *566*

MOUNT SHEET: type B

BIANCHINI fol. 34, I and II: Mosaic of the Apse of S. Pietro in Vaticano made by Innocent III (II:) published by Mons. Ciampini in the Volume *de edificijs à Constantino Magno construxis.*

The apse mosaic of Old St Peter's, remade during the pontificate of Innocent III (1198–1216), survived until the final demolition of the Constantinian basilica in 1592. It depicted the enthroned figure of Christ, flanked by Saints Peter and Paul; beneath, twelve lambs processed from the cities of Bethlehem and Jerusalem towards the *agnus Dei* in the centre. The processions were headed by the figures of Pope Innocent III and a personification of the Roman Church, and the heads of these two are among the three fragments of the mosaic which are known to survive, now in the collection of the Museo di Roma (Margiotta 1988; Iacobini 1989a).

Numerous copies of the mosaic are known, most deriving either from a coloured drawing of 1592 kept in the archive of St Peter's, or from drawings in the Ciaconio codices (cf. Waetzoldt 1964, nos 943–55). Ruysschaert has demonstrated convincingly, however, that the dal Pozzo drawing is taken from a third source,

independent of the other two, an oil painting now in the Vatican Library. This painting was previously in the possession of Agostino Mariotti (1724–1806), whose collection was acquired in 1819 by Pope Pius VII. Its earlier provenance is unknown, but it is likely to have been commissioned by Cardinal Alessandro Orsini (d. 1626). Ruysschaert notes that Cassiano was among Cardinal Orsini's circle of close friends, and he thus would have had ample opportunity to obtain this copy. However, its high 'Pozzo' number belongs to Carlo Antonio's inventory and suggests that the drawing was not acquired until the 1660s, probably after 1666 (see Volume One, p. 38).

Although Ciampini acknowledges Carlo Antonio and Gabriele dal Pozzo's help in connection with his account of the old Vatican basilica (*De sacris aedificiis*, p. 4), the apse mosaic was clearly not involved; his plate XIII copied the drawing in the St Peter's archive.

LITERATURE: Waetzoldt 1964, no. 948; Ruysschaert 1968, fig. 9; *Cassiano* cat. 1993, no. 152

OBJECT DRAWN: BAV, Museo Cristiano, inv. 973. Ruysschaert 1968

OTHER DRAWINGS: Vatican, Archivio S. Pietro, MS A64 ter, fol. 50 (Waetzoldt 1964, no. 943, fig. 490; Ruysschaert 1968, fig. 4), copied by Grimaldi, BAV, Barb. lat. 2733, fols 158 and 159 and BAV, Vat. lat. 11988, fol. 209 and Barb. lat. 4410,

fol. 26; also engraved for Ciampini *De sacris aedificiis*, p. 47, p. XIII.

[Ciaconio] BAV, Vat. lat. 5408, fols 29v–30 and 31v–32 (Recio Veganzones 1974, pp. 316–18, fig. 3; Iacobini 1991, p. 240); BAV, Vat. lat. 5407, pp. 103, 112, with copies in Milan, Biblioteca Ambrosiana, F227 inf., fols 10v–11.

[Copies of Grimaldi] Milan, Biblioteca Ambrosiana, A.168 inf., fol. 4

Comp. fig. 177 (opposite): Anonymous, *Apse mosaic in Old St Peter's, Rome.* Oil painting. BAV, Museo Cristiano, inv. 973

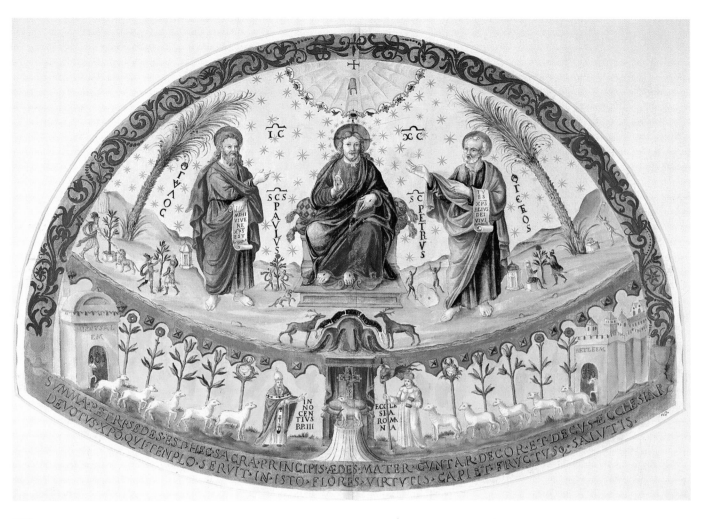

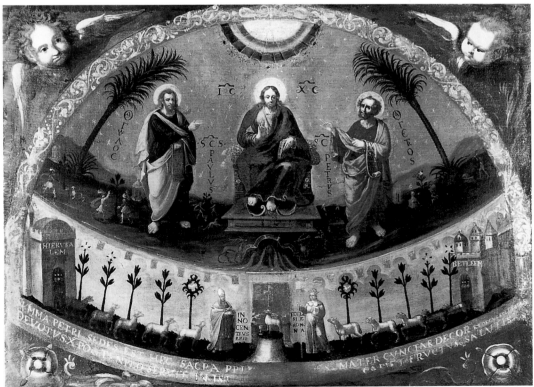

178. Apse mosaic of S. Andrea cata Barbara, Rome

SEVENTEENTH-CENTURY ITALIAN

Windsor, RL 9172

Watercolour and bodycolour, with gold powder in gum arabic, and pen and ink, over graphite

265 × 415 mm. Irregular shape. *Watermark*: unidentified

NUMBERING: *957*

MOUNT SHEET: type B

BIANCHINI fol. 159, I: Mosaic carefully copied from the Apse of S. Andrea in Catabarbara and published by Ciampini. II: Mosaic commissioned by his Holiness Pope Simplicius in the Church of S. Andrea in Cata Barbara, printed by Monsignor Ciampini Vet. Mon. Volume I chap. 27.

Destroyed when the church was demolished in 1686, the 5th-century apse mosaic of S. Andrea cata Barbara (see also **1–3**) contained a central image of Christ, shown standing on the mount of Zion from which flowed the four rivers of Paradise. Christ was flanked by Saints Peter and Paul, and four other apostles. The design of the mosaic is known in drawings made for Alfonso Ciaconio at the end of the 16th century, and the two drawings here (see also **179**). Another drawing was recorded in a Barberini album in the Vatican in the late 19th century but then disappeared (Hülsen). A second copy of **178**, with the annotations on **179** transcribed across the top, by the same hand and with the same 'Pozzo' number *957*, has been identified by Louisa Connor among the Coleraine drawings in Oxford (purchased in Rome in 1723). A comparable example of duplication is found in **293–4**. The engraving published by Ciampini in 1690 (*Vet. mon.* I, pl. LXXVI) agrees so closely in size and detail that it could derive from one or the other, or a third common source, since Ciampini acknowledges Carlo Antonio's help only with regard to drawings of lost *opus sectile* decorations in the church (*Vet. mon.* I, p. 58, cf. **1**).

The drawing records the state of the apse mosaic in the late 17th century, demonstrating considerable losses to the saints on the left side but including those portions of the figures which had been restored in paint in the year 1630 (see **179**). Waetzoldt's attribution of the drawing to Antonio Eclissi can be discounted (see discussion of Eclissi's style and technique in Volume One, pp. 63-6). The artist here has used a fine brush to model the facial features and his colours are well-prepared and evenly applied. The same hand was surely responsible for the companion drawing **180**, and possibly also those of S. Martino ai Monti, **187–92**, and the Ciaconio copies **167–70**, all of which have similarly high 'Pozzo' numbers indicating that they were acquired in the late 1670s and early 1680s.

LITERATURE: Lanciani 1895, p. 182; Wilpert 1916, I, p. 106, fig. 33; Hülsen 1927, p. 60; Lugli/Ashby 1932, fig. 17; Enking 1964, fig. 10; Waetzoldt 1964, no. 38, fig. 15; Cecchelli 1991, p. 72f.; Herklotz 1992b, p. 45, fig. 10; Andaloro 1992, fig. 16

OBJECT DRAWN: destroyed 1686. Ciampini *Vet. mon.* I, p. 243, pl. LXXVI; De Rossi 1871; Hülsen 1927, pp. 57, 60; Enking 1964; Cecchelli 1991

OTHER DRAWINGS: Oxford, Corpus Christi College, Coleraine coll. Roma X, fol. 63 (unpublished).

[Ciaconio] BAV, Vat. lat. 5407, pp. 189–93 (Armellini/Cecchelli 1942, figs on p. 1009; Waetzoldt 1964, nos 33–5), and Milan, Biblioteca Ambrosiana, F229 (Waetzoldt 1964, no. 36). [Peiresc— Menestrier] BAV, Vat. lat. 10545, fol. 47v.

[Lost] previously BAV, Barb. lat. 4402, preceding fol. 32 (Hülsen 1927, p. 56, citing Gaetano Marini, BAV, Vat. lat. 9104, fol. 108)

179. Apse of S. Andrea cata Barbara, Rome

LATE SEVENTEENTH-CENTURY ITALIAN (after 1675)

Windsor, RL 9033

Pen and ink

282 × 434 mm. *Watermark*: Circles 2

ANNOTATION: [brown ink over black chalk] *Concavum Tribunae ecclesiae olim / dictae S. Andreae in Barbara nunc / intra Hospitale S. Antonii prope S. Mariam / Maiorem*

('Conch of the apse of the church formerly called St Andrea in Barbara, now within the hospital of St Anthony near S. Maria Maggiore')

Inscriptio suppleta ex Platina in vita Sixti Tertii

('Inscription supplied from Platina's Life of Sixtus III')

[key] *a.b. Musaico che mancava nel dissegno vecchio, c.d.e.f.g. Musaico che manca del 1675 supplito con punti dal dissegno predetto, h.i.l.m.n. pittura fatta del 1630*

('a.b. Mosaic which was missing in the old drawing; c.d.e.f.g. Mosaic missing since 1675 supplied on the basis of the aforesaid drawing; h.i.l.m.n. painting made in 1630')

MOUNT SHEET: type B

BIANCHINI fol. 92, I and II: Mosaic commissioned by his Holiness Pope Simplicius in the Church of S. Andrea Cata Barbara (II:) near Santa Maria Maggiore, which was destroyed to build the Monastery of the Church of S. Antonio, Ciampini Volume One page 243.

The sketch of the apse composition reconstructs portions of the figures which had been lost, and provides an alphabetical key to differentiate between two areas at the left, which were already missing in an otherwise unidentified 'older copy', an adjacent patch, which was already missing by 1675, dotted in outline on the basis of that 'older copy', and areas which had been restored in paint in the year 1630. Waetzoldt's suggestion that the 'older copy' may have been the second Windsor drawing, **178**, seems improbable, since it already shows some of the reconstructed areas as missing.

Also lost by the 17th century were the beginning and end of both lines of the dedicatory inscription naming the papal donor, which was placed at the base of the apse. The annotation records that the missing words have here been supplied on the basis of the copy made in the mid 15th century by Platina, who included it in his biography of Pope Simplicius (*RIS* iii, p. 79). This is essentially correct, although Platina gives the third word as 'mens', whereas the drawing gives it as 'mea', and there are minor discrepancies between the two in that portion of the text which is shown as still being intact (see the recent study of the apse inscription, Cecchelli 1991).

LITERATURE: Lanciani 1895, p. 181f.; Lugli/Ashby 1932, fig. 18; Waetzoldt 1964, no. 37; Cecchelli 1991, p. 72f.; Herklotz 1992b, fig. 9

OBJECT DRAWN: see **178**

OTHER DRAWINGS: Oxford, Corpus Christi College, Coleraine coll. Roma X, fol. 63 (cf. **178**)

Comp. fig. 178, 179: Anonymous, *Apse mosaic in S. Andrea cata Barbara*, engraving, Ciampini, *Vet. mon.* I, pl. LXXVI

178

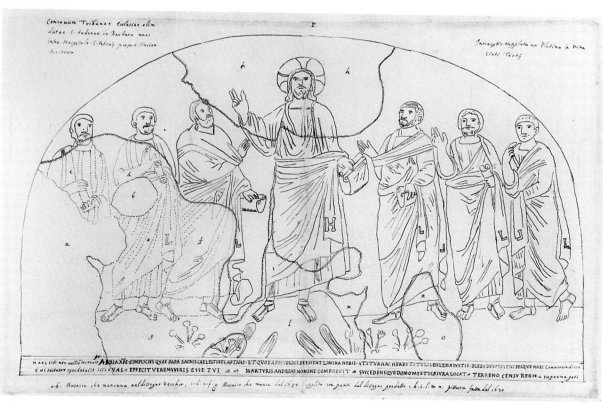

179

180. Mural in S. Andrea cata Barbara, Rome

SEVENTEENTH-CENTURY ITALIAN

Windsor, RL 9164

Watercolour and bodycolour, over graphite

343 × 243 mm. Irregular shape

NUMBERING: *965*

MOUNT SHEET: type B

BIANCHINI fol. 156, I and II: Early painting representing the Predication and the Martyrdom of the Apostles St Peter and Paul in Rome, which was in the old Church of S. Andrea in Cata Barbara, where today is the Monastery of S. Antonio Abbate near S. Maria Maggiore, printed by Monsignor Ciampini Vet. Mon. Volume 1 chap. 7.

At an unknown date, possibly the 11th century (Krautheimer *CBCR* I [1937], p. 63), some of the side windows of the basilica were closed in, and the new brickwork decorated with murals. Only one of these paintings appears to have survived into the 17th century, and it is known only from the dal Pozzo drawing and the engraving published by Ciampini (which, like **178**, is so similar to the dal Pozzo copy that they probably share a common source). The mural was presumably destroyed when the whole building was demolished in 1686. It depicted Saints Peter and Paul, shown preaching in the upper zone. Their martyrdoms, by crucifixion and decapitation respectively, are figured beneath. The curious zigzag borders on the sides were possibly intended to give the impression of the folds of hanging tapestries or curtains, taking as their model the Late Antique *opus sectile* panels which decorated the wall between the windows (cf. **1**).

The drawing, in addition to capturing the brilliance of the colours of the mural, is also remarkable in its attempt to represent the wall itself, complete with the blocking of the window and the patches where the fresco has fallen away to reveal the rubble structure behind.

LITERATURE: Lanciani 1895, p. 181f.; Wilpert 1916, I, p. 158, fig. 41; Hülsen 1927, p. 67; Hülsen *Chiese*, p. 180f.; Lugli/Ashby 1932, fig. 20; Enking 1964, fig. 11; Waetzoldt 1964, no. 40, fig. 16

OBJECT DRAWN: destroyed. Mellini, Vat. lat. 11905, fols 215–19 (*c.* 1650); Ciampini *Vet. mon.* I, p. 63f., pl. XXV; De Rossi 1871; Hülsen 1927, pp. 60, 64; Hülsen *Chiese*, pp. 179–81

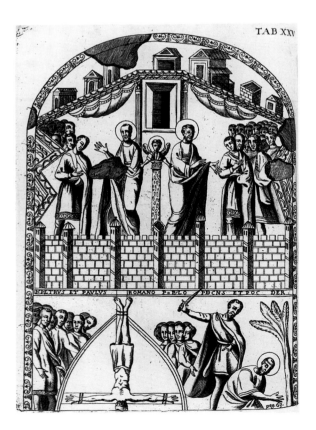

Comp. fig. 180: Anonymous, *Mural in S. Andrea cata Barbara*, engraving, Ciampini, *Vet. mon.* I, pl. XXV

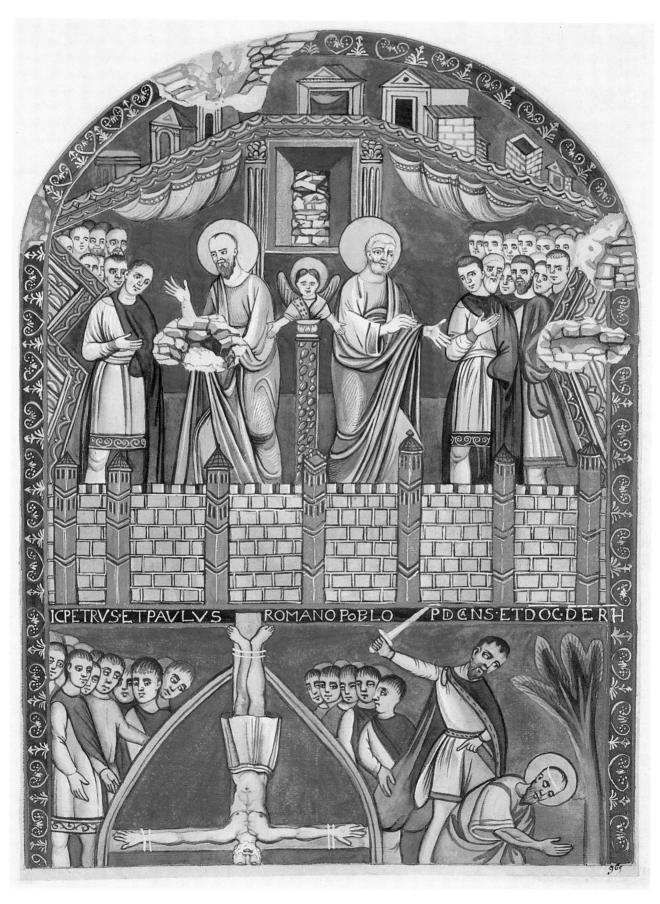

IC·PETRVS·ET·PAVLVS ROMANO·POPLO PDCNS·ET·DOCDERH

181. Mural: martyrdom of St Sebastian, Lateran Palace, Rome

SEVENTEENTH-CENTURY ITALIAN

Windsor, RL 9096

Watercolour, over black chalk

420 × 213 mm. *Watermark*: Fleur de Lys 71

NUMBERING: *977*

MOUNT SHEET: type B

BIANCHINI fol. 136, I and II: Picture of the Martyrdom of S. Sebastian.

The mural depicting the martyrdom of St Sebastian was rediscovered in 1947 in the substructures of the Scala Santa in the Lateran Palace. It is thought to date from the early 12th century, and may have decorated an oratory of St Sebastian founded in the 7th century by Pope Theodore I (*Liber Pontificalis* i, p. 333). The painting must still have been visible in the 17th century, as the dal Pozzo copy is one of three made at that time. The other two differ from the dal Pozzo drawing in two respects: both show a large area of loss in the lower body of the archer on the right, and both give the inscription as 'S. BASTIANUS'.

In colouring and technique, as well as its 'Pozzo' numbering, the drawing appears to be a companion to **182**, which is mounted on the following folio.

LITERATURE: Waetzoldt 1964, no. 245

OBJECT DRAWN: extant. Garrison 1956a; Garrison 1956b; Matthiae/Gandolfo 1988, pp. 50, 260

OTHER DRAWINGS: BAV, Vat. lat. 9071, p. 251 (Waetzoldt 1964, no. 229, fig. 123). BAV, Barb. lat. 4426, fol. 5a (Waetzoldt 1964, no. 237)

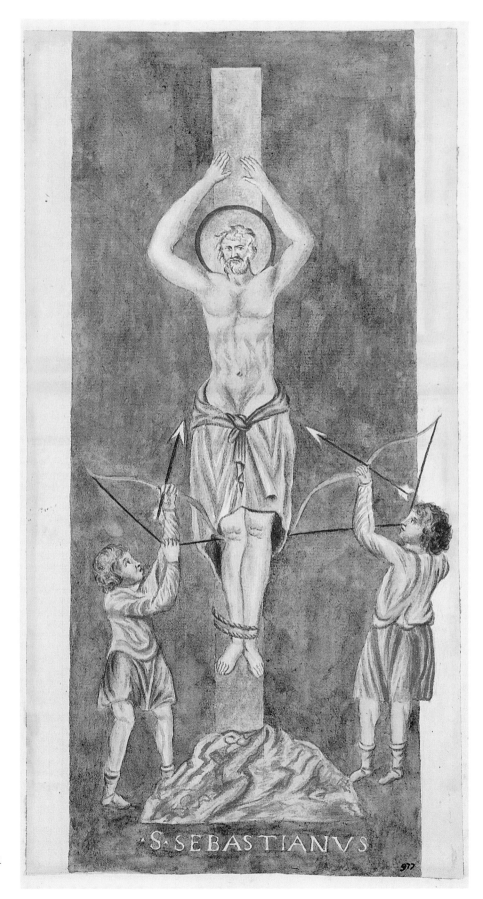

·S·SEBASTIANVS

181

977

182. Mural in the oratory of St Thomas, S. Giovanni in Laterano, Rome

SEVENTEENTH-CENTURY ITALIAN

Windsor, RL 9097

Watercolour and bodycolour, with gum heightening, over traces of graphite

247 × 420 mm

NUMBERING: *979*

VERSO: graphite offset of **251**

MOUNT SHEET: type B

BIANCHINI fol. 137, I and II: Picture of Pope John the Twelfth, printed by Lord Cardinal Rasponi (II:) in the Volume on the Lateran Basilica with the inscription of his name as it was in that Basilica, and reprinted by Monsignor Ciampini without the name of the Pope.

The drawing depicts a mural formerly situated over the door of the oratory of St Thomas, located in the façade portico of the Lateran basilica. It depicted a pope, possibly John XII (955–64) who built the chapel, shown in the act of being vested by two deacons. The chapel functioned as the *secretarium* where the popes were robed before entering the basilica for services and was demolished in 1649.

The mural is known from a series of early 17th-century copies, principally in codices which once belonged to the antiquary Jacopo Grimaldi (d. 1623), but also including one in a Barberini codex dating from the decade of the 1630s (BAV, Barb. lat. 4410). The Grimaldi copies show fewer attendant figures, are not coloured, and seem unrelated to the dal Pozzo drawing. Closer is the Barberini version, in watercolour, which bears a lengthy Latin annotation stating that the copy had been made in April 1633 at the request of Cardinal Francesco Barberini (for the text see Müntz 1888, p. 114; Ladner *Papstbildnisse* I (1941), p. 167). However, while the number of figures accords with the dal Pozzo copy, it differs in the placement of the pope's hands and shows much less detail of the elaborate designs on the garments.

Ciampini based his published version of 1693 on the dal Pozzo drawing, acknowledging (p. 14) Carlo Antonio and Gabriele dal Pozzo's assistance in the matter, and observed that the engraving published earlier in the century by Rasponi (*Basilica*, p. 63) had not rendered the tonsured heads correctly.

The hand can be compared with **181**, **194**, and A.I.60.

LITERATURE: Waetzoldt 1964, no. 149

OBJECT DRAWN: Ciampini *De sacris aedificiis*, p. 14; Lauer 1911, p. 142f.; Ladner, *Papstbildnisse* I (1941), pp. 163–7

ENGRAVINGS: Ciampini *De sacris aedificiis*, pl. IV

OTHER DRAWINGS: [Grimaldi, *c.* 1617] Milan, Biblioteca Ambrosiana, A.178 inf. fol. 99 (Waetzoldt 1964, no. 145, fig. 89). [Grimaldi, *c.* 1621] Milan, Biblioteca Ambrosiana, A.168 inf., fol. 116. [Grimaldi] BAV, Barb. lat. 2733, fol. 49v (Ladner *Papstbildnisse* I (1941), pl. XVIIa). BAV, Barb. lat. 4410, fol. 27 (Lauer 1911, fig. 54; Ladner, op. cit., p. 165, fig. 119; Wilpert 1916, I, p. 212, fig. 66)

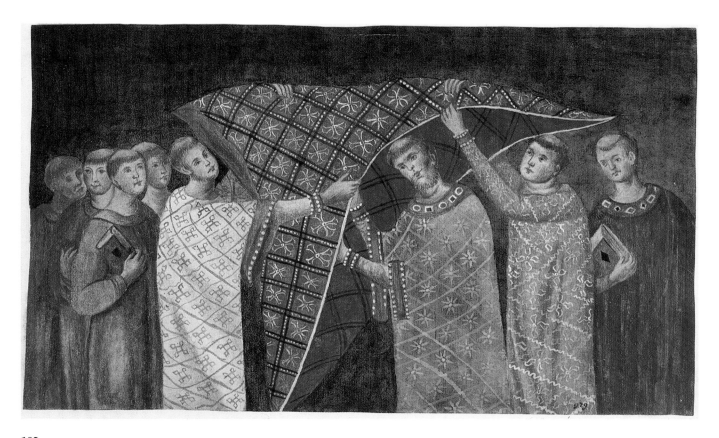

182

Comp. fig. 182: Anonymous,
Mural in the oratory of St Thomas, S. Giovanni in Laterano,
engraving, Ciampini, *De sacris aedificiis*, pl. IV

S. Urbano alla Caffarella, near Rome [183–185]

Three small drawings mounted on one folio show details taken from the murals in the church of S. Urbano alla Caffarella, situated about three kilometres outside the walls of Rome, near the Via Appia Pignatelli and now deconsecrated. The extensive eleventh-century decorative cycles of the Infancy and Passion of Christ, and the lives of various Roman martyrs (notably Saints Urban and Cecilia), were restored in 1637 by Simone Lagi (fl. 1624–37) and Marco Tullio Montagna (fl. 1618–38) under the patronage of Cardinal Francesco Barberini. The Barberini collection in the Vatican Library contains two sets of watercolour copies of the murals: Barb. lat. 4402, fols 1–18, by Antonio Eclissi, made before the restoration work (*c.* 1630), and Barb. lat. 4408, fols li–lxvi, at least some of which are very possibly the work of the restorers. The dal Pozzo drawings, however, do not derive from either Barberini set and although mounted together on one folio are a miscellany. Two (**183–4**) placed in the centre of the folio are a pair and bear Carlo Antonio's inventory numbers denoting acquisitions of 1683. **185**, a head of Christ, unnumbered and by a different hand, was inlaid in the space above them at a later stage, perhaps at the same time that a small print showing another figure of Christ (**186**), not from S. Urbano but of similar type, was added in the space below.

LITERATURE: Busuioceanu 1924; Ladner 1931; Waetzoldt 1964, p. 75f.; Williamson 1984 and 1987

9144

9144

1012

9145

1011

9146

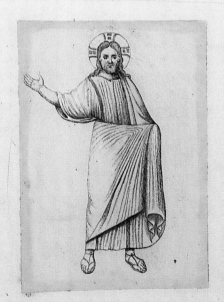

183. Christ's body in mummy wrapping: detail from a mural painting in S. Urbano alla Caffarella, Rome

SEVENTEENTH-CENTURY ITALIAN

Windsor, RL 9146

Pen and ink, and brown wash, over graphite

81 × 165 mm. Graphite offset from **292** verso

NUMBERING: *1011*

MOUNT SHEET: type B. Also bears **184–6**. *Watermark*: Fleur de Lys 75

BIANCHINI fol. 145, II: the Image of the Deposition of Christ our Lord in the tomb bound with spices according to the custom of the Jews, and the Egyptians.

The dal Pozzo drawing, one of a pair (see also **184**), takes a detail from the scene of the Entombment of Christ. As Bianchini's commentary indicates, it was presumably of particular interest for the mummy wrapping. The drawing is not copied from either of the Barberini watercolours, but reflects the restorations of 1637. From the 'Pozzo' number *1011* it is likely to have entered the Paper Museum in 1683 (see Volume One, p. 38).

A similar use of pen and light brown wash is found in many of the drawings in the dal Pozzo *Bassi Rilievi* series, but Blunt's attribution to Pietro Testa, which rests on such technical grounds alone, may be doubted.

LITERATURE: Blunt 1971, p. 122

OBJECT DRAWN: extant. Busuioceanu 1924, p. 38, fig. 17; Ladner 1931, fig. 74

OTHER DRAWINGS: BAV, Barb. lat. 4402, fol. 16, upper right panel (Waetzoldt 1964, no. 1087); Barb. lat 4408, fol. lx, upper right (Busuioceanu 1924, p. 39, fig. 18; Waetzoldt 1964, no. 1100, fig. 570)

Comp. fig. 183 (i): Anonymous, *Entombment of Christ, panel from a mural painting in S. Urbano alla Caffarella.* BAV, Barb. lat. 4408, fol. lx (top right)

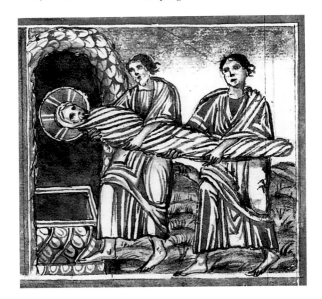

Comp. fig. 183 (ii): Antonio Eclissi, *Entombment of Christ, panel from a mural painting in S. Urbano alla Caffarella.* BAV, Barb. lat. 4402, fol. 5 (top right)

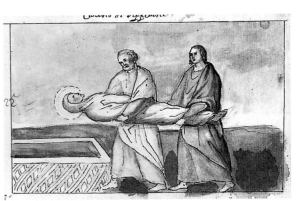

183 (actual size)

Comp. fig. 183 (iii): Anonymous, *Entombment of Christ, detail from a mural painting in S. Urbano alla Caffarella*

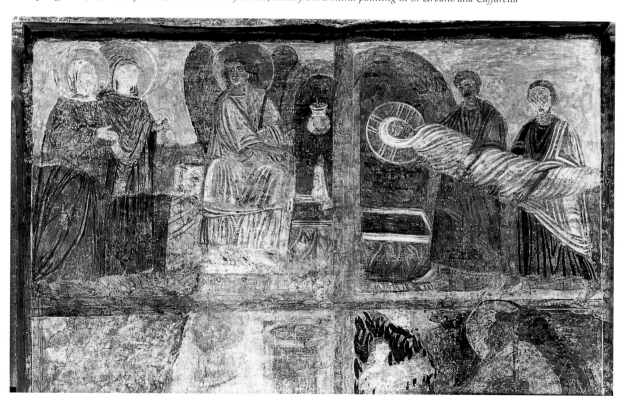

184. Winged male figure holding a scroll: detail from a mural painting in S. Urbano alla Caffarella, Rome

SEVENTEENTH-CENTURY ITALIAN

Windsor, RL 9145

Pen and ink, and brown wash, with white heightening, over graphite

84 × 151 mm. Graphite offset from **292** verso

NUMBERING: *1012*

MOUNT SHEET: type B. Also bears **183**, **185–6**.
Watermark: Fleur de Lys 75

BIANCHINI fol. 145 [not mentioned]

Like **183**, the drawing is not copied from either of the versions in the Barberini collection. It shows a detail of a scene, after the restorations of 1637, in which a winged figure appears to the Roman Saints Valerian and Urban, holding a scroll. The copyist has omitted the Latin text on the scroll, which reads 'One Lord. One Faith. One Baptism. One God and Father of all'. Waetzoldt's identification of the figure as God himself is problematic. Wilpert (1916, II, p. 991) preferred to see it as a personification of Faith. There are no obvious parallels elsewhere in medieval art.

LITERATURE: Blunt 1971, p. 122

OBJECT DRAWN: extant. Busuioceanu 1924, p. 49f., fig. 23; Ladner 1931, fig. 71

OTHER DRAWINGS: BAV, Barb. lat. 4402, fol. 7 (Waetzoldt 1964, no. 1111); Barb. lat. 4408, fol. liii (Wilpert 1916, II, p. 991, fig. 485; Busuioceanu 1924, p. 51, fig. 24; Waetzoldt, no. 1120, fig. 583)

Comp. fig 184 (i): Antonio Eclissi, *Winged figure, panel from a mural painting in S. Urbano alla Caffarella.* BAV, Barb. lat. 4402, fol. 7, (top)

184 (actual size)

Comp. fig. 184 (ii): Anonymous, *Winged figure, panel from a mural painting in S. Urbano alla Caffarella.*
BAV, Barb. lat. 4408, fol. liii, (top)

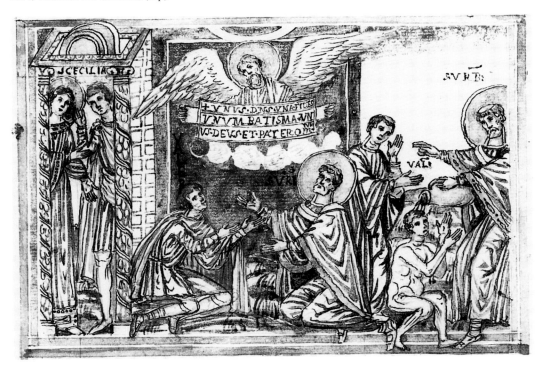

185. Head of Christ: from a mural painting in S. Urbano alla Caffarella, Rome

SEVENTEENTH-CENTURY ITALIAN

Windsor, RL 9144

Black and red chalk; graphite offset from **292** verso

102 × 93 mm

ANNOTATION: [black chalk] colour annotations: *G*[iallo], *T*[urchino]

MOUNT SHEET: type B. also bears **183–4**, **186**.
Watermark: Fleur de Lys 75

BIANCHINI fol. 145 [not mentioned]

The head belongs to the mural situated over the altar, depicting an enthroned Christ between angels and flanked by Saints Peter and Paul. Waetzoldt identified it erroneously with the Christ in the Brancacci tabernacle at S. Maria in Trastevere (see **116**), although admitting some uncertainty. Unlike the other two S. Urbano drawings mounted on the same folio (see **183–4**), this has no 'Pozzo' number, and it is clearly by a different hand. However, like them, it is not copied from either of the Barberini sets and would appear to postdate the restorations of 1637.

LITERATURE: Waetzoldt 1964, no. 505

OBJECT DRAWN: extant. Busuioceanu 1924, p. 14, fig. 5; Ladner 1931, fig. 82

OTHER DRAWINGS: BAV, Barb. lat. 4402, fol. 5 (Waetzoldt 1964, no. 1075); Barb. lat. 4408, fol. li (Waetzoldt 1964, no. 1091, fig. 561)

Comp. fig. 185 (i): Antonio Eclissi, *Head of the enthroned Christ, detail of a panel from a mural painting in S. Urbano alla Caffarella.* BAV, Barb. lat. 4402, fol. 16

Comp. fig. 185 (ii) (opposite): Anonymous, *Christ enthroned, mural painting in S. Urbano alla Caffarella*

185 (actual size)

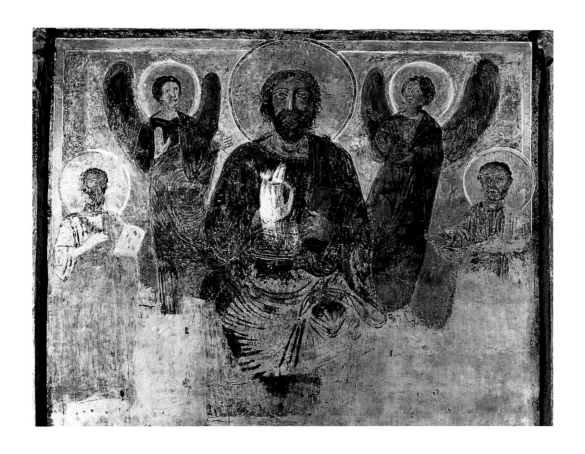

186. Figure of Christ from the apse of S. Maria in Monticelli(?)

SEVENTEENTH-CENTURY ITALIAN ENGRAVER

Windsor, RL 9146A

Engraving and etching

149 × 101 mm

MOUNT SHEET: type B. Also bears **183–5**. *Watermark*: Fleur de Lys 75

BIANCHINI fol. 145, I and II: Image of the Saviour standing, which is preserved in mosaic in the Apse of S. Maria in Monticelli.

The print is mounted on the same folio as the drawing of the Christ from S. Urbano alla Caffarella (**185**), presumably because of the similarity between the two heads. The figure no longer survives but is plausibly located by Bianchini's inventory, and is also recorded in an Eclissi drawing (see **83**).

LITERATURE: unpublished

OBJECT DRAWN: see **83**

OTHER DRAWINGS: **83**

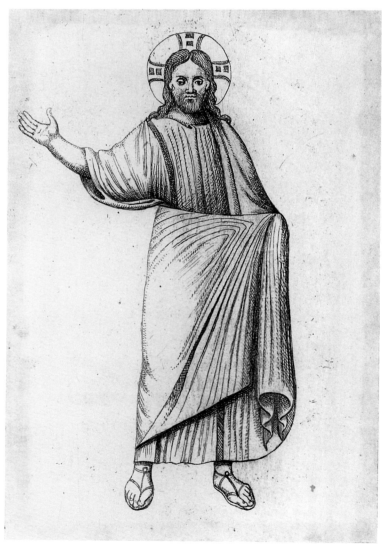

186

S. Martino ai Monti [187–192]

A set of six drawings, mounted in pairs on three consecutive folios, records medieval mural paintings in the monastic complex adjoining the Roman church of S. Martino (St Martin of Tours) on the Esquiline hill, behind the Baths of Trajan. The first and last in the series (**187** and **192**) depict thirteenth-century murals in the monastery chapel, which were replaced in the middle of the seventeenth century (in the course of radical alterations to the church commissioned by the Barberini from Pietro da Cortona) and completely destroyed when the chapel itself was demolished in 1927. The other four drawings (**188–91**) show yet older paintings which were discovered in 1637 in substructures on the site, at the start of the Barberini building operations. In 1639 a monograph celebrating the new finds was published by the Carmelite prior of the monastery, Giovanni Antonio Filippini, with a detailed written description of all the paintings, including their inscriptions and colours.

All six drawings are matched, in the same order but on a considerably larger scale, in a Barberini album now in the Vatican Library, Barb. lat. 4405, fols 42, 45–9. Those are the work of the artist Marco Tullio Montagna (fl. 1618–38), as noted on the verso of fol. 49: '*Alcune copie fatte da Marco Tullio dalle pitture sacre antiche di S. Martino de' Monti*' ('Some copies made by Marco Tullio of the ancient holy pictures in S. Martino ai Monti'). The dal Pozzo examples, which have all been given the same high 'Pozzo' number (*1166*) but also bear letters from *A* to *F*, could be a set of Montagna's working drawings, like Eclissi's working drawings of S. Lorenzo fuori le mura and S. Maria in Trastevere (see **27–70**, **89–116**). Alternatively, they could be copies made from the Barberini album at a later date. The latter possibility, already proposed by Waetzoldt (1964, p. 54) and reiterated by Herklotz (1992, p. 42), is the more likely. The high 'Pozzo' number suggests that the drawings did not enter the Paper Museum until the mid 1680s (see Volume One, p. 37) and the watermark on **188** and **191** (Fleur de Lys 67) is found elsewhere only on drawings with similarly high numbers.

The particular order in which the drawings are organized suggests that the images were primarily of interest for the richness and detail of the costumes they display.

LITERATURE: Wilpert 1916, I, pp. 322–37; Krautheimer *CBCR* III (1967), pp. 87–124; Davis-Weyer/Emerick 1984

187. Apse and arch paintings in the S. Silvestro chapel, S. Martino ai Monti, Rome

SEVENTEENTH-CENTURY ITALIAN

Windsor, RL 9088

Watercolour and bodycolour, and pen and ink, over graphite

251 × 269 mm. Irregular shape

NUMBERING: [lower left] *1166*; [lower right] *A*

MOUNT SHEET: type B. Also bears **188** [below]

BIANCHINI fol. 132, I and II: Picture of the Restoration of a church of
St Sylvester, perhaps (II:) must have been on the old apse (I and II:) of
S. Silvestro in Capite [in the Campus Martius].

The monastery chapel over the oratory of St Sylvester (the 4th-century pope who was traditionally the founder of the adjacent church of St Martin) was installed in a room on the upper floor of an ancient Roman building of the third century AD. In the early 17th century, three of its walls still retained their original pagan wall-paintings (Wilpert 1916, I, p. 327, fig. 104). The apsed fourth wall had been redecorated by Guala Bicchieri of Vercelli, titular cardinal of the church between 1211 and 1227. The conch of the apse was occupied by an enthroned Madonna and Child flanked by Saints Peter and Paul, and two popes, dressed in bishops' insignia and carrying books. Both Peter and Paul and the pope on the right preserved traces of identifying inscriptions (recorded by Filippini but not in the drawings), the pope being named as Sylvester. The other was presumably Martin. The inscription along the lower border read FRACTA VETUSTA NIMIS SOLISQ(ue) RELICTA RVINIS NE SILVESTRI OBEAT NOCTIS AMICA DOMVS P(res)B(yte)R HANC RENOVAT

SACRVMQ(ue) ALTARE VETVSTVM REPARAT (h)IN(c)Q(ue) DEI PRAESULIS (h)IN(c)Q(ue) DECVS. The inscription across the top of the arch framing the apse refers to an earlier painting in the apse, showing the Annunciation (VIRGO MARIA SALVTATVR STVPET ANNVIT ET GRAVIDATVR CONCIPIT AD VERBVM ANGELI PER SPIRITVM SANCTVM).

The larger drawing by Montagna in the Barberini collection includes additional details not shown here, for example the decoration on the border of the arch. Filippini's description and the Barberini drawing agree in giving the Madonna's cloak as 'leonato' (tawny yellow).

Bianchini's difficulty in identifying the St Sylvester of the drawing is curious, not entirely to be explained by the fact that the chapel at S. Martino had been completely redecorated by his day, since he might have made the connection through Filippini's book or the other drawings in the set.

The murals on the lower wall of the apse are drawn in **192**.

LITERATURE: Waetzoldt 1964, no. 561; Herklotz 1992b, fig. 8

OBJECT DRAWN: destroyed. Filippini 1639, p. 13f.; Wilpert 1916, I, pp. 335-7; Krautheimer *CBCR* III (1967), pp. 91-3, over room 'C' on plan

(pl. III); Davis-Weyer/Emerick 1984, with further bibliography

OTHER DRAWINGS: BAV, Barb. lat. 4405, fol. 42 (Wilpert 1916, I, p. 335f., fig. 109; Waetzoldt 1964, no. 559, fig. 308; Iacobini 1991, p. 260)

Comp. fig. 187 (opposite): Marco Tullio Montagna,
Apse and arch, paintings in the S. Silvestro chapel, S. Martino ai Monti.
BAV, Barb. lat. 4405, fol. 42

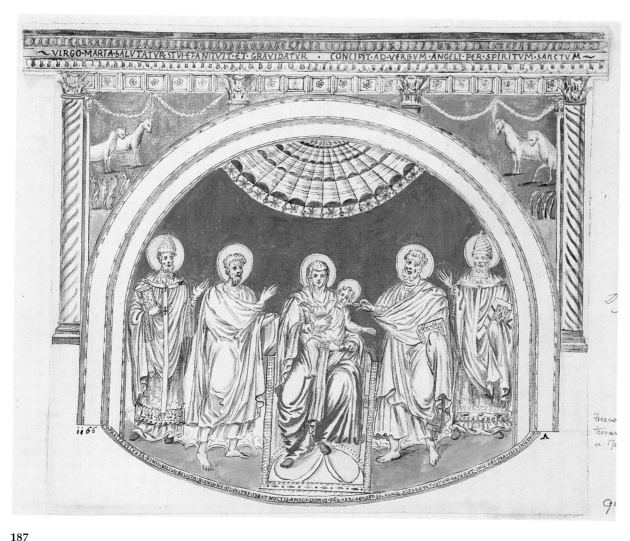

187

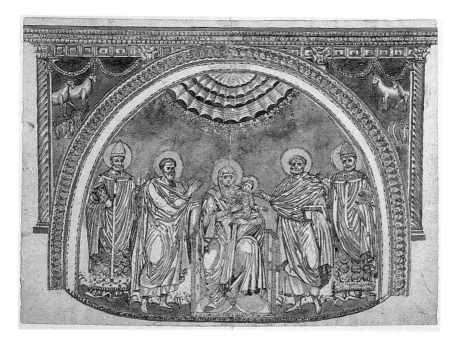

188. Mural: St Sixtus, S. Martino ai Monti, Rome

SEVENTEENTH-CENTURY ITLIAN

Windsor, RL 9089

Watercolour and bodycolour, and pen and ink, over graphite

229 × 128 mm. *Watermark*: Fleur de Lys 67

NUMBERING: [bottom centre] *1166 B*

MOUNT SHEET: type B. Also bears **187** [above]

BIANCHINI fol. 132 [not mentioned, see **187**]

The large Roman building underneath the monastic complex adjoining S. Martino is generally identified with the *titulus* of Equitius, beside which St Sylvester was believed to have instituted the first church dedicated to St Martin of Tours. The structure underwent various alterations in the Late Roman period and the Early Middle Ages, and preserves fragments of paintings from several periods (see Davis-Weyer/Emerick 1984, pp. 25–8). Although not precisely dated, they are usually associated with the reconstruction of the adjoining church by Pope Sergius II in 844–7.

The standing figure in bishop's clothing is painted on the north wall of room M (Krautheimer *CBCR* III (1967), plan III = Wilpert 1916, I, p. 323, fig. 100, room D2e). The dal Pozzo and Barberini versions are very close, but the latter includes four letters of a vertical inscription which identified the figure as Pope Sixtus.

LITERATURE: Waetzoldt 1964, no. 568

OBJECT DRAWN: extant. Wilpert 1916, I, p. 333f., IV, pl. 206.1

OTHER DRAWINGS: BAV, Barb. lat. 4405, fol. 45 (Waetzoldt 1964, no. 563, fig. 310)

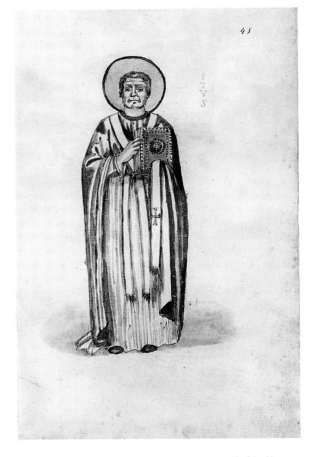

Comp. fig. 188: Marco Tullio Montagna, *Mural of St Sixtus*, S. Martino ai Monti. BAV, Barb. lat. 4405, fol. 45

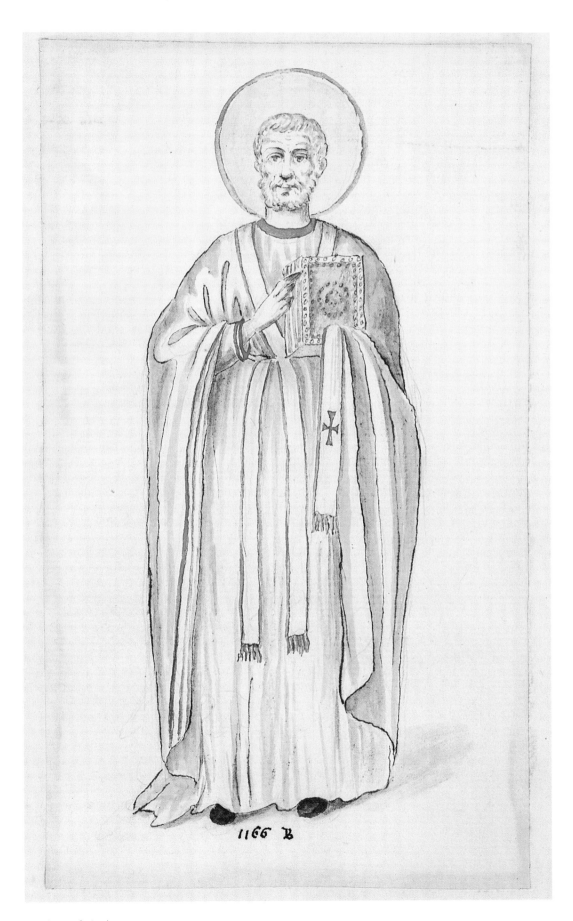

188 (actual size)

189. Mural: Madonna and Child with four saints, S. Martino ai Monti, Rome

SEVENTEENTH-CENTURY ITALIAN

Windsor, RL 9090

Watercolour and bodycolour, and pen and ink, over graphite

202 × 298 mm

NUMBERING: [bottom centre] *1166*

[right of bottom centre] *C*

MOUNT SHEET: type B. Also bears **190** [below]

BIANCHINI fol. 133, I and II: Painted image of the Blessed Virgin amid other Virgin Saints, perhaps taken from (I: the Oratory of) the same *Titulus*, (II:) where there is the old marble Tablet with the names of the Virgin Saints whose relics were there and whose feast was celebrated [the reference is to S. Silvestro in Capite, cf. **187**].

The 8th/9th-century mural of a standing Madonna and Child, flanked by four female saints wearing crowns and holding crowns, is located at the top left of the east wall of room M in the substructures beside S. Martino (Krautheimer *CBCR* III (1967), pl. III = Wilpert 1916, I, p. 323, fig. 100, room D2h).

LITERATURE: Waetzoldt 1964, no. 566

OBJECT DRAWN: extant. Filippini 1639, p. 32; Wilpert 1916, I, p. 334, IV, pl. 205.1

The corresponding drawing in the Barberini album is considerably larger than the dal Pozzo one, occupying a double folio, but neither records the inscription which Filippini saw and which is still visible, identifying the figure on the far left as St Agnes. The other saints are thought to be Cecilia, Euphemia and Agatha.

OTHER DRAWINGS: BAV, Barb. lat. 4405, fol. 47 (Waetzoldt 1964, no. 564, fig. 311)

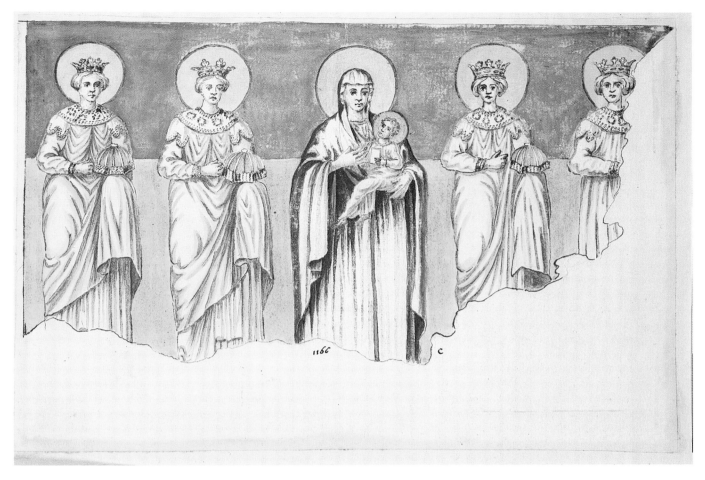

189

190. Mural: enthroned Madonna and Child with two saints, S. Martino ai Monti, Rome

SEVENTEENTH-CENTURY ITALIAN

Windsor, RL 9091

Watercolour and bodycolour, and pen and ink, over graphite

220 × 317 mm

NUMBERING: [bottom left] *1166*

[bottom right] *D*

MOUNT SHEET: type B. Also bears **189 [above]**

BIANCHINI fol. 133 [see **189**]

The 8th/9th-century mural is located at the top of the east wall of room H in the substructures beside S. Martino (Krautheimer *CBCR* III (1967), pl. III = Wilpert 1916, I, p. 323, fig. 100, room C2k). The corresponding drawing in the Barberini album is significantly larger and more detailed. Not surprisingly, however, neither of the drawings, nor Filippini, recorded the inscriptions by which the two female saints holding crowns were identified as Agape and Irene; they were only deciphered at the beginning of this century by Wilpert, after prolonged study.

LITERATURE: Waetzoldt 1964, no. 570a

OBJECT DRAWN: extant. Filippini 1639, p. 33; Wilpert 1916, I, p. 334f., IV, pl. 205.3

OTHER DRAWINGS: BAV, Barb. lat. 4405, fol. 46 (Waetzoldt 1964, no. 570, fig. 314)

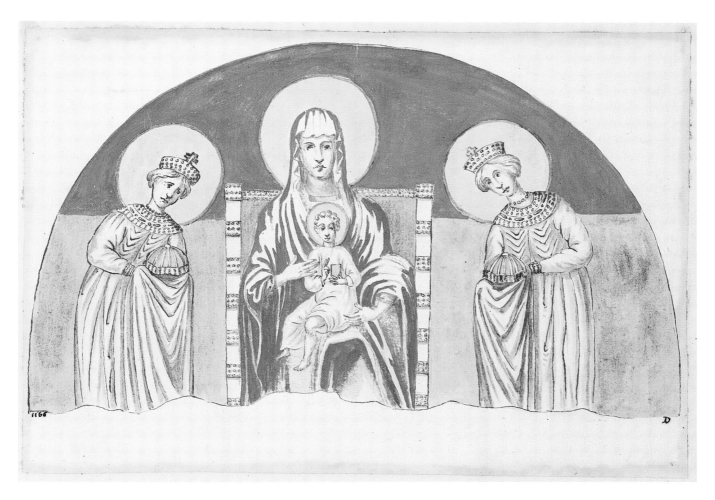

190

191. Mural: Christ with four standing saints, S. Martino ai Monti, Rome

SEVENTEENTH-CENTURY ITALIAN

Windsor, RL 9092

Watercolour and bodycolour, and pen and ink, over graphite

193 × 314 mm. *Watermark*: Fleur de Lys 67

NUMBERING: [bottom left] *1166*; [bottom right] *E*

MOUNT SHEET: type B. Also bears **192** [below]

BIANCHINI fol. 134, I and II: More images of male and female Saints.

The mural faces that shown in **189**, on the opposite wall of room M in the Roman structure adjoining S. Martino, and is now much decayed. Neither this drawing, nor its equivalent which occupies a double folio in the Barberini album, records the inscriptions which flanked the heads of the attendant saints at the left. They were transcribed by Filippini and are still visible, identifying the martyr Processus (with the cross) and the apostle Paul (with book). The two to the right are presumably their counterparts, the apostle Peter (with the key) and the martyr Martinianus. Filippini describes the colours of the apostles' over-mantles as yellow with red folds, their tunics as blue and white; the martyrs' garments as yellow with red stripes.

LITERATURE: Waetzoldt 1964, no. 567

OBJECT DRAWN: extant. Filippini 1639, p. 27f.; Wilpert 1916, I, p. 334, IV, pl. 205.2

OTHER DRAWINGS: BAV, Barb. lat. 4405, fol. 48 (Waetzoldt 1964, no. 565, fig. 312)

191

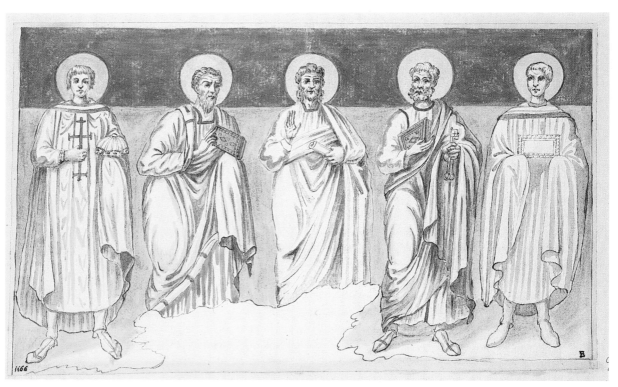

192

192. Mural in the apse of the S. Silvestro chapel, S. Martino ai Monti, Rome

SEVENTEENTH-CENTURY ITALIAN

Windsor, RL 9093

Watercolour and bodycolour, and pen and ink, over graphite

176 × 370 mm

NUMBERING: [bottom left corner] *1166*; [bottom right corner] *F*

ANNOTATION: [at window frame, graphite] colour annotation

MOUNT SHEET: type B. Also bears **191** [above]

BIANCHINI fol. 134 [see **191**]

The lower wall of the apse of the St Silvester chapel (see also **188**), pierced by three narrow windows, depicted four standing saints. The corresponding drawing in the Barberini album is considerably larger, occupying a double folio. Neither drawing records the inscriptions, read by Filippini, which identified the lateral females, each holding a lily stalk in her right hand and a burning lamp in her left, as the virgin martyrs St Agnes and St Cecilia. Inscriptions also identified the intervening bearded males as St Eusebius, Bishop of Vercelli, and St Thomas à Becket, Archbishop of Canterbury, a relic of whom Cardinal Bicchieri brought to Rome from England in 1219 (Vielliard 1931, p. 113f.).

LITERATURE: Waetzoldt 1964, no. 562

OBJECT DRAWN: destroyed. Filippini 1639, p. 13f.; Wilpert 1916, I, p. 336f.

OTHER DRAWINGS: BAV, Barb. lat. 4405, fol. 49 (Wilpert 1916, I, p. 336f., fig. 110; Waetzoldt 1964, no. 560, fig. 309; Iacobini 1991, p. 260)

193. Mural depicting the Madonna and Child, with plan and elevation of a large Roman building in which it was located

SEVENTEENTH-CENTURY ITALIAN*c. 1666*

Windsor, RL 9176

Pen and ink, and brown ink wash, over graphite

417 × 256 mm. *Watermark*: Figure 18A

NUMBERING: *558*

ANNOTATION: [key, brown ink]

A. Luogo dell'Immagine

B. Entrata nel luogo

C. Nichia

D. Nave grande

MOUNT SHEET: type B

BIANCHINI fol. 163, I and II: Plan of an early Church (I: Basilica), and Image of the Blessed Virgin (perhaps at S. Martino ai Monti).

An identical drawing, apparently by the same hand, is bound into one of the Barberini volumes in the Vatican Library and annotated on the verso: '*Hauta dal S^r Lionardo. E in una vigna presso le terme Anton(in)iane la quale è di un P. Domenicano*' ('Received from Signor Lionardo. It is in a vineyard near the Baths of Caracalla belonging to a Dominican priest'). Lanciani (*FUR*, pl. 42) locates the structure in a vineyard on the urban stretch of the via Appia, between the Via Antoniniana (which ran along the south flank of the Baths of Caracalla) and the garden of the church of S. Cesareo, where excavations were undertaken in 1658 by Maestro Fanelli, a Dominican priest (presumably the same one referred to in the annotation on the Barberini drawing), and then in June 1666 by a certain Mansueti (cf. Avetta 1985). The 'Signor Lionardo' of the Barberini annotation could be Leonardo Agostini (see p. 305), one time antiquary to Cardinal Francesco Barberini and Commissioner of Antiquities for Rome and Lazio from 1655 to 1670.

The drawing (the dal Pozzo copy of which bears a Carlo Antonio inventory number) may be directly related to the 1666 discoveries, described at the time as '*vestigi di luogo sacro*' ('remains of a holy place'). This description suits the Christian subject matter of the wall-painting copied separately at the top of the drawing, and accords well with the accompanying annotations, referring to the elevation and plan beneath, which twice employ the same word, 'luogo', and refer to the main space as a 'nave'. Though no mention is made of the fact, it is evident from the plan and elevation that this Christian shrine was situated within the ruins of a substantial ancient Roman building, of which no trace is visible today and no other documentary evidence is known. Recent commentators have variously interpreted the structure as part of a bath complex (Insalaco 1984), a large private house (Avetta 1985), or a commercial establishment (Cecamore 1989, pp. 86, 91f.).

The mural sketched at the top is lettered 'A', corresponding to the 'A' on the elevation and plan beneath. It was evidently located on the back wall of one of the vaulted rooms on the ground floor of the ancient building. A large area in the middle and lower right of the painting is shown as damaged or missing. In the upper zone two angels bear the Madonna and Child in an almond-shaped 'glory', or mandorla, witnessed by at least three figures beneath, who raise their arms in gestures of prayer and acclamation. This iconography is unusual, and does not correspond to any

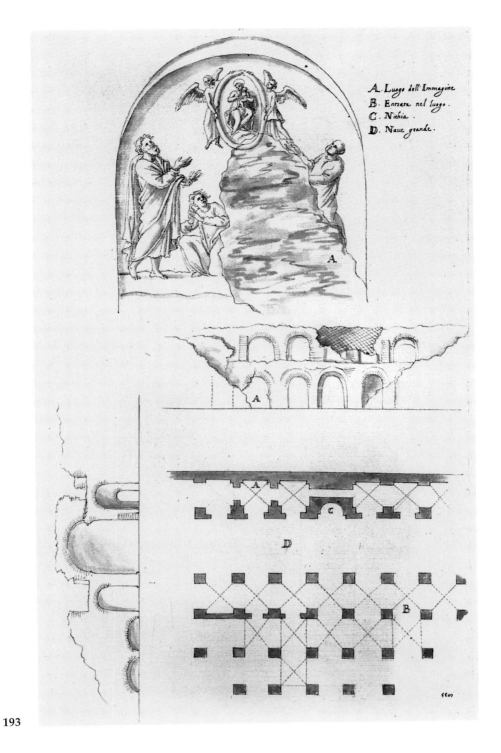

A. *Luogo dell' Immagine*
B. *Entrata nel luogo*.
C. *Nichia*.
D. *Naue grande*.

193

known narrative event, although it is not impossible that the copyist may have misinterpreted a depiction of Christ's Transfiguration.

LITERATURE: Blunt 1971, p. 122

OBJECT DRAWN: probably destroyed; Lanciani *FUR*, pl. 42; Avetta 1985, p. 32, no. 24

Given the likely date of the drawing, Blunt's attribution of the drawing to Pietro Testa (d. 1650) is untenable.

OTHER DRAWINGS: BAV, Barb. lat. 4426, fol. 24 (partially reproduced by Cecamore 1989, p. 87, pl. 23)

194. Mural?: Madonna and Child, with Saints Peter and Paul, and donor

SEVENTEENTH-CENTURY ITALIAN

Windsor, RL 8975

Watercolour and bodycolour, and brush and ink, over graphite

242 × 282 mm

NUMBERING: *578*

MOUNT SHEET: type B. *Watermark*: Figure 33

BIANCHINI fol. 43, I: The Blessed Virgin holding the boy Jesus seated between Saints Peter and Paul. At her feet kneeling in prayer is his Holiness Pope Paul I, with a square frame around his Head

II: Image of the Mosaic of his Holiness Pope Paul I whose portrait is seen with squared ornament at his head, sign that he was still living. He is represented in the act of kneeling in worship at the feet of the blessed Virgin and her Divine Son, while the Holy Apostles Peter and Paul look on.

No such image survives in Rome today, and Bianchini's reference to a mosaic of Pope Paul I (757–67) is obscure; but there is another drawing of it in a codex in the Vatican Library. The source of the second drawing is equally unknown (the codex in question is a miscellaneous compilation of *c.* 1800 by the Prefect of the Library, Gaetano Marini), but it is associated with a larger group of drawings by a single artist. Since all the others in the group represent fragmentary 12th-century paintings in rooms 6 and 7 of the oratory of S. Sebastiano, beneath the Scala Santa in the Lateran Palace, Waetzoldt has suggested that the Madonna and Child was also located there. The format could suggest a date in the 12th or 13th century.

LITERATURE: Waetzoldt 1964, no. 244

OBJECT DRAWN: uncertain

OTHER DRAWINGS: BAV, Vat. lat. 9071, p. 257 (Waetzoldt 1964, no. 236, fig. 129)

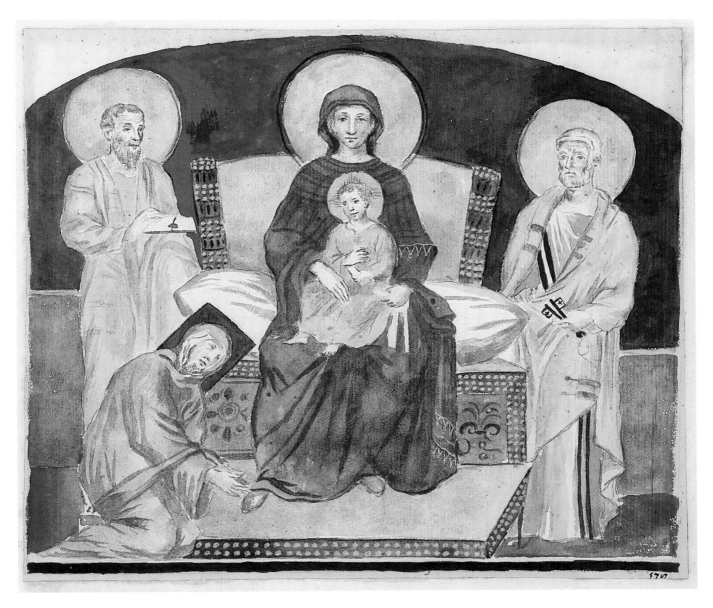

194

111

195. Apse mosaic of S. Agata Maggiore, Ravenna

SEVENTEENTH-CENTURY ITALIAN

Windsor, RL 9094

Pen and ink, and grey/green wash, over graphite

167 × 170 mm. *Watermark*: Fleur de Lys 68

NUMBERING: [bottom left] *1153*

MOUNT SHEET: type B. Also bears 196 [below]

BIANCHINI fol. 135, I and II: Drawing of the Apse in Mosaic at Ravenna printed by Monsignor Ciampini in volume two.

The Early Christian apse mosaic in the church of S. Agata at Ravenna was destroyed in an earthquake on 11 April 1688 (although some fragments have come to light in recent excavations, see Russo 1987). Christ, seated on a lyre-backed throne, his right hand raised in benediction, was flanked by two standing angels. Suggested dates for the mosaic range from the second half of the 5th century (Deichmann), to the second half of the 6th century (Russo).

Ciampini, who placed it about AD 400, published an engraving which is slightly larger and more elaborately detailed than the dal Pozzo version; the throne and the steps of the footstool are studded with jewels, the angels stand in a field of lilies. In the accompanying text (p. 184) he records his debt to Padre Cesare Pronti of Ravenna (alias Fra Cesare Bacciocchi (1626–1708), a well-known local painter, see Thieme-Becker II, p. 309), for the drawing, and also to one Francesco Brandi, who sent him notes on the colours.

The dal Pozzo example does not appear to be a simplified copy of the Pronti drawing, however; rather, it forms a pair with another (**196**), also showing a mosaic from Ravenna, mounted on the same folio and executed in precisely the same technique. Their high 'Pozzo' numbers suggest acquisitions of the mid to late 1680s, presumably about the time that Ciampini acquired his, but the two sets would seem to be independent. The watermark Fleur de Lys 68 on **195** is possibly paired with that on a copy from Ciaconio (**168**), the copies of Barberini drawings of S. Martino ai Monti (**188, 191**), and one of the gold-glass

drawings (271). From these and other considerations of style and technique Blunt's attribution of the Ravenna drawings to Testa can be discounted.

LITERATURE: Blunt 1971, p. 122

OBJECT DRAWN: destroyed. Deichmann *Ravenna* II, 2 (1976), pp. 283–97, esp. 293–4; Russo 1987

OTHER DRAWINGS: Ciampini *Vet. mon.* I, p. 185, pl. XLVI

Comp. fig. 195: Anonymous, *Apse mosaic in S. Agata Maggiore, Ravenna*, engraving, Ciampini, *Vet. mon.* I, pl. XLVI

195 (actual size)

196. Mosaic in the dome of the Arian Baptistery, Ravenna

SEVENTEENTH-CENTURY ITALIAN

Windsor, RL 9095

Pen and ink, and grey wash, over graphite

246 × 245 mm

NUMBERING: [bottom centre] *1154*

MOUNT SHEET: type B. Also bears **195** [above]

BIANCHINI fol. 135 [not mentioned]

The mosaic decoration in the dome of the late 5th-century Arian Baptistery at Ravenna is, in Ciampini's words (*Vet. mon.* I, p. 78), of most singular character. In the central medallion, Christ is immersed up to his crotch in the River Jordan. John the Baptist, wearing a camel skin, is holding a *patera* full of water over Christ's head, onto which a dove, symbol of the Holy Spirit, projects rays of grace. The figure seated to the right, with horns, which earlier commentators had seen as Moses, Ciampini recognized as the personification of the Jordan. The outer ring contains a procession of the twelve apostles, led by Saints Peter and Paul, approaching the prepared throne of judgement.

Although the high 'Pozzo' number suggests that they could be nearly contemporary, it is unlikely that this drawing provided the model for the engraving published by Ciampini. He does not actually cite a source, but the respective images differ in various significant respects (they are not of a size, nor is the proportion between the two circles the same; the dal Pozzo drawing misses the rays from the dove's beak and Christ's halo, and makes a strange loop out of the waves below his feet, but is more accurate in some other details).

See also **195**.

LITERATURE: Blunt 1971, p. 122

OBJECT DRAWN: extant. Deichmann 1958, pls 249–73; Deichmann *Ravenna* I,1 (1974), pp. 251–8; Von Matt/Bovini 1971, p. 44f., pl. 17

OTHER DRAWINGS: Ciampini *Vet. mon.* II, p. 78, pl. XXIII

Comp. fig. 196: Anonymous,
Mosaic in the dome of the Arian baptistery, Ravenna,
engraving, Ciampini, *Vet. mon.* II, pl. XXIII

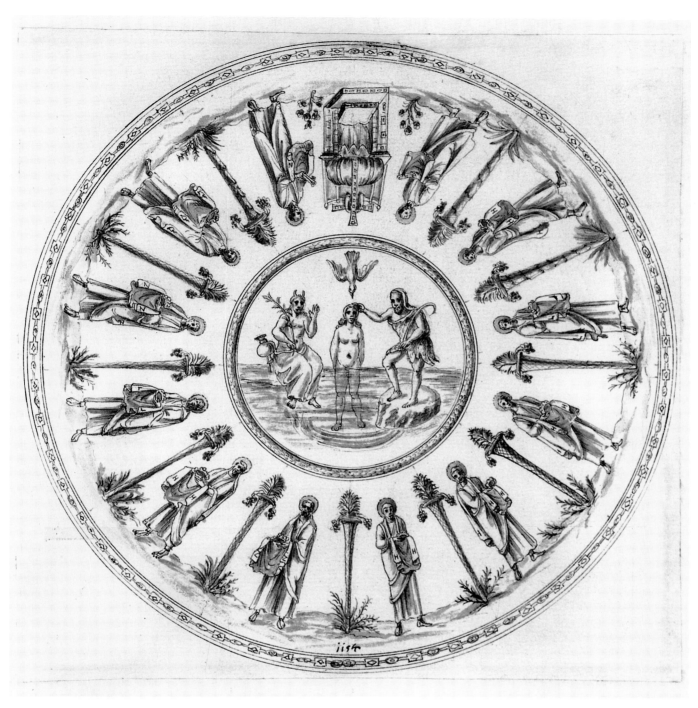

196

197. Votive painting: Ieradina Dallumote and her daughter Genevra give thanks to the blessed Camilla

SIXTEENTH- OR SEVENTEENTH-CENTURY ITALIAN

Windsor, RL 9063

Watercolour and bodycolour, over pen and ink

301 × 384 mm. Fold marks; damage to surface

ANNOTATION: [lower right, red chalk] *O stupendo* [illegible word]?*usto*?*uesto*

[bottom centre, scratched into bodycolour]?*A f Cibanij*

MOUNT SHEET: lost (the drawing was removed from *Mosaici Antichi* volume in 1944, remounted, and is now stored separately)

BIANCHINI fol. 117, II: Old drawing in which it is written (I and II:) Thanks for the cure made by the Blessed Camilla (I:) original painting of the 14th century.

The drawing copies a votive painting in which two kneeling women, named in the inscription as Ieradina Dallumote and her daughter Genevra, give thanks to the blessed Camilla for a miraculous cure: 'O wonderful miracle worked upon the Lady Ieradina Dallumote of S. Maria in Casciano through her daughter Genevra who found her unconscious on the ground and made all contorted by a terrible shock. On the pledging of a vow, she was released by the Blessed Camilla'. The latter is undoubtedly the *beata* Camilla Rovellone (Gentili) of the 14th or 15th century, whose relics were venerated in the church of S. Domenico at S. Severino in the Marche (*Bibl. Sanct.* iii, 707). The original painting is lost but was attributed by Philip Pouncey (cited by Popham and Wilde), presumably on the basis of the dal Pozzo drawing, to the Perugia-born artist Bernardino di Mariotto (1478–1566), who was active at S. Severino in the first two decades of the 16th century (Thieme-Becker III, p. 441f.).

S. Severino is only a few kilometres from Tolentino, site of an Early Christian sarcophagus which is also the subject of a group of drawings in the *Mosaici Antichi* (**230–33**), but the precise nature of the dal Pozzo contact with this region has not yet been determined. One possibility is the person of Giovanni Severano, who was a native of S. Severino and well-known to Cassiano through his work on Bosio's *Roma Sotterranea* (see Volume One, p. 45). The drawing has been folded and is badly rubbed, and has no 'Pozzo' number.

LITERATURE: Popham/Wilde 1949, p. 181, fol. 37

OBJECT DRAWN: lost

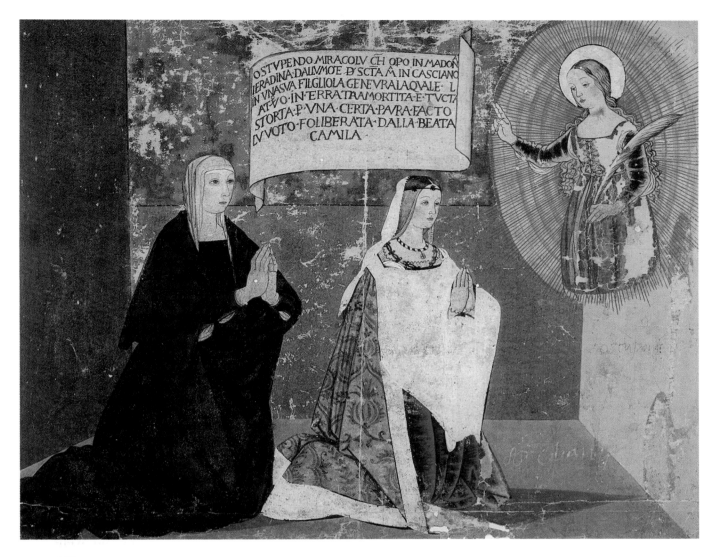

OSTVPENDO MIRACOLV CH OPO IN MADON
IERADINA DALVMO E D SCTA M IN CASCIANO
IN VNASVA FILGLIOLA GENEVRA LAQVALE L
AT VO IN ERRATA AMORTITA E TVCTA
STORTA P VNA CERTA PAVRA FACTO
LV VOTO F O LIBERATA DALLA BEATA
CAMILA

197

198. Oculus in wall of the church of S. Lorenzo 'in castro Montis Iovis'

LATE SIXTEENTH- OR SEVENTEENTH-CENTURY
ITALIAN

Windsor, RL 9101

Pen and ink

151 × 114 mm

ANNOTATION: [brown ink] *In oculo Parietis ecclesiae S. Laurentii in Castro Montis Iovis*; [lower left of circle, black chalk] *V*

MOUNT SHEET: type B. Also bears **200–201**, **299**

BIANCHINI fol. 138, I: 'In oculo parietis Ecclesiae S. Laurentii in Castro Montis Iovis' II: Picture, which is said to be copied from the Church of S. Lorenzo in the Castle called Monte di Giove.

The *oculus* (a circular window) was made out of three blocks of stone. To judge by the section of a pediment sketched at the top right corner it was located on the façade of the church. The significance of the rope-like device and the associated lettering ARNUS NARNUS/B/ MC and the number 46 is highly problematic. Given that a drawing of a coat of arms (200) was subsequently mounted alongside, it is possible that the device is heraldic and Arnus Narnus (or Marnus) a name, the 46 his age. It has proved equally difficult to identify a suitable castle or hill-top settlement called Monte Giove. The toponym is quite common in Italy, yet no modern instance seems to possess a church of S. Lorenzo. An annotation on the verso (see **199**) speaks of gates in the plural, which suggests a settlement of some size. There is a *Montegiove* 35 km south of Rome, near Lanuvio, traditionally the ancient *Corioli*, which was owned in the 16th century by the Roman monastery of S. Lorenzo fuori le mura (Tomassetti 1910, II, p. 281, fig. 57; 1979 edn II, p. 342), and had a church (of unknown dedication) but the site is now occupied solely by an early 17th-century villa, with no evidence of substantial earlier settlement.

LITERATURE: unpublished

OBJECT DRAWN: not traced

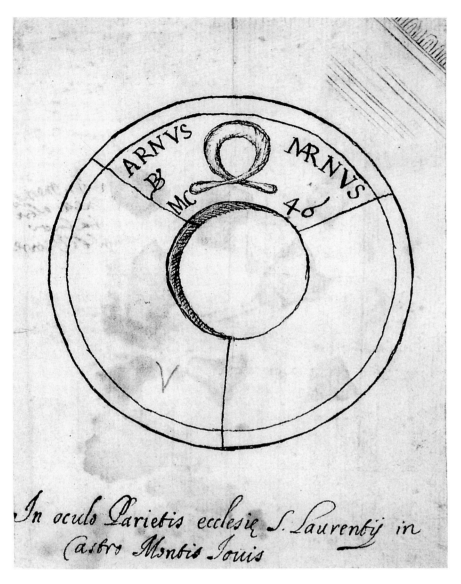

198 (actual size)

In oculo Parietis ecclesiæ S. Laurentij in Castro Montis Iouis

199. Sketch of a heraldic device(?) similar to that shown in 198

LATE SIXTEENTH- OR SEVENTEENTH-CENTURY
ITALIAN

Windsor, RL 9101A

Pen and brown ink

72 × 66 mm. Badly stained with glue, tears at edges

ANNOTATION: [top, continuing onto verso of **198**, brown ink]

Alli Porte di Monte / Giove Va cosi rotta In mez [cut]*/ la trecia nelli altr*
[cut]*/ armi ha fatto / errori il Pittor* [cut]

[lower centre, black chalk] *V*

MOUNT SHEET: pasted onto verso of **198**

The annotation has been cut off at the right edge but presumably refers to the accompanying sketch of the rope-like device with tassles and to the example drawn on the recto:

'On the gates of Monte Giove. It is broken thus In the middle [of] the plait in the other [..?] arms the artist has made mistakes'.

LITERATURE: unpublished

OBJECT DRAWN: not traced

199 (actual size)

200. Arms of the family of Pope Urban VI(?) with the date 1387

SEVENTEENTH-CENTURY

Windsor, RL 9100

Pen and ink

148 × 77 mm. Stained; hole lower centre.
Watermark: coat of arms (unidentified)

NUMBERING: *968*

MOUNT SHEET: type B. Also bears **198**, **201**, **299**

BIANCHINI fol. 138 [not mentioned]

The arms may be those of Pope Urban VI (1378–89), or more generally of the Prignano family of Naples, for which the 1387 date would be appropriate. Urban VI's papal *stemma* is known to have comprised an eagle of this type, surmounted by a tiara; it appears thus on his tomb in the Vatican grottoes (Galbreath 1930, p. 79, fig. 138; Montini 1957, p. 263, pl. 95; see also RL 11720, to be published in A.VIII). The drawing bears one of Carlo Antonio's high 'Pozzo' numbers, marking it as an addition of the early 1680s.

LITERATURE: unpublished

OBJECT DRAWN: not traced

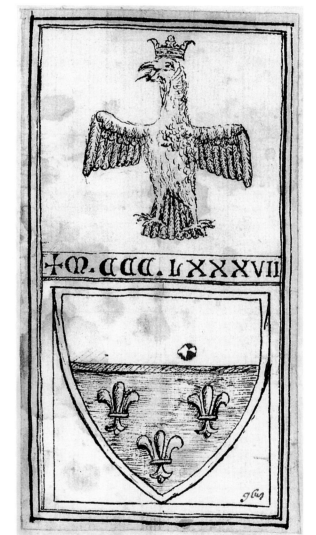

200 (actual size)

201. Painting(?) of the Lamentation

SIXTEENTH- OR SEVENTEENTH-CENTURY

Windsor, RL 9098

Pen and ink, traces of black chalk

83 × 152 mm. Irregular shape, cut around brown ink mount line; pricked for transfer; hole, centre right, repaired with thin backing sheet

NUMBERING: [bottom centre] *839*

[bottom left] *A*

[bottom right] *B*

VERSO: [top left, brown ink] *tenta* [illegible] / *Tofeo* [or *Tosco*] / *inch* [illegible]

MOUNT SHEET: type B. Also bears **198–200, 299**

BIANCHINI fol. 138 [not mentioned]

Mounted at the top of the same folio as the preceding three drawings, the subject appears to be a scene of Mary and St John mourning over the body of Christ. Two other figures, one on each side, wearing crowns, stand in a landscape background. The location and date of the original are not known, but it is at the earliest late medieval. The drawing, which is little more than a sketch, seems to have been prepared for transfer as part of a larger composition (to which the letters A and B probably refer). Worn and damaged, it is unlikely to have been a dal Pozzo commission, though it bears one of Carlo Antonio's high numbers.

LITERATURE: unpublished

OBJECT DRAWN: not traced

201 (actual size)

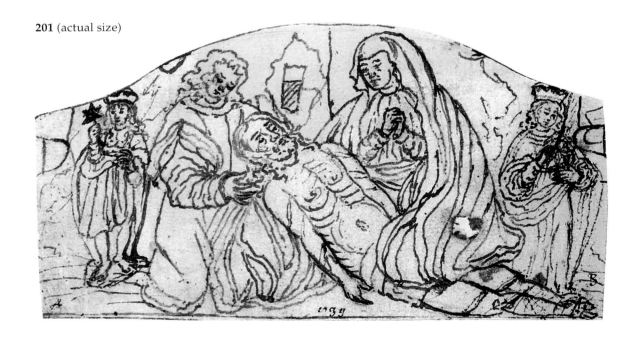

202. ?Painting or manuscript illustration: family of the Byzantine emperor Michael VIII Palaeologos

SEVENTEENTH-CENTURY (?)

Windsor, RL 8938

Watercolour and bodycolour, pen and ink, over traces of black chalk

250 × 254 mm. Irregularly cut; once folded in four; stained and foxed

NUMBERING: [bottom centre, on mount between drawing sheet and double ink framing line] *113*

VERSO: see **203**

MOUNT SHEET: type A. Frame lines 9.5 mm apart, heavy.
Watermark: Figure 27 (cut)

BIANCHINI fol. 11, I. Images of the Palaeologos Emperor and his wife and their son, in Christian Constantinople. II. Image of the Emperor Michael and his wife, the empress Theodora Comnena, with their son Constantine Porphyrogenitus, printed by Sig. Du Cange in his dissertation *de Inferioris Evi numismatibus* as Plate VI.

The same figures, reproduced as three separate images, were published in Lyons in 1601, accompanying a French translation of excerpts from the Byzantine historian Niketas Choniates, appended to the *Chronique* of Villehardouin (see Grabar 1955 and 1968). There, inscriptions identify them as the Emperor Michael VIII Palaeologos (1259–82), the Empress Theodora and their second son Constantine Porphyrogenitos, and a prefatory note states that the images had been brought back to Venice in 1559 by Marino de Cavalli, the Venetian *bailo* (ambassador) at Constantinople. The three appeared in print again, this time without inscriptions, at the beginning of Paolo Rannusio's account of the Fourth Crusade, published in Venice in 1604, with a similar explanation of their provenance. Unfortunately, what it was that de Cavalli brought back from Constantinople is not specified and no suitable candidate can be found in the surviving corpus of Late Byzantine art. Comparable representations of Late Byzantine rulers appear in a variety of wallpaintings and manuscripts, such as the two portraits of John VI Kantakouzenos in a copy of his theological writings (Omont 1929, pls cxxvi, cxxvii), or that of Michael VIII himself in a copy of the history of George Pachymeres (Spatharakis 1976, fig. 109). All show the emperor dressed in the *sakkos* and *loros*, holding a cross-sceptre in his right hand and

the ceremonial pouch (*akakia*) in his left, and standing on a *suppedion*.

In pl. VI of Du Cange's discussion of imperial iconography, appended to his *Glossarium ad scriptores mediae et infimae latinitatis* of 1678, the three figures are shown again with Greek inscriptions, this time as a group (as in the dal Pozzo drawing, but with the positions of Michael and Theodora reversed). Du Cange's commentary says that they were copied from the church of St Mary Peribleptos at Constantinople, a possibility which has also been entertained by Cyril Mango (1972, p. 217; the church was destroyed in 1782). But, as Grabar remarked on the basis of the illustrations of 1601, the absence of Michael's eldest son and eventual successor Andronikos (who, rather than the younger son, should stand between his parents) is easier to understand if they were separate images.

Such is the degree of correspondence in dimensions and even small detail between the printed versions of 1604/1634 and the dal Pozzo drawing that they must be interdependent, but the precise nature of the relationship is difficult to define. The colouring of the dal Pozzo drawing might imply that it is somehow closer to the original. (On the drawing the emperor's *sakkos*, which one would expect to be purple, is coloured in dark brown ink retouched with black paint. If this followed the

original, it could imply a panel painting, in which azurite had been discoloured through prolonged contact with varnishes, rather than a manuscript.) It is equally possible, however, that the drawing is a composition based on the prints and coloured up according to 17th-century expectations.

The drawing is rather worn and at some time was folded in four, perhaps having been enclosed in a letter, suggesting that it was not a dal Pozzo commission, but supplied by one of their many northern correspondents. In the process of mounting it has been trimmed around the edges. The verso of the sheet bears some miscellaneous pen sketches (see 203). The 'Pozzo' number (113) could associate it with the drawing of the consular diptych of Anastasius (241), numbered 114, both being of interest primarily as illustrations of Byzantine costume. Both drawings are inlaid within double ink frame lines of the same type.

LITERATURE: Osborne 1993

OBJECT DRAWN: not known. Rannusio 1604 and 1634, 3 unnumbered plates between the preface and p. 1; Du Cange *De imp. Const.*, pl. VI (1755 edn, p. 105f. and pl. VI); Grabar 1955 and 1968, pls 22a–b, 23a; Velmans 1971, p. 99; Mango 1972, p. 217

 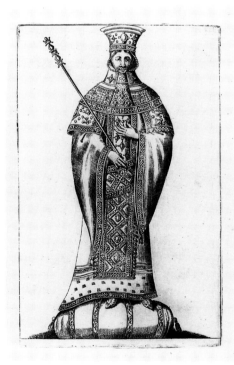

Comp. fig. 202: Anonymous, *Emperor Michael VIII Palaeologos*, *Empress Theodora* and *Constantine*, engravings, Rannusio 1604, three unnumbered plates before p. 1

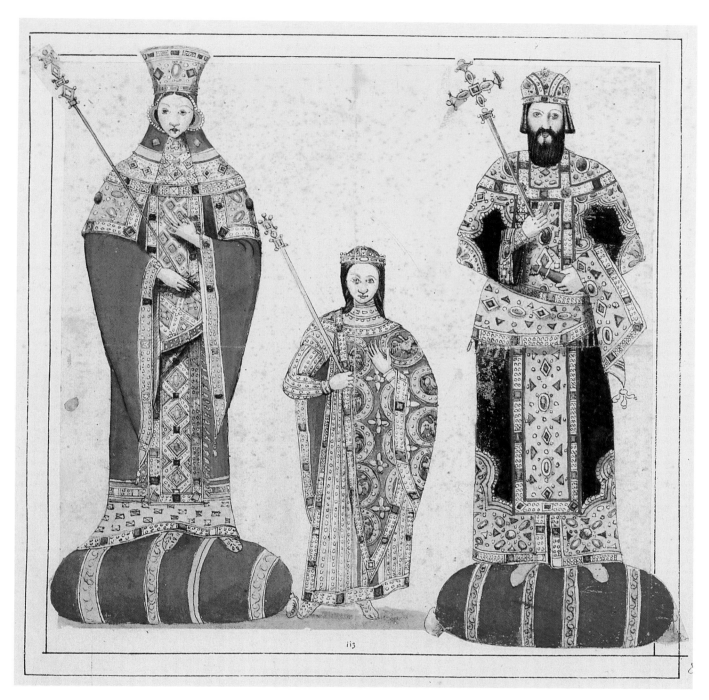

202

125

203. Miscellaneous pen sketches

SEVENTEENTH-CENTURY ITALIAN (?)

Windsor, RL 8938 verso

Pen and dark brown ink

250 × 254 mm

RECTO: see **202**

BIANCHINI fol. 11v [not mentioned]

Some pen sketches, including two bearded ram-horned satyrs and a pan-pipe. Blunt's suggestion that they could be from the hand of Pietro Testa is unsubstantiated.

LITERATURE: Blunt 1971, p. 122

Copies from the 'Roman' Vergil (BAV, Vat. lat. 3867) [204–205]

Two drawings, one unfinished but both by the same hand, reproduce very closely a pair of full-page miniatures from the so-called 'Roman' Vergil in the Vatican Library, a late fifth-century copy of the *Eclogues*, *Georgics* and *Aeneid* of the poet Vergil (70–19 BC). Each Eclogue, and each book of the other two works, was once prefaced by an illustration, nineteen of which survive. The pair represented in **204–5** preface Book X of the *Aeneid*, and show the Olympian Gods gathered in council debating the conflict between Aeneas and Turnus (verses 10. 6–113). In the original the two miniatures appear side by side on facing pages; in the *Mosaici Antichi* they occupy a single folio, one set above the other: the unfinished copy of what should be the right-hand scene (**205**) is inlaid into the upper half of the sheet on which the left-hand scene is drawn. This rather suggests that the mounter was unaware of their actual source; indeed their inclusion in the *Mosaici Antichi* presumably means they were mistaken for Early Christian images (an inattentive eye might well have been misled by the beards and haloes).

The rough method used to inlay the upper drawing is characteristic of Carlo Antonio's later years, but neither drawing has a 'Pozzo' number, and the other physical evidence (see **204**) would be compatible with an earlier date. We know that Cassiano was permitted to borrow three illustrated Classical manuscripts from the Vatican in the course of 1632–4, first the more famous 'Vatican' Vergil (BAV, Vat. lat. 3225), then the 'Roman' Vergil, then the 'Vatican' Vergil again, and lastly the Terence (BAV, Vat. lat. 3868), in order to copy their illustrations for the '*intelligenza e chiarezza di diversi buoni autori*' ('for the information and enlightenment of various good scholars'), the principal interest being the representations of dress and personages (BAV, Arch. bib. 26, fol. 520). Many of the results of this campaign survive at Windsor (to be published in Volume A.VI of this catalogue) and include copies of eight other miniatures from the 'Roman' Vergil, three from the Eclogues (RL 26668–9, 26294) and five more from the Aeneid (26682–3, 26695–7). All those eight, however, are executed in pen and wash, by a different hand and in a very different style from **204–5**, which may therefore have been made on some other occasion. The association of **204–5**, via the watermark Figure 29, with the drawings of the Tolentino sarcophagus (**230**) and thence to the Catacomb paintings (**171**) could signify a date of *c.* 1639.

The 'Roman' Vergil had entered the Vatican Library by 1475 and was recognized as a valuable copy of the text, yet before Cassiano very few seem to have taken any interest in its illustrations (artistically they were far less appealing than those in the 'Vatican' Vergil which had been studied by Raphael and others since the early sixteenth century). One exception was Philips van Winghe in the early 1590s (Schuddeboom 1996, pp. 79, 100) who copied the author portrait for the second Eclogue and one other miniature, both his drawings subsequently being copied for Peiresc (in the 'Menestrier' codex, BAV, Vat. lat. 10545, fols 66, 67) and Dionysius de Villers (Paris, BN, nouv. acq. lat. 2343, fols 72, 79). Van Winghe's copy of the author portrait was also copied for Alfonso Ciaconio (Biblioteca Angelica, MS 1564, fol. 44; see above p. 48).

LITERATURE: *Cod. Vat. Sel.* II (1902); Wright 1992b.

204. Miniature: Council of the Gods (left half)

SEVENTEENTH-CENTURY ITALIAN
Windsor, RL 9074
Watercolour and bodycolour and brush and ink over black chalk
550 × 410 mm; image size: 221 × 220 mm. *Watermark*: Figure 29
MOUNT SHEET: not mounted. Also bears **205**
BIANCHINI fol. 123, I and II: Rather crude pictures of Pagan Deities.

The figure seated in the centre is Jupiter, holding the sceptre and orb, with his mantle draped in his customary manner, so as to leave his chest bare. To either side are the other members of the Capitoline triad: on the left Minerva, in helmet and breastplate, holding a spear, her shield propped against her chair; on the right is Jupiter's consort Juno with her hand raised, the fore- and middle finger extended in a gesture of speech. Standing behind Minerva, is Jupiter's son Mercury, with his herald's staff (*caduceus*) in his left hand; the figure behind Juno is Vulcan, the god of fire. The dal Pozzo copy is made at actual size and is remarkably faithful to the style, colour and detail of the Late Antique original.

LITERATURE: Wright 1992a, p. 152

The drawing was made with the sheet folded in half. Considerable foxing along the right half of the folded sheet (from the recto, which bears the drawing) suggests that the sheet was kept folded in this way for some time, while stains on the verso indicate that another, loose piece of paper (197 × 267 mm) was once stored inside the fold. Although no drawing of precisely those dimensions is to be found in the *Mosaici Antichi*, it is interesting to note that the drawing of the front of the Tolentino sarcophagus (**230**) is only 3 mm smaller in each direction, possibly having been trimmed slightly in the process of its mounting. The association is strengthened by the fact that the watermarks on **230** and **204** probably form a pair (see p. 297).

OBJECT DRAWN: BAV, Vat. lat. 3867, fol. 234v. Wright 1992b, pp. 109–14, fig. 37

205. Miniature: Council of the Gods (right half)

SEVENTEENTH-CENTURY ITALIAN

Windsor, RL 9073

Watercolour and bodycolour and brush and ink over black chalk

221 × 225 mm. Glue stains around all edges

MOUNT SHEET: mounted on **204**

BIANCHINI fol. 123 [see **204**]

The composition echoes that of **204** but the figures are all frontal (listening to Juno's speech in the other half of the council). Seated in the middle is Neptune, Jupiter's marine counterpart, wearing a similar costume; to the left is Diana, goddess of woodland and wild animals, dressed in hunting tunic and ankle boots, her bow in her lap; to the right Mars, god of war, in scale armour. Behind Diana is her brother Apollo, god of poetry and music. Behind Mars is his consort Venus, both with their right hands half-raised as if about to speak.

Evidently made by the same artist as **204**, careful to follow the style of the original without attempting to improve upon it, the drawing is on a different paper and is not finished (it lacks the background and colouring on the heads of Apollo, Neptune and Venus), perhaps signifying that it was preparatory to a fully finished version (like many of the drawings by Eclissi catalogued in Volume One).

LITERATURE: Wright 1992a, p. 152

OBJECT DRAWN: BAV, Vat. lat. 3867, fol. 235. Wright 1992b, pp. 109–14, fig. 38

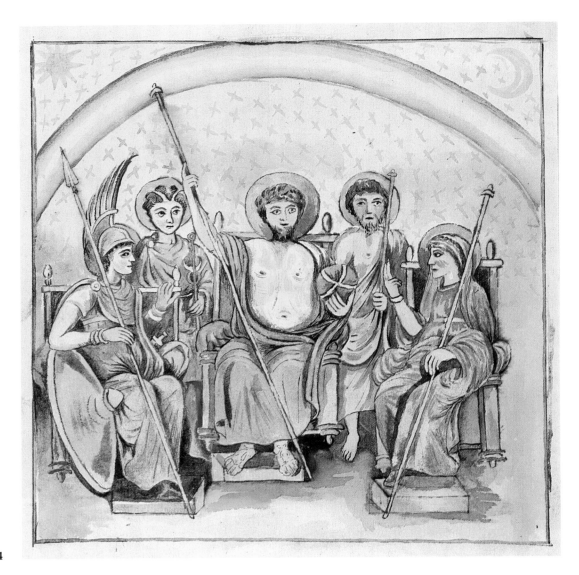

204

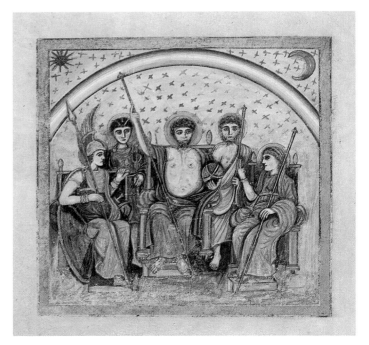

Comp. fig. 204: Anonymous,
Council of the Gods (left half),
miniature in the 'Roman' Vergil.
BAV, Vat. lat. 3867, fol. 234v

130

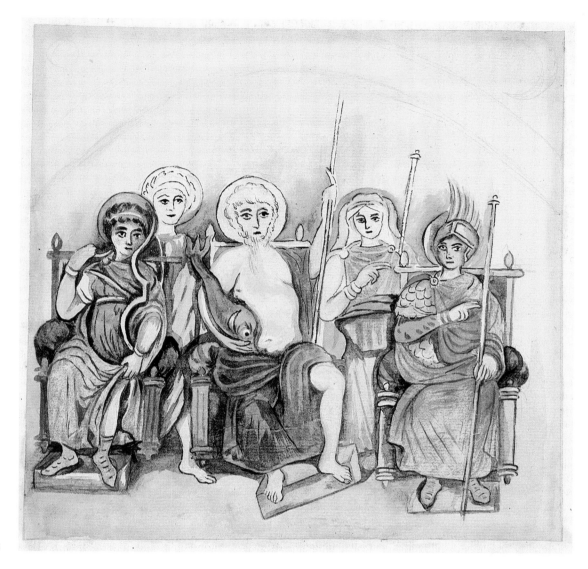

205

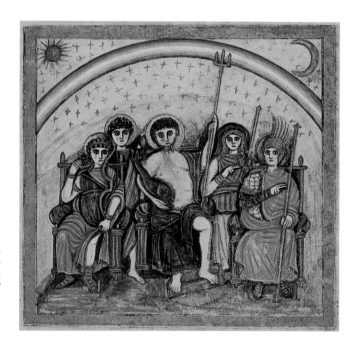

Comp. fig. 205: Anonymous,
Council of the Gods (right half),
miniature in the 'Roman' Vergil.
BAV, Vat. lat. 3867, fol. 235

Illustrations from the *Benedictio Fontis* [206–219]

A series of 14 drawings, mounted in pairs on seven consecutive folios, copies the 14 miniatures in a rotulus manuscript containing the text of the *Benedictio Fontis*, the prayer for the blessing of the baptismal font on Easter Saturday. Believed to have been made for Landolf I, Bishop of Benevento from 957 to 984, the manuscript is one of three Beneventan rolls which were owned in Rome in the late seventeenth century by Cardinal Girolamo Casanate (1620–1700). On his death his library passed to the Dominican convent of S. Maria sopra Minerva, constituting the nucleus of the present Biblioteca Casanatense. At the end of the eighteenth century the rolls were cut into sheets and bound as a single volume: MS 724 (B.I.13), in which the *Benedictio Fontis* is the second. The order in which the drawings are mounted in the *Mosaici Antichi* volume preserves that of the miniatures in the roll, with one picture to illustrate each verse of the prayer. The drawings are excellent copies, closely reflecting the style, colour and detail of the originals; the 'Pozzo' no. *1188* on the first in the set (**206**) indicates that they were acquired by Carlo Antonio dal Pozzo in the mid 1680s.

LITERATURE: Langlois 1886; Bertaux 1903, i, p. 214f.; Avery 1938,
p. 28f., pls CX–CXVII; R. Zuccaro, in Bertaux 1978, p. 426f.; Brenk 1994

Comp. figs. 206–207: miniatures in the *Benedictio Fontis*, Rome, Biblioteca Casanatense, MS 724 (B.I.13)

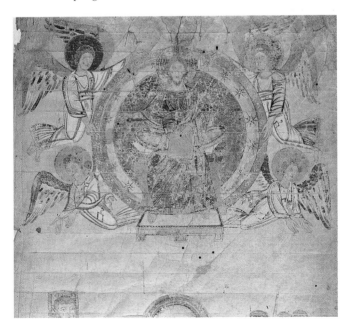
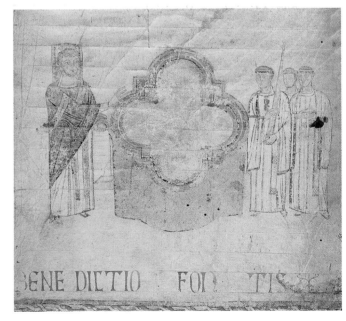

206. Miniature: Christ and four angels

SEVENTEENTH-CENTURY ITALIAN

Windsor, RL 9147

Watercolour and bodycolour, and pen and ink, over traces of graphite

198 × 263 mm

NUMBERING: *1188*

MOUNT SHEET: type B. Also bears **207** [below]

BIANCHINI fol. 146, I: Figures from the Hymn in the Praise of the Paschal Candle, where the Pontiff is perhaps Gregory VII.
II: Figures copied from a parchment volume in which is written the Hymn in Praise of the Paschal Candle which records the devotions with which it is blessed and the rituals by which those are represented. I think I have seen the original in the Cathedral at Salerno and that the Pope shown in the ceremonies is St Gregory VII.

Christ, dressed in light purple robes, is shown enthroned in an aureole supported by angels in light blue tunics and white mantles, illustrating the invocation of the prayer: '*Omnipotens sempiterne Deus...*' ('All powerful, everlasting God'). The image and its companion showing the font (**207**) appear in the manuscript one above the other as they are mounted on the dal Pozzo folio, in preface to the text of the benediction.

Bianchini confused the manuscript with the Exultet roll in the Museo diocesano at Salerno (Avery 1938, p. 36, pls CLIII–CLXIII; d'Aniello 1994).

LITERATURE: unpublished

OBJECT DRAWN: Rome, Biblioteca Casanatense, MS 724 (B.I.13), 2. Avery 1938, pl. CX,1; Brenk 1994, p. 87, no. 1(a), colour plate p. 91

207. Miniature: the bishop approaches the baptismal font

SEVENTEENTH-CENTURY ITALIAN

Windsor, RL 9148

Watercolour and bodycolour, and pen and ink, over traces of graphite

162 × 256 mm

MOUNT SHEET: type B. Also bears **206** [above]

BIANCHINI fol. 146 [see **206**]

A bishop, distinguished from the other ranks of clergy throughout the roll both by his chasuble and *pallium*, and by his square 'nimbus', approaches the baptismal font from the left. In his hand is an open rotulus, presumably containing the text of the *Benedictio fontis*. Three other clerics stand to the right of the font, the first holding the burning Paschal candle.

LITERATURE: unpublished

OBJECT DRAWN: Rome, Biblioteca Casanatense, MS 724 (B.I.13), 2. Avery 1938, pl. CX,2; Brenk 1994, p. 87, no. 1(b), colour plate p. 91

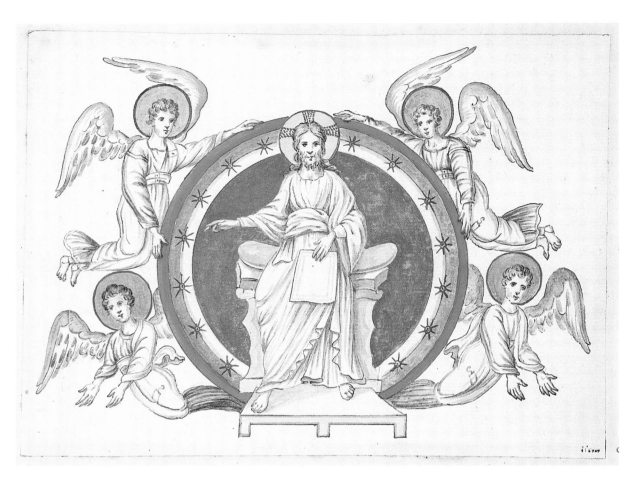

206

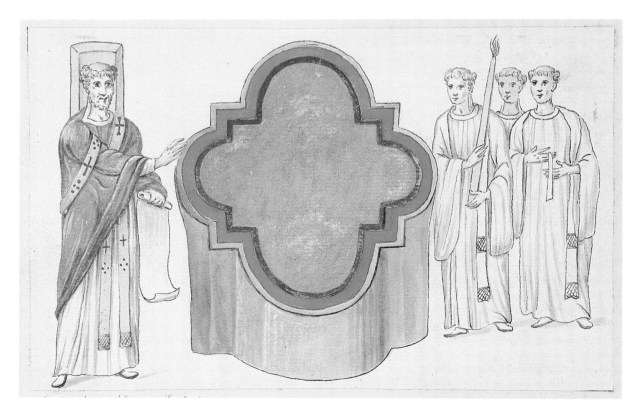

207

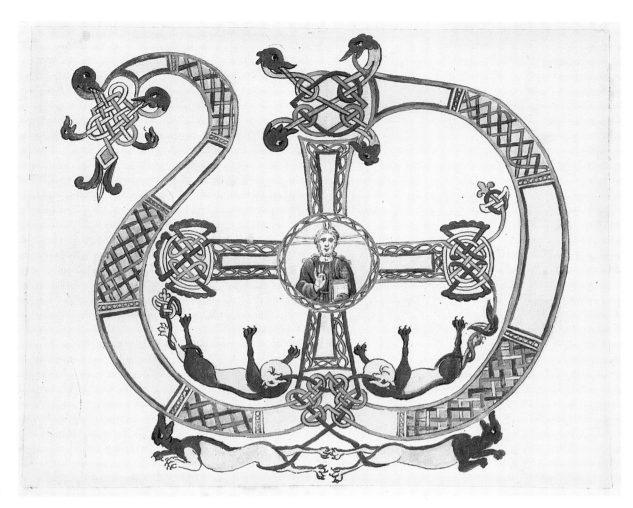

208

209

208. Miniature: illuminated monogram VD

SEVENTEENTH-CENTURY ITALIAN

Windsor, RL 9149

Watercolour and bodycolour, and pen and ink, over traces of graphite

211 × 262 mm

MOUNT SHEET: type B. Also bears **209** [below]

BIANCHINI fol. 147 [see **206**]

A large initial V and D, beginning the verse *'Vere dignum et iustum est...'*. The bowl of the initial is occupied by a large cross, with a half-figure of Christ contained in the roundel at its centre.

LITERATURE: unpublished

OBJECT DRAWN: Rome, Biblioteca Casanatense, MS 724 (B.I.13), 2. Avery 1938, pl. CXII,5; Brenk 1994, p. 87, no. 3(a), colour plate p. 93

209. Miniature: dove and two angels

SEVENTEENTH-CENTURY ITALIAN

Windsor, RL 9150

Watercolour and bodycolour, and pen and ink, over graphite

142 × 236 mm

MOUNT SHEET: type B. Also bears **208** [above]

BIANCHINI fol. 147 [see **206**]

A dove representing the Holy Spirit, flanked by two bowing angels, hovers over an expanse of water, illustrating the phrase *'spiritus super aquas'*.

LITERATURE: unpublished

OBJECT DRAWN: Rome, Biblioteca Casanatense, MS 724 (B.I.13), 2. Avery 1938, pl. CXII,6; Brenk 1994, p. 87f., no. 3(b), colour plate p. 93

210. Miniature: three angels and three demons

SEVENTEENTH-CENTURY ITALIAN

Windsor, RL 9151

Watercolour and bodycolour, and pen and ink, over traces of black chalk

153 × 255 mm

MOUNT SHEET: type B. Also bears **211** [below]

BIANCHINI fol. 148 [see **206**]

Three angels in blue tunics and white mantles, their heads encircled with orange haloes, drive away three naked demons, illustrating the text *'Omnis spiritus immundus abscedat'*.

LITERATURE: unpublished

OBJECT DRAWN: Rome, Biblioteca Casanatense, MS 724 (B.I.13), 2. Avery 1938, pl. CXIII,7; Brenk 1994, p. 88, no. 4, colour plate p. 94

211. Miniature: the four rivers of Paradise

SEVENTEENTH-CENTURY ITALIAN

Windsor, RL 9152

Watercolour and bodycolour, and pen and ink, over graphite

156 × 252 mm

MOUNT SHEET: type B. Also bears **210** [above]

BIANCHINI fol. 148 [see **206**]

Illustrating the text *'seperavit ab arida et in quattuor flumenibus'*, the separation of the earth from the waters (Genesis 1:9–12 and 2:10–14). The sea ('MARE') is in turmoil to the left; the earth and the four rivers of Paradise to the right, two of the rivers named in inscriptions as 'GEON' and 'EUFRATES'.

LITERATURE: unpublished

OBJECT DRAWN: Rome, Biblioteca Casanatense, MS 724 (B.I.13), 2. Avery 1938, pl. CXIII,8; Brenk 1994, p. 88, no. 5(a), colour plate p. 95

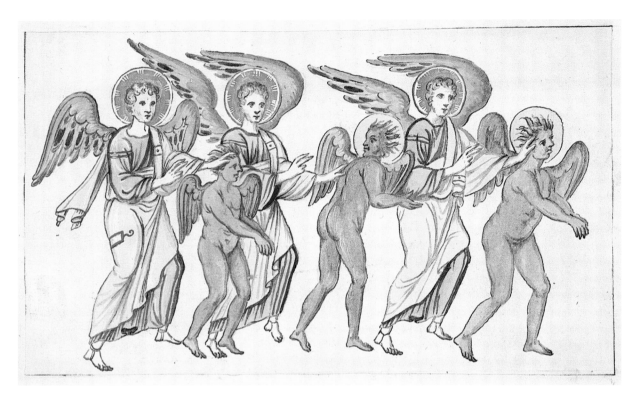

210

211

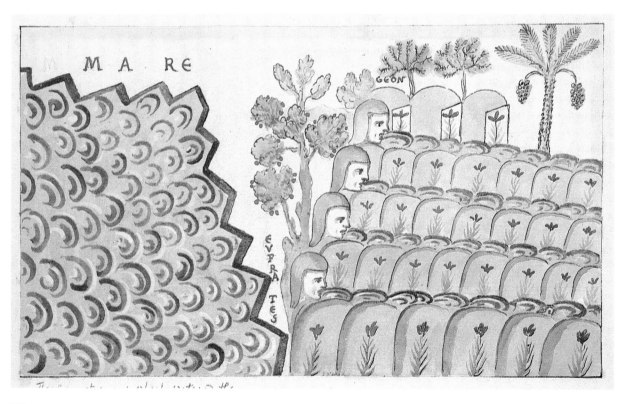

138

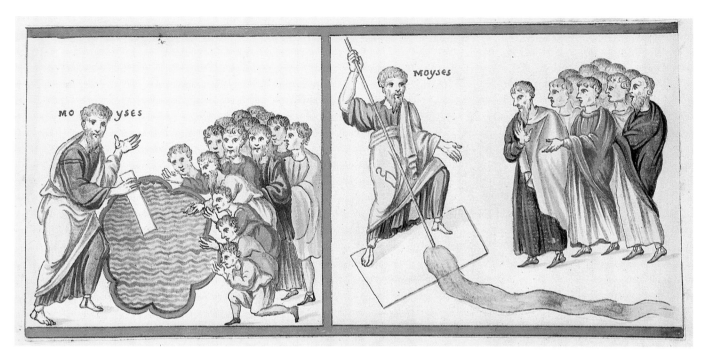

212

213

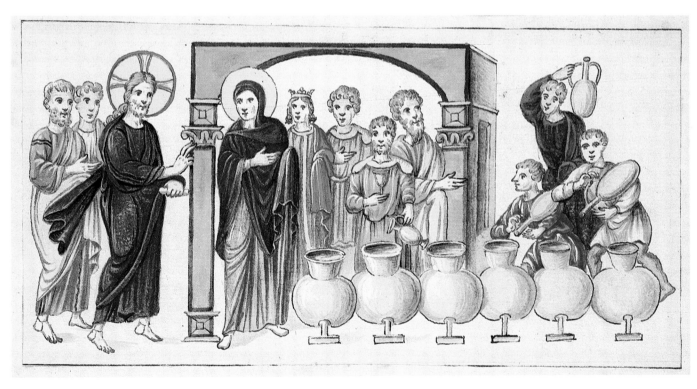

212. Miniature: two miracles from the life of Moses

SEVENTEENTH-CENTURY ITALIAN

Windsor, RL 9153

Watercolour and bodycolour, and pen and ink, over traces of graphite

131 × 267 mm

MOUNT SHEET: type B. Also bears **213** [below]

BIANCHINI fol. 149 [see **206**]

The prophet Moses is identified in each scene by the inscription 'MOYSES'. At the left he sweetens the bitter waters of Marah (Exodus 15:23–5); on the right, watched by the Israelites, he produces a spring of water by striking a rock (Exodus 17:6).

LITERATURE: unpublished

OBJECT DRAWN: Rome, Biblioteca Casanatense, MS 724 (B.I.13), 2. Avery 1938, pl. CXIV,9; Brenk 1994, no. 5(b), colour plate p. 95

213. Miniature: the marriage feast at Cana

SEVENTEENTH-CENTURY ITALIAN

Windsor, RL 9154

Watercolour and bodycolour, and pen and ink

133 × 248 mm

MOUNT SHEET: type B. Also bears **212** [above]

BIANCHINI fol. 149 [see **206**]

The wedding couple are shown standing in a triumphal arch, with their cupbearer (with a glass and wine-jug) and a guest to the right. The haloed woman on the left is Mary, turning towards Jesus, who is approaching from the left, dressed in blue, accompanied by two disciples. On the right are three servants filling a line of large containers with the water which Jesus miraculously changed into wine (John 2:1–10).

LITERATURE: unpublished

OBJECT DRAWN: Rome, Biblioteca Casanatense, MS 724 (B.I.13), 2. Avery 1938, pl. CXIV,10; Brenk 1994, p. 88, no. 5(c), colour plate p. 95

214. Miniature: the baptism of Christ

SEVENTEENTH-CENTURY ITALIAN
Windsor, RL 9155
Watercolour and bodycolour, over pen and ink
140 × 217 mm
MOUNT SHEET: type B. Also bears 215 [below]
BIANCHINI fol. 150 [see 206]

The baptism of Christ in the river Jordan, with the hand of God descending from on high.

LITERATURE: unpublished

Both Christ and St John the Baptist are identified by abbreviated inscriptions.

OBJECT DRAWN: Biblioteca Casanatense, MS 724 (B.I.13), 2. Avery 1938, pl. CXV,11; Brenk 1994, p. 88, no. 6(a), colour plate p. 96

215. Miniature: the Crucifixion

SEVENTEENTH-CENTURY ITALIAN
Windsor, RL 9156
Watercolour and bodycolour, over pen and ink
153 × 228 mm
MOUNT SHEET: type B. Also bears 214 [above]
BIANCHINI fol. 150 [see 206]

Christ, clad in a loincloth, hangs with head erect on a pearl-studded cross, and is flanked by two figures: Longinus on the left stabbing the lance into Christ's side and Stephaton on the right, with the sponge and bucket of vinegar.

LITERATURE: unpublished

OBJECT DRAWN: Rome, Biblioteca Casanatense, MS 724 (B.I.13), 2. Avery 1938, pl. CXV,12; Brenk 1994, p. 88, no. 6(b), colour plate p. 96

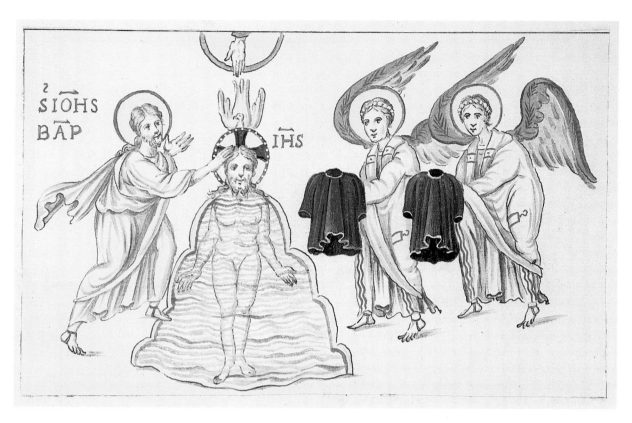

214

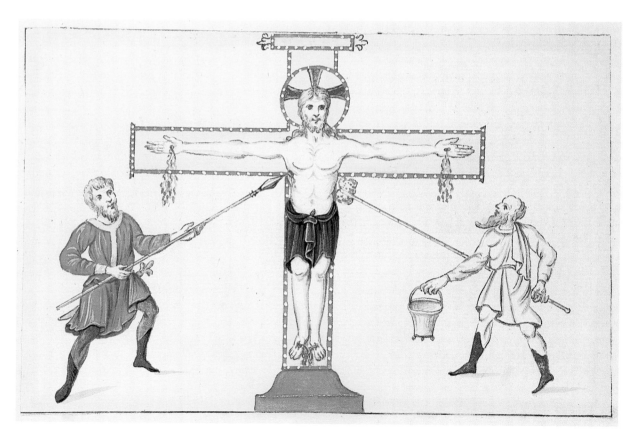

215

216

217

216. Miniature: the ceremony of baptism

SEVENTEENTH-CENTURY ITALIAN

Windsor, RL 9157

Watercolour and bodycolour, over pen and ink

141 × 256 mm

MOUNT SHEET: type B. Also bears **217** [below]

BIANCHINI fol. 151 [see **206**]

At the left, Christ instructs his disciples to baptize believers. To the right, his command is carried out at a quatrefoil font, with three disciples each shown holding an infant in various stages of baptism by immersion.

LITERATURE: unpublished

OBJECT DRAWN: Rome, Biblioteca Casanatense, MS 724 (B.I.13), 2. Avery 1938, pl. CXVI,13; Brenk 1994, p. 88, no. 6(c), colour plate p. 96

217. Miniature: the blessing of the Paschal candle

SEVENTEENTH-CENTURY ITALIAN

Windsor, RL 9158

Watercolour and bodycolour, over pen and ink

155 × 259 mm

MOUNT SHEET: type B. Also bears **216** [above]

BIANCHINI fol. 151 [see **206**]

The text of the *Benedictio fontis* reads: '*Hic mittis cereum in fontem*' and, accordingly, the bishop is shown immersing the base of the Paschal candle in the font, assisted by his clergy and watched by the families of the children to be baptized. As he does so, the deacon immediately behind him holds up a scroll to remind him of the liturgy he should recite DES/CEN/DAT/IN HA/NC PLEN/ITU/DINEM ('descend into this plenty').

LITERATURE: unpublished

OBJECT DRAWN: Rome, Biblioteca Casanatense, MS 724 (B.I.13), 2. Avery 1938, pl. CXVI,14; Brenk 1994, p. 88f., no. 7(a), colour plate p. 97

218. Miniature: blowing on the font

SEVENTEENTH-CENTURY ITALIAN
Windsor, RL 9159
Watercolour and bodycolour, over pen and ink
139 × 258 mm
MOUNT SHEET: type B. Also bears **219** [below]
BIANCHINI fol. 153 [see **206**]

The bishop, clutching his robes out of the way, bends to blow on the water, following the instructions of the text. On the right, three naked infants are brought forward in the arms of their fathers for baptism; the mothers stand to the rear.

LITERATURE: unpublished

OBJECT DRAWN: Rome, Biblioteca Casanatense, MS 724 (B.I.13), 2. Avery 1938, pl. CXVII,15; Brenk 1994, p. 89, no. 7(b), colour plate p. 97

219. Miniature: baptism of the children

SEVENTEENTH-CENTURY ITALIAN
Windsor, RL 9160
Watercolour and bodycolour, over pen and ink
147 × 250 mm
MOUNT SHEET: type B. Also bears **218** [above]
BIANCHINI fol. 152 [see **206**]

Other members of the clergy assist the bishop with the baptism of the children.

LITERATURE: Marriott 1868, pl. xxxvii

OBJECT DRAWN: Rome, Biblioteca Casanatense, MS 724 (B.I.13), 2. Avery 1938, pl. CXVII,16; Brenk 1994, p. 89, no. 8, colour plate p. 98

218

219

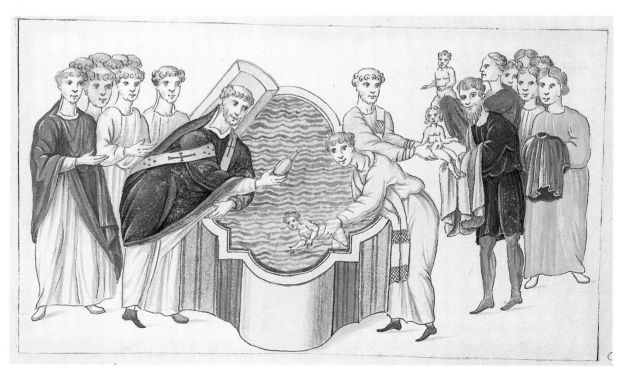

SARCOPHAGI [220–236]

Marble sarcophagi (known generically in Italian as *pili*) featured strongly in antiquarian studies at Rome by the fifteenth century. But Early Christian examples were not well known, and rarely drawn, until the spectacular discoveries from the Vatican cemetery under St Peter's in 1590–92. Philips van Winghe (1560–92, see p. 311), the subject of a recent monograph (Schuddeboom 1996), was one of the earliest to take a close interest. He commented on four sarcophagi with Christian iconography in his Roman notebook of 1589–92 (Brussels, Royal Library 17872–3, fols 17, 19v, 20, 43v) and apparently made detailed drawings of about thirty altogether, at least twenty of which were copied for Ciaconio (Rome, Biblioteca Angelica, MS 1564, fols 32 and 38 and BAV, Vat. lat. 5409, fols 12, 46, 48–49v). Later, Peiresc also obtained copies, from Philips' brother Hieronymus in Tournai, which Schuddeboom identifies with twenty-eight in the 'Menestrier' codex (BAV, Vat. lat. 10545). An almost identical set is to be found in the De Villers codex (Paris, BN, nouv. acq. lat. 2343).

Antonio Bosio included forty-three sarcophagi in his study of the Early Christian cemeteries (*Roma Sotterranea*), limiting his choice to those of known provenance: twenty-one from the Vatican and twenty-two from other suburban cemeteries. In preparing Bosio's work for publication during 1630–32, Giovanni Severano added another three whose specific provenance was not known but which were of interest for the symbolism of their subject matter, on which he contributed a lengthy commentary.

Only ten sarcophagi are represented in the *Mosaici Antichi*: eight were in Rome (**220–29**), one at Tolentino in the Marche (**230–33**), and one at Tortona in Piedmont (**234–6**). The drawings of this last bear high Carlo Antonio inventory numbers; the others were apparently collected well within Cassiano's lifetime. All but two of the drawings are mounted with the type A mounts characteristic of the early collections; six bear low 'Pozzo' numbers and were drawn by hands familiar in the *Bassi Rilievi* volumes (**222–7, 229**): three or four could be documents at first hand, but at least one was copied from another drawing. They were probably caught up in Cassiano's general sweep of figural reliefs in Roman collections, initially forming part of other volumes of the Paper Museum. Two (**220, 228**) could result from Cassiano's particular involvement with Severano and the publication of Bosio's *Roma Sotterranea* (see Volume One, p. 45f.).

LITERATURE: Recio Veganzones 1969, 1982; Schuddeboom 1996,
pp. 113–19; 181–210

220. Early Christian sarcophagus: scenes from the life of Christ

EARLY SEVENTEENTH-CENTURY ITALIAN

Windsor, RL 9191

Pen and dark brown ink, and brown wash, over black chalk,
with graphite

203 × 320 mm. Stained, foxed; old horizontal fold across centre;
horizontal tear from left centre edge repaired by a small patch
on verso. *Watermark*: Keys 3

NUMBERING: [top right, brown ink] *1*

ANNOTATION: [top right, brown ink] *questo pilo sta a S. Pietro in uno
orto dietro a S. Marta et fa il primo che se intaglia / nel quale orto stavano
ancora il pilo delle bove et il pilo dell' alberi*

[upper zone, centre] *cuperchio*

VERSO: see **221**

MOUNT SHEET: type A. Frame lines 10 mm apart, medium thick

BIANCHINI fol. 172, I and II: Sarcophagus from the Vatican cemetery with
the entry of the Lord to Jerusalem on the day of the Palms, printed by
Aringhio.

This 4th-century sarcophagus was found at the Vatican in 1590, during the construction of the new basilica of St Peter's, as recorded at the time by Alfonso Ciaconio, who was the first to commission a copy. In the decades which followed it was kept in a garden behind the church of S. Marta, as stated in the annotation at the top of the drawing: 'this sarcophagus is at St Peter's in a garden behind S. Marta and is the first to be engraved; in this garden are still the sarcophagus of the oxen and the sarcophagus of the trees'. Only a few fragments survive, now in the collection of the Vatican Museums.

The reliefs on the front of the sarcophagus combine events from the New Testament narrative with the popular Early Christian theme of the 'Traditio Legis' (Christ handing the 'law' to Saints Peter and Paul). At the far left is Christ's triumphal Entry into Jerusalem (Matthew 21:1–11), and at the right Christ stands before the Roman governor, Pontius Pilate, the latter shown washing his hands (Matthew 27:11–24).

The sarcophagus was published both in Bosio's *Roma Sotterranea* and in Aringhi's subsequent Latin version, with the latter providing a detailed identification of the various scenes. Herklotz plausibly proposes that the dal Pozzo drawing was the model for the engraving used to illustrate Bosio's text; it is presumably this use which is referred to in the annotation (and the numbering), and the verso bears evidence of transfer. It is improbable, however, that the drawing was supplied by Cassiano for this purpose (*pace* Herklotz 1992b, p. 35). The watermark Keys 3 (otherwise unattested among the dal Pozzo drawings) is closely related to a mid 16th-century type, and an annotation on the verso (see **221**) was presumably made before 1607. The style of the drawing is very different from the other copies of Early Christian sarcophagi in the *Mosaici Antichi* album and has no parallels among the *Bassi Rilievi* either. Equally unusual is the artist's indication of the ground on which the sarcophagus is standing, although this is found throughout the plates in the *Roma Sotterranea*. Most likely, the drawing is one of about 200 illustrations which Bosio had already prepared, and which had been engraved, before his death in 1629, only afterwards finding its way into the Paper Museum. If so, it may date from about 1610–15, and be the work of Sante Avanzini (1582–after 1632), born in Siena but trained in Rome (Thieme-Becker II, p. 269). He

is named in the documentary sources as Bosio's artist, together with an engraver Francesco Fulcaro (Thieme-Becker XII, p. 580, s.v. Fulcaro Sebastiano), who began making the plates in 1615, or earlier (*DBI* xiii, p. 258 [N. Parise]).

LITERATURE: Herklotz 1992b, pp. 34–6, fig. 3

OBJECT DRAWN: fragment in Vatican, Museo Pio Cristiano (ex-Lateranense), inv. 31486. Wilpert *Sarcofagi* I (1929), p. 179f., no. 9, pl. CLI.1; Deichmann 1967, pp. 24–6, no. 28, pl. 9

A small graphite sketch of a profile head with long hair, towards the right-hand end of the blank space for the lid, does not seem to reflect any of the figures on the sarcophagus.

ENGRAVINGS: Bosio *Roma Sotterranea* p. 63; Aringhi *Roma Subterranea* I, p. 295

OTHER DRAWINGS: [Ciaconio] BAV, Vat. lat. 5409, fol. 46 [84] (Schuddeboom 1996, p. 209f. (S27), fig. 110)

221. Reverse image of 220 and unrelated sketch of four figures

FLORENTINE SCHOOL *c.* 1620

Windsor, RL 9191 verso

Stylus and black chalk

DRAWING SHEET: see **220**

ANNOTATION: [black chalk] *P. giorgio dura assistente del Padre generale*

MOUNT SHEET: see **220**

BIANCHINI fol. 172v [not mentioned]

The outlines of the sarcophagus drawn on the recto (**220**) have been retraced in black chalk and stylus. Later, an unidentified scene with at least four standing figures and a hint of a landscape setting has been confidently drawn in heavy black chalk (part of the male figure to the extreme right has been lost through trimming). The attribution to the Florentine School is Blunt's, who considered it 'close to Jacopo da Empoli' (1551–1640).

The annotation, which predates the sketch, names one Giorgio Dura, Assistant to the Father General (of the Jesuit order). He was Georges-Jean d'Oyenbrugge de Duras, of Liège, rector at Antwerp, appointed Assistant for Germany in 1597. He died at Rome in 1607 (Poncelet, p. 20, n. 7).

LITERATURE: Blunt 1971, p. 82, no. 167, fig. 20

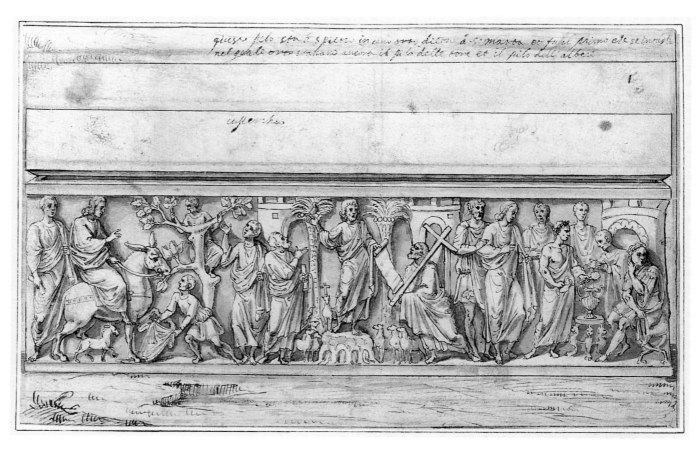

220

221

222. Biblioteca Angelica, MS 1564: fragment of a sarcophagus lid with scene of the Fiery Furnace

SEVENTEENTH-CENTURY ITALIAN *c.* 1630

Windsor, RL 9087

Pen and dark brown ink, and brown wash, over traces of graphite

69 × 264 mm

NUMBERING: *29*

MOUNT SHEET: type A. Single frame line on drawing; double lines on mount, 9 mm apart, thick. *Watermark*: Figure 38 (cut)

BIANCHINI fol. 131, I: another with the three boys Ananias, Azarias, Misael. II: another with the Three Boys in the furnace of Babylon.

Originally from the Vatican cemetery, during the late 16th and 17th century the fragment could be seen on the façade of a house on the Piazza di S. Paolo alla Regola (Bosio *Roma Sotterranea*, p. 101; Aringhi *Roma Subterranea* I, p. 332f.). It is now in the Villa Doria Pamphilj, set in the terrace wall of the Villino della Servitù (Wilpert *Sarcofagi* II (1932), p. 261, pl. CLXXXI,5; Deichmann 1967, p. 401f., no. 959, pl. 154; Calza 1977, p. 260f., no. 320, pl. CLXX).

At the left, a winged *putto* holds one edge of the *tabula* (the space for the inscription naming the deceased), while to the right are depicted two Old Testament scenes of deliverance: the Three Youths in the Fiery Furnace (Daniel 3:8–30), and Noah's Ark. This combination was particularly popular on sarcophagus lids in the early years of the 4th century (cf. Deichmann 1967, nos 121, 143, 637, 834).

The dal Pozzo drawing was clearly not made from the original relief but from a drawing in the codex of Alfonso Ciaconio in the Biblioteca Angelica, one of two very closely related copies in Ciaconio's possession, which Schuddeboom (1996, pp. 115–17) has argued are both likely to derive from drawings by Philips van Winghe (1560–92). They have a close equivalent in the codex which later belonged to Claude Menestrier (d. 1639), but had probably been made for Peiresc from van Winghe's drawings in Louvain sometime during 1608–23, in its turn matched by one among the set of copies from van Winghe's drawings made for Dionysius de Villers (1546–1620) and now in Paris.

222 is preceded in the *Mosaici Antichi* album by two other copies of Early Christian sarcophagi (**223–4**), both drawn by the same hand using the same technique and bearing the consecutive low 'Pozzo' numbers (*30, 31*). The hand was responsible for a large group of sarcophagus drawings in the Bassi Rilievi volumes (A.III), many copied from secondary sources.

LITERATURE: Herklotz 1992b, p. 36, n. 13; Schuddeboom 1996, p. 204 (S20)

OBJECT DRAWN: Rome, Biblioteca Angelica, MS 1564, fol. 38. Schuddeboom 1996, p. 204f. (S20), fig. 43

OTHER DRAWINGS: [Ciaconio] BAV, Vat. lat. 5409, fol. 49 [82]. [Peiresc—Menestrier] BAV, Vat. lat. 10545, fol. 203v. [De Villers] Paris, BN, nouv. acq. lat. 2343, fol. 115

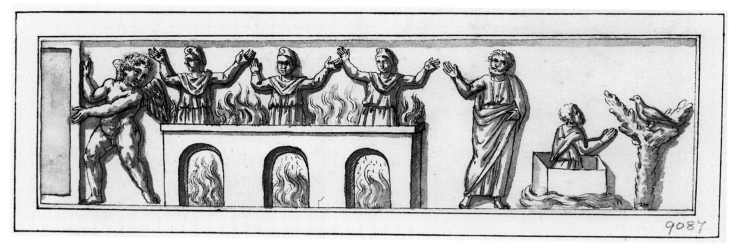

222

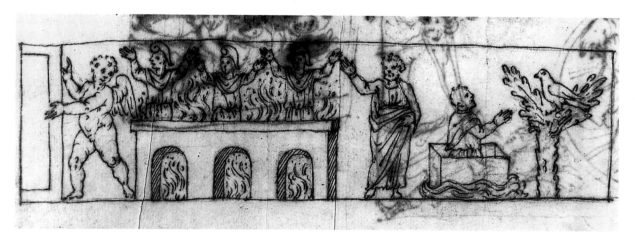

Comp. fig. 222 (i): Anonymous, *Fragment of an Early Christian sarcophagus: the fiery furnace*, Rome, Biblioteca Angelica, MS. 1564, fol. 38

Comp. fig. 222 (ii): Anonymous, *Fragment of an Early Christian sarcophagus: the fiery furnace*, BAV, Vat. lat. 10, 545, fol. 203v

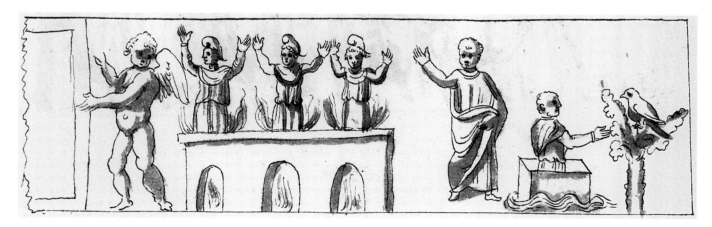

223. Early Christian sarcophagus: story of Jonah

SEVENTEENTH-CENTURY ITALIAN *c.* 1630

Windsor, RL 9086

Pen and dark brown ink, and brown wash, over traces of graphite

149 × 433 mm. Heavily foxed

NUMBERING: *31*(?), before ink frame drawn, corrected to *30*, and then partially erased; [below, between frame lines] *30*

MOUNT SHEET: type A. Frame lines on drawing sheet, 10 mm apart; at left and right ends, outer line on mount. Foxed

BIANCHINI fol. 130, I: another in which Jonah is thrown overboard and ejected onto the shore, published &c. II: another with the Story of the Prophet Jonah.

Bosio included the sarcophagus among those from the Vatican cemetery. Previously in the della Valle collection, by 1591 it had passed to the Villa Medici on the Pincian hill and was used as a fountain basin. It is now in the Vatican Museums.

A work of the late 3rd/early 4th century AD, the reliefs on the front are principally devoted to three episodes from the Old Testament story of Jonah, widely popular in the Early Christian period because of its interpretation as a prefiguration of the death and resurrection of Christ. At the left, Jonah is cast into the sea (Jonah 1:15); in the centre he is delivered alive from the stomach of the *ketos* (Jonah 2:10); and at the right he reclines under the gourd vine (Jonah 4:6). Other biblical scenes of miraculous salvation include the Raising of Lazarus (John 11:43–4), Moses striking the rock (Exodus 17:6), and Noah's Ark (Genesis 8:6–12).

The dal Pozzo drawing misses a few elements (such as the fish in the sea and the tree beside Noah in the Ark), but it reproduces quite accurately, at about one fifth lifesize, the overall proportions of the reliefs and most of their detail. It appears to be independent of Bosio's engraving and other known copies, such as that in the 'Peiresc—Menestrier' and de Villers codices (derived from a van Winghe drawing of 1591), and a large red and black chalk drawing in a Barberini miscellany, annotated '*Romae, in palatio de la valle...*' (see Comp. fig. ii). It is possible, nonetheless, that (like **222**, which is by the same hand and to the same scale) the drawing was not taken from the original sculpture but copied from some secondary source.

LITERATURE: Herklotz 1992b, p. 36, n. 13; Schuddeboom 1996, p. 200 (S15)

OBJECT DRAWN: Vatican, Museo Pio Cristiano (ex-Lateranense), inv. 31448. Marble, 0.66 × 2.23 m. Bosio *Roma Sotterranea*, p. 103; Aringhi *Roma Subterranea* I, p. 334f.; Wilpert *Sarcofagi* I (1929), p. 109, pl. IX,3; Deichmann 1967, pp. 30–32, no. 35, pl. 11

OTHER DRAWINGS: [Peiresc—Menestrier] BAV, Vat. lat. 10545, fol. 197 (Schuddeboom 1996, fig. 86). [De Villers] Paris, BN, nouv. acq. lat. 2343, fol. 111 (Schuddeboom 1996, fig. 89). [Miscellany] BAV, Barb. lat. 4423, fol. 13 (Müntz 1888, p. 117)

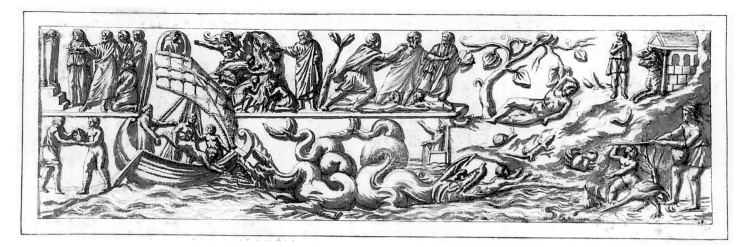

223

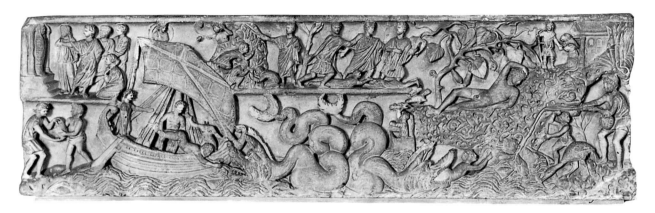

Comp. fig. 223 (i): Early Christian sarcophagus, *Story of Jonah.* Vatican, Museo Pio Cristiano

Comp. fig. 223 (ii): Anonymous, *Early Christian sarcophagus: story of Jonah.* Black and red chalk. BAV, Barb. lat. 4423, fol. 13

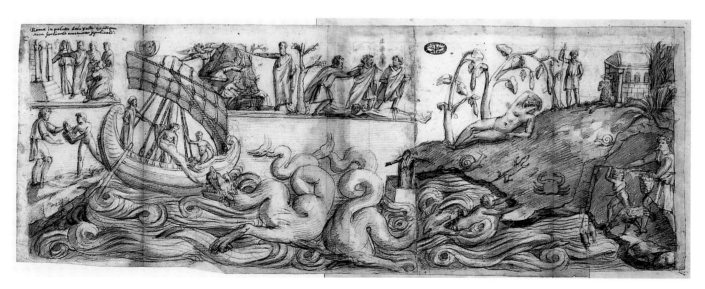

224. Early Christian sarcophagus: scenes from the Life of Christ

SEVENTEENTH-CENTURY ITALIAN *c.* 1630

Windsor, RL 9085

Pen and dark brown ink, and brown wash, over traces of black chalk

115 × 416 mm. Heavily foxed

NUMBERING: *31*

MOUNT SHEET: type A. Frame lines on drawing sheet, 10 mm;
at left end (trimmed) outer line on mount. Foxed.
Watermark: Fragment, Figure (unidentified), probably 38

BIANCHINI fol. 129, I and II: Another with the figure of the Samaritan
woman (I:) published by Aringhi.

Discovered in the Vatican cemetery in 1592 when excavating the foundations of the new St Peter's, according to Bosio and Aringhi the sarcophagus was then acquired by Monsignor Giusto, and taken to his house in Rome at Monte Giordano (in the Campus Martius, opposite the Castel S. Angelo), later the residence of the ambassador of Bologna. It has since disappeared.

The scene in the centre of the sarcophagus front depicts the 'Traditio Legis' (cf. **220**). Christ stands on a small hill, his right hand raised and his left hand holding an open scroll. He is flanked by Saints Peter and Paul, to whose governance the Christian Church is being conferred. Peter steps forward to receive the law in the folds of his cloak. His left hand and shoulder support the lower part of a cross, the upper part and cross-bar of which have been lost. These missing details are shown in the engraving published by Bosio, which also includes the four rivers of Paradise flowing from the hill beneath Christ's feet. The other scenes are taken from the New Testament narrative of the life of Christ: from left to right, Peter's Denial of Christ (Mark 14:66–72), the Multiplication of the Loaves and Fishes (Matthew 14:15–21), Christ and the Samaritan Woman (John 4:7–26), and a scene identified by Wilpert as the Gratitude of the Canaanite Woman (Matthew 15:22–8).

The drawing is unrelated to Bosio's engraving, from which it differs markedly in the form of the winch on the wellhead and various other details. As in the case of the two other sarcophagus drawings by the same hand (222–3) the scale is about one fifth lifesize. Like those, it could have been copied from a secondary source.

LITERATURE: Herklotz 1992b, p. 36, n. 13

OBJECT DRAWN: lost. Marble, 0.60 × 2 m (approx.). Bosio *Roma Sotterranea*, p. 65; Aringhi *Roma Subterranea* I, p. 296f.; Wilpert *Sarcofagi* I (1929), p. 159, fig. 92; Deichmann 1967, p. 421f., no. 1008

224

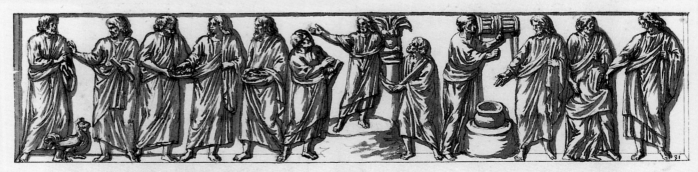

225. Early Christian sarcophagus: scenes from the Life of Christ

SEVENTEENTH-CENTURY ITALIAN *c.* 1630

Windsor, RL 9084

Pen and dark brown ink, and brown wash, over black chalk

143 × 595 mm. Heavily foxed; hinged flap 189mm from right; earlier fold 220 mm from right, possibly marked by a black chalk line

NUMBERING: *163*

MOUNT SHEET: type A. Frame lines on drawing sheet, 10 mm apart, medium thick. Heavily foxed

BIANCHINI fol. 128, I and II: Christian sarcophagus on which is carved the birth of the Saviour.

Of unknown origin, in the early 17th century this sarcophagus formed part of the 'museum' of Francesco Gualdi (see Volume One, p. 50) and was located in his house near Trajan's Markets. In 1630 he presented it to the church of S. Maria Maggiore, along with a lid which had been found in the cemetery adjoining the church of S. Lorenzo fuori le mura. Giovanni Severano added an illustration of it at the end of the third book of Bosio's *Roma Sotteranea*, one of three such additions that he made in connection with an iconographical essay he appended to the work (see also **228**). The Severano engraving reproduces the style and squat proportions of the original more accurately than the dal Pozzo drawing, in which the figure height has been increased to more naturalistic effect. In technique the drawing is similar to **222–4** but by a different hand; it is also at a different scale (about one third).

The reliefs depict a series of New Testament scenes relating to the Life of Christ: from left to right, Christ before Caiaphas, the Denial by Peter(?) (although no cock is visible, and Aringhi identifies it as the seizure of Christ by the Jews), the Nativity, the Baptism of Christ in the Jordan, and the Raising of the Daughter of Jairus (Mark 5:22–4, 35–42). This last scene is identified by Aringhi as the Raising of Lazarus, but it does not follow the well-established iconography for depicting that miracle, and the figure rising from the sarcophagus seems clearly to be a child.

LITERATURE: Herklotz 1992b, p. 35

OBJECT DRAWN: Vatican, Museo Pio Cristiano (ex-Lateranense), inv. 31542. Marble; 0.45 × 2.07 m. Bosio *Roma Sotterranea*, p. 589; Aringhi *Roma Subterranea* II, p. 394f.; Wilpert *Sarcofagi* I (1929), pp. 24, 128f., pl. VIII,4; Deichmann 1967, p. 12f., no. 13, pl. 5; Franzoni/Tempesta 1992, p. 14f., ded. 2

157

LIBRO III. CAP. LXVI. 589

SARCOPHAGI DVO MARMOREI EX COEMETERIIS (VT CREDITVR) EFFOSSI

Questi due Pili sono in casa del Sig. Caualier Francesco Gualdi da Rimini: li quali così vniti esso
Caualiere hà destinato locarli nel Portico della Chiesa di Santa Maria Maggiore.
Il primo staua nel Conuento di S. Lorenzo fuori delle mura: è lungo
palmi noue; & alto vno, e due terzi. Il secondo è lungo
parimente palmi noue; & alto tre, & vn terzo.

Ddd Questo

Comp. fig. 225 (i): Anonymous, *Early Christian sarcophagus: scenes from the Life of Christ,*
engraving, Bosio *Roma Sotterranea*, p. 589

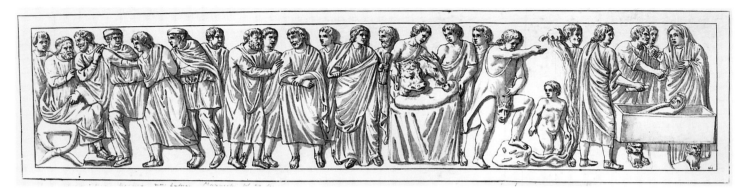

225

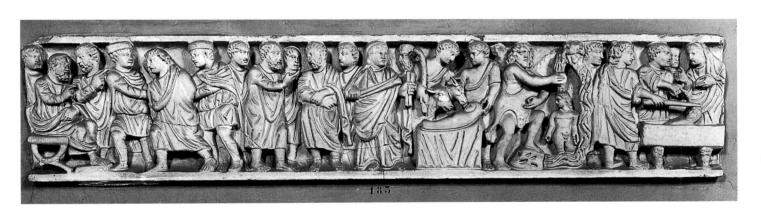

Comp. fig. 225 (ii): Early Christian sarcophagus, *Scenes from the Life of Christ*. Vatican, Museo Pio Cristiano

226. Strigillated sarcophagus: praying woman and shepherds

attrib. PIETRO TESTA (1612–50)

Windsor, RL 9190

Pen and dark brown ink, and yellowish brown wash, over graphite

139 × 439 mm

NUMBERING: *323*

MOUNT SHEET: type A. Frame lines 10 mm apart, medium thick

BIANCHINI fol. 171, I and II: Christian sarcophagus with the Good Shepherd (I:) and a praying woman.

The design on the front is divided into five panels, a female figure in the centre with hands outstreched in prayer, and a shepherd at either end, the intervening spaces filled with wave-like channelling (strigillation). In 1892, on the basis of the dal Pozzo drawing, J.P. Richter identified two fragments then incorporated into the decoration of a funerary chapel in the Campo Verano cemetery, belonging to the German College of S. Maria dell'Anima, as having constituted the central and far left-hand panels. These were later removed from the chapel and donated to the Museo Cristiano Lateranense (Galli 1934, p. 78f.), now transferred to the Vatican Museums. In 1964 the third figure, the shepherd at the right, was identified by Bovini as corresponding to another fragment in the Vatican Museums. Although the sarcophagus was probably taken for an Early Christian work (as Bianchini and others did since), the presence of the small flaming altar beside the praying woman suggests differently. Bovini dates it in the 3rd century AD.

Previously the sarcophagus may have been in the Palazzo Barberini, prior to the dispersal of that collection in the second half of the 19th century, for it appears to correspond to one recorded there by Matz, which von Duhn could not then find when checking Matz's work for publication in 1881 (Matz/Duhn II, no. 2555).

The drawing has been attributed to the hand of Pietro Testa by Nicholas Turner.

LITERATURE: Wilpert *Sarcofagi* II (1932), p. 333, fig. 211; Klauser 1964, pl. 2; Bovini 1964, pl. 4; Turner 1992, p. 142

OBJECT DRAWN: fragments in Vatican, Museo Pio Cristiano (ex-Lateranense), inv. 31460. Marucchi 1892; Wilpert *Sarcofagi* II (1932), p. 333 and pl. CCL,2; Bovini 1964

226

227. Strigillated Sarcophagus: cross and balance

attrib. PIETRO TESTA (1612–50)

Windsor, RL 9068

Pen and ink, and yellowish brown wash, over graphite

101 × 303 mm

NUMBERING: *324*

MOUNT SHEET: type B. Also bears **174**, **228**, **284–5**.
Watermark: Figure 13

BIANCHINI fol. 122, II: monument from a Christian cemetery.

The half-completed drawing, whose 'Pozzo' number *324* and slight perspective view of the right-hand end associate it with **226** ('Pozzo' no. *323*), is attributed by Blunt to the hand of Pietro Testa. It represents the front of an unusual strigillated sarcophagus. Whereas most sarcophagi of the type have figures carved in panels at the two ends and in the middle, this example had only symbolic motifs (a cross in the centre, and a steelyard balance at the right), in addition to the large initials V and C (for *vir clarissimus*?). No immediate parallels are known and the sarcophagus has not been traced.

LITERATURE: Blunt 1971, pp. 121–2

OBJECT DRAWN: lost?

227

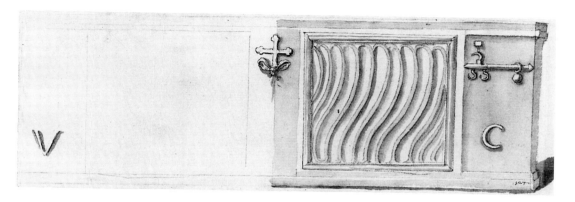

228. Early Christian sarcophagus: Crossing of the Red Sea

attrib. PIETRO TESTA (1612–50)

Windsor, RL 9072

Pen and pale brown ink, and yellowish grey-brown wash, over graphite

112 × 334 mm. Creamy yellow paper

MOUNT SHEET: type B. Also bears **174, 227, 284–5**.
Watermark: Figure 13

BIANCHINI fol. 122, II: monument from a Christian cemetery.

In the 17th century the sarcophagus belonged to Marchese Asdrubale Mattei, and was exhibited in the garden of the Palazzo Mattei in Via dei Funari. Guerrini's suggestion (1972, p. 14) that it might be identified with a relief, said to show Alexander the Great, restored by Pompeo Ferrucci in 1608, seems unlikely. Two large fragments are today set into a wall in the gardens of the Villa Doria Pamphilj.

The scene is the Old Testament story of the exodus of the Israelites from Egypt. At the left, the Egyptian army, on horseback or riding in chariots, takes up the pursuit with weapons drawn. To the right, Moses extends his staff to effect the parting of the waves of the Red Sea. According to Severano's iconographical discussion appended to Bosio's *Roma Sotterranea* (p. 611), the scene signified baptism consecrated by the blood of Christ. Moses' staff represented the Cross with which the baptized were blessed, or the Cross on which Christ died. The Pharaoh's drowning army are the past sinners, submerged in the waters of salvation.

The drawing is attributed by Blunt and Turner to the hand of Pietro Testa. Herklotz proposes that it was the model not only for a second drawing of the same sarcophagus which is to be found on another folio in the *Mosaici Antichi* (**229**), but probably also for the engraving in the *Roma Sotterranea*, which Severano says (ibid., p. 588) he added on his own initiative. That Severano does not acknowledge help from Cassiano on this score, Herklotz interprets as an unusual lack of scholarly courtesy. However, it is equally possible that Testa (perhaps on Cassiano's recommendation but not in his pay) originally made the drawing for Severano and that it only ended up in the dal Pozzo collection later (cf. also **220**), perhaps when Testa used it to make a larger version (**229**). The smaller drawing certainly appears to have been calculated from the outset to fit the standard width of the pages in the *Roma Sotterranea* of 313 mm, for there is a black chalk line at that width running under the right-hand edge of the drawing (the slight overlap was adjusted in the engraving). All other dimensions correspond exactly: the height of the relief panel (without borders) 94 mm; height of Moses, 75 mm.

LITERATURE: Blunt 1971, p. 121f.; Herklotz 1992b, pp. 35–7, fig. 4; Turner 1992, p. 142

OBJECT DRAWN: Rome, Villa Doria Pamphilj, wall of W. stair to *Giardino Segreto*. Preserved height (max.) 0.50 m; length 2.10 m. Bosio *Roma Sotterranea*, p. 591; Aringhi *Roma Subterranea* II, p. 397; Wilpert *Sarcofagi* II (1932), p. 248, pl. CCX,1;

Deichmann 1967, p. 398f., no. 953, pl. 153; Rizzardi 1970, pp. 103–5, no. 28; Calza 1977, p. 254f., no. 314

ENGRAVINGS: Bosio *Roma Sotterranea*, p. 591

OTHER DRAWINGS: **229**

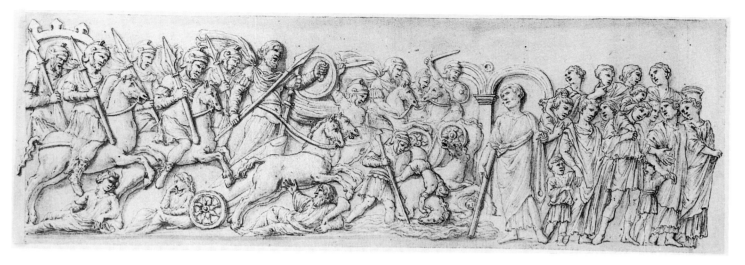

228

Comp. fig. 228 (i): Early Christian sarcophagus, *Crossing of the Red Sea*. Rome, Villa Doria Pamphilj

Comp. fig. 228 (ii): Anonymous, *Early Christian sarcophagus, Crossing of the Red Sea*, engraving, Bosio *Roma Sotterranea*, p. 591

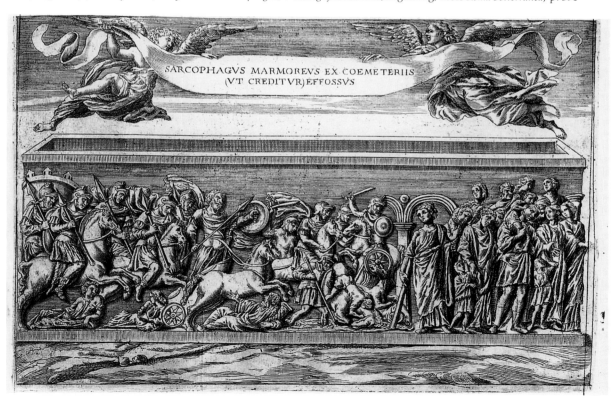

229. Copy of 228

attrib. PIETRO TESTA (1612–50)

Windsor, RL 9189

Pen and brown ink, and yellowish grey-brown wash, over black chalk

164 × 560 mm. Composed of two sheets, overlapping at right; hinged flap, right; trimmed at upper edge

NUMBERING: *371*

MOUNT SHEET: type A. Frame lines 10 mm apart, fine. Bound with base of drawing facing spine

BIANCHINI fol. 170, I and II: Christian sarcophagus with the Story of the drowning of Pharaoh.

Another drawing, approximately one-and-a-half times as large, of the same sarcophagus drawn in **228**, from which it appears to be derived, by the same hand, inadvertently omitting the wheel-like archway at the top left-hand corner. Unlike its model, it has a low 'Pozzo' number, which fits a gap in one of the sequences in the *Bassi Rilievi* volumes, and is mounted within a double inked frame. The upper edge of the image has been lost through trimming.

LITERATURE: Blunt 1971, p. 121f.; Herklotz 1992b, p. 35, n. 12; Turner 1992, p. 142

OBJECT DRAWN: see **228**
OTHER DRAWINGS: **228**

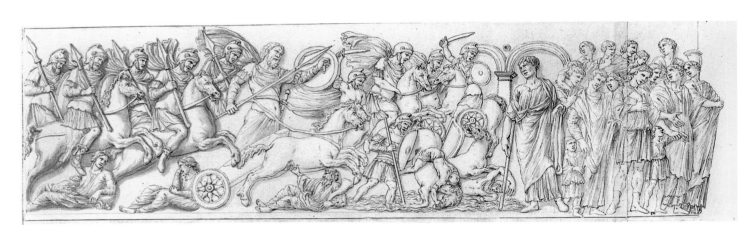

229

Sarcophagus of Fl. Julius Catervius at Tolentino [230–233]

Four drawings illustrate a Christian sarcophagus dating from the late fourth century AD, which stands in a chapel in the cathedral at Tolentino, a small town in the Marche, some 230 km north-east of Rome and 18 km south-west of Ancona.

The sarcophagus was always intended to be free-standing and has remained above ground since antiquity, on or very near its original site. By the seventeenth century it had become the object of considerable veneration, being believed to contain the relics of Tolentino's patron saint and martyr, S. Catervo, and his disciples and fellow martyrs, Severina and Bassus. A life of the saint, known from a group of sixteenth-century manuscripts and first published at nearby Macerata in 1649 (U. Marioni, *Vita gloriosi Iesu Christi martyris sancti Catervi civitatis Tolentini patroni admirabilis*), related that he was born at Rome in the first century AD to noble parents. Following his conversion to Christianity, he had a series of adventures, amongst which, on a trip to Palestine, he met the disciples of Christ, who were then still alive. After returning to Italy, he was persecuted for his beliefs, and tortured and ultimately beheaded at Tolentino in the reign of Trajan.

In reality, the S. Catervo legend was pure invention (Delehaye 1943; cf. also Klauser 1967 and 1968). It grew out of medieval curiosity about the sarcophagus itself (which was opened in 1455 and found to contain three skeletons: Santini 1789, p. 50f.; Ioli 1971, p. 8), coupled with a misreading of the inscriptions (*CIL* IX, 5566; Diehl 1925, I, no. 98), which tell a quite different story. The principal inscription on the lid (see **231**), reads:

FL. IUL. CATERVIUS V.C. EX PRAEF. PRAETORIO QVI
VIXIT CVM SEPTIMIA SEVERINA C.F. DVLCISSIMA
CONIVGE ANNIS XVI MINUS D. XIII QVIEVIT IN PACE
ANNORVM LVI DIERVM XVIII XVI KAL. NOB. DEPO
SITVS EST IIII KL. DCB. SEPTIMIA SEVERINA C.F.
MARITO DVLCISSIMO AC SIBI SARCOFAGVM
ET PANTEVM CVM TRICORO DEPOSVIT
ET PERFECIT

'Flavius Julius Catervius, *vir clarissimus* (i.e. of senatorial rank) and former praetorian prefect, who lived here with Septimia Severina, *clarissima femina* (i.e. of equally high rank), his most beloved wife for 16 years less 13 days. He rested in peace, aged 56 years and 18 days, on the 17 October. He was buried on the 28 November. Septimia Severina, *clarissima femina*, for her most beloved husband and herself, commissioned the sarcophagus and the triple-apsed 'pantheon' (funerary chapel) and saw them completed'.

Far from suffering martyrdom, therefore, Catervius had been an important official in the Late Roman West, probably to be identified with the *comes sacrarum largitionum* of AD 379 (*PLRE* I, p. 186f.). His wife was a lady of power and influence too, if she managed to arrange for the sarcophagus and its 'pantheon' to be finished in less than six weeks.

Running along the length of the lid under Catervius' inscription was subsequently added an elegaic verse for his son, Bassus, with whose tragic death at the age of eighteen the family line was extinguished:

FLENDE IACES IN BASSO ITERVM DEFVNCTE CATERVI
OCCIDIT ORE GENVS NOMINE POSTERITAS
TU MEDIVS GEMMA ET GERMANIS CLAVSA METALLIS
MORTE TUA FRACTVM EST. BASSE MONILE PIVM
OCTAVVS DECIMVS VIX TE SVSCEPERAT ANNVS
OCYUS ERIPITVR QVOD PLACET ESSE DEI

On the opposite side (**231**) is the epitaph for Septimia Severina, all transcriptions of which made prior to 1953 tend to contain errors because until then this side was set very close to the wall. The actual reading is (Ioli 1971, p. 43, fig. 5):

QUOS PARIBUS MERITIS VINXIT MATRIMONIO DVLCI
OMNIPOTENS DOMINVS TVMVLVS CVSTODIT IN AEVVM
CATERVI SEVERINA TIBI CONIVNCTA LAETATVR
SVRGATIS PARITER CRISTO PRAESTANTE BEATI

and beneath, on the upper edge of the box:

QUOS DEI SACERDVS PROBIANVS LAVIT ET VNXIT

Some particular dal Pozzo connection with the Tolentino region is possible, for the *Mosaici Antichi* album contains record of another local cult, the *beata* Camilla Rovellone at S. Severino (**197**) and Lucas Holstenius visited Tolentino and its cathedral on one of the various epigraphical missions he undertook for Francesco Barberini during 1637–49 (cf. *CIL* IX, p. xlv). However, the drawings are unlikely to have been made directly from the sarcophagus. The proportions are quite wrong and the inscriptions are written in a formal seventeenth-century script, with various mistakes which suggest copies at second or third hand. Style and technique are very close to the copy of Ciaconio's drawings of catacomb paintings (here **171**), which is dateable *c.* 1639, and to the copies of the Peiresc drawings of the Calendar of AD 354 (in the *Nettuno* album at Windsor, RL 11363–11374, to be published in A.VI).

The drawings of the long sides, **230–31**, were copied for Jean Mabillon on his visit to Rome in 1686 and engraved, together with those of the sarcophagus of P. Aelius Sabinus, **234–6**, to illustrate his account of Tortona (*Iter Italicum*, p. 223). Apparently, he had been led to believe that the Catervius sarcophagus was in Tortona as well, since both sets of drawings were said to have come from the Milanese antiquarian, Carlo Settala, Bishop of Tortona, but he noted that according to Ughelli (*Italia sacra* 1647), Catervius was buried in Tolentino. Presumably the confusion arose from the fact that, as now, the two sets of drawings were adjacent in the *Mosaici Antichi* album. There is no other reason to suppose they had a common origin.

LITERATURE: Garrucci *Arte Cristiana* V (1879), p. 13f., pls 303.1–3, 304.1; Wilpert *Sarcofagi* I (1929), p. 90f., pls LXXII–III, XCIV,1; Ioli 1971; Nestori 1992

230. Sarcophagus of Fl. Julius Catervius at Tolentino: back

SEVENTEENTH-CENTURY ITALIAN
Windsor, RL 9182
Pen and ink, and blue wash, over traces of graphite
170 × 246 mm. Heavily foxed
MOUNT SHEET: type B. Also bears **231** [below]
BIANCHINI fol. 167 [see **231**]

The decoration is divided into three panels, the central one occupied by a medallion bearing the portraits of Septimia Severina and Flavius Julius Catervius beneath a victory wreath. Around the medallion are Christian symbols: in the upper angles chi-rho monograms (with α and ω in the arms of the cross); below, two doves with olive branches. The palmette in the corner acroterion on the lid, part of the general repertory of ancient funerary symbolism, was once believed to denote martyrdom.

That the drawing misses much of the detail and character of the portraits and the wreath, while it has elaborated upon the doves and their branches, is readily explained by the fact that this side of the sarcophagus stood against the wall. The transcription of the wording of Septimia Severina's epitaph, though Italianizing *coniuncta* as 'congiunta' and erring (as in the case of Bassus' on the front, see **231**) in placing the second line of text on the body of the sarcophagus instead of the lid, is actually as accurate as any until much more recent times (see p. 166).

LITERATURE: unpublished

OBJECT DRAWN: see **231**. Wilpert *Sarcofagi* I (1929), pl. XCIV,1; Ioli 1971, pp. 29–36, 43f., figs 5–6

Comp. fig. 230, 231: Anonymous, *Sarcophagus of Fl. Julius Catervius*, engraving, Mabillon, *Iter Italicum*, p. 223.2

231. Sarcophagus of Fl. Julius Catervius at Tolentino: front

SEVENTEENTH-CENTURY ITALIAN

Windsor, RL 9183

Pen and ink, and blue wash, over traces of graphite

200 × 264 mm. Heavily foxed. *Watermark*: Figure 38

MOUNT SHEET: type B. Also bears **230** [above]

BIANCHINI fol. 167, I: Two Sarcophagi, of Catervius and Severina, on the first the Good Shepherd. II: Sarcophagus of Catervius, and Severina, with their Inscriptions.

The lid bears the funerary inscriptions naming Catervius and his son Bassus, with portrait busts in the corner acroteria: Catervius on the left and his wife Septimia Severina on the right. The box of the sarcophagus is decorated with three standing figures in relief separated by strigillated panels. The central figure is Christ, shown as the Good Shepherd with a lamb on his shoulders. The other two lack specific attributes, but they are probably the apostles, Saints Peter and Paul (see Wilpert, Ioli). An inscription above the head of the figure at the right is apparently a medieval addition and now largely indecipherable (cf. *CIL* IX, 5566; Ioli 1971, p. 14). It is reported on the drawing as: *pax ingminat tursus pridie preconia Pauli* (i.e. *pax ingeminat rursus pridie praeconia Pauli*) 'may peace return before the feast of Paul'.

Although the drawing omits the form of the inscribed panel on the lid, the text which it bears is transcribed in approximately the right position. The transcription is full of inaccuracies, however, not only as regards the number and division of the lines but also slips of the pen, such as 'Elio ul' for Fl. Iul, the omission of 'praetorio' after 'ex praef', 'ili' instead of cum, C.E. instead of C.F. Catervius' age appears as 106 [CVI] instead of 56 [LVI], etc. (compare text p. 165). Also, the funerary inscription of Bassus is divided between the lid and the upper edge of the sarcophagus box, when both lines should be on the former. In fact, Mabillon did not include the inscriptions in his published engraving of the drawing; instead they are reported in the body of his text, where he corrects some of the errors by reference to Ughelli (*Italia sacra* II [1647], p. 853).

LITERATURE: unpublished

OBJECT DRAWN: Tolentino, Cathedral. Chapel of the Trinity or of S. Catervo. Marble. Height 1.26 m, width 2.20 m, depth 0.90 m. Wilpert *Sarcofagi* I (1929), p. 90, pl. LXXII; Ioli 1971, pp. 9–17, 36–40, fig. 1

ENGRAVINGS: Mabillon *Iter Italicum* (1687), at p. 223

Quos paribus meritis iunxit matrimonio dulci Caterui seuerina tibi congiunta lætatur

Omnipotens Dominus: tumulus custodit in æuum Surgatis pariter Cristo præstante beati

Quos Dei Sacerdos Probianus lauit et unsit

230

91

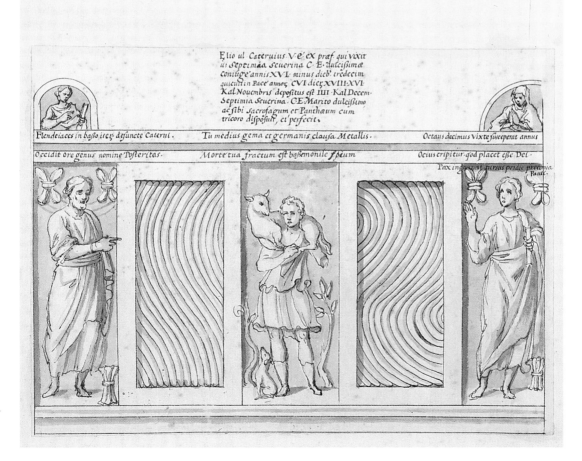

Elio ul Cateruius V.C. ex præf. qui vixit
iis Septimaa seuerina C.E. dulcissimæ
contuge annis XVI. minus dieb. tredecim
quicuui in Pace anno; CVI diei XVIII XVI
Kal. Nouembris depositus est IIII Kal Decem-
Septimia Seuerina. C.E. Marito dulcissimo
ac sibi sacrosagum et Panthæum cum
tricoro disposuit, et perfecit.

Flendeiaces in basso iteq; desuncte Caterui. Tu medius gema et germanis clausa Metallis. Octaus decimus vixte suceperat annus

Occidit ore genus nomine Posteritas. Morte tua fractum est basse monile spium Ocius eripitur qod placet esse Dei

Pax ingreq; at purus pridie pretonia. Pauli.

231

169

232. Sarcophagus of Fl. Julius Catervius at Tolentino: left end

SEVENTEENTH-CENTURY ITALIAN

Windsor, RL 9184

Pen and ink, and blue wash, over graphite

192 × 160 mm. Heavily foxed. *Watermark*: Figure 38

ANNOTATION: [brown ink] *Questa è la facciata a man diritta nel entrar della Cappella* ('This is the face on the right side as one enters the chapel')

MOUNT SHEET: type B. Also bears **233** [below]

BIANCHINI fol. 168, I and II: Sarcophagus (I: sides) with the Adoration of the Magi.

The end of the sarcophagus has a scene of the Adoration of the Magi in relief. In the tympanum on the lid above, two lambs are shown flanking a monogrammed cross of the *chrismon* type.

LITERATURE: unpublished

OBJECT DRAWN: see **230**. Wilpert *Sarcofagi* I (1929), pl. LXXIII,2; Ioli 1971, pp. 17–24, 41f., fig. 3

233. Sarcophagus of Fl. Julius Catervius at Tolentino: right end

SEVENTEENTH-CENTURY ITALIAN

Windsor, RL 9185

Pen and ink, and blue wash, over graphite

201 × 201 mm. Heavily foxed

MOUNT SHEET: type B. Also bears **232** [above]

BIANCHINI fol. 168 [see **232**]

The identification of the scene on this end of the sarcophagus has been problematic, but Ioli has argued convincingly for an earlier moment in the story of the three Magi, when they visit King Herod (Matthew 2:1–8). Other examples are found on sarcophagi in the Marche region, notably the sarcophagus of Gorgonius in the cathedral at Ancona, on which the Tolentino one was probably modelled (Ioli 1971, p. 66, fig. 8). On the end of the lid is a wreath with a chi-rho in the centre, flanked by two doves. The drawing represents the wreath as a medallion and (perhaps thinking of the monograms on the back, see **231**) puts the Greek letters alpha and omega between the arms of the cross, but they are not part of the original.

LITERATURE: unpublished

OBJECT DRAWN: see **230**. Wilpert *Sarcofagi* I (1929), pl. LXXIII,1; Ioli 1971, pp. 24–9, 42f., fig. 4

232

Questa e la facciata a man diritta nel entrar della Cappella.

9184

233

171

Sarcophagus of P. Aelius Sabinus at Tortona [234–236]

Three drawings mounted on a single folio, all drawn by the same unskilled hand and full of small errors, show the four sides of an early third-century sarcophagus from Tortona, a town in Piedmont, 100 km south-west of Milan near the river Po. Although their 'Pozzo' numbers *663–5* could signify that they were not accessioned by Carlo Antonio until 1673 or later (see Volume One, p. 38), the drawings are apparently those which Carlo Settala, Bishop of Tortona, sent to Rome on 19 April 1655. In his covering letter (Fea 1790, p. 17f.; Lumbroso 1874, p. 279, no. 87; Lumbroso 1875, p. 151f.) Settala announced that he had discovered the sarcophagus when extending the fortifications of Tortona, on the site of the Early Christian church of S. Martiano. Actually, he was mistaken, in that the sarcophagus had already been found in 1598, accounts of the finding being published in 1599 (Ludovicus da Milano, *Historia della vita, martirio e morte di San Martiano e di S. Innocentio, primi vescovi di Tortona ed altre cose partenenti si alle antichità delle religione comme ad essa città*, p. 161f.) and again in 1618 (N. Montemerlo, *Historia dell'antica città di Tortona*). Its inscriptions were included by J. Gruterus ('*ex Cantonii e Merulae schedis*') in his *Inscriptiones antiquae* of 1603 (p. 1120, no. 4). Be that as it may, Settala, a keen antiquary with a famous museum in the family house in Milan (Fogolari 1900), said he was enclosing one opinion on the significance of the reliefs, but would welcome more, as well as any other information which might be available on the history of ancient Tortona (the Roman *Colonia Julia Dertona*).

The addressee of Settala's letter is unknown; Fea assumed it was the pope, Alexander VII (Chigi, 1655–67), with whom Settala had been a student at Siena. Lumbroso took it to be Cassiano dal Pozzo, since he also knew Settala and the document is among the dal Pozzo papers which Fea saw when they were still in the Albani library and which also contain a letter of 25 June 1655, to Cassiano from the Prefect of the Vatican library Lucas Holstenius, saying that he was returning the drawings and notes (Lumbroso 1874, p. 270, no. 29; 1875, p. 142), along with his account of the meaning of the inscriptions and reliefs. Of course, Alexander VII could have passed the letter on to Cassiano, who then passed it to Holstenius. In any event, a copy of Holstenius' commentary, entitled *Expositio inscriptionum et figurarum sarcophagi marmorei Dertonensis* has also survived (Fea 1790, pp. cclxxxiv–viii). Lumbroso mistook it for that referred to by Settala (Lumbroso 1874, p. 279, n. 1; 1875, p. 151, n. 1).

Lucas Holstenius (see p. 310) was renowned in the Republic of Letters for his erudition, especially in Greek epigraphy, and his commentary on the Tortona sarcophagus in fact starts with the inscriptions on the front (see **235**), correcting Gruterus' transcription in accordance with the drawing, and then considers the reliefs: first those on the short sides, then the front, then the back, that is, in the same order as they are mounted on the *Mosaici Antichi* folio.

The inclusion of the sarcophagus among the drawings of Christian antiquities is probably explained by the figure of a shepherd carrying a lamb on his shoulders (see **236**), which could have been interpreted as depicting Christ, the Good Shepherd (as on **230**). Neither Holstenius, nor Jean Mabillon, who used copies taken from the dal Pozzo drawings to illustrate the passage recounting his visit to Tortona in June 1686 (*Iter Italicum*, p. 223), thought the figure was Christ, but others did, including Giuseppe Bianchini, and the latter view persisted into the twentieth century until thoroughly laid to rest in two studies by Klauser (1958, pp. 41–3, and 1965, p. 151).

LITERATURE: Robert ASR III.3 (1919), p. 434, no. 350 a–b, pls 114–15; Wilpert Sarcofagi II (1932), p. 348, pl. CCLXI,3–4; Gabelmann 1973, p. 89

234

234. Sarcophagus of P. Aelius Sabinus at Tortona: short sides

SEVENTEENTH-CENTURY ITALIAN *c.* 1655 (?)

Windsor, RL 9186

Pen and ink, over black chalk

162 × 250 mm

NUMBERING: [bottom right and left] *665*

MOUNT SHEET: type B. Also bears **235–6** [below]

BIANCHINI fol. 169, I and II: Sarcophagus of P. Aelius Sabinus with the myth of Phaethon.

On one end of the sarcophagus is a relief of two naked *putti* playing *astragali* (knucklebones); on the other they are watching a cock-fight. Holstenius commented in 1655 (see opposite p. 172, Fea 1790, p. cclxxxv f.) that both scenes 'clearly refer to the childish pursuits of the dead youth, the game and the contest being popular among small boys, and often to be seen depicted on their funerary monuments'.

LITERATURE: unpublished

OBJECT DRAWN: Tortona, Museo Civico. Marble. Height (including lid) 1.64 m, width 1.03 m. Robert *ASR* III.3 (1919), p. 434, no. 350 a–b, pls 114– 15; Wilpert *Sarcofagi* II (1932), p. 348, pl. CCLXI,3–4; Gabelmann 1973, p. 89

235. Sarcophagus of P. Aelius Sabinus at Tortona: front

SEVENTEENTH-CENTURY ITALIAN *c.* 1655 (?)

Windsor, RL 9187

Pen and ink, *pentimenti* in graphite

155 × 259 mm

NUMBERING: *663*

ANNOTATION: [vertically at left-hand side, brown ink, scratched out] illegible letters

MOUNT SHEET: type B. Also bears **234 [above]**, **236 [below]**

BIANCHINI fol. 169 [see **234**]

The drawing depicts the principal side of the sarcophagus, with its two inscriptions (*CIL* V, 7380). That in Latin, along the bottom edge of the lid and the upper edge of the chest, reads: P. AELIO SABINO Q VIXIT ANNOS XXIIII DIES XLV / ANTONIA THISIPHO MATER FILIO PIENTISSIMO 'To Publius Aelius Sabinus, who lived 24 years and 45 days. His mother, Antonia Thisipho, to a most pious son'.

Small portrait busts of mother and son are crudely carved in the corner acroteria on the lid, which is decorated with a vine scroll growing from a vase in the centre (largely invented in the drawing).

The front of the chest below is divided into three compartments by arcades supported on spirally-fluted columns. Framed in the central arcade is a representation of the myth of Phaethon, whose father Helios, the Sun God, reluctantly granted his foolhardy wish to drive the heavenly chariot. Phaethon was unable to control the horses, and to avoid them burning up the Earth, Helios killed him with a thunderbolt. His fall is witnessed by a shepherd and some sheep. The figures in the lateral arcades are generally interpreted as Castor and Pollux, whose story is similarly symbolic of youthful tragedy. Over their heads is the Greek text: ΘΑΡϹΕΙ ΕΥΓΕΝΕΙ, ΟΥΔΕΙϹ ΑΘΑΝΑΙΟϹ 'Take heart, Eugenius, nobody lives for ever'. (In the drawing, the two parts of the text are transposed, and the placing of the lettering is also wrong, although the letters themselves are correct.)

Holstenius commented (Fea 1790, p. cclxxxv) that the Greek is a common funerary epitaph, citing Gruterus for various other

Comp. fig. 235 (i): Sarcophagus of Publius Aelius Sabinus, front. Tortona, Museo Civico

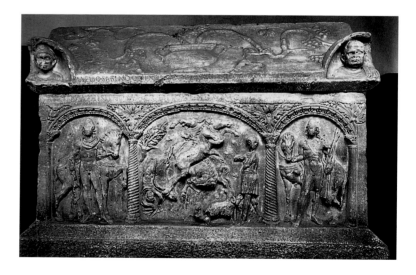

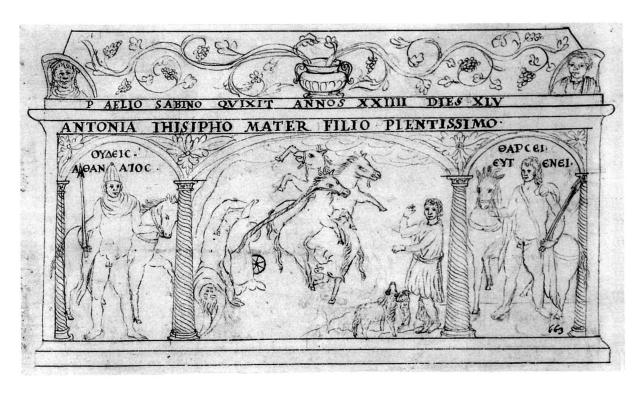

235

examples; 'Eugenius', he suggested, could have been Sabinus' nickname (see also Lattimore 1962, pp. 253, 331). He went on to argue that the 'Q' which follows Sabinus' name in the inscription on the lid (which modern commentators would simply expand as 'q(ui)' [who]) stood for Q(uiritis)—knight, in keeping with the predominantly equestrian character of the associated reliefs. In his view, the horseman at the left, with his close-fitting cap (*pileus*) and short cloak (*chlamys*) drawn around his shoulders, must be Castor, the horse-tamer (mortal son of Jupiter by Leda, with whom the god copulated in the guise of a swan, as portrayed on the back of the lid, see **236**), leading his celebrated horse Cyllaros. But the matching figure in the opposite arcade could not be Castor's immortal brother Pollux, since the drawing (erroneously) shows him without a pileus. He had to be P. Aelius Sabinus himself, portrayed as 'Castor's pupil in the matter of horsemanship, and not unlike him as regards his youthfulness and the fiery horse he holds and the javelin which indicates he has been similarly trained for the cavalry'. The scene of Phaethon's fall signifies his misfortune: 'his youthful daring not tempered by suitable skill, he took a great risk and lost his life'. Thus, Holstenius concludes, attempting to tie everything together, it is not entirely without reason that the imagery is accompanied by the Greek sentiment, 'no one is immortal': not Castor, son of Jupiter, nor Phaethon, son of the Sun.

LITERATURE: unpublished

OBJECT DRAWN: Tortona, Museo Civico. Marble. Height of chest 1.16 m, height of lid 0.48 m, width 2.48 m. Robert *ASR* III.3 (1919), pp. 432–5, no. 350, pl. 114; Wilpert *Sarcofagi* II (1932), pl. 261.1; Gabelmann 1973, pp. 88–90, 214, no. 56, pl. 24.1

ENGRAVINGS: Mabillon, *Iter Italicum* (1687), at p. 223

236. Marble sarcophagus of P. Aelius Sabinus at Tortona: back

SEVENTEENTH-CENTURY ITALIAN *c.* 1655 (?)

Windsor, RL 9188

Pen and ink, *pentimenti* in black chalk

157 × 250 mm

NUMBERING: *664*

MOUNT SHEET: type B. Also bears **234–5** [above]

BIANCHINI fol. 169, [see **234**]

The rear of the chest bears two figures of shepherds, one playing a flute and the other a pan-pipe while carrying a sheep on his shoulders. In Holstenius' opinion (Fea 1790, p. cclxxxviii), the imagery signified the alternative to Sabinus' fate: 'a quiet, happy and contented rural life; a striving towards humble pastimes, the fall of Phaethon not to venture, relieving toil simply in the melody of a reed-pipe. Like the dogs with their collars, no less bound to their shepherds are the wool-bearing sheep (Varro, *de re Rustica* 2, 9). The vinescroll on the lid is simply decorative, in which one looks in vain for a hidden message'. The acroterion at the right of the lid, as Holstenius noted, depicts Leda and the Swan, in reference to Castor on the front (see **235**). Mabillon, misled by the poor quality of the drawing, saw the swan as an eagle, and Leda as a nude man reclining with a vase gushing water and thus as a personification of a river, the Eridanum or the Padum (Po), where Phaethon was reputed to have fallen to Earth.

LITERATURE: unpublished

OBJECT DRAWN: see **235**. Robert *ASR* III.3 (1919), p. 434, pl. 115; Wilpert *Sarcofagi* II (1932), p. 348f., pl. 261.2; Gabelmann 1973, 89, pl. 24.2

ENGRAVINGS: Mabillon, *Iter Italicum* (1687), at p. 223

Comp. fig. 236 (i): Sarcophagus of Publius Aelius Sabinus, back. Tortona, Museo Civico

236

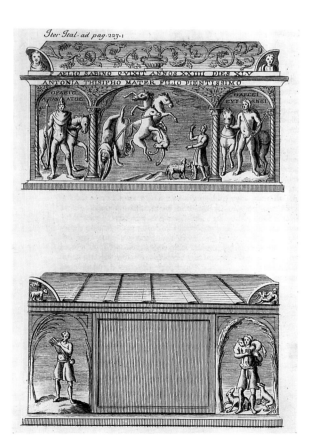

Comp. figs. 235 (ii), 236 (ii): Anonymous,
Sarcophagus of Publius Aelius Sabinus,
engraving, Mabillon, *Iter Italicum*, p. 223.1

177

237. Relief: 'Madonna and Child'

attrib. PIETRO TESTA (1612–50)

Windsor, RL 9173

Pen and pale brown ink, and yellowish brown wash, over traces
of red chalk

218 × 181 mm. Creamy yellow paper

NUMBERING: *119*

MOUNT SHEET: type A. Frame lines 10 mm apart, fine black.
Watermark: Crown 27

BIANCHINI fol. 160, I: Figured relief in which a seated woman holds a
child wrapped in swaddling. II: Antique bas-relief of the Blessed Virgin
holding the Baby Jesus.

The drawing records a highly classicizing relief of a seated woman holding a swaddled infant in her lap. The precise model is not known, although it is reminiscent of Attic grave *stelai* (cf. other examples of swaddled infants in Conze, I (1881), pls LXIV, no. 276, and LXXIII). The inclusion of this drawing in the *Mosaici Antichi* album presumably stems from its interpretation (cf. Bianchini) as an image of Mary with the Infant Jesus.

It is the first of three related drawings which were probably transferred as a group from another part of the Paper Museum (see also **238** and **239**). They have been attributed to the hand of Pietro Testa by both Blunt and Turner, and all are framed within the double inked lines characteristic of the earlier dal Pozzo mounts. The watermark (Crown 27) on **237** and **238** is also prevalent among the earlier drawings and the low 'Pozzo' numbers (*118, 119, 132*), correspond to gaps in one of the sequences in the *Bassi Rilievi* albums (see A.III).

LITERATURE: Michaelis 1874, p. 67; Blunt 1971,
p. 121f.; Turner 1992, p. 142f.

OBJECT DRAWN: unlocated

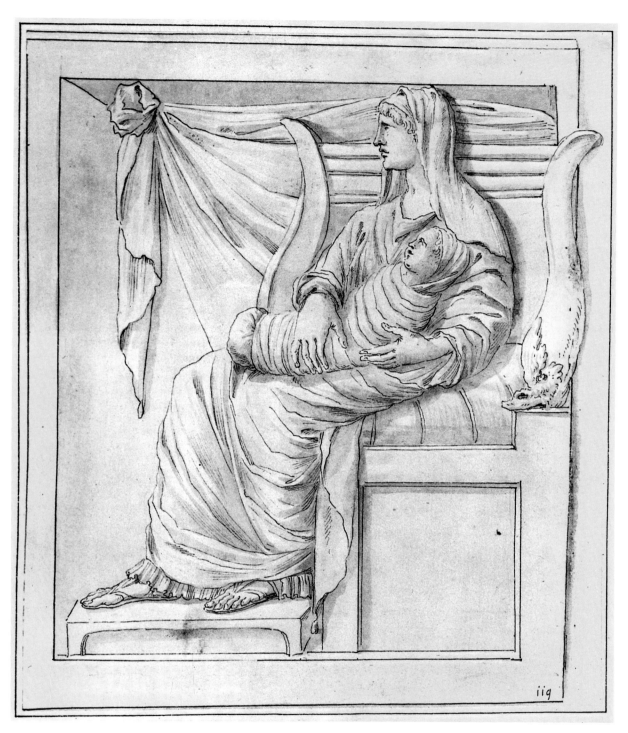

119

237

238. Fragment of a relief carving: 'Madonna and Child'

attrib. PIETRO TESTA (1612–50)

Windsor, RL 9174

Pen and pale brown ink, and yellowish grey wash, over black chalk

277 × 205 mm. Creamy paper

NUMBERING: *132*

MOUNT SHEET: type A. Frame lines 10 mm apart, fine.
Watermark: Crown 27 (cut)

BIANCHINI fol. 161, I and II: Another bas-relief of a Mother, who holds her swaddled son, (II:) which I presume represents the Blessed Virgin with the Child, as above (237).

See **237**. The drawing records a fragment of a carved relief, of which only a few figures and part of the upper edge survived intact. At the right, a woman holds a naked child; two male figures stand to the left. While a 17th-century eye could perceive it as Mary and the Infant Jesus, it was probably not a Christian work at all, though its subject and date are uncertain. It might have been a relatively elaborate version of the bathing of a newly born infant, from a Roman sarcophagus (for examples, see Amedick 1991, pp. 60–63).

LITERATURE: Blunt 1971, p. 121f.; Turner 1992, p. 142f.

OBJECT DRAWN: unlocated

132

239. Relief: Christ healing the Blind Man(?)

attrib. PIETRO TESTA (1612–50)

Windsor, RL 9175

Pen and pale brown ink, and yellowish grey-brown wash, over black chalk

233 × 170 mm

NUMBERING: *118*

MOUNT SHEET: type A. Frame lines 10 mm apart, fine black

BIANCHINI fol. 162, I and II: Bas-relief of Christ our Lord, who cures the man born blind.

See **237**. The drawing records what may be a stone relief panel depicting Christ's miraculous healing of the blind man but the model and its date have not been identified. The relief is unlikely to be classical but it is in classical style and most probably a work of the late 16th or 17th century, unless the draughtsman, whom Blunt and Turner identify as Testa, has taken enormous liberties in altering the style of an earlier model.

LITERATURE: Blunt 1971, p. 121f.; Turner 1992, p. 142f.

OBJECT DRAWN: unlocated

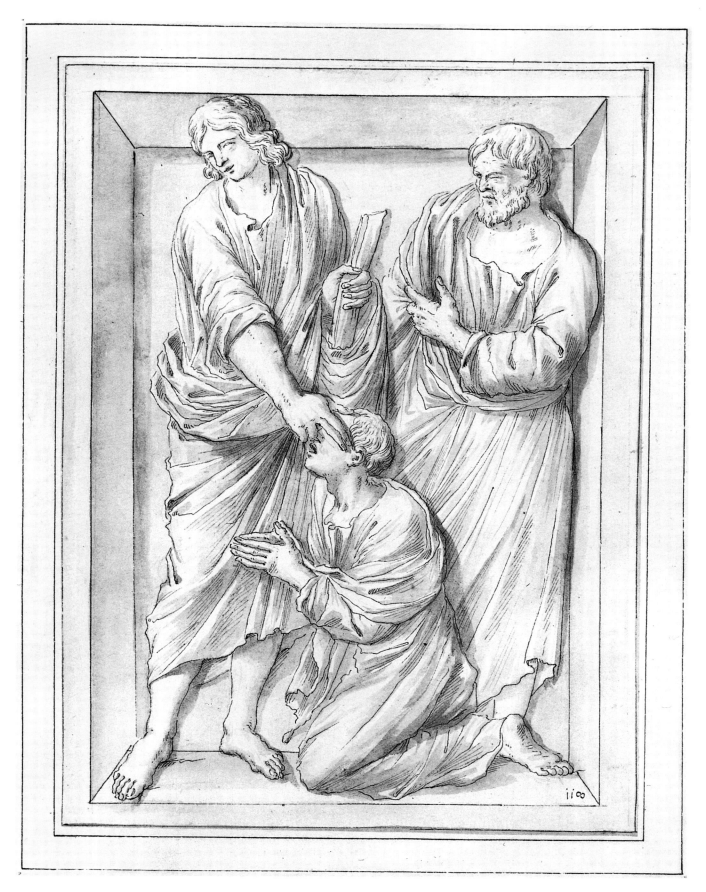

239

240. Relief fragment: 'The Adoration of the Magi'

attrib. PIETRO TESTA (1612–50)

Windsor, RL 9181

Pen and pale brown ink, and pale grey wash, over black chalk

137 × 196 mm. Very thin paper

NUMBERING: *268*

MOUNT SHEET: type B. Also bears **173**, **298**.

BIANCHINI fol. 166, II: Adoration of the Magi taken from the Antique (I:) a bas-relief.

The drawing records a fragment of a carved relief, location unknown, in which five men, four of whom wear Phrygian caps, approach a woman and child seated at the right. The scene bears many similarities to the Adoration of the Magi, except that the number of Magi had been fixed at three by an early date; however, it was presumably this identification (cf. Bianchini) which led to the drawing being included in the *Mosaici Antichi*. It is possible that the relief ac-tually came from some Roman imperial trium-phal monument, or a battle sarcophagus, de-picting a barbarian family fleeing the Roman army.

The drawing has been attributed to the hand of Pietro Testa by both Blunt and Turner. It should be noted, however, that the placing and calligraphy of the 'Pozzo' number *268* would also suit Carlo Antonio dal Pozzo's inventory (see Volume One, p. 37f.).

LITERATURE: Blunt 1971, p. 121f.; Turner 1992, p. 142

OBJECT DRAWN: unlocated

240

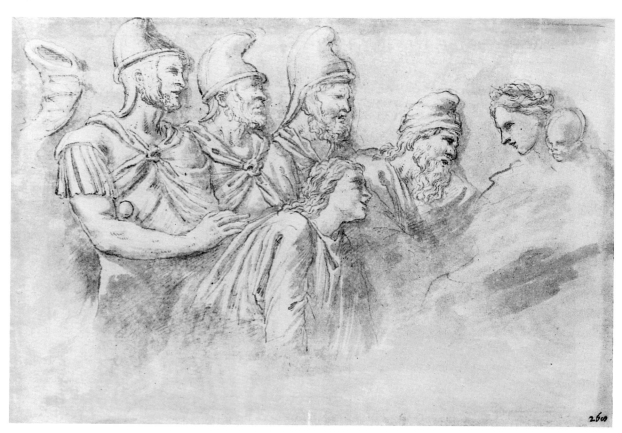

241. Ivory diptych of Anastasius, consul in AD 517

SEVENTEENTH-CENTURY

Windsor, RL 9177

Pen and brown ink and various shades of yellow-brown wash, with white heightening, over traces of black chalk

354 × 258 mm

NUMBERING: *114*

MOUNT SHEET: type A. Frame lines, 10 mm apart, thick

BIANCHINI fol. 164: I and II: Consular diptych of Flavius Anastasius, Consul Ordinarius.

(I:) Fl. Anastasius. Paul. Procos. V in L. Com. domest. Equit Savinianus Pomp. Anast. et Cons. Ord
(II:) Printed by Padre Wilthemius in the Diptychon Leodiense.

A late Roman ivory diptych, of the type distributed by new consuls to celebrate the honour of their appointment, in this case FL(avius) ANASTASIUS PAUL(us) PRO(b)US SAVINIANUS POMP(eius) ANAS(tasius), V(ir) INL(ustris) COM(es) DOMEST(icorum) EQUIT(um) ET CONS(ul) ORD(inarius), eastern consul in the year 517 (PLRE II, Anastasius 17). He is shown in the middle of each side, holding the napkin and sceptre of his new office, seated on an elaborate aedicular throne surmounted by medallion portraits of his namesake (possibly great-uncle) the Emperor Anastasius, the Empress Ariadne and another member of the imperial family. Below are scenes of the public games he will have presided over as part of his duties: animals and men fighting in the circus arena on the right, two scenes from an unidentified theatrical farce on the left.

Although the two leaves and their respective inscriptions are transposed in the drawing, the diptych is surely the *diptychon Leodiense*, one leaf of which (on the left in the drawing, and actually inscribed with the text shown on the right) is now in London and missing the upper and lower right-hand corners; the other leaf, earlier in Berlin, has been lost since 1945. Prior to the French Revolution, however, both were in the treasury of the Cathedral of St Lambert at Liège, inscribed with the names of the local bishops (Miraeus 1622, p. 463). It was almost the first to be studied when consular diptychs began to attract scholarly attention in the 17th

century (many stood on church altars, being used to record the litany of local saints to be inserted at appropriate places during the mass; some served as covers for holy books). Jacques Sirmond included a brief account of the subject in the notes to his edition of the works of Sidonius Apollinaris, published in Paris in 1614 ('Notae', p. 139), and in the second edition he illustrated the diptych of Philoxenus (AD 525), then in the monastery at Compiègne (Sirmond 1652, 'Notae', p. 83f.; cf. Volbach 1976, p. 39, no. 28). The Liège Anastasius followed in 1659, published at Liège, with a learned commentary by Alexander Wiltheim (Wilthemius) and an engraving by Richard Collin (1627–97) from a drawing by the Liègois Michel Natalis (1610–68). Further individual examples were presented in Du Cange, *De imp. Const.* (1678), Bourdelot *Utilità* (1693), Mabillon *Annales bénédictines* (1706), p. 202, and Buonarroti appended a discourse on three more to his discussion of gold-glass (1716, pp. 231–83).

Ingo Herklotz has kindly drawn our attention to the possibility that the dal Pozzo drawing is derived from a large parchment copy in a codex compiled by Joseph-Marie Suarès (see p. 311f.), accompanying his notes on the medieval reuse of consular diptychs. Suarès' drawing makes the same error in transposing the inscriptions. A note on the verso records that he had been given it by Cardinal Giovanni-Francesco Guidi di Bagno (1578–1641). The Cardinal could have acquired it while

papal nuncio in Brussels from 1621 to 1627, during which period Suarès was his secretary (Lutz 1971, p. 509), or perhaps at some later date, since the two remained in touch and Guidi di Bagno continued to have contacts in the Liège region, as Protector of the University of Louvain (*DHGE* 6 (1932), p. 219).

The dal Pozzo drawing has a low 'Pozzo' number and the type A mount characteristic of the earlier collections.

LITERATURE: Osborne 1991b; Bailey 1992, p. 19, fig. 28

OBJECT DRAWN: *left wing* London, Victoria and Albert Museum, inv. 368–1871; 362 × 127 mm; *right wing* lost (previously Berlin), 360 × 125 mm.

Wilthemius 1659; Longhurst 1927, p. 28f., pl. 6; Delbrück 1929, pp. 127–31, pl. 20; Volbach 1976, p. 35f., nos 17–18; *Age of Spirituality* cat. 1979, p. 97f., no. 88; Lafontaine-Dosogne 1980–81, p. 16

OTHER DRAWINGS: [Suarès] BAV, Vat. lat. 9136, fol. 85

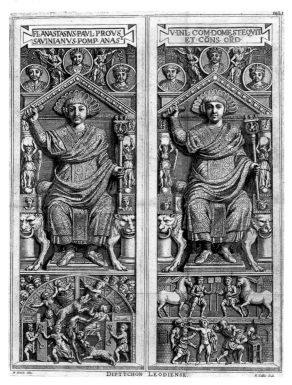

Comp. fig. 241 (i): R. Collin, *Diptych of Anastasius*, engraving after a drawing by M. Natalis, in Wilthemius 1659, p. 1

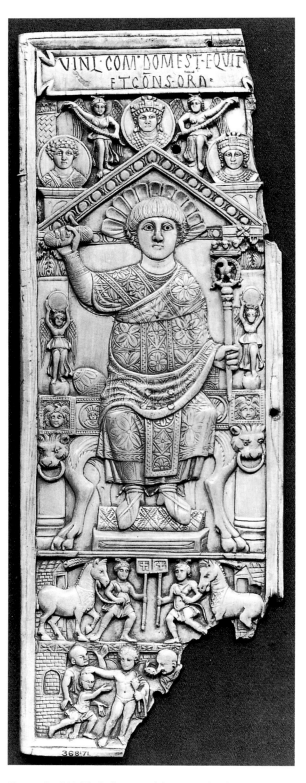

Comp. fig. 241 (ii): Left wing of the Diptych of Anastasius. London, Victoria and Albert Museum

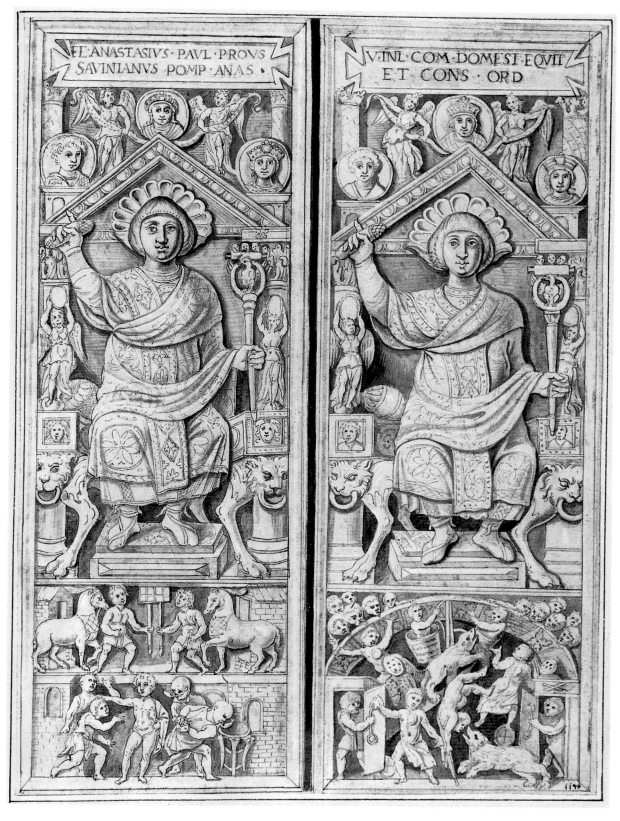

241

242. Inscriptions and monograms from two consular diptychs

SEVENTEENTH- OR EIGHTEENTH-CENTURY ITALIAN

Windsor, RL 9177A

Pen and ink

163 × 117 mm. Thin paper; hole, bottom centre

ANNOTATION: [brown ink] *questo più gotico*('this one more Gothic')

MOUNT SHEET: type B

BIANCHINI: [not mentioned]

Loosely inserted adjacent to **241** is a small sheet of paper with copies of the Latin inscriptions and monograms on both wings of the consular diptych of Orestes (AD 530), now in London, and the Greek monogram from a diptych of the consul Areobindus (AD 506), probably that now in the Louvre. Beside the latter is the notation *'questo più gotico'*, perhaps based on a misunderstanding of which language was being used. Both diptychs are first recorded in the 18th century, at which time they belonged to the Settala collection in Milan. Significantly, the founder of the collection, Manfredo Settala (1600–1680), was a friend of Cassiano, and a regular correspondent (see Sparti 1992, p. 83f.). In 1655 another member of the family, Carlo Settala, is known to have sent to Rome drawings of a classical sarcophagus at Tortona (cf. **234–6**), and this sheet may have entered the dal Pozzo album by a similar route.

LITERATURE: Osborne 1991b

OBJECTS DRAWN: London, Victoria and Albert Museum. Longhurst 1927, no. 139; Delbrück 1929, no. 32; Volbach 1976, no. 31, pl. 16. Paris, Louvre, inv. OA 9525. Volbach 1976, no. 13, pl. 6; *Byzance* cat. 1992, p. 52, no. 14

242 (actual size)

243. Byzantine ivory triptych

SEVENTEENTH-CENTURY ITALIAN

Windsor, RL 9178

Pen and ink, and brown wash, over graphite

255 × 331 mm. Stained

MOUNT SHEET: type B

BIANCHINI fol. 165, I: Images of Christ, the Blessed Virgin and other Saints, their individual names written in Greek. II: Greek images of Our Lord Jesus Christ, the B. Virgin, and other Saints.

In the early 17th century the triptych belonged to the Barberini family, being listed in an inventory of 1628 (Cutler 1995, p. 255f.). It later passed to the Casanatense library in the Dominican convent of S. Maria sopra Minerva in Rome, and is now in the collection of the Palazzo di Venezia. It is one of the finest pieces associated with the post-iconoclastic revival of the arts in Byzantium which has come to be known as the 'Macedonian renaissance' and was produced in Constantinople, probably for the Emperor Constantine VII Porphyrogenitos (913–59). The main panel depicts the standard Byzantine iconography of the *deesis* (intercession), with Christ flanked by Mary and St John the Baptist. Beneath are five apostles: from left to right, James, John, Peter, Paul and Andrew. The two outer wings are carved with the figures of popular Byzantine saints. The left wing depicts St Theodore Tyro and a military saint whose identifying inscription is no longer legible; and beneath, Saints Prokopios and Arethas. On the right wing are Saints Theodore Stratelates and George; and beneath, Saints Demetrios and Eustratios. The copyist has been careful to preserve the letter forms of the original very accurately.

LITERATURE: unpublished

OBJECT DRAWN: Rome, Museo Nazionale del Palazzo di Venezia, inv. 1490. Central panel 230 × 145 mm; side panels 210 × 75 mm. Goldschmidt 1934, II, p. 33, no. 30, pl. X; Morey 1936, pp. 22–4, fig. 16

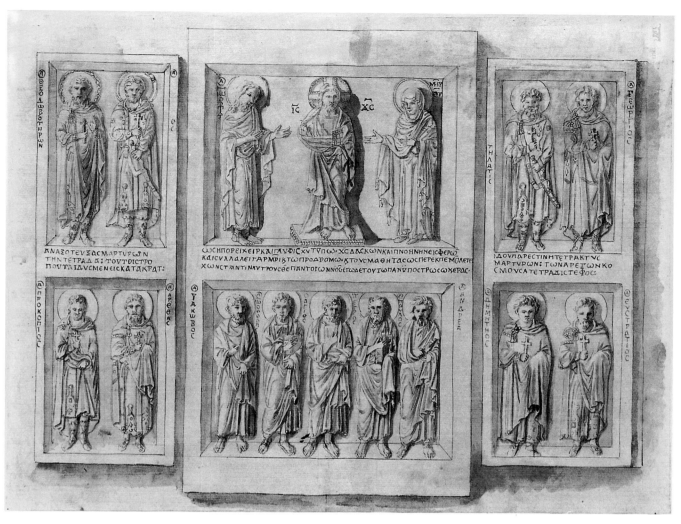

243

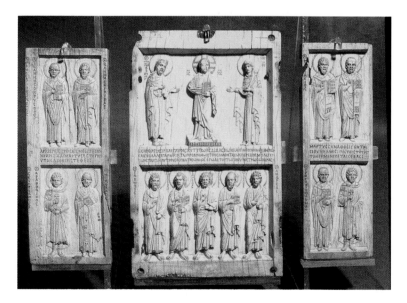

Comp. fig. 243: Byzantine ivory triptych.
Rome, Museo Nazionale del Palazzo di Venezia, inv. 1490

244. Ivory panaghiarion

SEVENTEENTH-CENTURY

Windsor, RL 9161

Pen and ink, and brown and grey wash

224 × 169 mm. Stained

NUMBERING: [lower centre] *810*

[upper centre] *A*

[lower centre] *B*

MOUNT SHEET: type B

BIANCHINI fol. 154, I: Linear Illyrian diptych donated in holy memory of Clement XI. II: circular wooden diptych with Holy Images and Illyrian characters. The original was donated in holy memory of Clement XI and was interpreted by Abbot Patrizio, who explained the Letters as part of the Troparion of the Greek Mass said to be of St James which is still recited today, proof of the Invocation of the Saints always maintained by the Church.

The drawing depicts the exterior and interior of a Russian Orthodox *panaghiarion* (container for eucharistic bread), formed by two ivory discs bearing scenes in low relief. On the outside (labelled 'A') are, to the left, three important 4th-century theologians, Basil of Caesarea, Gregory of Nazianzus, and John Chrysostom; and to the right, a depiction of the *tropaeum* at Golgotha, the cross bearing a victory wreath and flanked by the instruments of Christ's passion. On the inside (labelled 'B') are, on the left, a depiction of the Trinity in the form of the three angels who appeared to Abraham at Mamre (Genesis 18:1–15), set in an outer concentric ring formed by medallions containing busts of 12 apostles; and on the right, the Madonna orans with Child, accompanied by the symbols of the four evangelists, and various angels. The inscriptions are in Russian.

Although this particular example is elusive, there are two very similar *panaghiaria* in the collection of the Vatican Library *Museo Cristiano* (Kanzler 1903, pl. XXI,1–6; Morey 1936, pp. 96–8, A129–30, pls 34–5). Morey dates them to the 17th century, and suggests that they may have come from the Russian monastery on Mt Athos. The first could be that which Bianchini took to be the subject of the dal Pozzo drawing and says was a gift in remembrance of Clement XI (1700–1721). It is almost of a size with the dal Pozzo one and appears in an inventory of the time of Clement XIII (1758–69).

LITERATURE: unpublished

OBJECT DRAWN: not traced

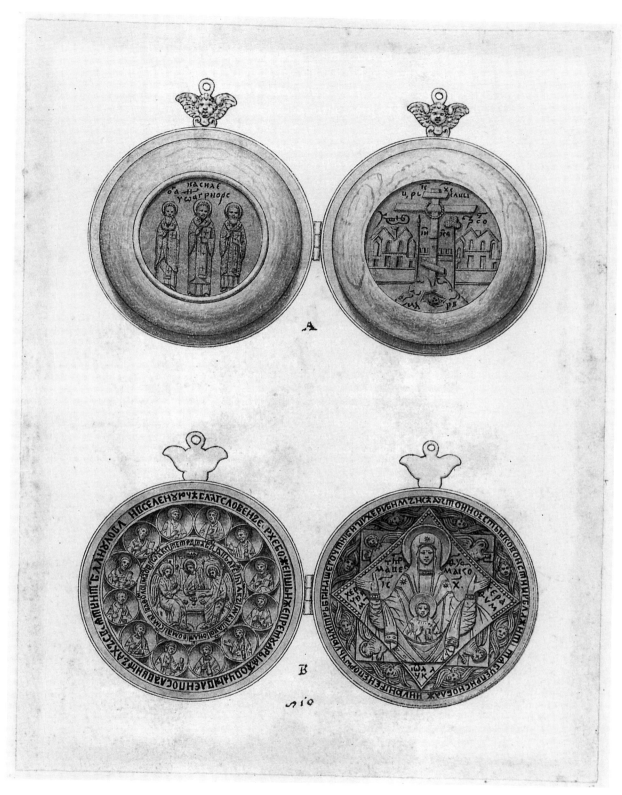

245. Ivory or bone hairpins(?): two small female busts

SEVENTEENTH-CENTURY

Windsor, RL 9105

Pen and ink, and brown wash, over graphite

146 × 96 mm

NUMBERING: [bottom centre] 1017

[beneath upper image] *1*

[beneath lower image] *2*

MOUNT SHEET: type B. Also bears **246–8** [above, see p. 12, Fig. 1.5]

BIANCHINI fol. 139 [not mentioned]

The two little female busts, each shown in a front and profile view, probably formed the ends of long, ornamental hairpins in ivory or bone. Their dress and hair-styles are characteristic of late antiquity (compare one published by Boldetti 1720, p. 502, no. 21 and two from the Carpegna collection in the Vatican Library, *Museo Profano*, nos 112–13: Kanzler 1903, pl. XIII 5–6). Although the actual objects have not been traced, they are likely to have been found in the catacombs. The high 'Pozzo' number indicates that the drawing was acquired in or shortly after July 1683. Blunt's attribution to Pietro Testa is not compelling.

LITERATURE: Blunt 1971, p. 122

OBJECTS DRAWN: not traced

245 (actual size)

246. Ivory relief plaque: standing Faun

SEVENTEENTH-CENTURY ITALIAN

Windsor, RL 9103

Pen and ink, and brown wash, with white heightening, over graphite

126 × 60 mm

NUMBERING: *1099*

MOUNT SHEET: type B. Also bears **245, 247–8**

BIANCHINI fol. 139 [see **248**]

Of unknown findspot, but now in the *Museo Profano* in the Vatican Library, which according to Kanzler (1903, p. viii) should signify that it came from the Carpegna collection, the relief may once have formed part of the decorative veneer applied to a Roman dining or funerary couch. It is likely to have been found in one of the ancient cemeteries on the outskirts of Rome, which may account for its inclusion in the *Mosaici Antichi* album despite its non-Christian subject matter (unless the figure was mistaken for a Good Shepherd). Kanzler proposes a date in the 4th century AD. The drawing shows its condition prior to minor stucco repairs.

The drawing is one of three showing similar small ivory panels carved in relief, mounted together on the same folio (and the 'Pozzo' numbers suggest they were acquired as a group in the late 1680s): see also **247–8**. Blunt's attribution of all three to Pietro Testa may be doubted.

LITERATURE: Blunt 1971, p. 122

OBJECT DRAWN: BAV, *Museo Profano*, no. 30. 117 × 73 mm. Kanzler 1903, p. 2, pl. V.3

247. Ivory relief plaque: Youthful Pan and dancing maenad

SEVENTEENTH-CENTURY ITALIAN

Windsor, RL 9104

Pen and ink and brown wash, with white heightening, over traces of graphite

124 × 78 mm

NUMBERING: *1100*

MOUNT SHEET: type B. Also bears **245–6, 248**

BIANCHINI fol. 139 [see **248**]

Like its companions, **246** and **248**, the findspot of the relief is not known but it was probably previously in the Carpegna collection and thus could well have come from the catacombs.

Kanzler proposes a date in the 3rd century AD. The drawing shows its condition prior to minor stucco repairs.

LITERATURE: Blunt 1971, p. 122

OBJECT DRAWN: BAV, *Museo Profano*, no. 28. 125 × 72 mm. Kanzler 1903, p. 2, pl. V.1

246 (actual size)

247 (actual size)

248. Ivory relief plaque: Jupiter seated on an eagle, accompanied by two erotes

SEVENTEENTH-CENTURY ITALIAN

Windsor, RL 9102

Pen and ink and brown wash, with white heightening, over graphite

80 × 114 mm

NUMBERING: [bottom centre] *1102*

MOUNT SHEET: type B. Also bears **245–7** [see p. 12, Fig. 1.5]

BIANCHINI fol. 139, I and II: Images of Jupiter, Pan etc. copied from ancient ivory figurines.

See also **246–7**. Kanzler suggests a date in the second or third century AD. The drawing shows its condition prior to minor stucco repairs.

LITERATURE: Blunt 1971, p. 122

OBJECT DRAWN: BAV, *Museo Profano*, no. 41. 74 × 108 mm. Kanzler 1903, p. 2, pl. VII.3

248 (actual size)

GOLD-GLASS [249–282]

Figured gold-glass is the best represented category of small objects in the *Mosaici Antichi*, with thirty-four drawings mounted in studied groups of related subject matter on four consecutive folios (see p. 12, Figs 1.6–1.9). All copy the glasses at actual size and, with one exception (**277**), appear to be work of a single hand, using gold powder and bodycolour and considerable miniaturist skill to reproduce the originals with great fidelity. The 'Pozzo' numbers (again with the exception of **277**, numbered *433*) are all high in Carlo Antonio's inventory, starting with a batch of twenty-two numbered from *1018* to *1042* (missing *1021–3, 1025*), that is, they followed almost directly on from a drawing (*1015*) which Carlo Antonio received from Raffaele Fabretti in May 1683 (see Volume One, p. 37). A second batch have numbers between *1050* and *1060*; the next is numbered *1103* and then three are numbered in sequence *1162–4*.

Gold-glass began to attract antiquarian interest in the late sixteenth and early seventeenth century, apace with the exploration of the catacombs in which most of it was found, used as tomb markers. Severano included five examples when editing Bosio's *Roma Sotterranea* in 1632–4 (pp. 126, 197, 509), among them one which Fulvio Orsini had acquired from Orazio della Valle in the later sixteenth century. Aringhi's subsequent edition of the *Roma* in 1651 (pp. 401–3, 405) added six more, several from another early collection belonging to the Marchesa Cristina Angelelli, said to have been found in the Catacombs of Priscilla on the via Salaria, and one owned by Francesco Gualdi (see Volume One, p. 50). Claude Menestrier acquired one for Francesco Barberini in 1636 (Tamizey de Larroque *Lettres* V, p. 816). In the second half of the seventeenth century Flavio Chigi (1631–93) enlarged upon a celebrated collection started by his uncle Pope Alexander VII (Chigi, 1655–67), and Gaspare Carpegna assembled an even larger one during his forty years as Cardinal Vicario of Rome from 1670 to 1714, in charge of Relics and Catacombs. Small collections were also made by Raffaele Fabretti (*c.* 1620–1700) and Marcantonio Boldetti (1663–1749), who served as Carpegna's Superintendents of Catacombs in 1687–9 and 1700–1749 respectively. Fabretti published two examples in 1683 (see **261**) when he was apparently planning to write a whole book on the subject, but by the time he presented a few more in his *Inscriptiones antiquarum* of 1699 (p. 593 and see **253, 262**) he had handed the larger task over to his much younger colleague and friend Filippo Buonarroti, who had just published Carpegna's coin collection (1698).

Buonarroti's monograph on gold-glass, printed in Florence in 1716, offered a comprehensive account of its subject which in some basic respects has not been bettered since (cf. Engemann 1968, pp. 9–11). In 1720 Boldetti also ventured into print, but his book was naive by comparison. The seventy-two examples Buonarroti used were taken predominantly from the Carpegna holdings, but included some from Fabretti and Boldetti and some of his own, and four examples in the Chigi collection. Interestingly, he included the Chigi glasses not from first-hand knowledge but on the basis of drawings given to him by Raffaele Fabretti, deriving from Fabretti's own earlier project. The relationship between the relevant Buonarroti plates and the dal Pozzo versions is so strikingly close (see **257, 259–60, 268**) that Fabretti's drawings may well have come from the same source as the dal Pozzo ones. That there could be some essential connection between the two is underscored by the evidence from the 'Pozzo' numbering (see above), which suggests that Carlo Antonio acquired the drawings during the period that Fabretti was thinking of his book. Most of the other glasses represented in the dal Pozzo drawings were either in the Carpegna or Fabretti collections and were subsequently

published by Buonarroti; but there are another four examples in the Chigi collection (**251**, **264**, **266**, **276**) which were not available to Buonarroti.

The glasses date from the third to the fourth centuries AD and illustrate pagan, Christian or secular motifs, scenes from classical mythology or the Bible, saints, charioteers, married couples and family groups. They are often called 'medallions', but most are the bases of drinking bowls or tall beakers with the sides broken off. The commonest (and actually most durable) method of their manufacture was to apply thin gold leaf to the circular piece of flanged transparent or palely tinted greenish glass which was to form the foot of the bowl or cup (which might range in diameter from as little as 30 mm up to and over 120 mm) and cut out the desired design, occasionally adding some extra detail in silver or red. The foot was then fused with the body of the vessel, which sandwiched the gold leaf between two layers of glass. The image, which is frequently labelled and/or surrounded by the text of a drinking toast, normally faced upwards, to be read from the inside—that is, by the user, not by a spectactor. Very small discs (less than 20 mm across), especially those in dark blue glass (cf. **275–6**, **278–9**, **282**), may have been attached in groups to the outer walls of vessels, as decorative knobs. A different method, often but not invariably on dark blue glass, used a rich combination of gold and coloured paints. The subjects in these cases are often portraits and the workmanship is generally of superior, even at times exceptional artistic quality. Some are very large (up to 200 mm in diameter) but many of the most spectacular finds seem to have disintegrated rapidly upon exposure to the atmosphere. The only instance that we have to deal with here (**251**) is probably a seventeenth-century replica, made to record a vanished or vanishing original.

For a flavour of the debates surrounding the interpretation of the glasses in the seventeenth century the entries below include frequent quotations from Buonarroti and his contemporaries.

LITERATURE: Buonarroti 1716; Engemann 1968; Pillinger 1984; Painter 1987

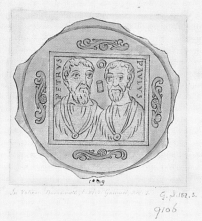

In Vatican. Buonarrotti t. XI.1 Garrucci XLf.3. G. pl. 182.3.

9106

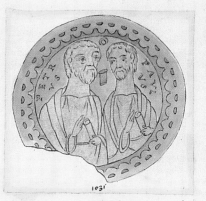

In Vatican. Buonarrotti t. XI.1 Garrucci XLf.2. G. pl. 182.2.

9107

In Vatican. Boldetti t. XI. Garrucci XLf.1.

9108

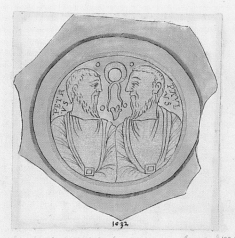

In Vatican. Buonarrotti t. XI.1 Garrucci XLf.1. Garrucci pl. 183.1.

9109

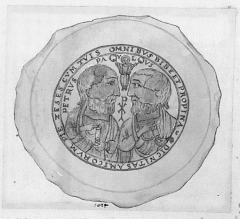

In Vatican. Buonarrotti t. XI.1 Garrucci XLf.2. Garrucci pl. 181.2.

9110

249. Gold leaf on greenish glass: the apostles St Peter and St Paul

LATE SEVENTEENTH-CENTURY ITALIAN

Windsor, RL 9106

Watercolour, with gold powder in gum arabic, over pen and ink

106 × 105 mm. *Watermark*: Crown 39 (cut)

NUMBERING: [bottom centre] *1029*

MOUNT SHEET: type B. Also bears **250–53**

Watermark: Fleur de Lys 71

BIANCHINI fol. 140, I and II: Images of Saints (II: and Christian people) taken from antique glass vessels found in the Cemeteries (II:) of the holy Martyrs.

When Buonarroti published the glass in 1716 it was still in the museum of Cardinal Gaspare Carpegna (see p. 308). In 1741 it passed with the rest of the Carpegna collection to the Vatican Library.

The saints appear in front view as half-figures, set within a square frame, PETRVS on the left and PAVLVS on the right. The copyist has corrected the original lettering, which starts Paul's name with an R instead of P, but has otherwise reproduced the piece faithfully in every detail, at actual size, accurately capturing the colour and style. The saints' over-mantles are clasped by circular brooches studded with gems. In the field between their heads is a crown and a tiny scroll.

Buonarroti proposed that the type of mantle they are wearing 'is not the ordinary *lacerna* (cloak) but a particular kind of medium-sized garment, like the Hebrew ephod, which Early Christians, both men and women, at least in cities, wore over their shoulders for prayer'. Later, he says, it was abandoned by the laity but retained by the clergy, becoming the *stola* or *orario*, as worn by the deacons St Stephen and St Lawrence in the mosaic in S. Lorenzo fuori le Mura (See 27). He laments the fact that in most gold-glass the two saints are identical in appearance and dress and are so poorly executed; if they had been better made they would be the earliest surviving images. He points out that the Roman Church had a particular interest in preserving the true likenesses of these two apostles, witnessed by early paintings and mosaics, which from age to age faithfully maintained the same physiognomy. Reflecting current concern within the contemporary Roman Church that St Peter should take precedence over Paul, Buonarroti also noted that in the gold-glasses St Peter is always on the right whereas in the mosaics, from which the custom passed to seals and papal bulls, it is not so: there St Paul is on the right and St Peter on the other side. Much depends, he observed judiciously, on 'whether the craftsman is thinking of Christ's right or the spectator's right and it is also possible that at the time the glasses were made no-one was yet concerned about the visible order or position from the spectactor's point of view'.

LITERATURE: unpublished

OBJECT DRAWN: BAV, Museo Cristiano, inv. 798 (ex-182); diam. 90 mm. Buonarroti 1716, pl. XI, 2, pp. 75–85 (not mentioned specifically); Garrucci 1858, p. 35, no. XIII.3, pl. CLXXXII; Morey 1959, no. 60, pl. X; Zanchi Roppo 1969, no. 165

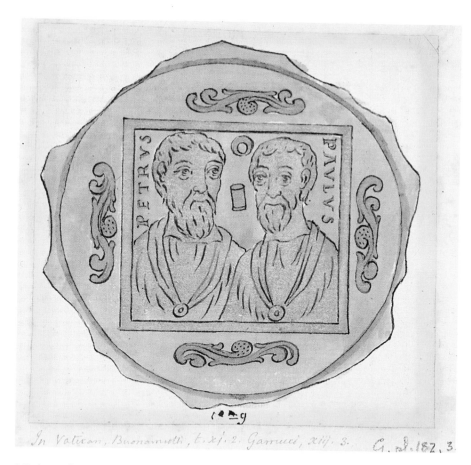

249 (actual size)

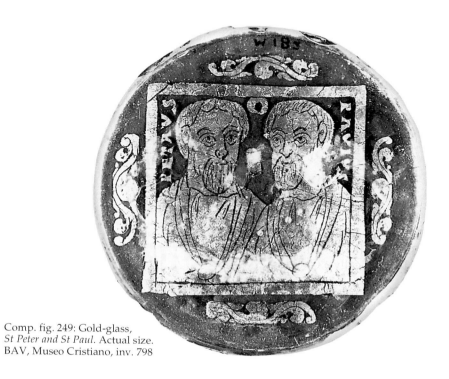

Comp. fig. 249: Gold-glass,
St Peter and St Paul. Actual size.
BAV, Museo Cristiano, inv. 798

250. Gold leaf on greenish glass: the apostles St Peter and St Paul

LATE SEVENTEENTH-CENTURY ITALIAN

Windsor, RL 9107

Watercolour, with gold powder in gum arabic, over pen and ink

114 × 113 mm

NUMBERING: [bottom centre] *1031*

MOUNT SHEET: type B. Also bears **249**, **251–3**
Watermark: Fleur de Lys 71

BIANCHINI fol. 140 [see **249**]

Previously in Cardinal Carpegna's collection, the piece is now in the Vatican.

Buonarroti took the opportunity to expound on the manner in which the two saints hold their right hands with two fingers together (how Latin bishops make the benediction) and on the significance of the scrolls: they either represent their own canonical works or the authority to preach the Holy Gospel and the little scroll in the space between them is to show that there is only one Gospel even if it is divided into various scriptures, symbolizing the unity of the Apostolic mission (viz. Tertullian *de praesciptione haereticorum* 23). The little crown above them, he speculated, could either be a further sign of the unity of their teaching, or because they were martyred on the same day, or because God is the only crown.

LITERATURE: unpublished

OBJECT DRAWN: BAV, Museo Cristiano, inv. 791 (ex-189); diam. 110 mm. Buonarroti 1716, pl. XII.1, pp. 79–83; Garrucci 1858, p. 35, XIII.2; Morey 1959, no. 63, pl. X; Zanchi Roppo 1969, no. 207

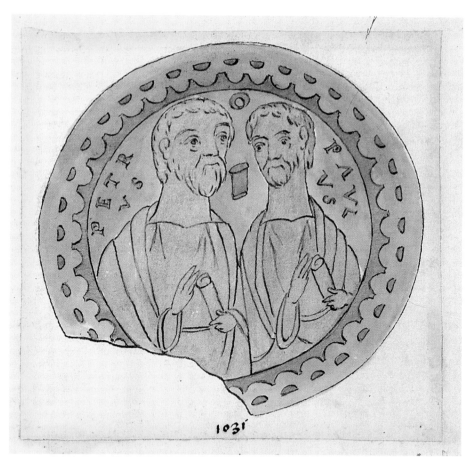

250 (actual size)

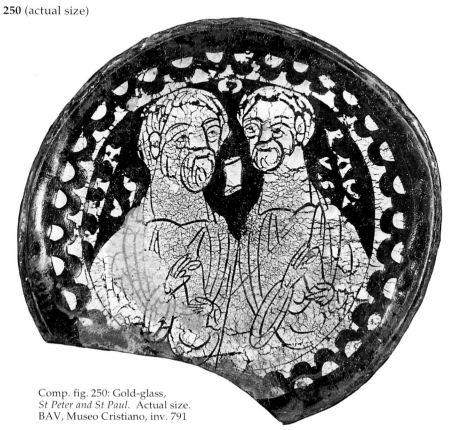

Comp. fig. 250: Gold-glass,
St Peter and St Paul. Actual size.
BAV, Museo Cristiano, inv. 791

251. Gold leaf and red paint on dark blue glass: portrait of a Late Roman official

LATE SEVENTEENTH-CENTURY ITALIAN

Windsor, RL 9108

Bodycolour, with gold and silver powder in gum arabic, and pen
and ink, over traces of graphite

159 × 157 mm

NUMBERING: [bottom centre] *1050*

MOUNT SHEET: type B. Also bears **249–50**, **252–3**
Watermark: Fleur de Lys 71

BIANCHINI fol. 140, see **249**, II: ... seems to me to refer to Minucius Felix,
the author of the Dialogue entitled Octavius. It is in the Casino in the
Chigi Museum.

The unusually large and finely executed portrait medallion (which Bianchini locates in the Chigi *casino* on the Quirinal near the Quattro Fontane) was the subject of a letter in the Chigi archives (Fea 1790, pp. cccxii–xvii), addressed to Pope Alexander VII (Fabio Chigi, *reg.* 1655–67) and signed by Joseph-Marie Suarès (see p. 311f.). The letter is not dated but Suarès was in Rome from 1653 to 1657, among other things seeing his book on ancient Palestrina, *Praenestes Antiquae* (1655), through the press (Petrucci Nardelli 1985, p. 165).

Suarès' commentary implies that the glass had been—or was reputed to have been—found in the catacombs of S. Agnese on the via Nomentana. He identified the two little female figures above the man's shoulders (perhaps the finials on a chairback) as St Constantia, on the left, and St Agnes on the right (making no reference to the small kneeling figure beside her). He believed the man, with his scarlet- and gold-banded tunic, golden cloak, and pen and open scroll, to be a *tribunus*, *chartularius* or *cubicularius*—that is, a Roman tribune, archivist or secretary in the service of the emperor. Suarès only mentions the letters CE PIE ZESES on the right side, not the other fragmentary ones on the left visible in the dal Pozzo drawing, and while realizing that PIE ZESES was transliterated Greek, signifying the toast (Drink up! To life!), he was by some tortuous process persuaded that CE was the end of the name Cyriac (KURIAKE), or rather Callinicus (KALINIKE) fourth exarch of Italy in AD 598.

What Suarès' account was based on, and what Bianchini knew in the Chigi casino, and indeed what the dal Pozzo drawing represents, is almost certainly the piece now in the reserve collections of the BAV, dismissed by Garrucci and Pillinger as fake, but better described as a replica. Bottari knew it as such when he used it on the frontispiece of the second volume of his new edition of Roma Sotterranea in 1746 and though it is not recorded there as coming from the Chigi collection, that was the year the collection entered the Vatican. It is mounted in one of the parchment-covered wooden panels which Francesco Vettori had made for the Museo Cristiano when he was keeper from 1757 to 1770 (Morello 1981, p. 76, caption to fig. 8). An inscription in Vettori's hand on the back of the panel reads ex antiquo vitro auro bracteato reperto in Cemeteriis Suburbanis, olim apud P. Virgilium Spadam ('copied from an ancient gold leaf glass discovered in the suburban cemeteries, once in the possession of Padre Virgilio Spada'). Vettori's authority for the latter statement was probably an earlier label associated with the glass, since the same information is reported in an inventory made of the Chigi museum in 1705 (Incisa della Rocchetta 1966, p. 153, no. 124). Virgilio Spada (1596–1662), a leading Oratorian, served as papal almoner to Innocent X (1644–55) and afterwards to Alexander VII Chigi. His museum included some significant pieces of liturgical glass (Ehrle 1928, p. 98). What happened to Spada's original is not recorded, but it could well have perished. Apropos a similarly large

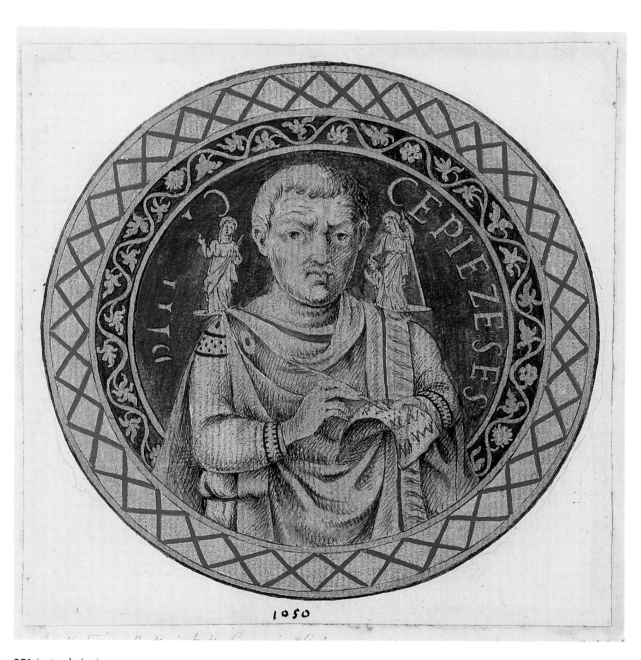

251 (actual size)

and richly decorated piece of figured glass which was found in the catacomb of S. Agnese in 1698, Buonarroti observed (1716, pl. XXX and p. 218) that it was lucky it was drawn immediately, for after only a few days it crumbled to dust.

LITERATURE: unpublished

OBJECT DRAWN: BAV, Museo Cristiano storerooms; diam. 150 mm. Bottari II, frontispiece and pp. xxiii–iv; Garrucci 1858, p. 84 (1864, p. 227), pl. XLI.1; Morello 1981, p. 76, fig. 8; Pillinger 1984, p. 42f., pl. 42, fig. 92

Bianchini's association of the portrait with a particular ancient writer is not surprising, but why he should have chosen the Christian apologist Marcus Minucius Felix (fl. AD 200–240), author of the dialogue *Octavius*, is a puzzle.

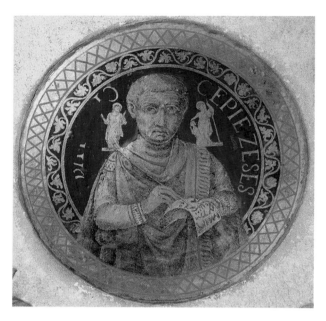

Comp. fig. 251: Gold-glass, *Portrait of a Late Roman official.*
BAV, Museo Cristiano, storerooms

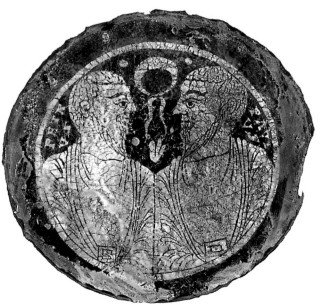

Comp. fig. 252: Gold-Glass, *St Peter and St Paul.*
BAV, Museo Cristiano, inv. 753

252. Gold leaf and greenish glass: the apostles St Peter and St Paul

LATE SEVENTEENTH-CENTURY ITALIAN

Windsor, RL 9109

Watercolour, with gold powder in gum arabic, and pen and ink, over traces of black chalk

132 × 123 mm. *Watermark*: Crown 39 (cut)

NUMBERING: [bottom centre] *1032*

MOUNT SHEET: type B. Also bears **249–51**, **253**
Watermark: Fleur de Lys 71

BIANCHINI fol. 140 [see **249**]

Buonarroti in 1716 recorded the glass as in the Carpegna collection; thence it passed to the Vatican in 1741. The dal Pozzo drawing makes it clear that it was a fragment of a dish or cup; it has since been trimmed around the outer of the two circular frames. The two saints, identical in appearance but labelled PETR/VS and PAVL/VS, face each other in profile, a wreath and flowers between them, with their chests in front view to show their mantles pinned with large rectangular jewelled brooches.

LITERATURE: unpublished

OBJECT DRAWN: BAV, Museo Cristiano, inv. 753; diam. 102 mm. Buonarroti 1716, pl. XI.1 and pp. 79–83; Boldetti 1720, p. 201, pl. 6, no. 20; Garrucci 1858, p. 35, XIV.1; Morey 1959, no. 61, pl. X; Zanchi Roppo 1969, no. 203

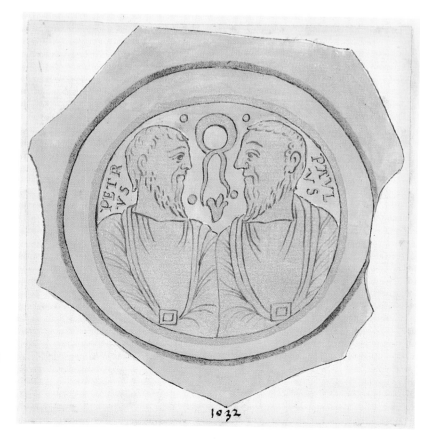

252

253. Gold leaf on pale green glass: the apostles St Peter and St Paul

LATE SEVENTEENTH-CENTURY ITALIAN

Windsor, RL 9110

Watercolour, with gold powder in gum arabic, and pen and ink, with white heightening, over traces of black chalk

125 × 137 mm. Stained. *Watermark*: Crown 39 (cut)

NUMBERING: [bottom centre] *1024*

MOUNT SHEET: type B. Also bears **249–52**. *Watermark*: Fleur de Lys 71

BIANCHINI fol. 140 [see **249**]

In the 17th century the glass belonged to Raffaele Fabretti, one of the fruits of his services to Cardinal Carpegna. Fabretti correctly interpreted the inscription which runs round the outer frame (DIGNITAS AMICORVM PIE ZESES CVM TVIS OMNIBVS BIBE ET PROPINA) as a drinking toast, an invitation to a companion to drink, that they in turn make to those beside them, so that all the company should drink—the meaning of 'propinare'. The centre is occupied by the busts of St Peter, named 'PETRVS', on the left, and St Paul, on the right, whose name appears interspacing the outstretched arms of a diminuitive figure of Christ at the top centre, identified by the chi-rho monogram beneath his feet. Christ is holding a crown in each hand over the saints' heads, and Buonarroti's commentary dwelt at length on the subject of crowns awarded in antiquity for victories in athletic and other contests.

LITERATURE: unpublished

OBJECT DRAWN: present location unknown, previously BAV, Museo Cristiano. Fabretti *Inscript. antiq.*, p. 593; Buonarroti 1716, pl. XV.1 and p. 97f.; Garrucci 1858, p. 33f. (1864, p. 94), pl. XII.2; Garrucci, *Arte Cristiana* III (1876), p. 151, pl. 181.2

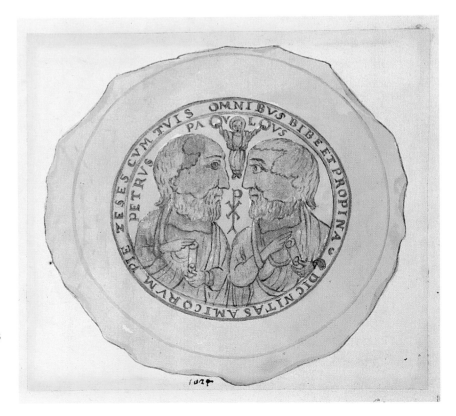

253

254–62

254. Gold leaf on greenish glass: St Agnes

LATE SEVENTEENTH-CENTURY ITALIAN

Windsor, RL 9111

Watercolour, with gold powder in gum arabic, pen and ink

101 × 97 mm

NUMBERING: [bottom centre] *1025* altered to *1035*

MOUNT SHEET: type B. Also bears **255–62**.
Watermark: Fleur de Lys 71

BIANCHINI fol. 141, I and II: Others follow, printed by Monsignor Fabretti
in part, and by Senator Bonarroti, (II:) and by Canon Boldetti.

The glass was first published by Buonarroti in 1716 when it was still in Cardinal Carpegna's collection. Thence it passed to Benedict XIV's *Museo Cristiano* in the Vatican Library in 1741. The letters A C N E around the figure in the centre field identify her as St Agnes, the virgin martyr of Rome, who died in about AD 305. Her grave, beside the via Nomentana, became a major shrine and parts of the associated catacombs were explored in the 17th century.

Buonarroti discusses the glass together with other examples (including **256**), noting that St Agnes was especially venerated in the Constantinian period and that numerous glasses variously labelled ANNE, ANGNE, ACNE all signify AGNES, simply reflecting different pronunciations, NN being a common alternative to GN. This one, he observes, has a C instead of G, which is typical of the early period, before G was invented. The saint stands with her hands outstretched in the attitude of prayer universally used in antiquity, by pagans and Christians alike (Tertullian, *de oratione* 9). She is wearing the *stola* (a version of the Hebrew ephod) but it is not fastened with a brooch (as, for example, in **256**) and on her head is the *mitra* or *mitella*—the band or belt worn by virgins (Tertullian, *de virginibus velandis* 16). The trees on either side of her perhaps represent Paradise, their leaves symbolizing the eternal happiness of the just, who cannot be told apart from the sinners in wintertime, only in the Spring, when their leaves begin to show.

LITERATURE: unpublished

OBJECT DRAWN: BAV, Museo Cristiano, inv. 774 (ex-739); diam. 88.5 mm. Buonarroti 1716, pl. XXI.1, and pp. 118–26; Garrucci 1858, p. 49, pl. XXI.5; Morey 1959, no. 82, pl. XIV; Zanchi Roppo 1969, no. 226, fig. 51

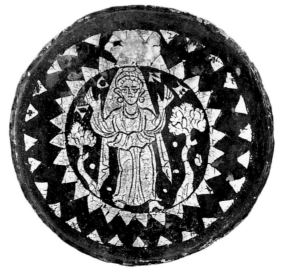

Comp. fig. 254: Gold-glass, *St Agnes*. BAV, Museo Cristiano, inv. 774

212

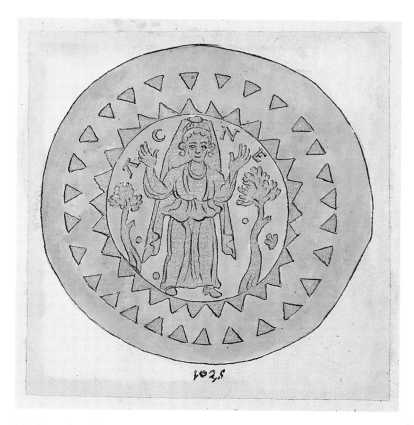

254 (actual size)

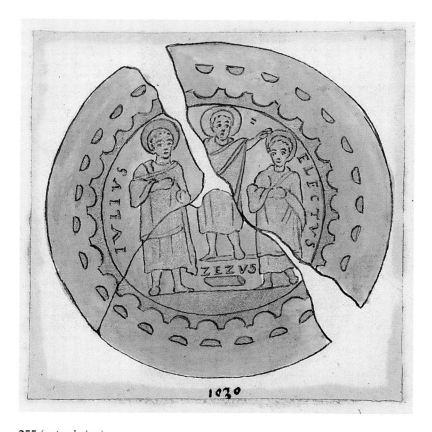

255 (actual size)

255. Gold leaf on greenish glass: Christ blessing Julius and Electus

LATE SEVENTEENTH-CENTURY ITALIAN

Windsor, RL 9112

Watercolour, with gold powder in gum arabic, and pen and ink

100 × 99 mm

NUMBERING: [bottom centre] *1030*

MOUNT SHEET: type B. Also bears **254**, **256–62** .
Watermark: Fleur de Lys 71

BIANCHINI fol. 141 [see **254**]

When published by Buonarroti and Boldetti, the glass was still in Cardinal Carpegna's collection. Since 1741 it has been in the Vatican Library, *Museo Cristiano*. The letters on the right-hand side, recorded in the dal Pozzo drawing and by Buonarroti as ELECTVS, were read by Boldetti and De Rossi as CASTVS and by Morey as SUSSTVS.

Two youths, one named IVLIVS, the other ELECTVS stand in front of Christ, beneath whose figure is written ZESVS. Buonarroti observed that there was an 'I' before ELECTUS which could be meant to be an 'E' (that is, 'ET'—'and') but he was principally interested in the clothing: Christ is wearing a garment which looked to him 'like a *paenula*, or rather

the *pallium* drawn over both shoulders; the boys' dress is extraordinary, apparently consisting of a sort of tunic with only one sleeve, on the right side. Not the same as the servile, lowly *exomis* (see **259**), it is longer and covers both shoulders, and just goes to show that there were obviously many forms of dress which do not get mentioned by ancient writers'. He suggested that the youths were about to enter some ecclesiastical order, observing that Christ's gesture, patting Electus' head, is that of the teacher towards children, the master among his disciples, as he appears in sarcophagi and in catacomb paintings (and cites Aringhi *Roma Subterranea* II, bk 6, chap. 10).

LITERATURE: unpublished

OBJECT DRAWN: BAV, Museo Cristiano, inv. 789 (ex-242); diam. 90 mm. Buonarroti 1716, pl. XVII.2, and pp. 113–16; Boldetti 1720, p. 205, pl. 8, no. 33; Garrucci 1858, p. 51, pl. XXIII.7; Morey 1959, no. 102, pl. XVII; Zanchi Roppo 1969, no. 219

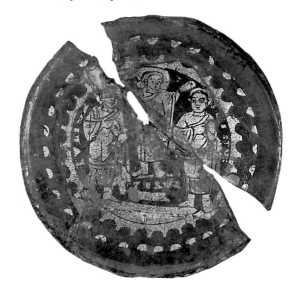

Comp. fig. 255: Gold-glass, *Christ blessing Julius and Electus*. BAV, Museo Cristiano, inv. 789

256. Gold leaf on greenish glass: St Agnes with two doves on pedestals

LATE SEVENTEENTH-CENTURY ITALIAN

Windsor, RL 9113

Watercolour, with gold powder in gum arabic, pen and ink

113 × 100 mm

NUMBERING: [bottom centre] *1027 / i*

MOUNT SHEET: type B. Also bears **254–5**, **257–62** .
Watermark: Fleur de Lys 71

BIANCHINI) fol. 141 [see **254**]

When Buonarroti first published the glass in 1716, it was in Cardinal Carpegna's collection and had been trimmed down around the circular frame; since 1741 it has been in the Vatican Library *Museo Cristiano*. It could be the one which Marcantonio Boldetti says (1720, pp. 14, 24) he found in the catacombs of St Calixtus (on the via Appia), though his illustration shows a different division of the inscription about the saint's head. Boldetti does not give the year of his discovery and was not appointed to Carpegna's office of Relics and Catacombs until 1689, when he was only 26, but he may have been active in the field for several years before then. The 'Pozzo' numbering suggests that the drawing was acquired in or soon after May 1683.

St Agnes is shown in the attitude of prayer, wearing a tunic and a mantle (*stola*) pinned on her chest with a large circular brooch studded with jewels. Her hair is arranged in a plaited turban style. Buonarroti observed that the doves holding wreaths to either side of her, chosen by God to bring news of peace after the universal flood, were common elements in Early Christian art, 'potent symbols of simplicity, innocence, chastity, humility, charity, contemplation, and perspicacity in recognizing insidious enemies'. Dovecotes, he expands, were kept in baptisteries to represent the Holy Spirit and dove-shaped containers were made for the eucharistic bread, but above all the symbol is found on tombs, representing the soul released from the body to fly to eternal repose. He suggests (p. 125) that since the two beside St Agnes are mounted on pedestals they might refer to a specific ornament or donation, set up on her tomb or in her church (citing Gregory of Tours, *De gloria martyr.* I, 72 apropos the dove on the tomb of Dionysos, Bishop of Paris, and the numbers of lamps in the shape of doves found in the catacombs).

LITERATURE: unpublished

OBJECT DRAWN: BAV, Museo Cristiano, inv. 759 (ex-743); diam. (circular frame) 78 mm. Buonarroti 1716, pl. XVIII.3 and p. 124; Garrucci 1858, p. 49f., pl. XXII.1; Morey 1959, no. 85, pl. XIV; Zanchi Roppo 1969, no. 121

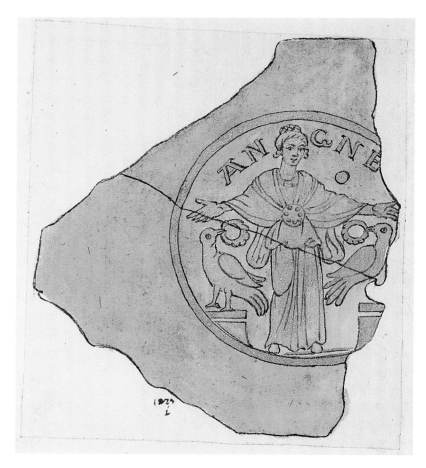

256 (actual size)

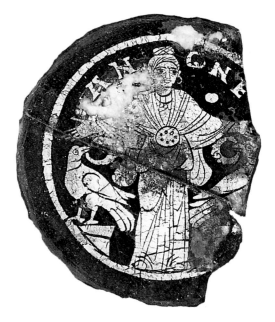

Comp. fig. 256: Gold-glass, *St Agnes with two doves*. BAV, Museo Cristiano, inv. 759

257. Gold leaf on greenish glass: the Raising of Lazarus and the Miracle at Cana

LATE SEVENTEENTH-CENTURY ITALIAN

Windsor, RL 9114

Watercolour, with gold powder in gum arabic, pen and ink, over traces of black chalk

92 × 97 mm

NUMBERING: [bottom centre] *1053*

MOUNT SHEET: type B. Also bears **254–6**, **258–63**.
Watermark: Fleur de Lys 71

BIANCHINI fol. 141 [see **254**]

In the late 17th century the glass was in the collection of Cardinal Flavio Chigi (1631–93) and is listed in the inventory of his possessions made in 1705 (Incisa della Rochetta 1966, p. 153, no. 123). By Buonarroti's day it had passed to Prince Augusto Chigi and is now in the Vatican Library *Museo Cristiano*.

The design is divided on two registers. In the upper one a youthful Christ, beardless and dressed in a short tunic with a mantle draped over his left arm, waves his wand at the corpse of Lazarus (wrapped in mummy-bands) to call him back from his rocky tomb (indicated by the three loops to the left). Below, an almost identical figure of Christ waves his wand amidst seven wine jars, referring to another miracle he performed at Cana.

LITERATURE: unpublished

OBJECT DRAWN: BAV, Museo Cristiano, inv. 777 (ex-438); diam. 90 mm. Buonarroti 1716, pl. VII.2 and pp. 49–54; Garrucci 1858, p. 25, pl. VIII.1; Morey 1959, no. 108, pl. XVIII; Zanchi Roppo 1969, no. 231

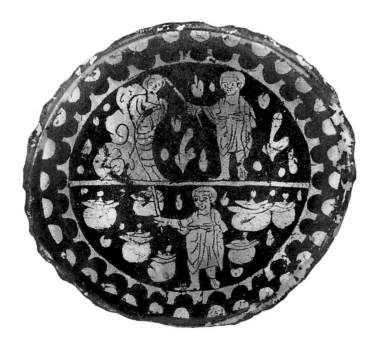

Comp. fig. 257: Gold-glass, *Raising of Lazarus and Miracle at Cana*. BAV, Museo Cristiano, inv. 777

258. Gold leaf and silver on green glass: the Raising of Lazarus

LATE SEVENTEENTH-CENTURY ITALIAN

Windsor, RL 9115

Watercolour, with gold and silver powder in gum arabic, and pen and ink, over traces of black chalk

108 × 109 mm

NUMBERING: [bottom centre] *1028*
MOUNT SHEET: type B. Also bears **254–7, 259–62**.
Watermark: Fleur de Lys 71
BIANCHINI fol. 141 [see **254**]

When Buonarroti and Boldetti published the glass it was in the collection of Cardinal Gaspare Carpegna. Since 1741 it has been in the Vatican Library Museo Cristiano.

Christ is identified by the inscription ZESVS CRISTVS around his head. Buonarroti was fascinated by the process by which the consonant I of IESVS, pronounced like DI, could get transformed to a Z, observing that the modern Greeks frequently changed Δ into Z, and his fellow Tuscans changed I into G, as the ancients did (who then went further and changed the G into Z, producing ZOBINO from IOVINO). He also points out that the depiction of Lazarus' tomb (see also **257**) reflects the tradition that it was high up a mountain, reached by ladders and steps.

The outer border is executed in silver and there are silver stripes on Christ's tunic and *pallium*. Lazarus' mummy-wrapping is also in silver, whereas his face is in gold. What appear to be details on the dome of the tomb are, as noted by Morey, actually blisters in the gold leaf.

LITERATURE: unpublished

OBJECT DRAWN: BAV, Museo Cristiano, inv. 705 (ex-436); diam. 100 mm. Buonarroti 1716, pl. VII.1, and p. 52; Boldetti 1720, p. 194, no. 5, pl. 3; Garrucci 1858, p. 25, pl. VIII.5; Morey 1959, no. 31, pl. V; Zanchi Roppo 1969, no. 161, fig. 42

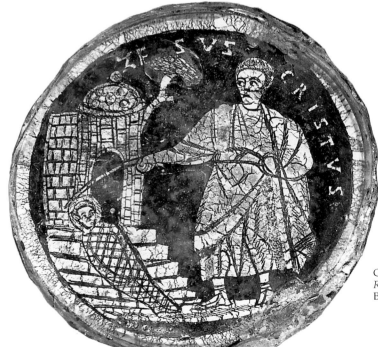

Comp. fig. 258: Gold-glass, *Raising of Lazarus*. Actual size. BAV, Museo Cristiano, inv. 705

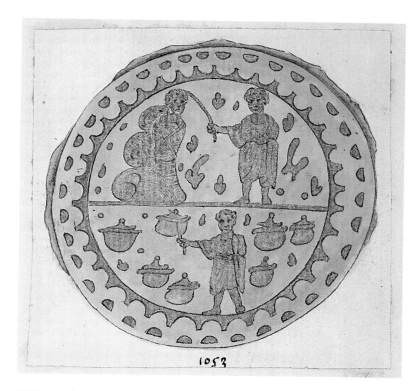

257 (actual size)

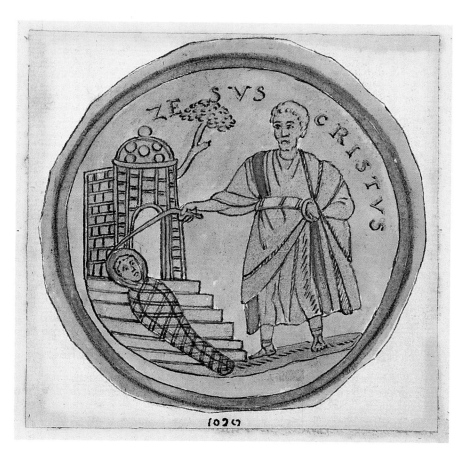

258 (actual size)

259. Gold leaf on glass: the Good Shepherd

LATE SEVENTEENTH-CENTURY ITALIAN

Windsor, RL 9116

Watercolour, with gold powder in gum arabic, and pen and ink, over traces of black chalk

104 × 99 mm

NUMBERING: [bottom centre] *1018*

MOUNT SHEET: type B. Also bears **254–8**, **260–2**.
Watermark: Fleur de Lys 71

BIANCHINI fol. 141 [see **254**]

In his publication of 1716 Buonarroti indicates that the glass was in the Chigi collection, his illustration being taken from drawings given to him by Fabretti, but the piece was not subsequently one of the Chigi glasses which passed to the Vatican Library in 1746 and Garrucci considered it lost. Possibly it is that described in the 1705 Chigi inventory (Incisa della Rocchetta 1966, p. 159, no. 252) as 'with a large figure in the middle and two small ones to the sides, full of bubbles (*subbollite*) and unrecognizable'.

Buonarroti, after quoting Tertullian (*de pudicitia* 7) on the subject of painting the Good Shepherd on glass vessels and remarking on the fact that the Shepherd carries a wand not a stick or crook, was particularly taken by the cloak that the Shepherd is wearing over his tunic, identifying it as the *exomis*: a short garment which stopped just below the shoulders (Gellius, 7.12.3) and had only one sleeve, the side where there was no sleeve exposing the shoulder (Festus, 81M s.v. *exomides*, and Salmasius *In Tertull. de Pallio*, p. 213). Although mentioned by ancient writers in connection with slaves, especially in theatrical performances (cf. Festus: s.v. *comices*), Buonarroti proposes that the cloak will also have been worn by artisans and labourers, so it would not be surprising if peasants and shepherds should wear it too. The inscription, which runs on three sides of the square frame: CONCORDI BIBAS IN PACE DEI, is a toast for the owner of the cup, Concordius, to live (and to drink) in peace with God.

LITERATURE: unpublished

OBJECT DRAWN: lost? Buonarroti 1716, pl. V.1 and p. 28; Garrucci 1858, p. 20, pl. VI.7

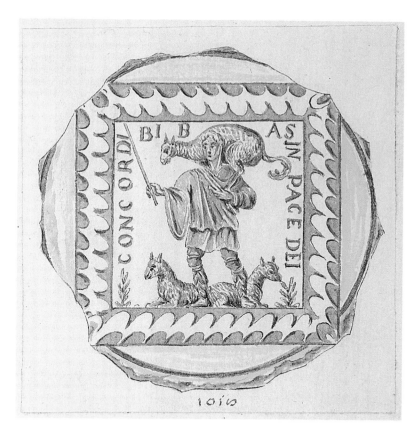

259 (actual size)

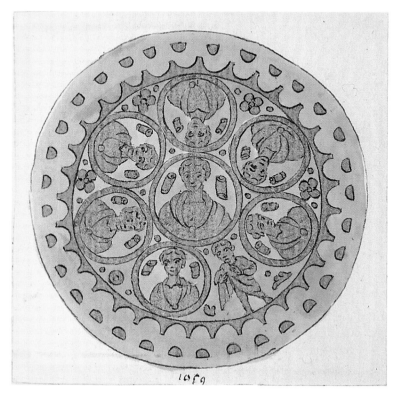

260 (actual size)

221

260. Gold leaf on greenish glass: eight figures

LATE SEVENTEENTH-CENTURY ITALIAN

Windsor, RL 9117

Watercolour, with gold powder in gum arabic, and pen and ink

102 × 100 mm

NUMBERING: [bottom centre] *1059*

MOUNT SHEET: type B. Also bears **254–9**, **261–2** .
Watermark: Fleur de Lys 71

BIANCHINI fol. 141 [see **254**]

The glass is listed in the 1705 inventory of Flavio Chigi's possessions (Incisa della Rochetta 1966, p. 161, no. 294) as *fondo di calice cimiteriale, con figurina in mezzo, et altre sette attorno* ('bottom of a funerary goblet, with a little figure in the middle and seven others around'). It is now in the Vatican Library *Museo Cristiano* and the identification of the eight figures—seven shown as busts enclosed in medallions, the eighth shown whole but on a much smaller scale—is still uncertain. Garrucci and Morey, followed by Zanchi Roppo, describe the figures as beardless youths, and no obvious candidates present themselves.

To Buonarroti, however, who published the glass in 1716 on the basis of a drawing given to him by Raffaele Fabretti, the central figure seemed to be a woman, surrounded by seven young men. He first entertained the possibility that she was St Felicity with her seven sons, who perished in Rome during the reign of the Emperor Marcus Aurelius. Their memory was celebrated in the city, the mother especially, who had a cemetery named after her on the via Salaria, where many other martyrs were subsequently buried. But he preferred a second alternative: the seven Maccabees with their mother, from the Old Testament, who died for their observance of the Old Law, and who were greatly venerated by the Early Christians, their feast day being celebrated by both the Latin and Greek Church. He points out that the seventh son is a whole figure, much smaller (and thus younger) than the others and that the story of the Maccabees includes just such a detail, absent from the story of St Felicity.

LITERATURE: unpublished

OBJECT DRAWN: BAV, Museo Cristiano, inv. 779 (ex-449); diam. 106 mm. Buonarroti 1716, pl. XX.1 and pp. 140–42; Garrucci 1858, p. 40, pl. XVIII.3; Morey 1959 no. 104, pl. XVIII; Zanchi Roppo 1969, no. 224; Pillinger 1984, p. 75, pl. 87, fig. 198

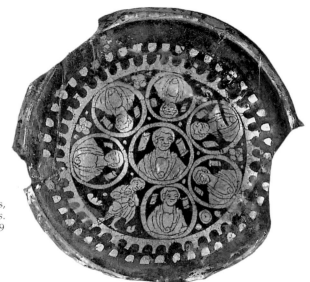

Comp. fig. 260: Gold-glass,
Eight Figures.
BAV, Museo Cristiano, inv. 779

261. Gold leaf, silver and paint on glass: charioteer and four horses

LATE SEVENTEENTH-CENTURY ITALIAN

Windsor, RL 9118

Watercolour and bodycolour, with gold, silver, and copper powder in gum arabic, and pen and ink, over traces of black chalk

115 × 120 mm

NUMBERING: [bottom centre] *1020*

MOUNT SHEET: type B. Also bears **254–60**, **262**.
Watermark: Fleur de Lys 71

BIANCHINI fol. 141 [see **254**]

The glass was once owned by Raffaele Fabretti, who published it himself in 1683 and again in 1699, on the latter occasion together with **262**, which also belonged to him. Buonarroti knew it from Fabretti, but it has long since disappeared (Garrucci describes it as lost).

Both Fabretti and Buonarroti commented upon it at length, characteristically concerned with dress, equipment and physical details: it portrayed a circus charioteer, in Latin an *auriga* or *agitator*, in a chariot drawn by four horses. He held a whip, or *flagellum*, of which only a trace beyond the handle in his right hand remained, and the palm of victory in his left. On his chest he wears a sort of breastplate made of leather thongs, which can be seen on other representations in bas-reliefs and recalled to Buonarroti Galen's term for a type of rib bandage (αρματηλας, *auriga*). *Fabretti drew attention to the marks or brands on the flanks of the middle two horses (an ancient custom), and the collars and the socks on their near hind hooves (protecting them from being hurt by the yoke), the plumes on their heads and the spots on their legs (these last perhaps signifying that the horses were actually dappled). The inscriptions round the outer edge of the group name the four horses: on the left* NICEFORVS *('Bringer of Victory') and* AEROPETES *('Flyer'), on the right* BOTROCALENES *(which Buonarroti translated as 'Bunch of Calena Grapes', famed for their prodigiosity, and suggested was an allusion to a generosity of spirit) and* ACCIATV *(meaning unknown).* Fabretti proposed that the letters beside the charioteer's head LEAEN/INICA represented a composite noun signifying a particular circus faction formed from the charioteer's name LEAENIUS (the Leaenians—feminine, people); Buonarroti instead read it as a mixture of Latin and Greek, common in Late Antiquity, with Leaenius in the vocative, followed by the transliterated Greek NIKA (he wins). He speculated that winners offered victory dinners, glass vessels like these being made for the occasion, or as gifts to be given to the guests or to friends at large.

LITERATURE: unpublished

OBJECT DRAWN: lost? Fabretti 1683, p. 340; Fabretti Inscript. antiq., p. 537, pl. LIV; Buonarroti 1716, pl. XXVII.1 and pp. 178–84; Garrucci 1858, p. 67, pl. XXXIV.3 (the actual plate is incorrectly labelled XXXIV.4)

262. Gold leaf on glass: the goddess Minerva with Hercules

LATE SEVENTEENTH-CENTURY ITALIAN

Windsor, RL 9119

Watercolour, with gold powder in gum arabic, and pen and ink, over traces of black chalk

111 × 105 mm

NUMBERING: [bottom centre] *1103*

MOUNT SHEET: type B. Also bears **254–261**.
Watermark: Fleur de Lys 71

BIANCHINI fol. 141 [see **254**]

In the late 17th century the glass disc belonged to Raffaele Fabretti, who published it himself and also made a drawing available to Buonarroti. It was subsequently lost; Garrucci based his account on the earlier two publications.

As Fabretti and Buonarroti both point out, Minerva and Hercules were closely connected, the goddess constantly helping the hero in all his great labours and finally leading him into the company of the Gods. Both figures appeared to Buonarroti to be standing on a boat, which he proposed to interpret as the fabled boat of Charon, god of the underworld, by which certain favoured heroes were conveyed to Elysium (the Islands of the Blest).

The inscription reads TICI ABEAS HERC-VLEAT. ENENTINO PROPITE (the last E being joined to the T). It was interpreted by Buonarroti as a mixture of Latin and Greek and translated as 'may the fortune of Hercules draw near Tenentinus (or Enentinus)'. In his view the glass was made for an athlete, the crown between the two figures referring to the prizes or victories won by the hero—the athlete, in whose honour the banquet, and the glass, were given.

LITERATURE: unpublished

OBJECT DRAWN: lost? Fabretti *Inscript. antiq.*, p. 537, pl. LV; Buonarroti 1716, pl. XXVII.2, and p. 184f.; Garrucci 1858, p. 71f., pl. XXXV.8

261 (actual size)

262 (actual size)

263. Gold leaf on green glass: two youths and a column with the monogram of Christ

LATE SEVENTEENTH-CENTURY ITALIAN

Windsor, RL 9120

Watercolour, with gold powder in gum arabic, over pen and ink

82 × 81 mm

NUMBERING: [bottom centre] *1027 / 2*

MOUNT SHEET: type B. Also bears **264–71**.
Watermark: Fleur de Lys 71

BIANCHINI fol. 142, I: others similarly published. II: see fol. 141 [**254**]

When Buonarroti published it, the disc belonged to Cardinal Carpegna's collection; in 1741 it was donated to the Vatican Library.

Within a square frame, which has three rectangular projections marked with crosses on the top and sides and a crown below, are two beardless male figures wearing the *pallium*. The figure on the right holds his right hand up with two fingers together in speech or benediction; the figure on the left appears instead to be pointing. Between them is a column supporting the chi-rho monogram, with jewelled points on the cross.

Buonarroti identified the figures as the apostles Peter and Paul, the column symbolizing the Church, raising the monogram of Christ above all other authorities. In his drawing the square frame has four projections (no crown below), which he proposed represented the books of the four evangelists (pointing out that not all ancient books were scrolls; that some, like the Vergils in the Vatican and one in the Medici library were 'like ours').

LITERATURE: unpublished

OBJECT DRAWN: BAV, Museo Cristiano, inv. 764 (ex-176); diam. 75 mm. Buonarroti 1716, pl. XIV.2 and p. 92f.; Garrucci 1858, p. 32f., pl. XI.2; Morey 1959, no. 76, pl. XII; Zanchi Roppo 1969, no. 222

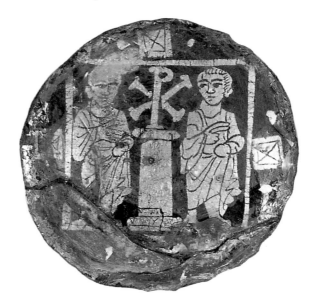

Comp. fig. 263: Gold-glass, *Two youths, column and monogram of Christ*. Actual size.
BAV, Museo Cristiano, inv. 764

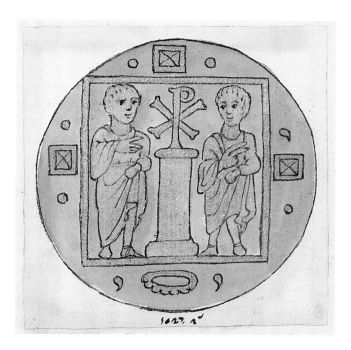

263 (actual size)

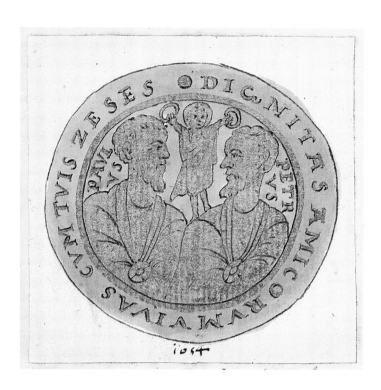

264

264. Gold leaf on greenish glass: Christ crowning Saints Peter and Paul

LATE SEVENTEENTH-CENTURY ITALIAN

Windsor, RL 9121

Watercolour, with gold powder in gum arabic, pen and ink

90 × 80 mm

NUMBERING: [bottom centre] *1054*

MOUNT SHEET: type B. Also bears **263**, **265–71**.
Watermark: Fleur de Lys 71

BIANCHINI fol. 142 [see **263**]

Not included among those published by Buonarroti, the disc is listed in the inventory of Cardinal Flavio Chigi's possessions made after his death in 1693 (Incisa della Rocchetta 1966, p. 158, no. 237) and passed to the Vatican Library in 1746.

The saints, indistinguishable from each other in appearance, with their busts frontal and their heads in profile, have their names inscribed beside them. Unusually, PAVLVS is on the left and PETRVS on the right. As if standing on Peter's shoulder is a diminuitive haloed figure, presumably Christ, holding a wreath over the head of each saint. Round the outside runs the toast, beginning in the top centre: DIGNITAS AMICORVM VIVAS CVM TVIS ZESES which, in all but the last word ZESES (to life!), is the same as that on **271**, which Buonarroti would have rendered as 'Worthy (gathering of) friends, drink to yourselves, to life!' See also **273**.

LITERATURE: unpublished

OBJECT DRAWN: BAV, Museo Cristiano, inv. 717 (ex-171); diam. 95 mm. Perret 1851, IV, no. xxxiii, 93; Garrucci 1858, p. 34, pl. XII.5 (the actual plate is incorrectly numbered XII.6); Morey 1959, no. 37, pl. VI; Zanchi Roppo 1969, no. 155

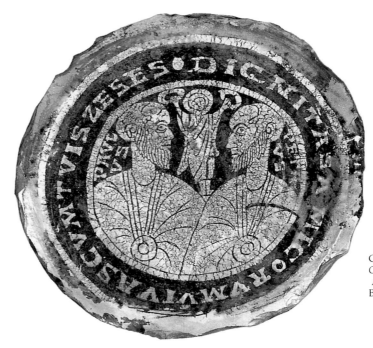

Comp. fig. 264: Gold-glass,
Christ crowning Saints Peter and Paul.
Actual size.
BAV, Museo Cristiano, inv. 717

265. Gold leaf on greenish glass: the married couple Palin and Egazosa

LATE SEVENTEENTH-CENTURY ITALIAN

Windsor, RL 9122

Watercolour, with gold powder in gum arabic, pen and ink

84 × 80 mm

NUMBERING: [bottom centre] *1042*

MOUNT SHEET: type B. Also bears **263–4**, **266–71**.
Watermark: Fleur de Lys 71

BIANCHINI fol. 142 [see **263**]

According to Buonarroti the glass formed part of the Carpegna collection; it is now in the Vatican Library Museo Cristiano.

Within an octagonal border (compare also **266**) are the images of a married couple, the husband on the right and the wife on the left, wearing earrings, a richly embroidered mantle (*palla*), and a necklace like a jewelled collar. The lettering of their names, P AL (i)/ N, EG AZ/OSA followed by the toast PIE (ze)SES, is distributed without much concern for legibility on three notional lines around their heads.

Buonarroti introduced his commentary by observing that the practice of putting portraits on vases was very old, citing among other examples Suetonius's anecdote (*Vita Vesp.* 7) of how excavations at the ancient city of Tegea in Arcadia during Vespasian's reign (AD 69–79) uncovered primitive vessels with images on them looking exactly like the emperor. The woman's hair-style he compared (not unreasonably) with those on coins of the early third century AD. Her type of necklace, he observed, is not only found on many figures representing Provinces in the *Notitia Dignitatum*, of Constantinian date, but much earlier as well, on the images of the Egyptian deities Isis and Osiris in the *Tabula Bembina* published by Pignoria and others. He is rather concerned that wives in these glass portraits generally appear on their husband's right; this he hastens to explain is not because women actually had precedence, but are simply occupying the principal, *secondary* position.

LITERATURE: unpublished

OBJECT DRAWN: BAV, Museo Cristiano, inv. 781 (ex-250); diam. (approx.) 73 mm. Buonarroti 1716, pl. XXII.1 and p. 156; Garrucci 1858, p. 56, pl. XXVII.2; Morey 1959, no. 91, pl. XV; Zanchi Roppo 1969, no. 194

Comp. fig. 265: Gold-glass, *Palin and Egazosa*. Actual size. BAV, Museo Cristiano, inv. 781

266. Gold leaf on greenish glass: a married couple

LATE SEVENTEENTH-CENTURY ITALIAN

Windsor, RL 9123

Watercolour, with gold powder in gum arabic, pen and ink

81 × 79 mm

NUMBERING: [bottom centre] *1060*

MOUNT SHEET: type B. Also bears **263–5**, **267–71**.
Watermark: Fleur de Lys 71

BIANCHINI fol. 142 [see **263**]

The glass was not included among those published by Buonarroti, but is listed in the 1705 inventory of Cardinal Flavio Chigi's possessions (Incisa della Rocchetta 1966, p. 153, no. 128): *fondo di calice di vetro con due figure huomo, e donna, e lettere, intorno PIE ZESES* ('base of a glass drinking cup with two figures, a man and a woman, and around them the letters PIE ZESES'). It is now in the Vatican Library Museo Cristiano, but has been broken into four pieces and the upper left corner is missing.

In an octagonal frame (compare also **265**), the wife, on the left, wears double pendant earrings, a necklace, tunic and *palla*; her husband wears the toga folded in a broad band across his chest. The inscription PIE ZESES in transliterated Greek is a toast given at banquets 'Drink! Live!'

LITERATURE: unpublished

OBJECT DRAWN: BAV, Museo Cristiano, inv. 725 (ex-248); diam. 87 mm. Morey 1959, no. 39, pl. VI; Zanchi Roppo 1969, no. 189

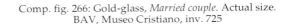

Comp. fig. 266: Gold-glass, *Married couple*. Actual size.
BAV, Museo Cristiano, inv. 725

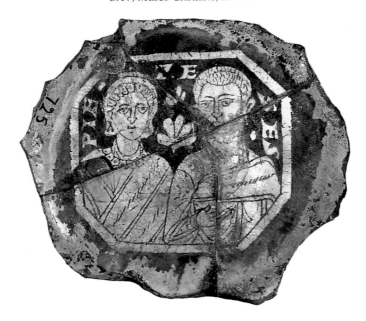

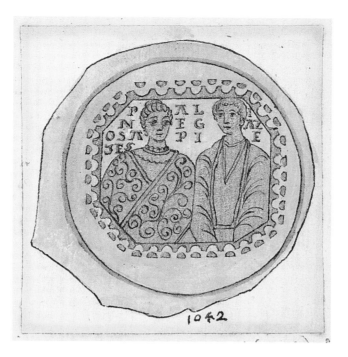

265 (actual size)

266 (actual size)

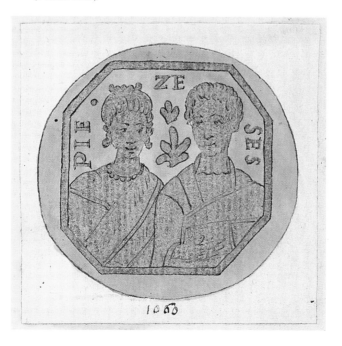

231

267. Gold leaf on green glass: a married couple, crowned by Christ(?)

LATE SEVENTEENTH-CENTURY ITALIAN

Windsor, RL 9124

Watercolour, with gold powder in gum arabic, and pen and ink, over traces of black chalk

97 × 103 mm

NUMBERING: [bottom centre] *1036*

MOUNT SHEET: type B. Also bears **263–6**, **268–71**. *Watermark*: Fleur de Lys 71

BIANCHINI fol. 142 [see **263**]

The fragment belonged to Cardinal Carpegna, and is now in the Vatican Library, Museo Cristiano. By the time it was published by Buonarroti and Boldetti another piece had been joined on, showing more of the busts of the couple, which is how it survives today.

Boldetti described the image as Christ crowning two 'saints', but Buonarroti expresses doubts as to whether it is Christian at all, in the first place because of the inscription DVLCIS ANIMA VIVAS ('Sweet soul/breath of life, Drink/Life). '*Anima dulcis*' he notes can be found on Christian tombs, but in the case of the glass is part of a drinking toast, which doesn't agree with the severity of Christian habits; nor does the little figure holding wreaths above the couple's heads. The figure has a beard and his *pallium* is drawn up over his head in the fashion of 'idolatrous' priests. From Tertullian (*de corona* 13) it is clear, says Buonarroti, that crowning newly-wed couples was a specifically pagan rite, though he allows that perhaps that was only in Tertullian's part of North Africa and that elsewhere Christians did it as well.

LITERATURE: unpublished

OBJECT DRAWN: BAV, Museo Cristiano, inv. 796 (ex-214); diam. 95 mm. Buonarroti 1716, pl. XVIII.1 and pp. 116–18; Boldetti 1720, p. 205, no. 32, pl. 8; Garrucci 1858, p. 58, pl. XXIX.2; Morey 1959, no. 109, pl. XVIII; Zanchi Roppo 1969, no. 198

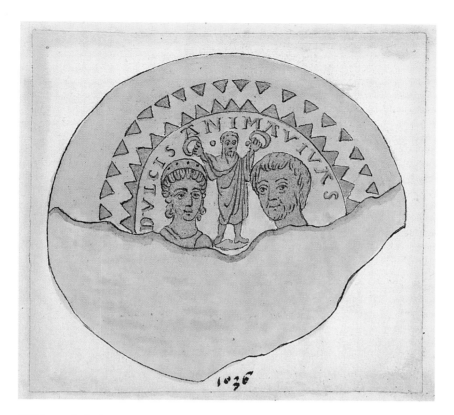

267 (actual size)

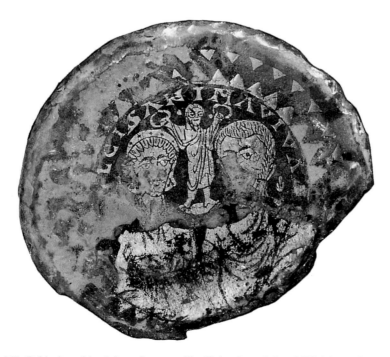

Comp. fig. 267: Gold-glass, *Married couple crowned by Christ*. Actual size. BAV, Museo Cristiano, inv. 796

268. Gold leaf on green glass: Saints Lawrence and Cyprian

LATE SEVENTEENTH-CENTURY ITALIAN

Windsor, RL 9125

Watercolour and bodycolour, with gold powder in gum arabic, and pen and ink, over traces of black chalk

92 × 89 mm

NUMBERING: [bottom centre] *1056*

MOUNT SHEET: type B. Also bears **263–7, 269–71.**
Watermark: Fleur de Lys 71

BIANCHINI fol. 142 [see **263**]

In the late 17th century the disc belonged to Cardinal Flavio Chigi and is listed in the inventory of 1705 (Incisa della Rocchetta 1966, p. 149, no. 49). Buonarroti published it in 1716 from a drawing given to him by Raffaele Fabretti but records that by his day it had become the property of Prince Augusto Chigi. It was acquired in 1746 for the Vatican Library Museo Cristiano.

For Buonarroti, the scrolls in their hands, the wreath and the monogram, all readily identified the two figures as saints and he noted that CRIPRANVS is surely a simple error for CIPRIANVS (Cyprian: Bishop of Carthage martyred in AD 258). He was more concerned with the inscription round the outside: HILARIS VIVAS CVM TVIS FELICITER SEMPER REFRIGERIS IN PACE DEI. It is a banqueting toast, the second half of which: 'semper refrigeris in pace dei' is without parallel and merits some reflection. Perhaps, he says, the glass is a fragment of a goblet made for a banquet commemorating the saints represented, since although the term 'refrigerio' is variously used by Tertullian to signify charity or alms (e.g. de Fuga 12, ad Martyr 2, 17) or a subsidy (de virginibus velandis 9), he uses it particularly of feasts to signify the agape, the love-feast of the Early Christians (Apolog. 39): the relief that food gives our bodies. Expectate refrigera, notes Buonarroti, was scratched in the cement of a tomb in the via Salaria cemetery (Aringhi Roma Subterranea, p. 324) and 'refrigeri tibi domus Ipolitus sid' in the Catacombs of Cyriaca (ibid., p. 141), and privata dulcis in refrigerio & in pace in one published by Gruterus (Inscriptiones antiquae, p. 1057, no. 10). So in this glass it is likely to refer to the feast, especially since it follows the other toast 'Hilaris vivas cum tuis feliciter', the whole generally exhorting each diner to be of good cheer, to restore themselves with food in the peace of the Lord.

LITERATURE: unpublished

OBJECT DRAWN: BAV, Museo Cristiano, inv. 766 (ex-433); diam. 98 mm. Buonarroti 1716, pl. XX.2 and pp. 142–5; Garrucci 1858, pp. 46–7, pl. XX.6; Morey 1959, no. 36, pl. VI; Zanchi Roppo 1969, no. 168

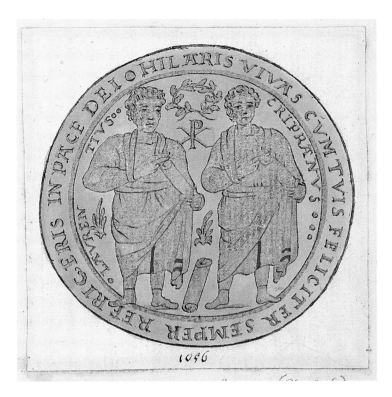

268 (actual size)

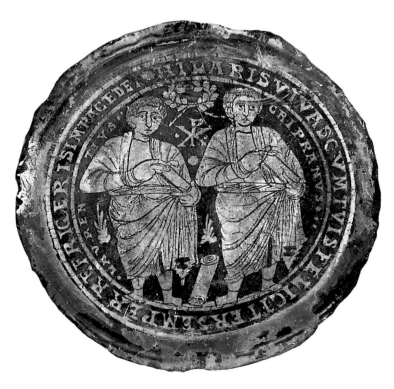

Comp. fig. 268: Gold-glass, *Saints Lawrence and Cyprian*. Actual size. BAV, Museo Cristiano, inv. 766

269. Gold leaf on greenish glass: a married couple with a wreath and scrolls

LATE SEVENTEENTH-CENTURY ITALIAN

Windsor, RL 9126

Watercolour, with gold powder in gum arabic, and pen and ink,
over traces of black chalk

117 × 118 mm

NUMBERING: [bottom centre] *1026*

MOUNT SHEET: type B. Also bears **263–8**, **270–71**.
Watermark: Fleur de Lys 71

BIANCHINI fol. 142 [see **263**]

First published by Buonarroti in 1716, when it was in the Carpegna collection, the glass is now in the Vatican Library Museo Cristiano. It is no longer as large as it is shown in the dal Pozzo drawing, the irregular outline apparently having been trimmed already by Buonarroti's time to match the outer edge of the circular frame.

Between the unnamed couple is a spirally-fluted column bearing a jewel-studded wreath and in the field to either side of their heads are flowers and two scrolls. Buonarroti noted that the woman's hair-style resembles coin portraits of Etruscilla, wife of the Emperor Decius (249–51) and suggested that when there are two scrolls, as here, they could represent the couple's marriage contract (one for the wife's dowry, the other the husband's part). When there is only one (as on **274**) it could be the household diary, which Tertullian (*de cultu feminarum* 9) calls the *calendarium*.

LITERATURE: unpublished

OBJECT DRAWN: BAV, Museo Cristiano, inv. 756 (ex-215); diam. (of outer border of the medallion) 82 mm. Buonarroti 1716, pl. XXIII.3 (image reversed) and p. 161; Garrucci 1858, p. 56, pl. XXVII.1; Morey 1959, no. 98, pl. XVII; Zanchi Roppo 1969, no. 192

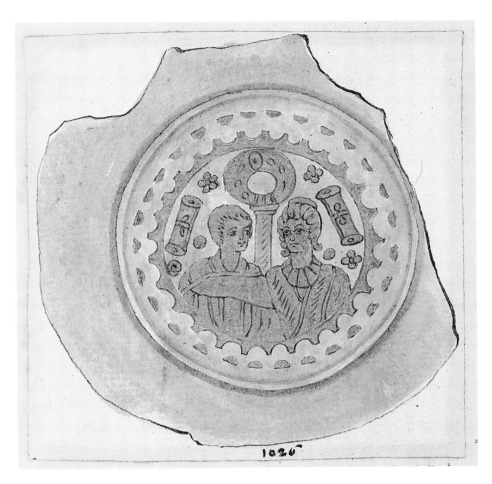

269 (actual size)

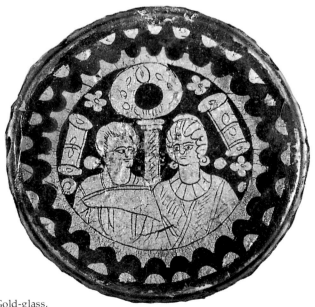

Comp. fig. 269: Gold-glass,
Married couple with wreath and scrolls.
Actual size.
BAV, Museo Cristiano, inv. 756

270. Gold leaf on glass: a family group

LATE SEVENTEENTH-CENTURY ITALIAN

Windsor, RL 9127

Watercolour, with gold powder in gum arabic, and pen and
ink, over traces of black chalk
78 × 93 mm

NUMBERING: *1163*

MOUNT SHEET: type B. Also bears **263–9**, **271.**
Watermark: Fleur de Lys 71

BIANCHINI fol. 142 [see **263**]

Buonarroti tells us that the glass, portraying a couple with their daughter and two sons, was once in the Carpegna collection. By his day, the crack shown in the dal Pozzo drawing had become two, with another running from the lady's left cheek through the body of the boy below. It cannot now be found, having perhaps disintegrated altogether.

LITERATURE: unpublished

OBJECT DRAWN: lost. Fabretti *Inscript. antiq.*, p. 595; Buonarroti 1716, pl. XXIII.1 and pp. 149–62; Boldetti 1720, p. 202, pl. 7, no. 25; Garrucci 1858, p. 60 (1864, p. 163), pl. XXXI.4, citing Fabretti and Buonarroti

271. Gold leaf on whitish glass: Christ and St Stephen

LATE SEVENTEENTH-CENTURY ITALIAN

Windsor, RL 9128

Watercolour, with gold powder in gum arabic, and pen and ink, over traces of black chalk

117 × 113 mm. *Watermark*: Fleur de Lys 67

NUMBERING: [bottom left] *1162*

MOUNT SHEET: type B. Also bears **263–70**
Watermark: Fleur de Lys 71

BIANCHINI fol. 142 [see **263**]

First published by Buonarroti, when it was in Cardinal Gaspare Carpegna's museum, the glass is now in the Vatican and in very poor condition, its design almost illegible.

Buonarroti's description went as follows: it purports to portray the protomartyr ISTE-FANVS (Stephen), labelled on the right, listening attentively to the heavenly doctrine of the divine Master who is seated opposite, labelled CRISTVS, with a book in his left hand, gesturing with his right. Beside him is a box of scriptures, and since his divine words conquered the world, he has a globe at his feet—as in other monuments one sees him seated on the world (e.g. Ciampini *Vet. mon.* I, p. 270, pl. 7 and II, p. 68, pl. 17 and p. 193, pl. 28 [see here **164**]). To signify the vision which St Stephen had during his martyrdom the craftsman has added another figure of Jesus Christ up above, making a gesture of benediction towards the saint, and to distinguish him from the other image of Christ and show that he is already glorified, has given him a halo. The way of writing ISTEFANVS, placing an I before words beginning with two consonants is found in many inscriptions, for example ISTEFANV in the Catacombs of Priscilla (Aringhi *Roma Subterranea*, p. 118) ISSPIRITO SANTO, ISPIRITO and ISPES in those of SS. Marcellino and Pietro, and is a sign of very late antiquity. The toast around the outside reads DIGNITAS AMICORVM VIVAS CUM TVIS FELICITER, a variant on **271**, FELICITER meaning 'Good luck'.

LITERATURE: unpublished

OBJECT DRAWN: BAV, Museo Cristiano, inv. 631 (ex-203); diam. 105 mm. Buonarroti 1716, pl. XVII.1 and pp. 110–13; Garrucci 1858, p. 45f., pl. XX.3; Morey 1959, no. 187, pl. XXII; Zanchi Roppo 1969, no. 159

270 (actual size)

271 (actual size)

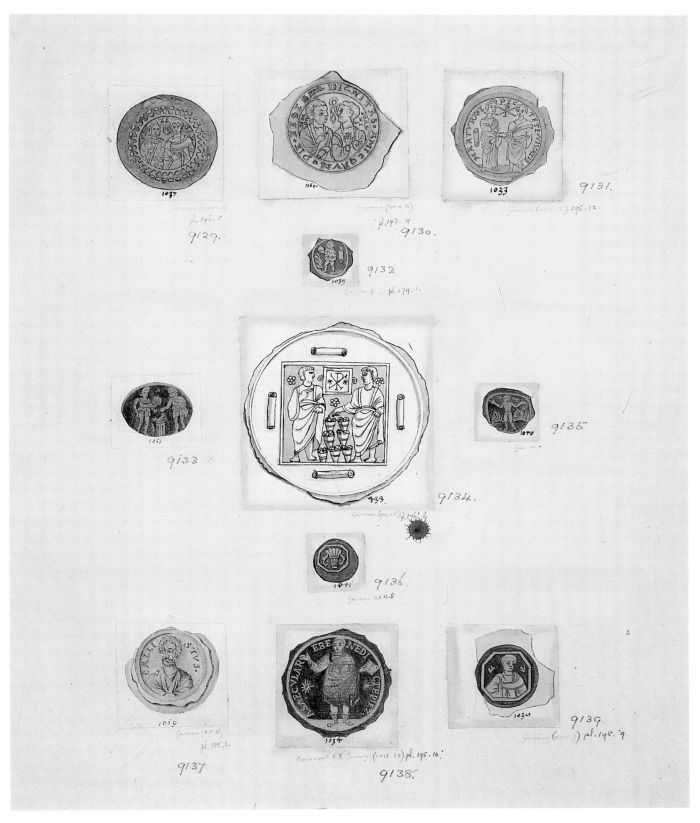

9129.

9130.

9131.

9132

9133

9134.

9135

9136.

9137

9138.

9139.

272–82

272. Gold leaf on green glass: a married couple

LATE SEVENTEENTH-CENTURY ITALIAN

Windsor, RL 9129

Watercolour, with gold powder in gum arabic, over pen and ink

64 × 62 mm

NUMBERING: [bottom centre] *1037*

MOUNT SHEET: type B. Also bears **273–82**.
Watermark: Fleur de Lys 70 (cut)

BIANCHINI fol. 143, II: Others, in one of which is CALLISTUS **[280]**, printed
similarly by Senator Bonarroti and Canon Boldetti.

When published by Buonarroti the glass be-
longed to the Carpegna collection; it is now in
the Vatican Library Museo Cristiano. The de-
sign shows frontal half-figures of a husband
and wife.

Buonarroti remarked mainly upon the wife's
hair-style, which is waved around her face,
covering her ears, with a bun on top and a roll
at the nape, like that of Julia Domna and other
imperial ladies in the early third century. He
also refers to her tunic with the collar-like
necklace.

LITERATURE: unpublished

OBJECT DRAWN: BAV, Museo Cristiano, inv. 794
(ex-222); diam. 62 mm. Buonarroti 1716, pl.
XXII.2 and pp. 149–62, esp. 155f.; Garrucci 1858,
p. 56, pl. XXVII.5; Morey 1959, no. 92, pl. XV;
Zanchi Roppo 1969, no. 190

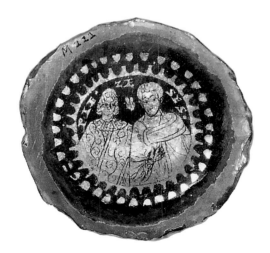

Comp. fig. 272: Gold-glass, *Married couple*. Actual size.
BAV, Museo Cristiano, inv. 794

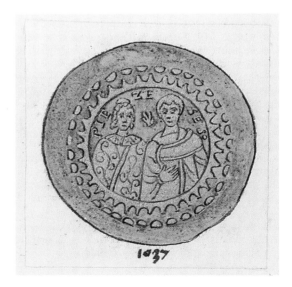

272 (actual size)

273. Gold leaf on glass: portrait busts of Simon and John

LATE SEVENTEENTH-CENTURY ITALIAN

Windsor, RL 9130

Watercolour, with gold powder in gum arabic, and pen and ink

71 × 81 mm

NUMBERING: [bottom left] *1164*

MOUNT SHEET: type B. Also bears **272**, **274–82**.
Watermark: Fleur de Lys 70 (cut)

BIANCHINI fol. 143 [see **272**]

The piece was once owned by Fabretti, who published it in 1699 (and from whom Buonarroti also took his information) but it subsequently disappeared. Garrucci based his account on the earlier two.

Buonarroti described it thus: '...the two portrait busts with a crown above are, according to the names written alongside, those of Simon and John (IOANNES). The rather inept craftsman should have given precedence to St John in the order of the apostolic college provided for us by St Mark (3:17), which St Luke also agrees with (6:13). Fabretti (p. 594) is of the opinion that the one on the right is actually St Peter, with his original name of Simon, but one may also doubt that the other is the apostle St John since he has not got the symbols of higher status, not holding his hand in blessing as the other does, nor holding a scroll. So he could be an ordinary martyr called John, the name being a very common one among Early Christians. In fact both could be martyrs whose memory has been lost, but if so, would have to be very early ones. Around the outside is written DIGNITAS. AMICORVM. PIE. ZESES, a drinking toast. *Dignitas* is a difficult word, to be interpreted perhaps as an appeal to reciprocal condescension, goodwill and humanity on the part of both the *patronus* of the house—the host—and the friends, in so far as the host invites them, and the friends accept, to enjoy his generosity. In Tuscan dialect we say "degnate" as an invitation to eat or drink, and "degnevole" is he who willingly accepts the invitation. Alternatively, *dignitas amicorum* could be a periphrasis, equivalent to saying "dignity of friends" in the vocative, inviting the "worthy gathering" of friends, rather as we say Excellence, Highness, Serenity and other such titles'. (See also **264** and **271**.)

LITERATURE: unpublished

OBJECT DRAWN: lost since the 18th century? Fabretti *Inscript. antiq.*, p. 594; Buonarroti 1716, pl. XIV.3 and pp. 94–7; Garrucci 1858, p. 52, pl. XXIV.4

274. Gold leaf on glass: a married couple, Martura and Epictetus

LATE SEVENTEENTH-CENTURY ITALIAN

Windsor, RL 9131

Watercolour, with gold powder in gum arabic, and pen and ink

72 × 63 mm

NUMBERING: [lower centre] *1033*

MOUNT SHEET: type B. Also bears **272–3, 275–82.**
Watermark: Fleur de Lys 70 (cut)

BIANCHINI fol. 143, I: MARTURA EPECTETE VIVATIS.

Raffaele Fabretti owned and published the piece in 1699 and it was published again by Buonarroti in 1716; Garrucci saw it in the Vatican Library as late as 1864 but it left the collections before the De Rossi inventory of the late 1880s (Vattuone, forthcoming).

It showed a standing couple, man on the right and woman on the left, their right hands joined (*dextrarum iunctio*), in the Roman symbol of marriage. Between their heads is the chi-rho monogram signifying Christ, behind the woman is a scroll, and around the outer edge of the scene runs the toast MARTVRA EPECTETE VIVATIS ('[To] Martura and Epectetus [more commonly spelled Epictetus] Drink up!/Live!').

Buonarroti's erudition was exercised first of all by the fact that, although the chi-rho monogram clearly shows that she was a Christian, the bride is not veiled, from which he sensibly deduces that the custom developed later, that in the early days the ceremonial use of the veil was too closely linked with pagan practices to be used by Christians, and that, whatever Tertullian might say (*de virginibus velandis* 11; *de corona* 4) perhaps in Rome it was not even the custom for young girls of marriageable age to go about veiled. Furthermore, he observes, it is against ecclesiastical custom, not only in the Latin but also the Greek Church, that the bride should stand as she is shown on this glass, on her husband's right, but it was the ancient custom—and actually did not imply precedence; rather, it was a sign of inferior, secondary status. Regarding the couple's names, Buonarroti misread Martura as Matura (mature), which gave him an opportunity to digress on the subject of Early Christian inhibitions about marrying widows (Tertullian, *ad Uxorem*) and to speculate that Epictetus followed in the spirit of the eponymous Stoic philosopher.

LITERATURE: unpublished

OBJECT DRAWN: present location unknown, previously BAV, Museo Cristiano. Fabretti *Inscript. antiq.*, p. 595; Buonarroti 1716, pl. XXI.3 and pp. 146–9; Garrucci 1858, p. 56 (1864, p. 133), pl. XXVI.12

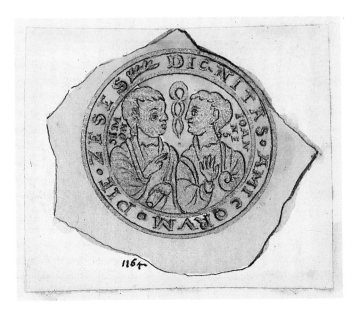

273 (actual size)

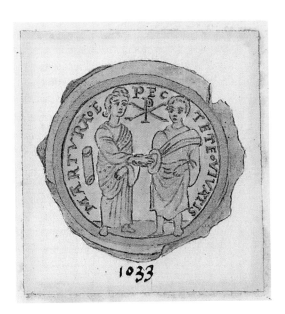

274 (actual size)

275. Gold leaf on dark blue glass: one of the Magi(?)

LATE SEVENTEENTH-CENTURY ITALIAN

Windsor, RL 9132

Watercolour, with gold powder in gum arabic, and pen and ink

29 × 30 mm

NUMBERING: *1039*

MOUNT SHEET: type B. Also bears **272–4**, **276–82** .
Watermark: Fleur de Lys 70 (cut)

BIANCHINI fol. 143 [see **272**]

From Cardinal Carpegna's collection, the tiny fragment is now in the Vatican Library Museo Cristiano.

It portrays a beardless male in a belted, sleeved tunic, with a *chlamys* (military cloak) over his shoulders, holding a circular object in his right hand, flanked by a scroll to the right and a plant to the left. The identification is disputed, modern authorities opting mainly for Daniel, holding the poisoned cake with which, in the Catholic version of the Apocrypha, he killed the dragon. However, Buonarroti (as Garrucci after him), cognizant of earlier debate (Bosio *Roma Sotterranea*, bk 4, chs 35 and 36, and Aringhi *Roma Subterranea* II, bk 6, ch. 25) concerning the respective dress of Daniel, the Magi and the youths in the Fiery Furnace of Babylon, was nevertheless confident that this is one of the Magi (the three Wise Men in the story of the Nativity of Christ). He cites similar figures, two on glass (Aringhi, II, p. 265) and in groups of three on sarcophagi (Aringhi, I, pp. 291, 327, 331), whose tunics had the same long sleeves, called sarabara by Tertullian (de oratione 12 and de resurrectione mortuorum 58), and the same little cloaks, though they have longer caps, folded back on the head.

LITERATURE: unpublished

OBJECT DRAWN: BAV, Museo Cristiano, inv. 653 (ex-185); diam. 22 mm. Buonarroti 1716, pl. 1X.3 and pp. 68–71; Garrucci 1858, p. 13, pl. IV.8; Morey 1959, no. 151, pl. XXI; Zanchi Roppo 1969, no. 127

275 (enlarged)

275 (actual size)

Comp. fig. 275: Gold-glass, *One of the Magi* (?). Enlarged. BAV, Museo Cristiano, inv. 653

276. Gold leaf on blue glass: two figures flanking a bird on a column

LATE SEVENTEENTH-CENTURY ITALIAN

Windsor, RL 9133

Watercolour, with gold powder in gum arabic, and pen and ink

40 × 49 mm

NUMBERING: [bottom centre] *1055*

MOUNT SHEET: type B. Also bears **272–5**, **277–82**.
Watermark: Fleur de Lys 70 (cut)

BIANCHINI fol. 143 [see **272**]

There appears to be no other visual record of this glass, but the 'Pozzo', number on the drawing (*1055*) would place it among items in the collection of Cardinal Flavio Chigi (here **257** (*1053*), **265** (*1054*), **268** (*1056*)) and it could easily be the one described in the 1705 inventory of the Chigi collection (Incisa della Rocchetta 1966, p. 182, no. 801) as *con due figure et un'ara con un gallo sopra in mezzo, picolissimo, murato in calcinaccio* 'with two figures and an altar with a cockerel on it in the middle, very small, imbedded in mortar'.

The design shows two little figures wearing Phrygian caps, short tunics with long sleeves and short cloaks, a costume generally associated in these glasses (e.g. **275**) with the Orient (Mesopotamia, Persia). Between them is a cockerel sitting on a column or table, a motif of uncertain significance in the context (elsewhere it generally refers to Peter's denial of Christ).

LITERATURE: unpublished

OBJECT DRAWN: lost

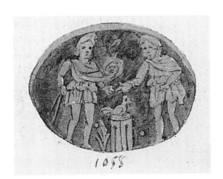

276 (actual size)

277. Gold leaf on greenish glass: Christ and the Miracle of the Loaves

SEVENTEENTH-CENTURY ITALIAN

Windsor, RL 9134

Pen and ink, and brown wash

107 × 103 mm. *Watermark*: Star 5

NUMBERING: *433* [written over *322* or *522*]

MOUNT SHEET: type B. Also bears **272–6**, **278–82**.
Watermark: Fleur de Lys 70 (cut)

BIANCHINI fol. 143 [see **272**]

In the later 17th century the glass was in the collection of Cardinal Gaspare Carpegna; in 1741 it was donated to the Vatican Library, where it still is.

Within a square frame are two standing figures, similarly dressed in tunic and *pallium*, facing one another. Christ is the one on the right stretching his hand over seven baskets, in reference to his miracle in multiplying the five loaves and two fishes to feed the multitude (Gospels of Matthew 14, Mark 6, Luke 9, John 6). The figure on the left, his right hand raised in an orator's gesture, should be one of the disciples.

Buonarroti observed that to the simple-minded the story could have been proof of the Resurrection: if the Divine power could multiply loaves it was all the more possible to bring back the dead. He adds that the monogram between two stars probably symbolizes heaven, the four scrolls round the outside the four evangelists (cf. **263**), and he speculated (p. 58), because it is exceptionally transparent, that the vessel was not for ordinary feasts but perhaps a holy chalice for use in the eucharistic mass or synaxis, as attested by Tertullian (*de Pudicitia* 10) and still customary in the late 5th/early 6th century. Boldetti confines his commentary to other illustrations of bread loaves to be found in the catacombs, and the question of whether the crosses on top were normal baking practice or a Christian symbol. The drawing is markedly different in technique and hand from the others in this general set. The watermark on the paper and the 'Pozzo' number (*433*) are also unrelated, reinforcing the likelihood that it entered the collections on some other occasion.

LITERATURE: unpublished

OBJECT DRAWN: BAV, Museo Cristiano, inv. 750 (ex-445); diam. 97 mm. Buonarroti 1716, pl. V.1 and pp. 54–8; Boldetti 1720, p. 207f., pl. 9, no. 38; Garrucci 1858, p. 24f., pl. VII.15 (the actual plate is numbered VII.16); Morey 1959, no. 72, pl. XII; Zanchi Roppo 1969, no. 229, fig. 52; Pillinger 1984, p. 77, pl. 101, fig. 231

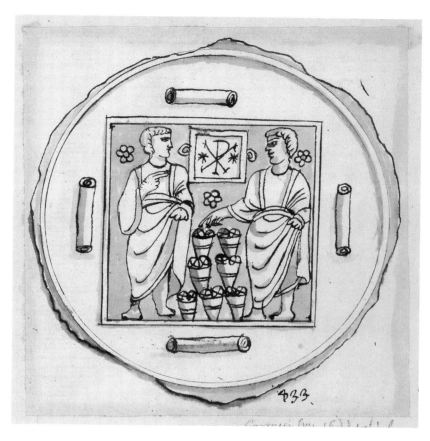

277 (actual size)

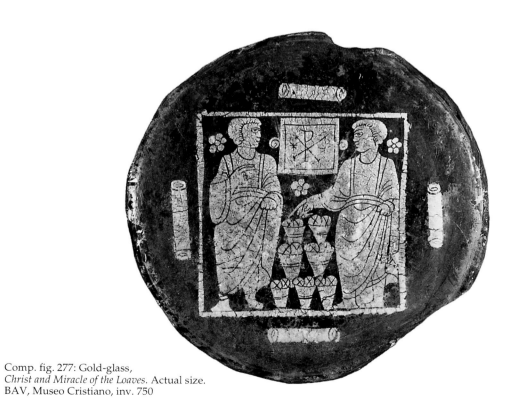

Comp. fig. 277: Gold-glass,
Christ and Miracle of the Loaves. Actual size.
BAV, Museo Cristiano, inv. 750

278. Gold leaf on dark blue glass: nude praying figure

LATE SEVENTEENTH-CENTURY ITALIAN

Windsor, RL 9135

Bodycolour, with gold powder in gum arabic, over pen and ink

32 × 35 mm

NUMBERING: *1040*

MOUNT SHEET: type B. Also bears **272–7**, **279–82**.
Watermark: Fleur de Lys 70 (cut)

BIANCHINI fol. 143 [see **272**]

According to Buonarroti, who was the first to publish it, the little disc belonged to Cardinal Gaspare Carpegna. It is now in the Vatican Library Museo Cristiano. It shows a frontal nude figure, arms stretched out in prayer, between two stylized plants. Buonarroti proposed that, on the basis of comparisons with examples in catacomb paintings illustrated by Aringhi, it should be Daniel, even if the lions are not shown, and symbolizes the Resurrection (see also **277**). He quotes Macarius (*orat. de Exalt. s. Crucis*), following St Gregory of Nazianzus (*orat.* 22) as saying that extending the arms like a cross rendered the lions gentle. Subsequent commentators have disagreed—largely, it seems, because the image has become less legible over the years. Garrucci drew the figure with breasts and identified her as the martyr Susanna; Morey thought it was wearing a tunic and thus might be one of the youths in the fiery furnace—the 'plants' being stylized flames.

LITERATURE: unpublished

OBJECT DRAWN: BAV, Museo Cristiano, inv. 662 (ex-004); diam. 27 mm. Buonarroti 1716, pl. II,3 and p. 18; Garrucci 1858, p. 12, pl. III.7; Morey 1959, no. 146, pl. XXI; Zanchi Roppo 1969, no. 174

278 (enlarged)

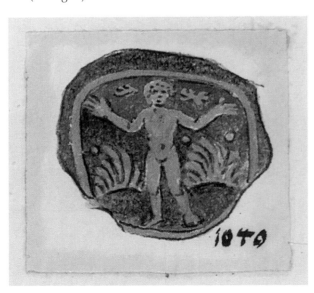

278 (actual size)

Comp. fig. 278: Gold-glass, *Nude praying figure*. Enlarged. BAV, Museo Cristiano, inv. 662

279. Gold leaf on dark blue glass: a basket of loaves

LATE SEVENTEENTH-CENTURY ITALIAN

Windsor, RL 9136

Bodycolour, with gold powder in gum arabic, and pen and ink

32 × 31 mm

NUMBERING: [bottom centre] *1041* ['0' written over and correcting '4']

MOUNT SHEET: type B. Also bears **272–8**, **280–82**.
Watermark: Fleur de Lys 70 (cut)

BIANCHINI fol. 143 [see **272**]

When published by Buonarroti in 1716 the little glass disc was in the collection of Cardinal Gaspare Carpegna; it is now in the Vatican Library Museo Cristiano. As Buonarroti ob-served, the design of the basket filled with bread presumably refers to the miracle of the Multiplication of the Loaves (see also **277**).

LITERATURE: unpublished

OBJECT DRAWN: BAV, Museo Cristiano, inv. 644 (ex-497); diam. 24 mm. Buonarroti 1716, pl. VIII.3 and pp. 54–8; Garrucci 1858, p. 60, pl. XXXI.5; Morey 1959, no. 172, pl. XXI; Zanchi Roppo 1969, no. 184

279 (actual size)

279 (enlarged)

Comp. fig. 279: Gold-glass, *Basket of loaves*. Enlarged.
BAV, Museo Cristiano, inv. 644

280. Gold leaf on green glass: St Callistus

LATE SEVENTEENTH-CENTURY ITALIAN
Windsor, RL 9137
Bodycolour, with gold powder in gum arabic, and pen and ink
58 × 59 mm
NUMBERING: [bottom centre] *1019*
MOUNT SHEET: type B. also bears **272–9**, **281–2**.
Watermark: Fleur de Lys 70 (cut)
BIANCHINI fol. 143, II: Others, in one of which is CALLISTUS.

Boldetti, who was the first to publish the glass, does not say where it was found or who owned it, but most of his examples were taken from the Carpegna collection. He is at greater pains to point out (p. 202) that Francesco Bianchini had already published it, from a drawing Boldetti had supplied at his request, in the new edition of the offices of S. Maria Maggiore (Basilica Liberiana), of which he was a canon.

The image is that of a bearded man wearing tunic and *pallium* in the 'omophorion' manner (i.e. drawn over both shoulders and fastened in front with a brooch). The inscription CALLISTVS probably refers to the saint Calixtus, born a slave, reformed convict, who was appointed keeper of the cemetery on the via Appia which now bears his name, and finally became pope from AD 217 to 222.

The drawing shows the piece, evidently the bottom of a drinking glass, at its actual size, faithfully reproducing the irregular edges where the body of the glass has been broken away.

LITERATURE: unpublished

OBJECT DRAWN: Paris, BN, Cabinet des Médailles, no number; diam. 44 mm. Boldetti 1720, p. 201, pl. 6, no. 17 (image reversed); Garrucci 1858, p. 42, pl. XIX.2; Morey 1959, no. 401, pl. XXXIII

280 (actual size)

Comp. fig. 280: *Gold-glass of St Callistus*, engraving (image reversed). Boldetti 1720

281 (actual size)

281. Gold leaf, silver and red on blue glass: man wearing a toga and holding an open book

LATE SEVENTEENTH-CENTURY ITALIAN

Windsor, RL 9138

Bodycolour, with gold, silver, and copper powder in gum arabic, and pen and ink

67 × 65 mm

NUMBERING: [bottom centre] *1034*

MOUNT SHEET: type B. also bears **272–80**, **282**.
Watermark: Fleur de Lys 70 (cut)

BIANCHINI fol. 143 [see **272**]

Part of Cardinal Gaspare Carpegna's collection, the piece was first published by Giovanni Ciampini in 1691, and then by Buonarroti in 1716. Since 1741 it has been in the Museo Cristiano of the Vatican Library.

It shows a beardless man wearing a silver tunic with red edges and two red stripes under a toga of the Late Roman *contabulatio* type and his boots are those of a person of high rank. His hands are outstretched, the left holding an open diptych or book. The inscription round the outside reads A SAECVLARE BENEDICTE PIE Z(eses). Ciampini suggested that the first section either referred to an a(nno) saecularis (a centenary of the foundation of Rome,

namely AD 247) or meant that the glass was a gift from, or made by, someone called Saecularis, in either case to (or for) someone called Benedictus (the Blessed). Buonarroti (and later Garrucci) ruled out the former and had reservations about the latter. Garrucci argued for 'blessed by Saecularis', Saecularis being the name of a bishop who had baptized the man portrayed on the glass, whose baptismal feast it therefore celebrated.

Both Ciampini and Buonarroti, however, were convinced that the figure was Christ, and Buonarroti was particularly taken by the form of the toga, which he proposed to identify as the *diplois* or doubled *pallium* referred to by

253

Tertullian (*de pallio* 85). It is a large garment, he says, pointing out that Christ's must have been very big, given that when the soldiers cut it up into four parts even thus divided each part was usable. Regarding the folds combined into the wide strip like a plank across the chest and the other set falling from the left shoulder, they are a feature of aristocratic *pallia* and obviously a carefully studied arrangement, which he conjectures might be what Tertullian called *moro-sius ordinatum* when describing Aesculapius' *pallium* in contrast to the simple *pallium* worn by philosophers and more austere Christians. He was intrigued by the footwear too: not the usual sandals but boots, a kind of *calceus* with thongs half way up the calf like the military *caliga* but with an opening at the top and a small hole at the toe, a form found, he notes, also on consular diptychs.

LITERATURE: unpublished

OBJECT DRAWN: BAV, Museo Cristiano, inv. 638 (ex-221); diam. 63 mm. Ciampini *De duobus emblematibus*, pp. 16–23; reprinted in *Vet. mon.* 1747 edn, III, pp. 233–49; Buonarroti 1716, pl. V.3 and pp. 35–9; Garrucci 1858, p. 54f., pl. XXVI.10; Morey 1959, no. 193, pl. XXIII; Zanchi Roppo 1969, no. 91

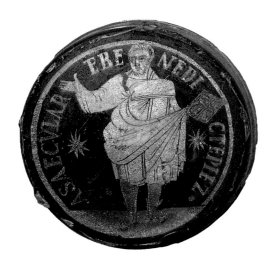

Comp. fig. 281 (i): Gold-glass,
Man wearing a toga, with open book. Actual size.
BAV, Museo Cristiano, inv. 638

Comp. fig. 281 (ii): Ciampini *De duobus emblematibus*, p. 16

282. Gold leaf on blue glass disc, on plain glass: man wearing a toga

LATE SEVENTEENTH-CENTURY ITALIAN

Windsor, RL 9139

Watercolour and bodycolour, with gold powder in gum arabic, and pen and ink

57 × 59 mm

NUMBERING: [bottom centre] *1038*

MOUNT SHEET: type B. Also bears **272–81**. *Watermark*: Fleur de Lys 70 (cut)

BIANCHINI fol. 143 [see **272**]

The piece was in the Carpegna collection when first published by Buonarroti (who had nothing particular to say about it); it is now in the Vatican Library Museo Cristiano. The drawing shows it before the remnants of the plain glass vessel it once decorated were trimmed off. In an octagonal frame (see also **265–6**) is the half-figure of a young man wearing a tunic and toga similar to that of **281**. There is no inscription to say who he might be, just a flower to either side of his head.

LITERATURE: unpublished

OBJECT DRAWN: BAV, Museo Cristiano, inv. 646 (ex-217); diam. 36 mm (trimmed). Buonarroti 1716, pl. XXII.3 and pp. 149–62, esp. 157f.; Garrucci 1858, p. 54, pl. XXVI.9; Morey 1959, no. 133, pl. XXI; Zanchi Roppo 1969, no. 106

Comp. fig. 282: Gold-glass, *Man wearing a toga* . Actual size.
BAV, Museo Cristiano, inv. 646

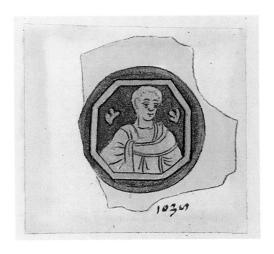

282 (actual size)

283. Fragmentary silvered bronze disc with the busts of Saints Peter and Paul

SEVENTEENTH-CENTURY ITALIAN

Windsor, RL 9080

Brush and ink, with white heightening, on blue paper

116 × 107 mm

NUMBERING: *713*

MOUNT SHEET: type B. Also bears **291**, **295**.
Watermark: Figure
12 (cut)

BIANCHINI fol. 125, I: another image of St Peter.

Still embedded in some of the cement from the tomb it marked, the disc was once in the Barberini collections and is now in the Vatican Library Museo Cristiano. Another copy of the drawing, by the same hand and on the same blue paper, is to be found in one of the Barberini albums and is annotated *Testa di Sto. Pietro e Sto. Pauolo in lamina d'Argento ritrovata de' Cimiteri di Sta Priscilla. L'originale la conservo a VS Em et profondamente la reverisco* ('Heads of St Peter and St Paul in silver leaf, found in the catacombs of St Priscilla. The original belongs to Your Eminence and I esteem it deeply'). De Rossi (1887) identified the handwriting of the annotation as that of Lucas Holstenius (d.1661) and pointed out that in the 17th century 'S. Priscilla' could signify any one of many catacombs on the via Salaria. He also notes that Holstenius erred in describing the metal as silver; it is actually thinly silvered bronze.

LITERATURE: unpublished

OBJECT DRAWN: BAV, Museo Cristiano, inv. 847 (ex 96); max. preserved height 67 mm; of disc, 54 mm. De Rossi 1864, p. 85 and chromatic plate, no. 2; Garrucci *Arte Cristiana* VI (1881), p. 54, pl. 435.8; De Rossi 1887, p. 135

OTHER DRAWINGS: BAV, Barb. lat. 4426, fol. 11 (illustrated but not discussed in Jaffé 1988, p. 57, fig. 62)

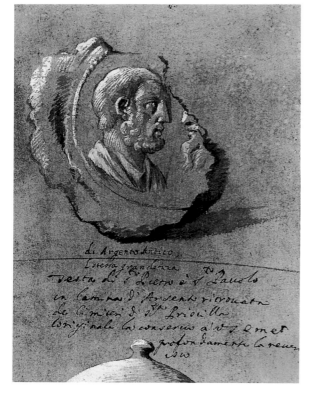

Comp. fig. 283 (i): Anonymous,
Fragmentary silvered bronze disc with Saints Peter and Paul.
BAV, Barb. lat. 4426 fol. 11

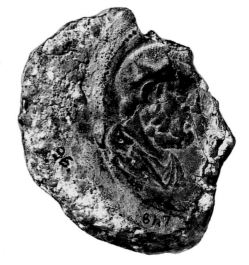

Comp. fig. 283 (ii): Fragmentary silvered bronze disc, *Saints Peter and Paul.*
BAV, Museo Cristiano, inv. 847

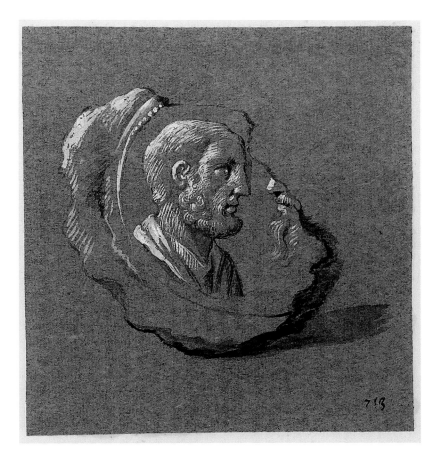

283

284. Gold(?) medallion: the Ascension of Christ

SEVENTEENTH-CENTURY

Windsor, RL 9069

Pen and ink, and yellow washes, over black chalk

90 × 80 mm

MOUNT SHEET: type B. Also bears **174**, **227–8**, **285**.
Watermark: Figure 13

BIANCHINI fol. 122, II: monument from a Christian cemetery.

This drawing and its companion (**285**) record the two faces of what was presumably the same medallion, one face depicting Christ's Ascension, and the other the Flight into Egypt. It was probably made of gold, and used as an *encolpion* (amulet worn on the chest). In the first scene, Mary and twelve apostles look up in astonishment as Christ, seated in a glory, is raised up to heaven by four angels. The object is otherwise unknown.

E. B. Smith suggested an eastern Mediterranean provenance and a date *c.* AD 600 (and in fact a similar medallion, depicting the Virgin and Child enthroned with Nativity scenes, and the Baptism of Christ, was found in Cyprus in 1902; Ross 1957; *Age of Spirituality* cat. 1979, p. 312f., no. 287).

LITERATURE: Smith 1914

OBJECT DRAWN: not traced

284 (actual size)

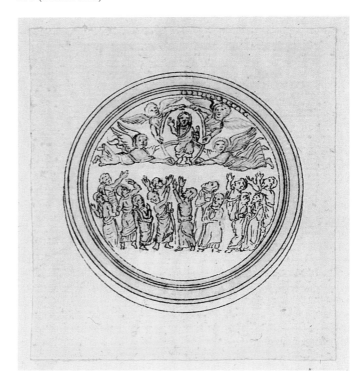

285. Gold(?) medallion: the Flight into Egypt

SEVENTEENTH-CENTURY

Windsor, RL 9070

Pen and ink, and yellow washes, over traces of black chalk

88 × 81 mm

MOUNT SHEET: type B. Also bears **174, 227–8, 284.**
Watermark: Figure 13

BIANCHINI fol. 122, II: monument from a Christian cemetery.

See **284**. Mary and the Infant Jesus are seated on a donkey, which is being led by Joseph. At the far right is the *tyche* (personification) of the city of Alexandria, with mural crown, who welcomes the Holy Family to Egypt.

LITERATURE: Smith 1914

OBJECT DRAWN: not traced

285 (actual size)

286. Small bronze disc: the Good Shepherd and biblical scenes

LATE SEVENTEENTH-CENTURY ITALIAN

Windsor, RL 9143

Pen and ink, and grey wash, with white heightening, over traces of graphite

61 × 70 mm

NUMBERING: [bottom centre] *1176*

MOUNT SHEET: type B. Also bears **292–4**.
Watermark: Fleur de Lys 70 (cut)

BIANCHINI fol. 144 [not mentioned]

Ciampini published a substantial discourse on this thin decorative bronze disc (a *bractea* in Latin) in 1691, when it was in the Carpegna museum (see also **282**). He says it had been found in the Catacombs of Pontianus, on the via Portuense, 'a few years back' and his illustration, like the dal Pozzo drawing, shows it at actual size.

The design centres on a figure of the Good Shepherd, which Ciampini doubts is Christ (in his own collection he had a marble slab showing a bearded man carrying a sheep on his shoulders, inscribed with the name Filumenus), though the surrounding scenes are certainly biblical: in the top register are Adam and Eve eating the forbidden fruit, with Noah's ark to the left of them, Jonah under the gourd-vine to the right, below which there is Daniel in the Lion's den on the left; on the right the Sacrifice of Isaac; in the lower register are other episodes from the story of Jonah.

Ciampini suggests that the disc may have been set in the bottom of a pottery or wooden bowl for use in Christian ritual. Such cups, he observes, could be made in all sorts of materials, as discussed by Aringhi (*Roma Subterranea* II, bk 4, chs 37 and 47; bk 6, ch. 50) and suitable examples could be seen in Carpegna's collection and that of Flavio, Cardinal Chigi. Buonarroti, who also discussed the imagery at length, proposed that if it did not come from a liturgical vessel it could have decorated a cross.

LITERATURE: unpublished

OBJECT DRAWN: BAV, Museo Cristiano, inv. 977; diam. 58 mm. Ciampini *De duobus emblematibus*, pp. 4–15; reprinted in *Vet. mon.* 1747 edn, III, pp. 225–32; Buonarroti 1716, pl. I, 1 and pp. 1–3. Garrucci *Arte Cristiana* VI (1881), p. 54, pl. 435.6

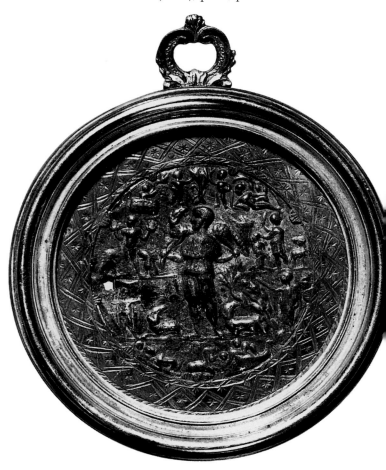

Comp. fig. 286 (i): Bronze disc, *Good Shepherd and biblical scenes*, set in 17th-century mount. BAV, Museo Cristiano, inv. 977.

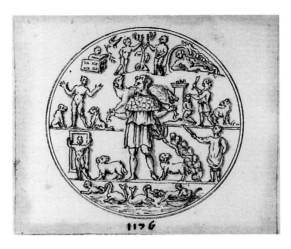

286 (actual size)

Comp. fig. 286 (ii): Ciampini *De duobus emblematibus*, p. 4 Comp. fig. 286 (iii): Buonarroti 1716, (pl. I)

287. Appliqué disc or medallion: Trigram of the name Jesus

SEVENTEENTH-CENTURY

Windsor, RL 9169

Pen and ink, and brown wash

83 × 86 mm. *Watermark*: Bird 12 (cut)

NUMBERING: [bottom centre] *803*

MOUNT SHEET: type B. Also bears **288–9.**
Watermark: Fleur de Lys 70 (cut)

BIANCHINI fol. 158, I and II: Antique plaquette with the name of the
Saviour.

The motif is a variation on the symbolic tri-gram, IHS, derived from the first three letters of the Greek spelling of Jesus *(iota-eta-sigma)*. Devotion to the Holy Name of Jesus, symbolized in this form, was actively promoted in the 15th century by S. Bernardino of Siena, and then subsequently taken up by other religious groups, among them the Jesuits. The small cross at the top, and what is probably intended to symbolize a heart beneath, recall the standard Jesuit version of this theme (see **288**). The specific model for the drawing has not been identified. The 'Pozzo' number suggests an acquisition of the later 1670s.

Blunt's attribution of the drawing to the hand of Pietro Testa may be doubted.

LITERATURE: Blunt 1971, p. 122

OBJECT DRAWN: not traced

287 (actual size)

288. Appliqué disc or medallion: Trigram of the name Jesus

SEVENTEENTH-CENTURY

Windsor, RL 9170

Pen and ink, over graphite

83 × 81 mm. *Watermark*: Star 7 (cut)

NUMBERING: [bottom centre] *849*

MOUNT SHEET: type B. Also bears **287**, **289**.
Watermark: Fleur de Lys 70 (cut)

BIANCHINI fol. 158 [see **287**]

This particular variant on the trigram IHS, with a cross rising from the bar of the H, and three nails piercing the heart beneath, was adopted by St Ignatius of Loyola in 1541 as the insignia of the Society of Jesus. It subsequently came to be widely used in the visual arts as an attribute of the Jesuits in general, and of St Ignatius himself in particular. The specific model for the dal Pozzo drawing has not been identified. See also **287**.

LITERATURE: unpublished

OBJECT DRAWN: not traced

288 (actual size)

289. Three appliqué discs or medallions, one with the Resurrected Christ

SEVENTEENTH-CENTURY

Windsor, RL 9171

Pen and ink, and grey wash, over traces of black chalk

162 × 177 mm

NUMBERING: [centre] *910*

MOUNT SHEET: type B. Also bears **287–8.**
Watermark: Fleur de Lys 70 (cut)

BIANCHINI fol. 158, I and II: ancient plaquettes, one with the resurrection of the Saviour.

The roundel at the upper left contains the figure of Resurrected Christ, triumphant over death, shown standing on a cloud and holding a large cross. The significance of the other two patterns is not clear, nor has the nature of the objects been identified.

Blunt's attribution of the drawing to Pietro Testa is unsubstantiated.

LITERATURE: Blunt 1971, p. 122

OBJECT DRAWN: not traced

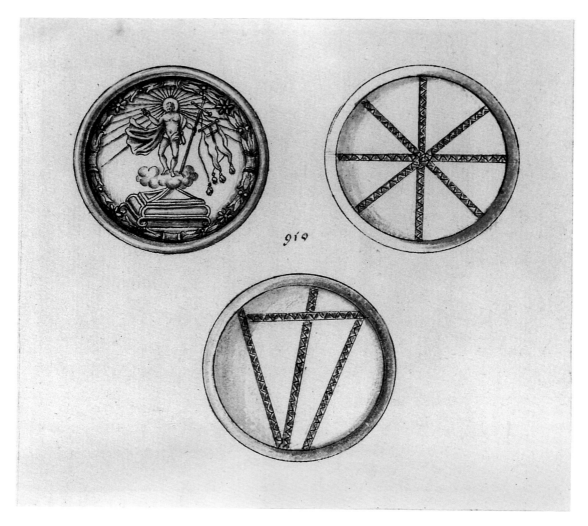

290. Gem of glass paste

SEVENTEENTH-CENTURY

Windsor, RL 9075

Pen and ink

83 × 73 mm. Small holes caused by concentrations of brown ink

MOUNT SHEET: type B. Also bears **172**, **175**, **296**.
Watermark: Figure 13 (cut)

BIANCHINI fol. 124 [not mentioned]

The gem, probably of moulded glass, depicted seven haloed saints. Identifying inscriptions in Latin reveal them to be the Seven Sleepers of Ephesus: Constantine, Silvanus (instead of the usual Maximian), John, Malchus, Martinianus, Dionysius and Serapion. By tradition, the seven suffered martyrdom in the mid-3rd century, during the persecution of the Emperor Decius, by being walled up in a cave and left to die of starvation. Their legend relates that they were discovered alive when the cave was opened two centuries later, during the reign of Theodosius II (408–50). The gem was probably intended for use as an amulet or pilgrim's souvenir. Its present location is unknown.

Similar gems of coloured glass paste, perhaps intended to resemble steatites and thought to have been produced in Italy in the late Middle Ages, may be found in the British Museum (Medieval & Later Antiquities OA 835 ex-Towneley Collection: *Byzantium* cat. 1944, no. 204c) and (without provenance) in the Museo Cristiano of the Vatican Library (see Righetti 1955a, p. 321, pl. XI.5; Righetti 1955b, p. 41, pl. XIII,7). However, these identify the saint in the upper right corner as Maximian.

LITERATURE: unpublished

OBJECT DRAWN: not traced

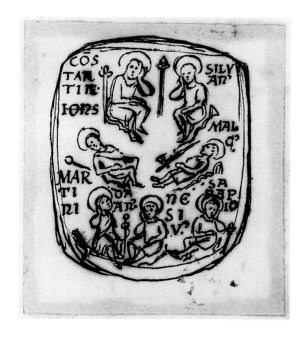

290 (actual size)

291. A Byzantine cameo, three intaglios and a coin

SEVENTEENTH-CENTURY

Windsor, RL 9079

Watercolour, and pen and ink

96 × 119 mm. *Watermark*: Figure 57A (cut)

NUMBERING: [bottom centre] *686.*

Individual items numbered from *1* to *6*

MOUNT SHEET: type B. Also bears **283**, **295**.
Watermark: Figure 12 (cut)

BIANCHINI fol. 125, I: another image of St Peter [cf. **295**].

1. Large rectangular cameo of seated Christ Pantocrator inscribed IE (should be IC) to left and XC to right, with ⌒ abbreviation marks. The original has not been identified, but the error in the inscription, if faithfully reproduced, suggests a western imitation of a Byzantine work. In general appearance (the heavy figure style in which the upper half of the body is too large for the lower) the cameo resembles an unpublished example in the Ashmolean Museum, Oxford, and one in the Hermitage (*Iskusstuo vizantii*, no. 915), both of 12th/13th-century date.

2. Intaglio with a male head in profile, facing right; probably a work of the first century BC or first century AD. The head-dress (a flamen's cap or the *petasos* of Mercury?) could have been mistaken in the 17th century for a halo.

3. Intaglio with a bearded and balding male head in profile, facing left, probably the portrait of a famous Greek (such as Hippocrates,

Aischylos or Hesiod), but mistaken in the 17th century for one of the apostles.

4. Intaglio showing two figures approaching a man who is lying on a bed with one leg in the air, perhaps Philoctetes in the Trojan legend. The scene could have been thought to represent the martyrdom of St Lawrence (compare Garrucci *Arte Cristiana* VI (1881), pl. 478.43).

5–6. A bronze coin minted by the Duchy of Naples. The obverse (5) bears the bust of the city's patron saint Januarius (S. Gennaro), and the reverse a cross on steps, flanked by the letters S and T. On the basis of the latter, the type is customarily assigned to the 9th-century Duke Stephen III (821–32): Sambon 1912, no. 282, pl. IV; Sambon 1919, p. 73, nos 171–2, but may be rather later (Grierson 1973, p. 85).

None of these objects has been traced, but it would seem likely that in the 17th century they all belonged to one collection. The 'Pozzo' number *686* indicates that the drawing was collected sometime after 1673.

LITERATURE: unpublished

OBJECTS DRAWN: untraced

291 (enlarged)

LAMPS [292–294]

Mounted together on one folio are a drawing of a bronze lamp with a Christian monogram and two copies of a drawing of a clay lamp decorated with the figure of the Good Shepherd and other scenes, between which is set a drawing of a small metal disc with similar imagery (**286**). Ancient bronze, glass and terracotta lamps were frequent discoveries in tombs and catacombs and popular collector's items in seventeenth-century Rome; the dal Pozzo brothers themselves owned several and had drawings of many more (to be catalogued in A.V). The first monographic study was published by Fortunio Liceto in Venice in 1621, with a second enlarged edition at Udine in 1653 and one at Padua in 1662. Pietro Santi Bartoli and Giovanni Bellori produced another in 1691, consisting mainly of lamps in Bellori's own collection, the third part devoted to lamps with Christian motifs. The two lamps represented here belonged to Bellori and were among those included in his book. The high 'Pozzo' numbers on the drawings (*1175, 1178*) signify acquisitions of the mid 1680s. Later still Carlo Antonio composed another folio of five lamps with Christian monograms, but did not put them in the *Mosaici Antichi* album; instead he kept them in a different album (British Museum, Franks 443–6), in company with thirty-four other drawings of lamps (Franks 435–6, 447–67, 469–74).

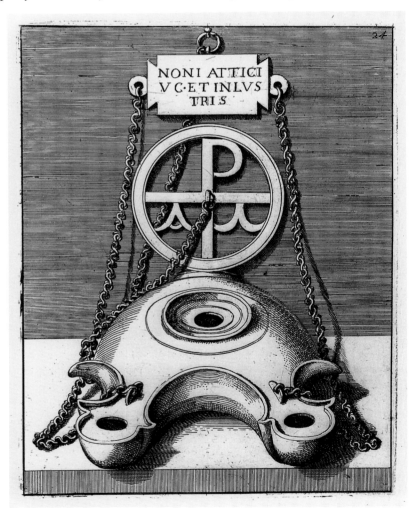

Comp. fig. 292: P. S. Bartoli, *Roman bronze lamp*, engraving, Bartoli/Bellori *Antiche lucerne* III, pl. 24

292. Roman bronze lamp with alien handle, chains and inscribed plaque

LATE SEVENTEENTH-CENTURY ITALIAN

Windsor, RL 9140

Watercolour, and pen and ink, with white heightening, over graphite; *pentimenti* in graphite

318 × 223 mm

NUMBERING: [bottom centre] *1178*

VERSO: sketch in graphite of the same lamp, viewed from a different angle

MOUNT SHEET: type B. Also bears **286**, **293–4**.
Watermark: Fleur de Lys 70 (cut)

BIANCHINI fol. 144, I: Christian Lamps Noni Attici V.C et illustris, and the Good Shepherd II: Christian lamps printed by Pietro Santi Bartoli.

In the late 17th century the lamp was in the collection of Giovanni Pietro Bellori (see p. 306) and drawn by Pietro Santi Bartoli for their *Antiche lucerne* of 1691. As pointed out by the editors of *CIL* (XV, 7176 = VI, 32023–1) it is clearly a pastiche. The small owner's plaque attached to the chains names Nonius Atticus (*PLRE* I Maximus 34), Praetorian Prefect in Italy in AD 384 and Suffect Consul in AD 397. He was most definitely *not* a Christian, whereas the handle (not original) takes the form of a Christian monogram. It is a variant on the chi-rho (the first two letters of the Greek word *Christos*) in which the *chi* is replaced by a cross, and the apocalyptic letters *alpha* and *omega* (Revelation 1:8). Bellori's brief commentary, however, is unaware of any incongruity, and concerned mainly with the significance of the alpha and omega.

LITERATURE: unpublished

OBJECT DRAWN: Berlin, Antikensammlung, the name plate detached and kept separately. Fabretti *Inscript. antiq.*, p. 676, no. 26; Bartoli/Bellori, *Antiche lucerne* III, p. 28, pl. 24; cf. Garrucci *Arte Cristiana* VI (1881), p. 107, pl. 471,4; *CIL* XV, 7161 = VI 32023–1; nameplate: Hübner 1885, no. 922

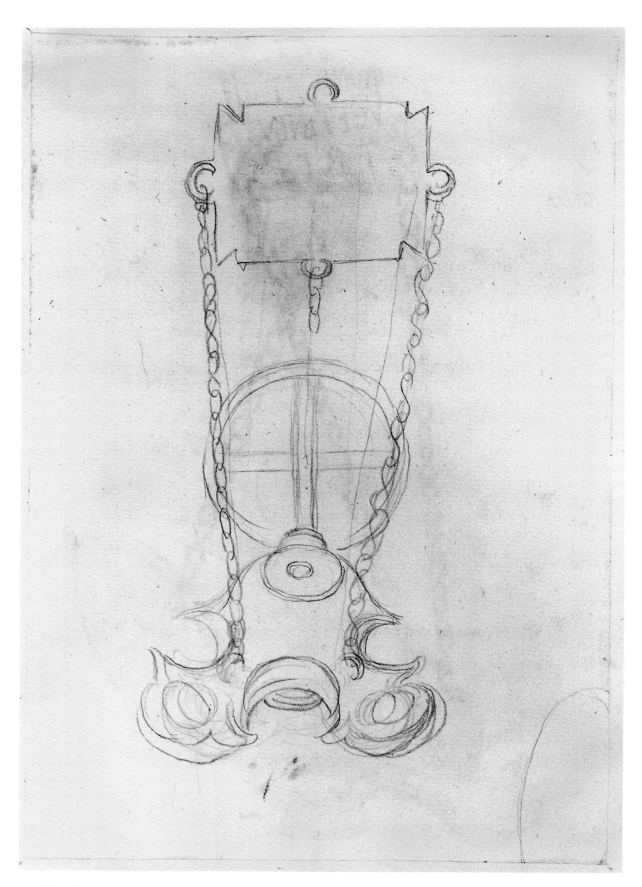

292 (Verso)

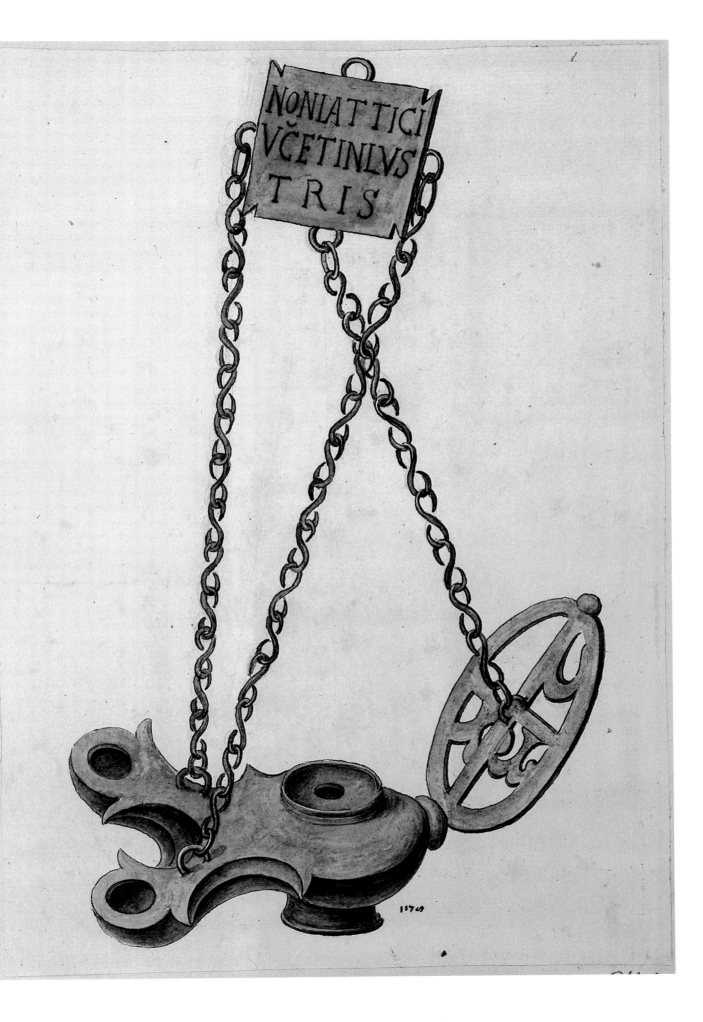

NONLATTICI
VGETINLVS
TRIS

292

13769

293. Early Christian pottery lamp: Christ as the Good Shepherd

attrib. PIETRO SANTI BARTOLI (1635–1700)

Windsor, RL 9141

Pen and ink, and pink and brown wash

152 × 108 mm

NUMBERING: [bottom centre] *1175*

VERSO: outline sketch in black chalk of part of a lamp or vessel

MOUNT SHEET: type B. Also bears **286**, **292**, **294**.
Watermark: Fleur de Lys 70 (cut)

BIANCHINI fol. 144 [see **292**]

An Italian product of the late second or early third century AD, stamped SAECVL on the underside, the lamp was once owned, like **292**, by Giovanni Pietro Bellori (see p. 306f.) and was drawn and engraved by P. S. Bartoli for their *Antiche lucerne* of 1691. The dal Pozzo drawing is so close to Bartoli's published engraving that it could well be by his hand.

Bellori's detailed commentary starts with the central figure of Christ as the Good Shepherd: 'he is wearing a short belted tunic and net stockings, with a heavy duty cloak (Latin, *lacerna*) pinned across his chest, and is carrying the lost sheep back to the pen. At his feet are seven other sheep looking towards him, meant to be the simple followers of Christ, innocent as lambs. To the left of Christ is a square object on which a dove is perched, signifying Noah's Ark. Beneath the ark is Jonah coming out of the mouth of the whale after having lived there three days: the symbol of the tomb and the Resurrection. On the right Jonah lies naked asleep under the gourd vine: the symbol of Christ's repose after his death and passion. At the top there are representations of the sun, the moon, and seven stars [the dal Pozzo drawing shows only six], probably referring to the seven of the Apocalypse, the lamps of the Church (Revelation 1:16,20)'. The Sun and Moon, Bellori continues, were often depicted by the Pagans to represent Eternity, and he suggests (citing Aleandro's iconographic study of 1626, *Navis Ecclesiam referentis symbolum*) that the other dove which appears under the Moon could personify the purity, simplicity, Concord and other virtues of the deceased.

According to Beger's edition of Bartoli/Bellori (Beger *Lucernae veterum* III, p. 10) the lamp was among those purchased for the Elector of Brandenburg, in which case it should be in Berlin; however, it is not. Gaetano Marini apparently saw it in the 'museum' of Mons. G. F. Di Bagno in Rome in the late 18th century (but it is not mentioned in Righini 1975). One in the British Museum (Bailey 1980, p. 357f., no. Q1370, pl. 80) is similar, but not the same.

LITERATURE: unpublished

OBJECT DRAWN: lost? Bartoli/Bellori *Antiche lucerne* III, p. 9f., no. 29; [G. Marini] BAV, Vat. lat. 9071, p. 265; De Rossi 1870; *CIL* XV, 6221.20; cf. Garrucci *Arte Cristiana* VI (1881), p. 110, pl. 474,2

OTHER DRAWINGS: **294**

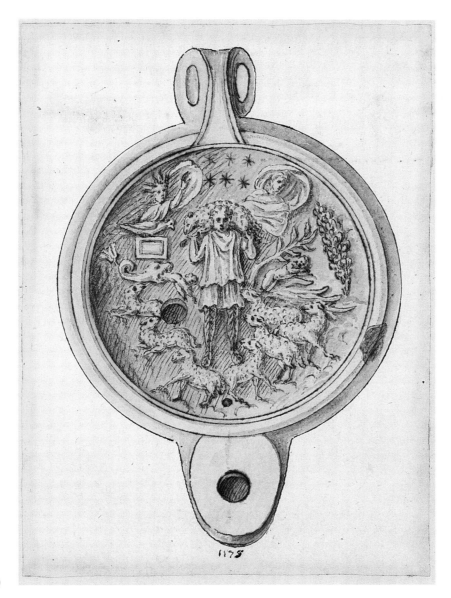

293 (actual size)

293 verso

294. Another copy of 293

attrib. PIETRO SANTI BARTOLI (1635–1700)

Windsor, RL 9142

Pen and ink, and pink and brown wash, with white heightening

153 × 109 mm

NUMBERING: [bottom centre] *1175*

MOUNT SHEET: type B. Also bears **292–3.**
Watermark: Fleur de Lys 70 (cut)

BIANCHINI fol. 144 [see **292**]

A second copy of the drawing **293**. Duplicates are not uncommon in the dal Pozzo corpus (see, for example, the sarcophagus **228–9**), though it is odd to find two identical drawings, as is the case here, with the same 'Pozzo' number, mounted on the same folio. However, it was probably normal practice to commission drawings in more than one copy, so as to have spare(s) available to be given to or exchanged with other interested parties. Another example of such intentional duplication is probably represented by the Coleraine copy of **178**.

LITERATURE: unpublished

OBJECT DRAWN: see **293**

OTHER DRAWINGS: **293**

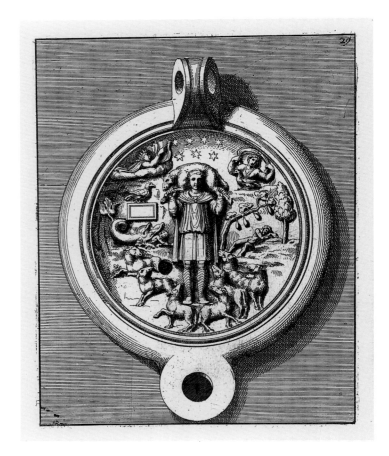

Comp. fig. 293, 294: P. S. Bartoli, *Roman pottery lamp*,
engraving, Bartoli/Bellori *Antiche lucerne* III, pl. 29

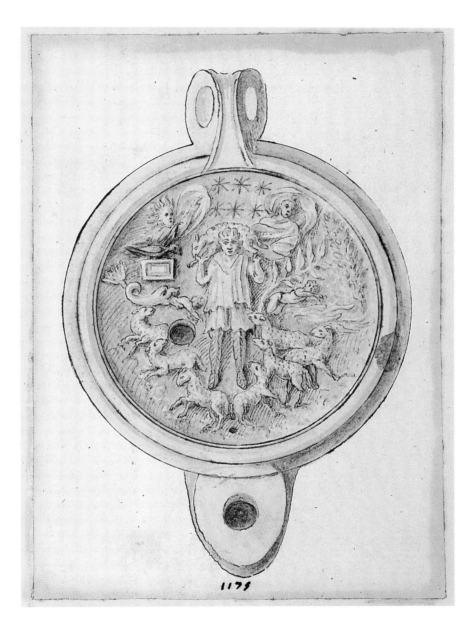

294 (actual size)

295. Three views of a bronze statuette of St Peter

SEVENTEENTH-CENTURY ITALIAN

Windsor, RL 9081

Pen and ink, and grey wash, over black chalk

145 × 248 mm

NUMBERING: [bottom centre] *682*

MOUNT SHEET: type B. Also bears **283**, **291**.
Watermark: Figure 12 (cut)

BIANCHINI fol. 125, I: Image of St Peter drawn by Bellori, and other images of the same [see **291**, **283**]

II: Image of St Peter the Apostle taken from an antique bronze statuette, which was printed by Pietro Santi Bartoli in the Lucerne Christiane with notes by Bellori.

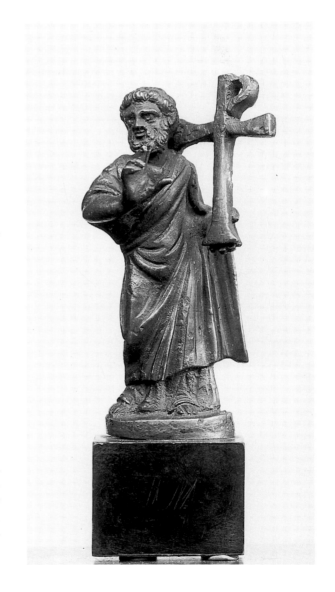

The small bronze statuette, only 93 mm high, probably dates from the late 4th or early 5th century. It portrays Peter holding a large *chrismon*, a popular Early Christian symbol which combines the cross with the chi-rho monogram of Christ and in a funerary context can signify the Resurrection (see also **232**).

In the 17th century, the statuette belonged to the Roman antiquary Giovanni Pietro Bellori (see p. 306f.) and appeared in his joint publication with Pietro Santi Bartoli in 1691 on ancient lamps (hence some modern misunderstanding that it once formed part of a lamp, but the *Antiche lucerne* is not exclusively composed of lamps). Philip Skippon saw it when he visited Bellori's museum in 1665 (Skippon, p. 682). For Bellori, who simply says it was found in the catacombs, the image was an interesting representation of St Peter wearing the apostolic *pallium*, one hand raised in a gesture of benediction; his monogrammed staff could refer to his 'bringing the Name of the Lord to the Good of the People'.

From Bellori's collection the statuette passed to Frederick I of Prussia, and is now in Berlin.

LITERATURE: unpublished

OBJECT DRAWN: Berlin, Staatliche Museen Preussischer Kulturbesitz, Frühchristlich-Byzantinische Sammlung, inv. 1. Bartoli/Bellori, *Antiche lucerne* III, no. 27; Wulff 1909, p. 162, no. 717; Schlunk 1939, p. 48, no. 129; Staatliche Museen 1966, p. 31, no. 19; *Age of Spirituality* cat. 1979, p. 571f., no. 509

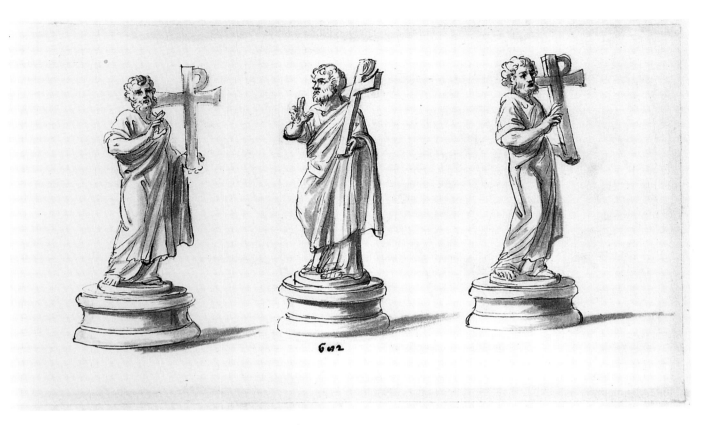

295

Comp. fig. 295 (opposite): Bronze statuette of St Peter. Berlin, Staatliche Museen

296. Bronze statuette(?): female figure with hands raised in prayer

SEVENTEENTH-CENTURY ITALIAN

Windsor, RL 9076

Pen and ink, and grey wash, over black chalk

145 × 110 mm

NUMBERING: [bottom centre] *683*

MOUNT SHEET: type B. Also bears **172**, **175**, **290**.
Watermark: Figure 13 (cut)

BIANCHINI fol. 124 [not mentioned]

The drawing shows a veiled female figure with hands uplifted, apparently standing on a crescent moon, which to a 17th-century eye might have signified Mary and the theme of the Immaculate Conception, the iconography being derived from the text of Revelation 12:1 ('And a great portent appeared in heaven, a woman clothed with the sun, with the moon under her feet, and on her head a crown of twelve stars'). Promoted by both the Franciscans and the Jesuits, the subject became particularly popular in the period of the Catholic Reform, and images of Mary standing on the crescent moon are frequent in Spanish and Italian art of the first half of the 17th century (see Le Bachelet 1930, cols 866–70, 1149).

However, the drawing is probably deceptive. Its 'Pozzo' number and technique link it to the little bronze St Peter in the Bellori collection (**295**) and there is a coloured drawing of the same image in another dal Pozzo album which indicates that the model was actually a Late Roman bronze statuette of a praying woman (see further **297**).

LITERATURE: unpublished

OBJECT DRAWN: not traced

OTHER DRAWINGS: **297**

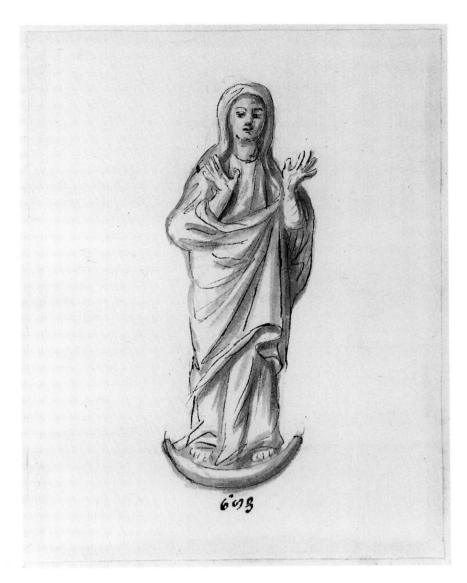

296 (actual size)

297. Bronze statuette: praying woman

SEVENTEENTH-CENTURY ITALIAN

Private collection, unknown, previously SMS fol. 67, no. 2

Pen and brown ink and watercolour, over black chalk

111 × 83 mm

NUMBERING: [bottom centre] *1169*

MOUNT SHEET: 531 × 402 mm. 19th-century laid cream folio; laid down; mounted with four other drawings after statuettes.

PROVENANCE: dal Pozzo; Albani; George III; Richard Dalton; John MacGowan; Charles Townley; Charles Towneley; William Stirling-Maxwell; sale, London (Phillips), 12 December 1990, lot 263

The statuette is either the same as that drawn in **296**, or another of exactly the same size and type. The two artists have rendered the proportions differently and what in the other drawing looks like a crescent moon, in this one appears merely as a small, perhaps sloping or distorted, plinth. In both respects, this drawing is probably the truer copy.

Their high 'Pozzo' numbers belong to Carlo Antonio's inventory and indicate that the drawings were probably acquired several years apart, which would help explain how they came to be mounted in separate albums (and perhaps interpreted in different ways). But they are in both cases associated with items in the Bellori collection: *1172* is a drawing of one of his ancient lamps, mounted in the Franks album, no. 459; *1175* is another lamp, catalogued here as **293–4**.

LITERATURE: unpublished

OBJECT DRAWN: not traced

OTHER DRAWINGS: **296**

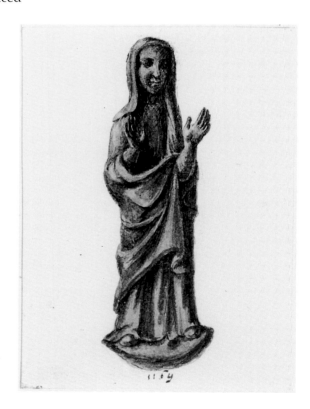

297

298. Statue or statuette(?): St Hilaria

SEVENTEENTH-CENTURY

Windsor, RL 9180

Red chalk

161 × 106 mm

NUMBERING: *637*

ANNOTATION: [brown ink] *S.ILARIA V. M.*

MOUNT SHEET: type B. Also bears **173**, **240**

BIANCHINI fol. 166, I and II: ... and St Hilaria (I:) Virgin and Martyr, from a painting or sculpture.

The drawing depicts the standing figure of a female saint, who reads from an open book held in her right hand and holds a martyr's palm frond in her left. An inscription identifies her as the virgin martyr Hilaria. She is presumably Hilaria of Rome, a third-century martyr whose feast day is celebrated on 3 December.

LITERATURE: Blunt 1971, p. 122

The indication of a base beneath her feet may suggest that the model was a statue or statuette. Its location is not known.

The 'Pozzo' number indicates that the drawing was added to the Paper Museum sometime after 1668; its attribution by Blunt to Pietro Testa thus seems unlikely.

OBJECT DRAWN: not traced

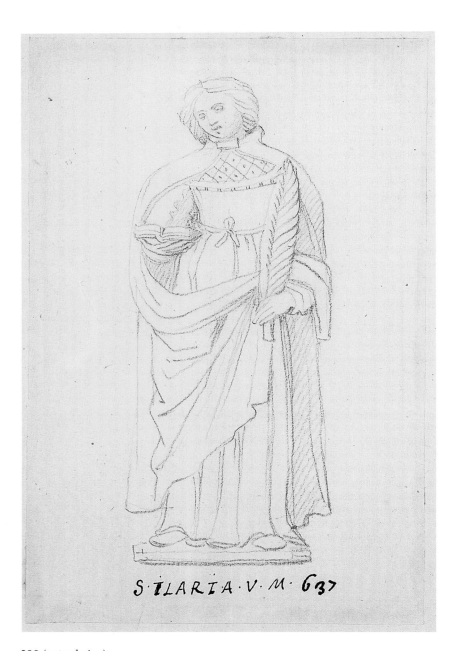

298 (actual size)

299. Two metal objects: a pin and a clasp(?)

SEVENTEENTH-CENTURY
Windsor, RL 9099
Pen and ink, and grey wash, over graphite
90 × 173 mm
NUMBERING: [upper object] *887*
[lower object] *888*
MOUNT SHEET: type B. Also bears **198, 200–201**
BIANCHINI fol. 138 [not mentioned]

The objects appear to be a small attachment with a cylindrical socket, through which is inserted a (broken) pin, of the same type as that drawn separately above. According to the 'Pozzo' number, the drawing was acquired in or soon after 1680.

LITERATURE: unpublished

OBJECT DRAWN: not traced

299 (actual size)

300. Iron shackle(?) and fragments of chains

attrib. VINCENZO LEONARDI (fl. 1621–46)

Windsor, RL 9082

Watercolour and bodycolour, over traces of black chalk

410 × 550 mm. Cream paper, heavier than other sheets in album.
Watermark: Crown 26

NUMBERING: [below linked chain, centre] *350*

[below hinged loop, top] *A*

[below single link, bottom] *B*

MOUNT SHEET: not mounted

BIANCHINI fol. 126, I and II: Ancient iron chains, with manacles.

Like those shown in **301**, with which this drawing forms a pair, the objects were probably found in the catacombs and believed to be the relics of an Early Christian martyr. The texture of the rusting metal is cleverly rendered with flecks of colour; the scale is presumably 1:1. Flat oval links are a common ancient shape and the basic form of the larger hinged loop (top centre) has parallels among Roman military/penal shackles (e.g. Feugère *et al.* 1992, p. 50f., nos 97–9). It is not unlike that on the famous chains of St Peter, venerated in his eponymous church in Rome since the 6th century (*DACL* iii.1 (1948), col. 18, fig. 2384; Matthiae

S. Pietro, p. 63, fig. 19). The dal Pozzo loop is odd, however, both in size (at 113 mm in diameter it is too large for wrist or ankle yet not large enough for the neck) and in having two rings for attachment on either side. Also, the provision for fastening at 'A' (perhaps by means of the separate link 'B') seems rather inadequate for the purpose of restraining a prisoner, as does the small nail(?) at the end of the chain on the right and the stud at the end of that on the left. It is possible that the assemblage had some other function (perhaps in harnessing or hobbling an animal, or for suspension).

LITERATURE: unpublished

OBJECT DRAWN: not traced

Comp. fig. 300: 'Chains of St Peter', Rome, S. Pietro in Vincoli.
Drawing from an illustration in the
Dictionnaire d'Archéologie chrétienne et de liturgie

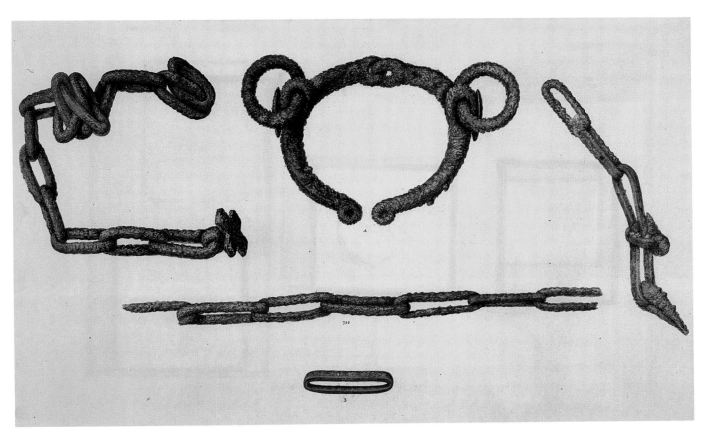

300

301. Chopping knife and scraper

attrib. VINCENZO LEONARDI (fl. 1621–46)

Windsor, RL 9083

Watercolour and bodycolour, over traces of black chalk

550 × 410 mm. Cream paper, heavier than other sheets in volume.

Watermark: Crown 26

NUMBERING: [below upper image, centre] *351*

[to right of upper image] *A*

[to left of lower image] *B*

MOUNT SHEET: not mounted

BIANCHINI fol. 127, I: Instruments of torture of the Holy Martyrs, iron scrapers and... II: Instruments of Martyrdom, iron scraper, hatchet etc.

The chopping knife (labelled 'A') and serrated scraper (labelled 'B') are both types of tool well-attested in the ancient Roman world (cf. Gaitzsch 1980, pp. 362, no. 177 and 382–3, nos 314–15). In the 17th century they were believed to have been instruments of martyrdom from the Early Christian period. Philip Skippon noted the drawing on his visit to the dal Pozzo collection in January 1665: 'A chopping-knife and a saw the martyrs were put to death with, were found in churchyards' (Skippon, p. 680; Blunt 1965, p. 71f.; see also Mabillon's account of a visit to the Catacomb of Castulus, p. 310). Early in the following century, an object similar to the 'saw' was discovered in the Catacomb of Calepodius on the via Aurelia (Boldetti 1720, p. 318f.). Curiosity about the torments suffered by the early martyrs was rife in Counter-Reformation Rome, and found expression both in scholarly works (for example A. Gallonio, *Trattato degli instrumenti di martirio*, Rome 1591)

and in the decoration of contemporary churches like S. Vitale and S. Martino ai Monti (for the sculpted frieze in S. Martino which depicted instruments of martyrdom, see Métraux 1979, pp. 101, 149–54).

The drawing clearly belongs with **300**, and the two have consecutive 'Pozzo' numbers. If the proposed attribution of both to Vincenzo Leonardi (see p. 14) is correct, the chronology of his other contributions to the collections could imply that the drawings were previously in some other part of the Paper Museum, only later transferred to the *Mosaici Antichi* volume. The watermark Crown 26 is found on a drawing of a vase in the *Nettuno* album (RL 11290), also attributed to Vincenzo Leonardi, as well as various drawings of sculptures and reliefs and their mounts among the Franks I and New drawings in the British Museum, many of which have 'Pozzo' numbers in the *200–300* range.

LITERATURE: unpublished

OBJECT DRAWN: not traced

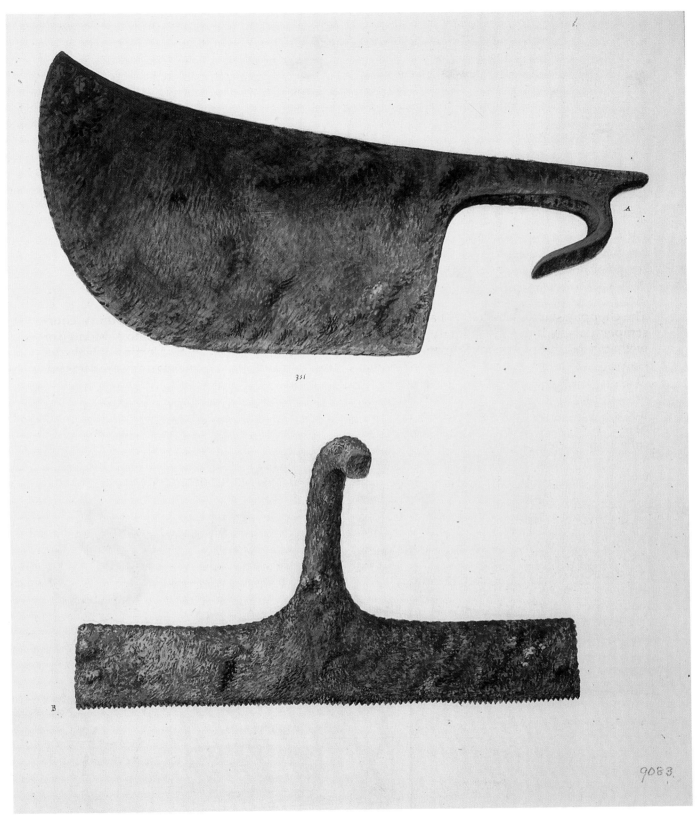

351

301

302. Device for experiments with magnetism

attrib. VINCENZO LEONARDI (fl. 1621–46)

Windsor, RL 9163

Watercolour and bodycolour, and traces of graphite

276 × 186 mm. *Watermark*: Crown 10

MOUNT SHEET: type B. Also bears **303** [above]

BIANCHINI fol. 155, I and II: Drawing of an armed (II: piece of) calamite (lodestone).

Sparked by the publication of William Gilbert's *De Magnete* in 1600, there was much scientific investigation of magnetism in the 17th century. Galileo Galilei was one of the first to pursue experiments using natural magnetic stone (calamite), fixed in an armature composed of two iron grips, which served to increase its magnetic power. The process is described in his *Dialogo sopra i due massimi sistemi del mondo* (1632), and one of his experimental instruments, not unlike that depicted here, is preserved in Florence (Maccagni 1967, no. 37). Also conducting experiments using magnetic armatures suspended from hooks was the German Jesuit scholar Athanasius Kircher (1602–80), who was introduced to the Barberini circle in Rome by Peiresc, with whom he had collaborated on a study of Egyptian hieroglyphics. Kircher remained in Rome from 1635 until his death in 1680, publishing the results of his study of magnetism in *Magnes, sive de arte magnetica* (1641). His collection of experimental devices was included with those representing his many other scientific and antiquarian interests in the famous 'Museum Kircherianum' (De Sepibus *Musaeum*, pp. 18–21). Cassiano dal Pozzo's own scientific interests seem to have included the study of magnetism, and a letter from Peiresc of 29 April 1636 thanks him for having provided a copy of a treatise on this subject by Porta (Lhote/Joyal 1989, p. 237). It seems likely that this drawing depicts a device for magnetic experiments, perhaps designed by or belonging to Kircher. The main hooked assemblage is drawn upside down.

There appears to be no obvious connection between magnetism (or the magnetic stone in the companion drawing, here **303**) and the Christian theme of the *Mosaici Antichi*.

LITERATURE: unpublished

OBJECT DRAWN: not traced

Comp. fig. 302, 303: Galileo's device for experiments with magnetism.
Istituto e Museo di Storia della Scienza. Florence

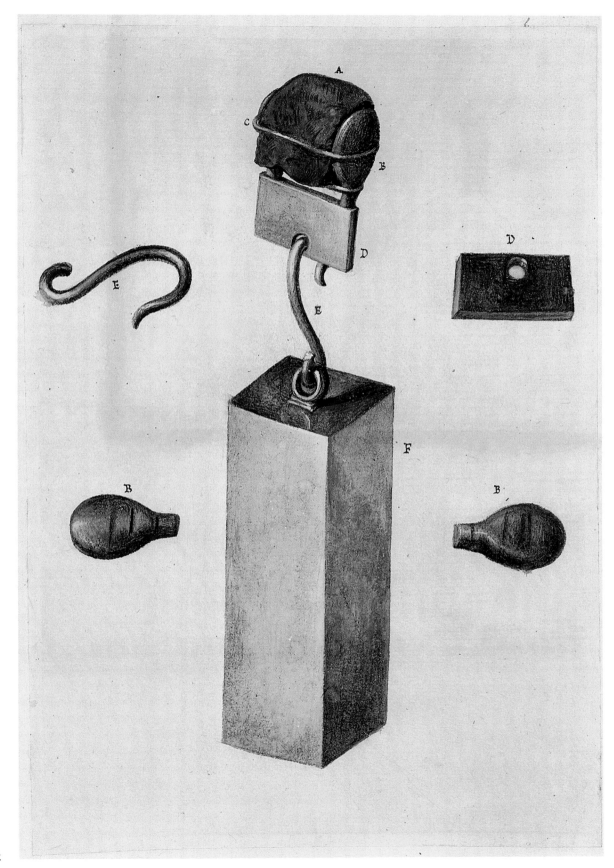

303. Magnetic stone (calamite)

attrib. VINCENZO LEONARDI (fl. 1621–46)
Windsor, RL 9162
Watercolour, and brush and ink
178 × 142 mm
MOUNT SHEET: type B. Also bears 302 [below]
BIANCHINI fol. 155 [see 302]

See 302. Other such drawings of rocks and minerals will be published in part B.III of the present catalogue.

LITERATURE: unpublished
OBJECT DRAWN: not traced

303

304. Mosaic pavement in the nave of S. Lorenzo fuori le mura, Rome

SEVENTEENTH-CENTURY

Private collection, USA, previously SMS fol. 104

Watercolour, pen and brown ink, with white heightening, over black chalk

221 × 210 mm

NUMBERING: *1228*

ANNOTATION: [brown ink] *scala di p.mi 6. Romani*

MOUNT SHEET: type B

PROVENANCE: dal Pozzo; Albani; George III; Richard Dalton; John MacGowan; Charles Townley; Charles Towneley; William Stirling-Maxwell; sale, London (Phillips), 12 December 1990, lot 288

The mosaic pavement was laid in the centre of the nave of S. Lorenzo fuori le mura (see **27–70**) in the early 13th century, in association with the construction and decoration of the nave, undertaken by Cencio Savelli following his appointment as titular cardinal of S. Lorenzo in 1191. The works were completed after his accession to the pontificate as Honorius III (1216–27). The two knights on horseback have the Savelli *stemma* of two rampant lions emblazoned on their standards and shields, and on their horses' saddle cloths. In the four corners of the design are facing pairs of dragons and griffins. The central portion was destroyed when the church was bombed in 1943, although the designs in the corners have since been reconstructed and reset in their original positions. The longer sides now measure 2.95 m, whereas the scale on the drawing gives 2.75 m (1 Roman palm = 0.223 m).

Ciampini illustrated the mosaic in his *Vetera monimenta*, not for its subject matter, but as part of his account of the origins and types of mosaic work; he cited it as an example of medium-sized tesserae combined with shaped fragments, and observed that the effect was rather crude. His engraving and the dal Pozzo drawing agree very closely in the representation of the two central horsemen (though the engraving does not show the lower ground indicated in the drawing). But they differ in various other respects: the engraving is smaller (186 × 176 mm as opposed to 198 × 189 mm) and shows the inner frame as overlapping the outer, not the reverse as in the drawing. It also represents the guilloche patterns in the outer and inner frames as continuous at the corners. Neither is correct according to the photograph reproduced by Muñoz, which shows the inner and outer frames to have been united, and the guilloche patterns altogether less regular.

The 'Pozzo' number indicates that the drawing was a very late Carlo Antonio acquisition, of the mid to late 1680s. It was not placed in the *Mosaici Antichi* album with its predominantly 'Christian' antiquities but, like **297**, in a miscellany of drawings of sculpture, architecture and architectural ornament, where it was mounted on the same sheet as a design for a ceiling, attributed to Perino del Vaga (1501–47).

LITERATURE: unpublished

OBJECT DRAWN: mostly destroyed; outer dimensions: 2.95 × 2.86 m. Ciampini *Vet. mon.* I, pl. XXXI,1 at p. 82; Muñoz 1944, pl. 62

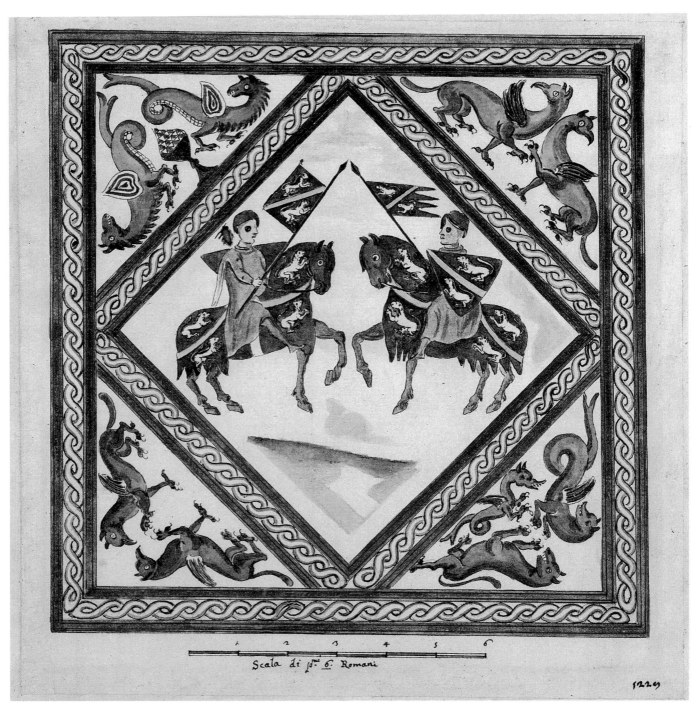

Scala di ꝑᵐⁱ 6 Romani

304

WATERMARK TYPES

by Eileen Kinghan and Amanda Claridge

(for recording method and typology see Volume One p. 347)

Of the 139 drawings in this second volume only 28 (20%) bear watermarks—compared with almost 50% (75/161) in Volume One—mainly because the drawing sheets are smaller. Correspondingly higher is the number of watermarks surviving on the 60 mount sheets: these yield 20 marks, compared with only nine out of 109 mounts in Volume One.

In keeping with the greater diversity of sources, the range of *types* on drawing sheets is wider than in Volume One, namely, *Bird, Circles, Coat of Arms, Crown, Figure, Fleur de Lys, Hills, Keys*, and *Star*. The types Crown and Figure are found in two different designs. Overall there are 20 variants, which form only limited groups.

The marks on mount sheets are of five types: *Anchor, Crown, Figure, Fleur de Lys, Hills*, each in a single design. In three isolated cases (Fleur de Lys 71, Figure 38 and the paired group Crown 26–7) the same mark is found on a drawing and on a mount sheet. As a rule, however, the same paper was not used for both purposes.

Dating

A number of dates are given in the watermark tables which follow, on the basis of a variety of evidence. The dates 1639 and 1640 given under Crown 26–7 and Hills 6, 9 are based on the occurrence of the same mark in the dateable sets of drawings of S. Lorenzo fuori le Mura (**27–70**) and S. Maria in Trastevere (**89–116**). The dates given as *c.* 1630–44 (Anchor 14, Coat of Arms 5, Figure 16–17) rely on the attribution of the drawing in question to Eclissi; similarly, 1621–46 (Crown 10) is the floruit of Vincenzo Leonardi. Two dates are furnished by dateable subject matter (Circles 2, Figure 18A). In the more numerous cases where a date in the 1670s or 80s is followed by PN (for 'Pozzo number') the dating should be treated with particular caution; the chronology is that of Carlo Antonio's inventory (see Volume One, p.38f.), which is only a guide to when the drawing was acquired (it may have been made much earlier). As regards mount sheets, the likelihood is that the majority are contemporary or near contemporary with the acquisition of the drawings they bear, but some drawings may have been mounted long after they were acquired, and it should also be noted that some mount sheets show signs of re-use.

Anchor

Water Mark	Drawing (Catalogue nos)	Mount (Catalogue nos)	Date	Remarks
14		**165**	*c.*1630–44	Drawing sheet bears *Figure* 17 Heawood no. 8 and Zonghi nos 1583–1614 same design. See also A.II. Volume 1, pp. 348–9

Anchor 14

Bird 12

Bird

Water Mark	Drawing (Catalogue nos)	Mount (Catalogue nos)	Date	Remarks
12	**287**		late 1670s (PN)	Mount sheet bears *Fleur de Lys* 70

Circles

Water Mark	Drawing (Catalogue nos)	Mount (Catalogue nos)	Date	Remarks
2	**179**		after 1675	Heawood 247–64 same design; 264 closest (1680)

Circles 2

Coat of Arms 5

Unidentified
Coat of Arms

Coat of Arms

Water Mark	Drawing (Catalogue nos)	Mount (Catalogue nos)	Date	Remarks
5	**164**		*c.*1630–44	
Unidentified	**200**			

Crown

Water Mark	Drawing (Catalogue nos)	Mount (Catalogue nos)	Date	Remarks
10	**302**		*c.*1621–46	Same design as *Crown* 26 and 27. cf. Woodward 264
26	**300**, **301**		1640	Same group as *Crown* 30–31 See A.II.1, p. 350
27		**237**, **238**	1640	
39	**249, 252–3** (mounted together)		early 1680s (PN)	Different design. Mount sheet bears *Fleur de Lys* 71 **252** and **253** same mark; sheet cut in two before mounting

Crown 10

Crown 26

Crown 27

Crown 39

Figure

Heawood 1351–3 same design

Water Mark	Drawing (Catalogue nos)	Mount (Catalogue nos)	Date	Remarks
12		283, 291, 295 (one mount) 291		Probably a pair. Found only on mounts. **291** drawing sheet bears *Figure* 57a
13		172, 175, 290, 296 (one mount) 174, 227, 228, 284, 285 (one mount)		Woodward 25 same group Briquet 7629 same design as 13 See also A.II.1 p. 354
16	**163**		*c.*1630–44	
17	**165**		*c.*1630–44	Same group; may be 2 pairs (16 and 17; 18 and 18A)
18	**177**		*c.* 1660 (PN)	Mount sheet of **165** bears *Anchor* 14
18A	**193**		*c.*1666	
27		**202**		
29	**204**			Same group. May be a pair
38	**230, 232**	**222**		
Unidentified		**224**		Probably *Figure* 38
33		**194**	?late 1660s (PN)	
57A	**291**		1673+ (PN)	

Figure 12

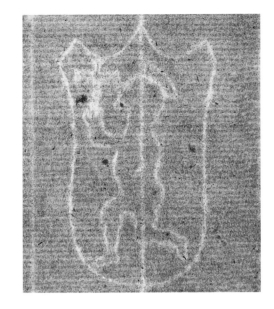

Figure 13

Figure 16

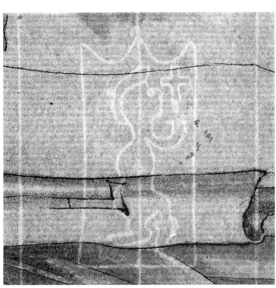

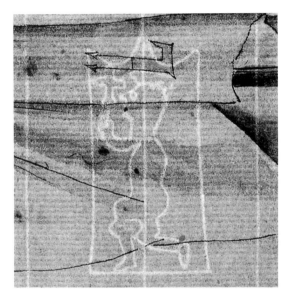

Figure 17

Figure 18

Figure 18 A

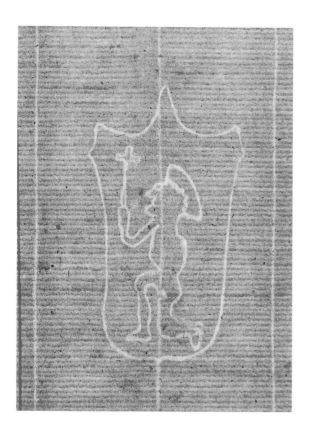

Figure 29

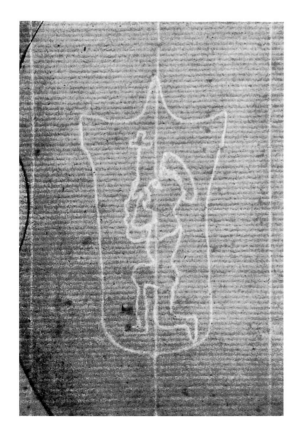

Unidentified Figure

Figure 38

Figure 57 A

Figure 33

Fleur de Lys

Water Mark	Drawing (Catalogue nos)	Mount (Catalogue nos)	Date	Remarks
67	**168, 188, 191, 271,**		early 1680s (PN)	Possibly paired. Woodward 111 (Rome, 1613) similar design with same chain lines
68	**195**			Mount sheet of **271** bears *Fleur de Lys* 71
70		**272–82** (one mount) **167–70** (one mount) **286, 292–4** (one mount) **287, 289** (one mount)	late 1670s to early 1680s (PN)	?Same mould: 'N' pendant changed **277** drawing sheet bears *Star* 5 **168** drawing sheet bears *Fleur de Lys* 67 **287** drawing sheet bears *Bird* 12 **288** drawing sheet bears *Star* 7
71	**181**	**249–53** (one mount) **254–62** (one mount) **263–71** (one mount)	?early 1680s (PN)	See also *Crown* 39 Heawood 1622 (Rome, mid 17th century)
75		**183–6**	c.1683 (PN)	

Fleur de Lys 67

Fleur de Lys 68

Fleur de Lys 70

Fleur de Lys 71

Fleur de Lys 75

Hills

Water Mark	Drawing (Catalogue nos)	Mount (Catalogue nos)	Date	Remarks
6	**171**		1639	Same design as 9. See A.II.1 p. 357
9		**166**	1639	Woodward 332–3 same design

Hills 6

Hills 9

Keys

Water Mark	Drawing (Catalogue nos)	Mount (Catalogue nos)	Date	Remarks
3	**220**		Pre - 1607, ?late 16th century	Same group as Woodward 114 (Rome, 1566). cf. Heawood 2824 (Venice, 16th century) and Woodward 115–18

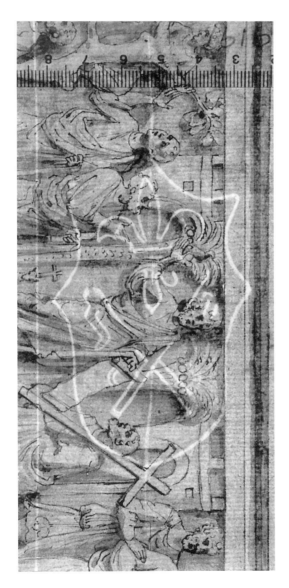

Keys 3

Star

Water Mark	Drawing (Catalogue nos)	Mount (Catalogue nos)	Date	Remarks
5	277			?Same group, if so, may be paired. Mount sheet bears *Fleur de Lys* 70
7	288		*c.* 1680s (PN)	Mount sheet bears *Fleur de Lys* 7

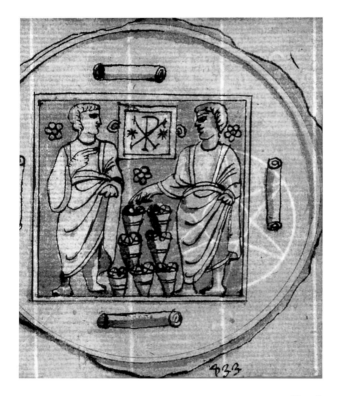

Star 5

Star 7

BIOGRAPHICAL NOTES:
COLLECTORS, ANTIQUARIES, ARTISTS AND OTHERS REFERRED TO IN THIS VOLUME

by Amanda Claridge

Leonardo Agostini[1] was born near Grosseto in 1593 and probably studied at Siena before moving to Rome early in the reign of Urban VIII (1623–44). An able draughtsman and antiquary, he quickly gained a reputation as an excavator and dealer in marbles and other ancient objects. Following the death of Claude Menestrier in 1639 and on the recommendation of Cassiano dal Pozzo, he was appointed antiquary to Francesco Barberini (q.v.), continuing to report to him in detail even during his exile in Paris. His interests and expertise mainly concerned coins and gems, of which he made a large collection.[2] In 1655 Alexander VII (Fabio Chigi, q.v.) nominated him Commissioner of Antiquities for Rome and Lazio. In 1657 he published the first part of a major study of gems, *Le gemme antiche figurate*, with 214 illustrations by G.B. Galestruzzi and help from Bellori on the commentary. The second part, printed in 1669, was much smaller and he planned a new edition of both parts but he died before he could finish it (probably in 1675), leaving as his executor Carlo Antonio dal Pozzo, under whose aegis the second edition eventually appeared in 1686.

Girolamo Aleandro (the Younger)[3] was born at Motta di Livenza in 1574. He studied law at Padua, took holy orders and then accompanied his uncle to Rome, where he was appointed secretary to Cardinal Ottavio Bandini. He then became secretary to Francesco Barberini, taking part in the 1625 legation to France, and also serving Urban VIII. With a particular talent for literature and moral and religious poetry (and an early member of the Accademia degli Umoristi), he was also a learned antiquary and ecclesiastical historian. Among his publications were *Antiquitae tabulae marmoreae Solis effigie symbolisque exculptae, accurata explicatio* (Rome 1616) and *Navis Ecclesiam referentis symbolum, in veteri gemma annulari insculptum, explicatione illustratum* (Rome 1626) and also, posthumously, some *Additiones* to Ciaconio's *Vitae Pontificum* (1630). It was probably through his influence that Holstenius (q.v.) was brought from Paris to join the Barberini circle in 1627. He died in 1629, and was buried in S. Lorenzo fuori le mura, where Francesco Barberini commissioned Pietro da Cortona to design his tomb, with a marble portrait bust by Antonio Giorgetti.

Nicolò Alemanni[4] was born in Ancona in 1583, of a Greek family from Andros. He studied at the Greek College in Rome and was ordained as a priest in the Latin rite. He then taught at the College, with Leo Allacci (q.v.) among his pupils, and also served as private tutor to the future Cardinal Librarian Scipione Cobelluzzi, by whom he was recommended as secretary to Cardinal Scipione Borghese. In 1614 he was appointed Head Custodian of the Vatican Library and embarked on various historical, literary and antiquarian researches. In 1623 he published an edition of Procopius, and in 1625 *de Lateranensibus parietinis*—a celebration and explanation of Francesco Barberini's restoration of the Triclinium of Leo III (see **168**). His unpublished works include *De ecclesiasticis antiquitatibus* and other tracts on Christian antiquities. He advised Urban VIII on the excavations for Bernini's *baldacchino* in St Peter's and was to have directed the operation but died suddenly of fever in 1626.

Leo Allacci[5] was born in 1586 on the Aegean island of Chios and studied in Rome 1599–1610. As secretary at the Vatican Library in 1622–4 he oversaw the transfer of the Biblioteca Palatina from Heidelberg to Rome, and was also Librarian to Francesco Barberini. Author of *Apes Urbanae* (1633), an ode to Barberini patronage, and *De templis graecorum recentionibis* (1645), revealing an interest in the Etruscans far ahead of his time, he was an expert in philology, theology, patristics, and antiquities. He died in 1669.

Francesco Angeloni,[6] born at Terni, probably after 1559, was a successful local author. By the end of the 16th century he had moved to Rome, where he took up the study and collection of antiquities and became secretary to Cardinal Ippolito Aldobrandini. His museum was enriched by short travels elsewhere in Italy, during which he wrote numerous letters to his Cardinal. In 1610 and 1614 he published two plays and much later in life two large works: *Historia augusta da Giulio Cesare infino a Costantino il Magno illustrata con la verità delle antiche medaglie* (Rome 1641) and *Historia di Terni* (Rome 1646). In 1632 he took on the young Giovanni Pietro Bellori (q.v.) as his assistant, coming to regard him as a son. When he died, extremely old, in 1652, he named Bellori his principal heir.

Paolo Aringhi[7] was born in Rome in 1600. A member of the Roman Oratory, he achieved international fame as the author of a Latin version of Antonio Bosio's *Roma Sotterranea*, first published in Rome in 1651 and elsewhere in several later editions; he has been much criticized in more recent times for the polemical bias that he introduced to the work, not present in the original. Little else is known about him; his few other published works were moral treatises.[8] He died in 1676.

Francesco Barberini[9] was born in Florence in 1597 and educated at Pisa, graduating in 1623. That same year his uncle Maffeo Barberini became Pope Urban VIII and called him to Rome, making him a Cardinal and showering him with other offices and privileges. He established a large household, including the dal Pozzo brothers Cassiano and Carlo Antonio, taking both of them on a legation he headed to France in 1625, and Cassiano on one to Spain in 1626 (see Volume One, p. 10). From 1627 to 1636 he was Cardinal Librarian of the Vatican library, with Holstenius as his assistant. By 1630 his annual income was estimated as 80–100,000 scudi and by 1633 he and his uncle Cardinal Antonio had built the Palazzo Barberini on the Quirinal hill, filling it with statuary and other antiquities and a huge library of printed books and manuscripts which grew to rival that in the Vatican. Briefly exiled in Paris following the death of Urban VIII in 1644, he returned to Rome in 1648 and regained most of his former wealth and position, devoting himself to promoting the arts and sciences and his own literary studies and financing numerous publications.[10] He died in 1679.

Pietro Santi Bartoli[11] was born in 1635 near Perugia. In early youth he moved to Rome to become a painter, training under Le Maire and then Poussin, but made his career primarily as an antiquary and a draughtsman, copyist and engraver of ancient paintings and other Roman antiquities. In the 1660s he was employed by Francesco Barberini on the illustrations for the Barberini edition of Georgios Pachymeres' *Byzantine History* (2 vols, Rome 1666–9).[12] In 1677 he copied the Vatican Vergil for Cardinal Camillo Massimi in 55 plates; in 1680, with explanatory notes and commentary by Bellori, he produced a highly successful monograph on the tomb of the Nasonii and its paintings (see A.I.82–127). In collaboration with Bellori, he went on to publish eleven other albums of plates: the reliefs on Rome's great triumphal arches, the Column of Trajan, Column of Marcus Aurelius, mausolea and other sepulchral monuments, a selection of the best sarcophagi and figural reliefs, and a study of ancient lamps. Christina of Sweden employed him as her antiquary and adviser on coins and medals. After Bellori's death he served in his place as Commissioner of Antiquities for Rome and Lazio. He died in 1700.

Giovanni Pietro Bellori[13] was born in 1613 in Rome, the son of a farmer from Lombardy. In or before 1632 Francesco Angeloni (q.v.) took

him on as his assistant and, from 1634, made him a member of his *famiglia*, training him as an artist as well as an antiquary. When Angeloni died in 1652 he named Bellori his principal heir and left him his house on the Pincian hill near S. Isidoro and all his collections. The will was successfully contested by the rest of the family and Angeloni's museum was dispersed. Bellori soon acquired another collection, however, including paintings by Titian, Tintoretto, Annibale Carracci and Carlo Maratta, and some master drawings. It was also rich in coins, gems and other small antiquities (later bought by Frederick I of Prussia). From the early 1650s he was a member of the Accademia di S. Luca and also closely involved with the French Academy in Rome when it opened in 1666. In 1670 Clement X made him Commissioner of Antiquities for Rome and Lazio (a role which he had already performed unofficially for some years under Alexander VII, substituting for the ailing Leonardo Agostini q.v.). He stayed in post until 1694, when he was over 80 (he was succeeded by Raffaele Fabretti q.v.). He also served as antiquary/librarian to Christina of Sweden from about 1680 until her death in 1689. He published widely, mainly on art, painters and painting, but he was a gifted numismatist and antiquary, collaborating with Pietro Santi Bartoli (q.v.) on many of his books. He died in 1696.

Francesco Bianchini[14] was born in 1662 in Verona and moved to Rome in 1684 to join Cardinal Pietro Ottoboni, future Pope Alexander VIII. In 1685 he contributed a disquisition (on measuring the parallax of the planets from a single point) to Ciampini's mathematical academy, but then abandoned astronomy and embarked instead on a history of the world, *La istoria universale*. Published in 1697, the book included (on p. 86) an image of Saturn drawn 'from the famous books of the Cavalier dal Pozzo, in which he has preserved precious documents regarding Antiquity and this above the others, in so far as it is the only whole figure of Saturn that I have yet found in all the copies of monuments of every kind, both Greek and Roman, in drawings, prints or original marbles, inside or outside Rome that I have sought with considerable study'. The image is

a detail from an illustration to the Calendar of AD 354, in the *Nettuno* volume (RL 11372, see A. VI), in its turn a copy from drawings which Peiresc had sent to Girolamo Aleandro in 1620 (BAV, Barb. lat. 2154, fol. 8). In 1703 Bianchini was 'President of Antiquities of Rome', charged by Clement XII with the protection of ancient monuments, overseeing excavations on the Aventine and Palatine. Among many projects left unfinished at his death in 1729 was a history of the Church based on the surviving artefacts and monuments, for which he also wanted to create a *Museo di antichità sacra*. Both endeavours were taken up and completed in the 1750s by his nephew Giuseppe Bianchini (q.v.) and one of Giuseppe's sources was Carlo Antonio's volume of Christian antiquities (see p. 20), tracked down in the library of Alessandro Albani, to whom Francesco had once been tutor.

Giuseppe Bianchini[15] born in Verona in 1704, nephew of Francesco, who took a close interest in his education. In 1725 he was made a canon in the Cathedral Chapter at Verona and spent several years cataloguing the remarkable collection of manuscripts there, encouraged by Scipione Maffei. In 1732 he joined the Congregation of the Oratory at the Chiesa Nuova in Rome, where he set to work cataloguing the manuscripts in the Biblioteca Vallicelliana and preparing his uncle's unfinished works for publication, one of which was the *Liber Pontificalis*. The most challenging was the *Historia Ecclesiastica* in which Francesco Bianchini had not got beyond the first century AD. In 1752–4 Giuseppe published the first three parts; the fourth (3rd–4th centuries) was announced but never completed. Other major projects (see above p. 19) drew his attention and his health had started to fail. He died in 1764.

Marcantonio Boldetti[16] was born in 1663 and entered the service of Cardinal Gasparre Carpegna in 1689. In 1700 he was appointed Custodian of Relics and Catacombs, remaining in the post until his death in 1749. He discovered the catacomb of Commodilla on the via Ostiense (near S. Paolo f.l.m.) and wrote a book *Osservazioni sopra i cimiterj de'Santi Martiri ed antichi cristiani di Roma*, which by his own ad-

mission took him far too long, not being published until 1720, by which time on the subject of gold-glass and similar issues Buonarroti and others had pre-empted him.

Filippo Buonarroti[17] was born in 1661 and came to Rome from Florence in 1684 to join Cardinal Carpegna's service as secretary and curator of his museum and library. There he met Ciampini (q.v.), becoming a member of his academy, as well as Fabretti (q.v.), by whom he was also befriended, and Scipione Maffei and Francesco Bianchini (q.v.). In the early 1690s he collaborated with Ciampini on field trips recording inscriptions and other antiquities from Rome to Città Castellana and Tarquinia. In 1698 he published an acclaimed study of the Cardinal's coin cabinet, *Osservazioni istoriche sopra alcuni medaglioni antichi*, then returned to Florence the following year, where he worked on and eventually published in 1716 a comprehensive account of the Cardinal's gold-glass, *Osservazioni sopra alcuni frammenti di vasi antichi di vetro ornati di figure trovati nei cimiteri di Roma* (see **249–82**), with an appendix on consular diptychs (see **241**). He died in 1733.

Gaspare Carpegna (Carpineo)[18] was born in Rome in 1625. Having first served as usher to Flavio Chigi, Cardinal nephew of Pope Alexander VII, then as usher to the Rota, he rose to real power under Clement X (Altieri, *reg.* 1670–76) when he was made Cardinal Vicario of Rome, a post which he held for 44 years, until his death in 1714. In 1672 his office was made responsible for the excavation and protection of martyr relics and catacombs.[19] Various papal edicts had been issued from the late 16th century onwards forbidding unlicensed digging for relics, without much effect. Under the new regulations all previous licences were revoked and members of Carpegna's household enjoyed a virtual monopoly on new explorations. As a result, the Cardinal assembled a significant museum of 'Christian antiquities'—one of the first and certainly the largest of its kind. It was especially rich in coins, medallions, gems, gold-glass, ivory, bone and other small objects found in the catacombs as grave markers. Some earlier cabinets had included Christian items, notably that assembled by the Chigi, but

Carpegna's was practically an official museum of the Church, his authority as Custodian of Relics allowing—even expecting—him to safeguard many of the latter on his own premises. Donated by his heirs to the Vatican Library in 1741, his collections went on to form the core of Benedict XIV's *Museo Cristiano* (see above p. 19).

Fabio Chigi (Alexander VII)[20] was born in 1599 in Siena. His family were on good terms with the Barberini, and in 1629 Urban VIII sent him as vice legate to Ferrara, then to Malta in 1634–9, after which he was papal nuncio at Cologne. Made a Cardinal in 1652, he grew in power and influence during the last years of Innocent X's reign and succeeded him as pope in 1655. He was a great builder and restorer, creating St Peter's square and the Scala Regia in the Vatican, and enlarging the Quirinal palace (Pietro da Cortona oversaw the painting of the Galleria), making the squares in front of the Pantheon and S. Maria sopra Minerva, opening up the Via del Corso, developing the university and its library (Biblioteca Alessandrina). He was an enthusiastic collector of ancient coins, medals, and gems, and protector of Allacci, Holstenius, Kircher, Ughelli, Nicio and Pallavicino. He died in 1667.

Flavio Chigi[21] born in Siena in 1631, nephew of Fabio Chigi (Alexander VII) was created Cardinal in 1657 and became a significant patron of the arts and architecture. In 1661 he began to make an important collection of ancient statues, purchasing new discoveries made in and around Rome and having them restored by Bernini's pupils. By the mid 1660s he had also installed a museum in a *casino* in the garden he owned on the Quirinal at Quattro Fontane, apparently building upon a collection begun some time before and previously housed in his castle at Formello. An inventory taken in 1705 ran to 837 entries, listing over a thousand items, ranging from natural curiosities, birds, fish, sea shells, minerals and fossils to arms and armour, Turkish, Chinese and Japanese costume, and from contemporary painted pottery, lamps, medallions, artists' clay and wax models to Etruscan and Roman vases, statuettes gems, cameos, with a particu-

lar predilection for carved ivory, rock crystal and gold-glass. Following Chigi's death in 1693 the sculpture was bought by Baron Le Plat in 1728 for the Royal collection in Dresden; the gold-glass from the *casino* cabinet was purchased by the Vatican Library in 1746.[22]

Giovanni Giustino Ciampini[23] was born in Rome in 1633 and studied law at Macerata, taking his degree in 1667. As one of Francesco Barberini's last protégés in the 1670s, he made a successful career in the papal Curia, combining this with the study of ecclesiastical history and archaeology as well as mathematics and physics. Interested in Palaeochristian and Early Medieval liturgy, in 1688 he produced the first edition of the *Liber Pontificalis,* and in 1690 the first part of what was to have been a four-part work on the iconography of Early Christian mosaics and other church decoration in Rome: *Vetera monimenta in quibus Musiva praecipuè Opera Sacrarum, profanarumque Aedium Structura, ac nonnulli antiqui Ritus, Dissertationibus, Iconibusque illustrantur* (the second and only other part which he completed appeared in 1699, after his death). In 1693 he published a study of Constantinian buildings in the city, *De sacris aedificiis a Constantino Magno constructis synopsis historia,* a remarkable attempt to establish a method of dating buildings on the basis of their formal characteristics and constructional techniques, in which he shows himself very aware of the importance of making accurate surveys and copies. His house near S. Agnese in the Piazza Navona—packed with statues, inscriptions, antiquities of all kinds, a huge library, early codices and prolific correspondence[24]—was the venue for both an academy of mathematics (founded in 1677 and supported by Queen Christina of Sweden until she died in 1689) and meetings of other scholarly churchmen with an equal interest in Christian antiquity. He died accidentally of mercury poisoning while experimenting in 1698.

Raffaele Fabretti[25] was born 1618 in Urbino. Trained as a lawyer and an expert legal draughtsman, he spent nine years as part of Cardinal Lorenzo Imperiali's embassy in Spain (1655–64) returning to Italy via Paris, where he met Jean Mabillon and Bernard de Montfaucon, keeping up the contact thereafter by correspondence. From 1673 he was employed by Carpegna in drafting papal edicts and other documents, but by 1680 had found time to write an account of the ancient aqueducts of Rome,[26] which involved considerable fieldwork, and in 1683 published a monograph on Trajan's Column and other essays.[27] During 1687–9 he held the post of Custodian of Relics and Catacombs (see above), with Cardinal Carpegna's permission to keep whatever finds interested him for his own museum.[28] His principal interest was epigraphy, and he possessed several hundred inscriptions, which he planned to install in the family house in Urbino. Given free run of the Barberini epigraphic and manuscript collections (the work of Allacci, Holstenius and others), in the last decade of his long life he devoted himself to completing his largest work *Inscriptionum antiquarum* (1699) cataloguing 4,876 examples, 428 of them his own, and including a sizeable section on Christian epitaphs. He died in 1700.

Jacopo Grimaldi[29] was born *c.* 1560 in Bologna and joined the Vatican as a supernumary cleric in 1581, becoming sacristan, archivist and then beneficiary of St Peter's (1602). Also a public notary, he was an indefatigable chronicler, primarily of the history of Old St Peter's but also other medieval monuments in Rome, collecting quantities of archival information and drawings for Cardinal Federico Borromeo in Milan (Biblioteca Ambrosiana) and other patrons. Other manuscripts are preserved in the Vatican (BAV), Rome (Biblioteca Casanatense), Florence (BN and Biblioteca Marucelliana) and Paris (BN). He died in January 1623.

Jean L'Heureux (latinized as **Macarius**).[30] Born in 1540(?) at Gravelines in Flanders, he studied philosophy at Louvain and moved to Rome in 1570, staying there for more than 20 years, earning his living by teaching Latin and Greek, and studying Christian archaeology. He was a relative of Philips van Winghe (q.v.) and befriended him during his stay in Rome in 1589–92, looking after his belongings when he died. He travelled extensively in Greece, bringing back a collection of Greek antiquities which he

left in Rome when he moved back to Flanders in the later 1590s. In 1605 he finished writing a commentary on the recent discoveries of Christian paintings and sculpture *Hagioglypta sive picturae et sculpturae sacra antiquiores, praesentim quae Romae reperiuntur explicatae,* and corresponded with Peiresc and Hieronymous van Winghe regarding its publication, but he died in 1614 and the project eventually failed (the work was not published until 1856, in Paris, edited by R. Garrucci).

Lucas Holste(nius)[31] was born in 1596 in Hamburg. He studied medicine at Leiden, then devoted himself to the study of ancient Greek philology and philosophy, visiting Italy and Sicily in 1618, then England in 1622. By 1624 he was in Paris, employed as librarian to Henri duc de Mesmes, and was introduced to Peiresc, who in his turn introduced him to Francesco Barberini and the French legation of 1625. That same year he converted to Roman Catholicism and in 1627, perhaps on the recommendation of Girolamo Aleandro, Francesco Barberini invited him to Rome to be his secretary; he became Barberini's librarian from 1636. In 1641 he was made a *custode* at the Vatican Library, and promoted to *primo custode* in 1653. Although he published little during his lifetime he maintained a prolific correspondence[32] and was renowned for his learning, especially as an epigrapher, but also in ancient and modern geography, biblical antiquity, Neoplatonism, Greek patristics, papal and monastic history. Sponsored by Francesco Barberini he undertook several long expeditions around Italy during the years 1637–49 recording inscriptions. In 1655 Alexander VII (Fabio Chigi) made him one of his *famiglia* and one of the *consulta rota* and sent him on various diplomatic missions, including one to Innsbruck, to accompany Queen Christina of Sweden to Rome. He died in 1661.

Jean Mabillon[33] was born in 1632 in Rheims. He entered the Benedictine order, and later ordained as a Dominican priest. He was principally a historian but carried out valuable archaeological studies. His study of ancient military diplomas *De re diplomatica* (Paris 1681) and its supplement (Paris 1704), in attempting to define the rules for their interpretation also provided useful principles for the investigation of other kinds of monuments. Though mainly based in Paris, Mabillon often travelled in pursuit of his research and with Michel Germain visited Italy in 1685–6, spending several months in Rome looking at early medieval sites and monuments. Their main contacts were Ciampini and Fabretti (qq.vv.), and the group went on various expeditions, in company also with Emanuele Schelstrate (1649–92) from Antwerp, Prefect of the Vatican Library and a canon of St Peter's.[34] One trip was to the Catacomb of Castulus near the Porta Maggiore, where excavations had just found several intact 'holy bodies'.[35] Mabillon was allowed by Cardinal Carpegna to keep one of the bodies, together with the glass phials and a serrated iron implement (compare **301**), which were believed to denote a martyr: the phials (often discolored reddish brown) were thought to contain the martyr's blood and the implement to be his or her instrument of martyrdom.[36] On the afternoon of 25 January 1686, introduced by Carlo Antonio's kinsman Giovanni Battista Palaggi (Abbot of St Anastasia and one-time usher to Francesco Barberini),[37] Mabillon also met the eighty-year old Carlo Antonio dal Pozzo and subsequently based three illustrations in the published account of his journey *Iter Italicum* (1687) on dal Pozzo drawings (**150, 230–36**).

Claude Menestrier[38] was born in the village of Vauconcourt near Jussey (Franche-Comté) of a family impoverished by war and pillage. Orphaned at an early age, he went to seek his fortune first in Spain and then in Italy, where he found an education and became a skilled antiquary. In 1626 he entered the service of Francesco Barberini, employed in various capacities as copyist, antiquary and museum curator, and was given a canonry at Besançon in 1632. He assembled a 'cabinet' of his own and dealt in antiquities and other collectables, counting Peiresc among his most important customers from 1629 to 1637. He died in 1639.

Nicolas-Claude Fabri de Peiresc[39] was born in 1580 in Aix-en-Provence. He travelled in Italy from 1599 to 1602, studying at Pisa (where he

met Galileo) and Rome (where he met Antonio Bosio), then returned to Aix-en-Provence, where he stayed for the rest of his life, corresponding with an international community of scholars. He was particularly interested in astronomy and science. Meeting Cassiano and Carlo Antonio dal Pozzo in October 1625, when they visited France as part of the entourage of Francesco Barberini's legation, he subsequently enlisted their help for his studies of ancient tripods, the shapes and capacity of vases, weights and measures and various other projects (see Lhote/Joyal 1989). He died in 1637.

Joseph-Marie Suarès[40] was born in 1599 at Avignon, where his father was *auditeur* to the local Rota. Entering the papal service in the early 1620s he first served as secretary to Cardinal Giovanni Francesco Guidi di Bagno, nuncio in Brussels, whence he was temporarily seconded to Francesco Barberini's French legation of 1625. He then joined the Barberini household in Rome, as secretary to Francesco and as *cameriere* to Urban VIII, who nominated him Bishop of Vaison-la-Romaine in 1633. In 1666 he resigned the bishopric and returned to Rome to be Prefect of the Vatican Library until his death in 1677. An able but hardly outstanding scholar he nonetheless published widely—on liturgy, the history of the Church and the popes, antiquity and antiquities (especially coins), including a study of ancient Palestrina *Praenestes antiquae* (Rome 1655) and *De Numismatis & Nummis Antiquis* (Rome 1668, Amsterdam 1683). His last work was a *Discorso sopra una medaglia trovata nuovamente nel Palazzo de' Signori Barberini* (Rome 1677).

Pietro Testa[41] was born in Lucca in 1612, son of a dealer in second-hand goods. Self taught until the late 1620s, when he went to Rome and became a pupil of Domenichino (and later, briefly, of Pietro da Cortona), he soon acquired a reputation for fine draughtsmanship and was employed by Cassiano dal Pozzo during the 1630s (and perhaps the early 1640s) in drawing ancient statues and reliefs for the Paper Museum. He was also one of the group of artists employed by Joachim von Sandrart in making drawings for the publication of the Marchese Vincenzo Giustiniani's great collection of statues and reliefs (*Galleria Giustiniani*, 2 vols, Rome 1636–7).[42] After struggling against circumstance and his own nature to make a career as a painter and printmaker, he drowned in the Tiber in 1650.

Philips van Winghe,[43] born in 1560 at Louvain in Flanders, of noble family. Educated in the humanist tradition, he developed a keen interest in the study of antiquity, visiting Paris in 1587 and then Rome, arriving in the autumn of 1589. He stayed three years in the city, where he met his fellow countryman Jean L'Heureux (q.v.) and other scholars of the Early Christian church, notably Alfonso Ciaconio (see p. 48) and Cesare Baronio (Volume One, p. 46f.). His Roman diary-notebook survives (Brussels, Royal Library 17872–3) containing hundreds of classical and medieval inscriptions and sketches of other monuments. A talented artist, he developed a particular interest in catacomb paintings and sarcophagi (1590–92 saw some spectacular new discoveries) and he is known to have made many of his own detailed drawings, of which Ciaconio acquired copies. In the summer of 1592 van Winghe went to Florence to see the Medici collections, caught malaria and died. His books and papers were sent to his brother Hieronymus, canon at Tournai, who lent the notebook to Peiresc (q.v.) during 1612–23 and also supplied him with copies of Philips' drawings, in connection with plans to publish them as illustrations to L'Heureux's *Hagioglypta*.[44] The originals are lost but two almost identical series of copies exist, one in a codex in the Vatican (BAV, Vat. lat. 10545), which bears the name of Claude Menestrier (q.v.), the other in Paris (BN, nouv. acq. lat. 2343), once owned by Dionysius de Villers, friend and colleague of Hieronymus at Tournay Cathedral. Menestrier's copies are probably those made for Peiresc.[45]

NOTES

1. Barabesi 1926; *DBI* i, p. 464f. [anon.]; Fileri 1991, pp. 106–15; Ridley 1992, p. 132f.; Sparti 1992, pp. 54, 83, 175.

2. For the inventory of his collection of small objects in metal, see Fileri 1991, pp. 115–19.

3. *DBI* ii, p. 135f. [A. Asor-Rosa].

4. *DBI* ii, p. 148f. [S. G. Mercati].

5. *DBI* ii, pp. 467–71 [D. Musti].

6. *DBI* iii, p. 241f. [A. Buiatti].

7. *Enciclopedia Cattolica* I (1948), p. 1899 [A. Ferrua]; *Lexicon für Theologie und Kirche* 1 (1993), col. 972 [P. Dückers].

8. *DHGE* 4 (1925), p. 169f. [R. Aigran].

9. Pastor *Papi* xiii–xiv.2 *passim*; *DBI* iv, pp. 166–70 [A. Merola]; *DBI* vi, pp. 172–6 [A. Merola]; Haskell 1963, pp. 24–61.

10. Petrucci Nardelli 1985.

11. Pio *Vite* pp. 136–8; Pascoli *Vite* pp. 228–33; *DBI* vi, pp. 586–8 [L. Petrucci]; Ridley 1992, p. 133f.; Pomponi 1992. For further discussion of his work in connection with the Paper Museum see H. Whitehouse, introduction to Volume A.I of this catalogue.

12. Petrucci Nardelli 1985, pp. 173–6.

13. Bellori 1730, preface; *DBI* vii, pp. 781–9 [K. Donahue]; Heres 1978; Ridley 1992, p. 132f.

14. Mazzoleni 1735; *DBI* x, pp. 187–94 [S. Rotta]; Ridley 1992.

15. *DBI* x, pp. 200–205 [S. Rotta].

16. *DBI* xi, pp. 247–9 [N. Parise].

17. *DBI* xv, pp. 145–7 [N. Parise]; Gallo 1986.

18. *DBI* xx, pp. 589–91 [G. Romeo].

19. Ferretto 1942, pp. 201–3.

20. *DBI* ii, pp. 205–15 [M. Rosa].

21. Incisa della Rocchetta 1925 and 1966; *DBI* xxiv, pp. 747–51 [E. Stumpo].

22. Pietrangeli 1985, p. 32.

23. *DBI* xxv, pp. 136–43 [S. Grassi Fiorentino].

24. Described by F. Bianchini, *La istoria universale* Rome 1697, pp. 150, 212. The 1747 edition of *Ve-tera monimenta* includes his biography as the preface to volume I.

25. *DBI* xliii, pp. 739–42 [M. Ceresa].

26. *De aquis et aqueductis veteris Romae disceptationes tres*, Paris and Rome 1680.

27. *De Colonna Traiana syntagma*, Rome 1683; second edition 1690.

28. Fabretti 1699, preface.

29. Müntz 1877; Ferretto 1942, pp. 103, 181–4; *Enciclopedia Cattolica* vi, p. 1167 [C. Carletti].

30. *DACL* ix, 1 (1930), cols 75–8 [H. Leclercq]; Schuddeboom 1996, pp. 50–56.

31. *NDB* 9, pp. 548–50 [P. Fuchs].

32. Selections are published in *Lucae Holstenii epistolae ad diversos..*, J. F. Boissonade (ed.) 1817, and L.-G. Pélissier, 'Les amis de Holstenius–lettres inédites', *Mélanges d'archéologie et d'histoire* 6, 1886, pp. 554–87; 7, 1887, pp. 62–128.

33. *DACL* x, 1 (1931), cols 427–724 [H. Leclercq]; Ferretto 1942, pp. 173–6; H. Leclercq, *Mabillon*, 2 vols, Paris 1953–7.

34. Mabillon, *Iter Italicum*, pp. 73–4 (to the villa Montalto and Baths of Caracalla), 78 (Catacombs of Callixtus, Praetextatus and Lucina, and the Circus of Maxentius), 81–6 (S. Lorenzo fuori le mura, S. Agnese fuori le mura, Fidenae), 90 (Catacomb of St Cyriac and S. Lorenzo fuori le mura, St Hippolytus, then via the Lateran to the Catacombs of SS. Peter and Marcellinus and St Matteo in Esquilino), 97 (St Anastasia). Schelestrato's *Antiquitas Ecclesiae dissertationibus, monumentis ac notis illustrata* (The Antiquity of the Church illustrated by documents, monuments and records), a work he had first published in Antwerp in 1678, was reprinted in Rome in 1692 (the second volume sometime after 1697).

35. *Iter Italicum*, p. 135f.

36. For the longstanding debate on how martyrs' graves might be distinguished from those of ordinary Christian dead, in which Marcantonio Boldetti (q.v.) took a major part, see Ferretto 1942, pp. 248–68.

37. *Iter Italicum*, pp. 142–3. See also Valery 1846, p. 416 and I, 213.

38. Tamizey de Larroque *Lettres*, V, pp. iv–vi; Bresson 1975.

39. Gassendi 1641; Tamizey de Larroque *Lettres*; Bresson 1975; Lhote/Joyal 1989; Jaffé 1989.

40. Niceron xxii, pp. 297–305; *DTC* xiv, col. 2637f. [É. Amann].

41. Passeri/Hess p. 183; Baldinucci, V, pp. 479–80 bis; *Testa* cat.1988; Turner 1992; *MDA* 30, pp. 525–9 [J. Clifton].

42. Cropper 1992.

43. De Rossi 1865; Hoogewerf 1927; Schuddeboom 1996.

44. Schuddeboom 1996, pp. 66–70.

45. For both series and the connection with Peiresc see Schuddeboom 1996, *passim*.

CONCORDANCE D

Royal Library inventory numbers, 'Pozzo' numbers, and Catalogue Raisonné numbers of drawings in this volume

RL no.	Pozzo	Catalogue	Subject of Drawing
8938	113	A.II.202	Painting or manuscript?: Byzantine imperial family
8966	56	A.II.177	Apse mosaic of Old StPeter's, Rome
8975	578	A.II.194	Mural?: Madonna and Child
9033	—-	A.II.179	Apse mosaic of S. Andrea cata Barbara
9063	—-	A.II.197	Votive painting at S. Severino
9067	—-	A.II.171	Ciaconio copy, Catacomb of Domitilla, Rome
9068	324	A.II.227	Sarcophagus with strigillated decoration
9069	—-	A.II.284	Gold(?) medallion: the Ascension of Christ
9070	—-	A.II.285	Gold(?) medallion: the Flight into Egypt
9071	724	A.II.174	Inscription set in the façade wall of S. Bibiana, Rome
9072	—-	A.II.228	Sarcophagus: Crossing of the Red Sea
9073	—-	A.II.205	Roman Vergil
9074	—-	A.II.204	Roman Vergil
9075	—-	A.II.290	Gem of glass paste
9076	683	A.II.296	Bronze statuette (?): praying woman
9077	—-	A.II.172	Inscription on triumphal arch of S. Paolo fuori le mura, Rome
9078	741	A.II.175	Brick stamp of the Emperor Constans
9079	686	A.II.291	Byzantine cameo, three intaglios and a coin
9080	713	A.II.283	Bronze disc with the busts of Saints Peter and Paul
9081	682	A.II.295	Three views of a bronze statuette of St Peter
9082	350	A.II.300	'Instruments of Martyrdom': shackles and chains
9083	351	A.II.301	'Instruments of Martyrdom': knife and scraper
9084	163	A.II.225	Sarcophagus: scenes from the Life of Christ
9085	31	A.II.224	Sarcophagus: scenes from the Life of Christ
9086	30	A.II.223	Sarcophagus: story of Jonah
9087	29	A.II.222	Ciaconio copy: sarcophagus: the Fiery Furnace
9088	1166A	A.II.187	Mural: S. Silvestro chapel, S. Martino ai Monti, Rome
9089	1166B	A.II.188	Mural: St Sixtus, S. Martino ai Monti, Rome
9090	1166C	A.II.189	Mural: Madonna and Child, S. Martino ai Monti, Rome
9091	1166D	A.II.190	Mural: Madonna and Child, S. Martino ai Monti, Rome
9092	1166E	A.II.191	Mural: Christ with four saints, S. Martino ai Monti, Rome
9093	1166F	A.II.192	Mural: S. Silvestro chapel, S. Martino ai Monti, Rome
9094	1153	A.II.195	Mosaic in the apse of S. Agata Maggiore, Ravenna
9095	1154	A.II.196	Mosaic in the dome of the Arian baptistery, Ravenna
9096	977	A.II.181	Mural: Martyrdom of St Sebastian, Lateran Palace, Rome
9097	979	A.II.182	Mural: oratory of St Thomas, S. Giovanni in Laterano, Rome
9098	839	A.II.201	Painting(?) of the Lamentation
9099	887-8	A.II.299	Two metal objects: a pin and a clasp (?)
9100	968	A.II.200	Arms of the family of Pope Urban VI (?)

RL no.	Pozzo	Catalogue	Subject of Drawing
9101	—	A.II.198	Oculus in church of S. Lorenzo 'in castro Montis Iovis'
9101v	—	A.II.199	detail of a heraldic device(?) ibid.
9102	1102	A.II.248	Ivory relief plaque: Jupiter
9103	1099	A.II.246	Ivory relief plaque: sFaun
9104	1100	A.II.247	Ivory relief plaque: Youthful Pan and maenad
9105	1017	A.II.245	Ivory or bone hairpins(?): two small female busts
9106	1029	A.II.249	Gold-glass: Saints Peter and Paul
9107	1031	A.II.250	Gold-glass: Saints Peter and Paul
9108	1050	A.II.251	Gold-glass: portrait of a Late Roman official
9109	1032	A.II.252	Gold-glass: Saints Peter and Paul
9110	1024	A.II.253	Gold-glass: Saints Peter and Paul
9111	1035	A.II.254	Gold-glass: St Agnes
9112	1030	A.II.255	Gold-glass: Christ blessing Julius and Electus
9113	1027	A.II.256	Gold-glass: St Agnes with two doves on pedestals
9114	1053	A.II.257	Gold-glass: Raising of Lazarus and the Miracle at Cana
9115	1028	A.II.258	Gold-glass: Raising of Lazarus
9116	1018	A.II.259	Gold-glass: Good Shepherd
9117	1059	A.II.260	Gold-glass: eight figures
9118	1020	A.II.261	Gold-glass: charioteer and four horses
9119	1103	A.II.262	Gold-glass: Minerva with Hercules
9120	1027	A.II.263	Gold-glass: two youths and a column with monogram of Christ
9121	1054	A.II.264	Gold-glass: Christ crowning Saints Peter and Paul
9122	1042	A.II.265	Gold-glass: married couple Palin and Egazosa
9123	1060	A.II.266	Gold-glass: married couple
9124	1036	A.II.267	Gold-glass: married couple, crowned by Christ (?)
9125	1056	A.II.268	Gold-glass: Saints Lawrence and Cyprian
9126	1026	A.II.269	Gold-glass: married couple with a wreath and scrolls
9127	1163	A.II.270	Gold-glass: family group
9128	1162	A.II.271	Gold-glass: Christ and St Stephen
9129	1037	A.II.272	Gold-glass: married couple
9130	1164	A.II.273	Gold-glass: portrait busts of Simon and John
9131	1033	A.II.274	Gold-glass: married couple, Martura and Epictetus
9132	1039	A.II.275	Gold-glass: one of the Magi (?)
9133	1055	A.II.276	Gold-glass: two figures with a bird on a column
9134	433	A.II.277	Gold-glass: Christ and the Miracle of the Loaves
9135	1040	A.II.278	Gold-glass: nude praying figure
9136	1041	A.II.279	Gold-glass: basket of loaves
9137	1019	A.II.280	Gold-glass: St Callistus
9138	1034	A.II.281	Gold-glass: man in toga holding an open book
9139	1038	A.II.282	Gold-glass: man in toga
9140	1178	A.II.292	Bronze lamp with alien handle, chains and inscribed plaque
9141	1175	A.II.293	Pottery lamp: Christ as the Good Shepherd
9142	1175	A.II.294	Another copy of 9141
9143	1176	A.II.286	Small bronze disc: the Good Shepherd and biblical scenes
9144	—	A.II.185	Head of Christ: mural in S. Urbano alla Caffarella, Rome
9145	1012	A.II.184	Winged male figure: mural in S. Urbano alla Caffarella, Rome
9146	1011	A.II.183	Christ's body: mural in S. Urbano alla Caffarella, Rome
9146A	—	A.II.186	Figure of Christ: S. Maria in Monticelli?
9147	1188	A.II.206	Benedictio fontis: Christ and four angels
9148	—	A.II.207	Benedictio fontis: the bishop approaches the baptismal font

RL no.	Pozzo	Catalogue	Subject of Drawing
9149	—-	A.II.208	Benedictio fontis: illuminated monogram VD
9150	—-	A.II.209	Benedictio fontis: dove and two angels
9151	—-	A.II.210	Benedictio fontis: three angels and three demons
9152	—-	A.II.211	Benedictio fontis: Four Rivers of Paradise
9153	—-	A.II.212	Benedictio fontis: two miracles from the life of Moses
9154	—-	A.II.213	Benedictio fontis: marriage feast at Cana
9155	—-	A.II.214	Benedictio fontis: baptism of Christ
9156	—-	A.II.215	Benedictio fontis: Crucifixion
9157	—-	A.II.216	Benedictio fontis: ceremony of baptism
9158	—-	A.II.217	Benedictio fontis: blessing of the Paschal candle
9159	—-	A.II.218	Benedictio fontis: blowing on the font
9160	—-	A.II.219	Benedictio fontis: baptism of the children
9161	810	A.II.244	Ivory panaghiarion
9162	—-	A.II.303	Magnetic stone (calamite)
9163	—-	A.II.302	Device for experiments with magnetism
9164	965	A.II.180	Mural in S. Andrea cata Barbara, Rome
9165	900-1	A.II.167	Ciaconio copy: three saints from mosaics in Rome
9166	904	A.II.168	Ciaconio copy: St Peter, Pope Leo III and Charlemagne, Rome
9167	902	A.II.169	Ciaconio copy: Pope Leo III, from S. Susanna, Rome
9168	903	A.II.170	Ciaconio copy: Charlemagne, from S. Susanna, Rome
9169	803	A.II.287	Disc or medallion: Trigram of the name Jesus
9170	849	A.II.288	Disc or medallion: Trigram of the name Jesus
9171	910	A.II.289	Three discs or medallions, one with the Resurrected Christ
9172	957	A.II.178	Mosaic in apse of S. Andrea cata Barbara, Rome
9173	119	A.II.237	Relief: 'Madonna and Child'
9174	132	A.II.238	Relief: 'Madonna and Child'
9175	118	A.II.239	Relief: Christ healing the Blind Man (?)
9176	558	A.II.193	Plan and elevation of Roman building with Christian mural
9177	114	A.II.241	Ivory diptych of Anastasius
9177A	—-	A.II.242	Inscriptions and monograms from two consular diptychs
9178	—-	A.II.243	Ivory triptych
9179	—-	A.II.173	Sketch of a church apse
9180	637	A.II.298	Statue or statuette?: St Hilaria
9181	268	A.II.240	Relief: 'The Adoration of the Magi'
9182	—-	A.II.231	Sarcophagus of Fl. Julius Catervius at Tolentino: back
9183	—-	A.II.230	Sarcophagus of Fl. Julius Catervius at Tolentino: front
9184	—-	A.II.232	Sarcophagus of Fl. Julius Catervius at Tolentino: left end
9185	—-	A.II.233	Sarcophagus of Fl. Julius Catervius at Tolentino: right end
9186	665	A.II.234	Sarcophagus of P. Aelius Sabinus at Tortona: short sides
9187	663	A.II.235	Sarcophagus of P. Aelius Sabinus at Tortona: front
9188	664	A.II.236	Sarcophagus of P. Aelius Sabinus at Tortona: back
9189	371	A.II.229	Sarcophagus: copy of 9072
9190	323	A.II.226	Sarcophagus: praying woman and shepherds
9191	[1]	A.II.220	Sarcophagus: scenes from the life of Christ
9191v	—-	A.II.221	Reverse image of 9191 and unrelated sketch of four figures
9192	9	A.II.164	Ciaconio copy: mosaic in apse of S. Agata dei Goti, Rome
9193	—-	A.II.163	Ciaconio copy: mosaic in apse of S. Agata dei Goti, Rome
9194	—-	A.II.165	Ciaconio copy: mosaic in apse of S. Agata dei Goti, Rome
9195	—-	A.II.166	Ciaconio copy: mosaic in apse of S. Agata dei Goti, Rome
9196	—-	A.II.176	Mosaic in apse of S. Pudenziana, Rome

CONCORDANCE E:

Drawings in this Volume:
'Pozzo' numberings and mount types, 17th-century location or source

1. Numbered drawings with type A mounts

RL no.	'Pozzo'	Cat.no.	Subject/location/attribution/date	Collection or source
9087	29	A.II.222	sarcophagus. Rome	?
9086	30	A.II.223	sarcophagus. Rome	?
9085	31	A.II.224	sarcophagus. Rome	?
8938	113	A.II.202	Byzantine imperial family	?
9177	114	A.II.241	consular diptych. Liège	Suarès
9175	118	A.II.239	relief. Unlocated. Testa 1630's	?
9173	119	A.II.237	relief. Unlocated. Testa 1630's	?
9174	132	A.II.238	relief. Unlocated. Testa 1630's	?
9084	163	A.II.225	sarcophagus. Rome. Testa 1630's	?
9190	323	A.II.226	sarcophagus. Rome. Testa 1630's	Barberini
9189	371	A.II.229	sarcophagus. Rome. Testa 1630's	copy of RL 9072 (table 2)
9191	[1]	A.II.220	sarcophagus. Rome. c. 1600-10	Bosio-Severano?

2. Unnumbered drawings, type B mounts

RL no.	'Pozzo'	Cat.no.	Subject/location/attribution/date	Collection or source
9067	—	A.II.171	catacomb paintings, Rome 1630's?	Ciaconio MS bib. Vallicelliana
9077	—	A.II.172	arch S. Paolo f.l.m. Rome 1592?	16th century notebook
9179	—	A.II.173	a church apse. Rome? c. 1600	16th century notebook
9196	—	A.II.176	mosaic S. Pudenziana. Rome	?Barberini
9033	—	A.II.179	mosaic S. Andrea cata Barbara	?
9144	—	A.II.185	S. Urbano alla Caffarella. Rome	?
9146A	—	A.II.186	S. Maria in Monticelli. Rome. Print	?
9101-A	—	A.II.198-9	oculus. S. Lorenzo Monte Giove	?
9074	—	A.II.204	illumination Roman Vergil 1630's	BAV original manuscript
9073	—	A.II.205	illumination Roman Vergil 1630's	BAV original manuscript
9072	—	A.II.228	sarcophagus. Rome. Testa 1630's	Severano/Testa?
9183-5	—	A.II.230-3	sarcophagus. Tolentino. 1630's?	?
9177A	—	A.II.242	diptych inscriptions	Settala, Milan?
9178	—	A.II.243	ivory triptych	Casanate
9069-70	—	A.II.284-5	medallion	?
9075	—	A.II.290	gem	?
9162-3	—	A.II.302-3	magnetic devices. Leonardi 1621-46	?

3. Numbered drawings with type B mounts:

RL no.	'Pozzo'	Cat.no.	Subject/location/attribution/date	Collection or source
9192-96	9	A.II.164	mosaic S. Agata dei Goti, Rome. Eclissi 1630-44	Ciaconio MS BAV
9181	268	A.II.240	relief. Testa 1630's (?)	?
9068	324*	A.II.227	sarcophagus. Testa 1630's	?
9134	433	A.II.277	gold-glass	Carpegna
9176	558	A.II.193	Roman building c.1666	=Barb.lat.4426
8966	566	A.II.177	apse of St Peter's, Rome	oil painting, Orsini?
8975	578	A.II.194	Madonna and child	?
9180	637	A.II.298	St Hilaria	?
9187	663	A.II 235	sarcophagus Tortona 1655	Settala
9188	664	A.II.236	sarcophagus Tortona 1655	Settala
9186	665	A.II.234	sarcophagus Tortona 1655	Settala
9081	682	A.II.295	bronze statuette	Bellori (by 1665)
9076	683	A.II.296	bronze statuette	?Bellori
9079	686	A.II.291	cameo, gems, coin	?
9080	713	A.II.283	bronze disc	Barberini
9071	724	A.II.174	inscription S. Bibiana, Rome	
9078	741	A.II.175	brickstamp	?
9169	803	A.II.287	disc	?
9161	810	A.II.244	ivory panaghiarion	?
9098	839	A.II.201	painting?	?
9170	849	A.II.288	disc	?
9099	887-8	A.II.299	pin and clasp?	?
9165	900-1	A.II.167	mosaics, Rome	Ciaconio MS Bib.Angelica
9167	902	A.II.169	mosaic, Rome	Ciaconio MS Bib.Angelica
9168	903	A.II.170	mosaic, Rome	Ciaconio MS Bib.Angelica
9166	904	A.II.168	mosaic, Rome	Ciaconio MS Bib.Angelica
9171	910	A.II.289	three discs	?
9172	957	A.II.178	mosaic. S.Andrea Cata Barbara	
9164	965	A.II.180	mural. S.Andrea Cata Barbara	
9100	968	A.II.200	coat-of-arms	?
9096	977	A.II.181	mural. Lateran, Rome	?
9097	979	A.II.182	mural. Lateran, Rome	?
9146	1011	A.II.183	S. Urbano alla Caffarella	?
9145	1012	A.II.184	S. Urbano alla Caffarella	?
9105	1017	A.II.245	ivory/bone hairpins	Carpegna?
9116	1018	A.II.259	gold-glass	Chigi
9137	1019	A.II.280	gold-glass	Carpegna?
9118	1020	A.II.261	gold-glass	Fabretti
9110	1024	A.II.253	gold-glass	Fabretti
9126	1026	A.II.269	gold-glass	Carpegna
9113	1027.1	A.II.256	gold-glass	Carpegna
9120	1027.2	A.II.263	gold-glass	Carpegna
9115	1028	A.II.258	gold-glass	Carpegna
9106	1029	A.II.249	gold-glass	Carpegna
9112	1030	A.II.255	gold-glass	Carpegna
9107	1031	A.II.250	gold-glass	Carpegna

3. Numbered drawings with type B mounts (continued):

RL no.	'Pozzo'	Cat.no.	Subject/location/attribution/date	Collection or source
9109	1032	A.II.252	gold-glass	Carpegna
9131	1033	A.II.274	gold-glass	Carpegna
9138	1034	A.II.281	gold-glass	Carpegna
9111	1035	A.II.254	gold-glass	Carpegna
9124	1036	A.II.267	gold-glass	Carpegna
9129	1037	A.II.272	gold-glass	Carpegna
9139	1038	A.II.282	gold-glass	Carpegna
9132	1039	A.II.275	gold-glass	Carpegna
9135	1040	A.II.278	gold-glass	Carpegna
9136	1041	A.II.279	gold-glass	Carpegna
9122	1042	A.II.265	gold-glass	Carpegna
9108	1050	A.II.251	gold-glass	Chigi
9114	1053	A.II.257	gold-glass	Chigi
9121	1054	A.II.264	gold-glass	Chigi
9133	1055	A.II.276	gold-glass	Chigi
9125	1056	A.II.268	gold-glass	Chigi
9117	1059	A.II.260	gold-glass	Chigi
9123	1060	A.II.266	gold-glass	Chigi
9103	1099	A.II.246	ivory plaque	Carpegna?
9104	1100	A.II.247	ivory plaque	Carpegna?
9102	1102	A.II.248	ivory plaque	Carpegna?
9119	1103	A.II.262	gold-glass	Fabretti
9094	1153	A.II.195	mosaic. Ravenna	?
9095	1154	A.II.196	mosaic. Ravenna	?
9128	1162	A.II.271	gold-glass	Carpegna
9127	1163	A.II.270	gold-glass	Carpegna
9130	1164	A.II.273	gold-glass	Fabretti
9088-93	1166	A.II.187-92	S. Martino ai Monti. Rome	Barb.lat.4405
SMS67.2	1169	A.II.297	bronze statuette	= 683 ?Bellori
9141	1175	A.II.293	pottery lamp	Bellori
9142	1175	A.II.294	same	Bellori
9143	1176	A.II.286	bronze disc	Carpegna
9140	1178	A.II.292	bronze lamp	Bellori
9147-60	1188	A.II.206-19	Benedictio fontis	Casanate
SMS104	1228	A.II.304	mosaic floor. Rome	?

4. Numbered drawings not mounted:

RL no.	'Pozzo'	Cat.no.	Subject/location/attribution/date	Collection or source
9082	350	A.II.300	'Instruments of martyrdom' Leonardi 1621-46	?
9083	351	A.II.301	'Instruments of martyrdom' Leonardi 1621-46	?

5. Unnumbered,, unknown mount type

RL no.	'Pozzo'	Cat.no.	Subject/location/attribution/date	Collection or source
9063	—	A.II.197	Votive Painting at S. Severino (Mount lost)	

BIBLIOGRAPHY

Institutions:

BAV	Vatican, Biblioteca Apostolica
Kew	London, Royal Botanic Gardens Library
London, BL	London, British Library
London, BM	London, British Museum
London, NHM	London, British Museum (Natural History)
London, V&A	London, Victoria & Albert Museum
Montpellier, BEM	Montpellier, Bibliothèque, École de Médecine
Naples, BN	Naples, Biblioteca Nazionale
Paris, BN	Paris, Bibliothèque Nationale
Paris, IF	Paris, Institut de France
RL	Windsor, Royal Library
Rome, BAL	Rome, Biblioteca dell'Accademia Nazionale dei Lincei

Books, articles and manuscripts:

AA. SS.
Acta Sanctorum
Acta sanctorum quotquot toto orbe coluntur, vel a Catholicis scriptoribus celebrantur, quae, collegit, digessit, notis illustravit Johannes Bollandus (and others), 68 vols, Antwerp (etc.) 1643–1940 (December still in progress).

Acconci 1991
A. Acconci, 'Le vicende storico-monumentali della chiesa di S. Maria in Portico', in *Giornata di studi su Santa Galla (Roma, 26 maggio 1990)*, Rome 1991, pp. 89–117.

Age of Spirituality cat. 1979
The Age of Spirituality, K. Weitzmann (ed.), exhib. cat., Metropolitan Museum of Art, New York 1979.

Aleandro 1626
G. Aleandro, *Navis Ecclesiam referentis symbolum, in veteri gemma annulari insculptum, explicatione illustratum*, Rome 1626.

Alemanni 1625
N. Alemanni, *De Lateranensibus parietinis*, Rome 1625.

Alessandrini 1978
A. Alessandrini, *Cimeli lincei a Montpellier (Indici e susside bibliografici della Biblioteca, Accademia dei Lincei, no. 11)*, Rome 1978.

Amedick 1991
R. Amedick, *Die Sarkophage mit Darstellungen aus dem Menschenleben*. IV. *Vita Privata* (= *Die antiken Sarkophagreliefs*, I, 4, B. Andreae and G. Koch eds), Berlin 1991.

Andaloro 1992
M. Andaloro, 'Pittura romana e pittura a Roma da Leone Magno a Giovanni VII', in *Committenti e produzione artistico-letteraria nell'alto medioevo occidentale*, Spoleto 1992, pp. 569–609.

Andrews 1968
K. Andrews, *Catalogue of Italian Drawings, National Gallery of Scotland*, 2 vols, Cambridge 1968.

d'Aniello 1994
A. d'Aniello, 'Salerno, museo diocesano, *Exultet*', in G. Cavallo (ed.), *Exultet. Rotoli liturgici del medioevo meridionale*, Rome 1994, pp. 393-407.

Aringhi *Roma Subterranea* — P. Aringhi, *Roma Subterranea Novissima*, 2 vols, Rome 1651.
Armellini/Cecchelli 1942

Armellini/Cecchelli 1942 — M. Armellini, *Le Chiese di Roma dal secolo IV al XIX*, C. Cecchelli (ed.), Rome 1942.

Ashby 1904 — T.A. Ashby, 'Some account of a volume of epigraphic drawings now preserved in the British Museum', *Classical Review* xviii, 1904, pp. 70–75.

Ashby 1913 — T.A. Ashby, 'Addenda and corrigenda to "Sixteenth-century Drawings of Roman buildings attributed to Andreas Coner"', *Papers of the British School at Rome* vi, 1913, pp. 184–210.

Ashpitel 1862 — A. Ashpitel, *Catalogue of the Architectural MSS and Drawings in the Royal Library at Windsor Castle*, 1862, unpublished MS, Print Room, Royal Library.

Assunto 1973 — R. Assunto, *L'antichità come futuro*, Rome 1973.

Avery 1938 — M. Avery, *The Exultet Rolls of South Italy*, Princeton 1938.

Avetta 1985 — *Roma - Via Imperiale. Scavi e scoperte (1937–1950) nella costruzione di Via delle Terme di Caracalla e di Via Cristoforo Colombo*, L. Avetta (ed.), Rome 1985.

Baglione *Nove chiese* — G. Baglione, *Le nove chiese di Roma*, Rome 1639.

Bailey 1980 — D. Bailey, *A Catalogue of the Lamps in the British Museum 2. Roman Lamps made in Italy*, London 1980.

Bailey 1992 — D. Bailey, 'Small objects in the Dal Pozzo-Albani drawings. Early gatherings', in *Quaderni puteani* 2, pp. 3–30.

Baldinucci — F. Baldinucci, *Notizie dei professori del disegno da Cimabue in qua*, 6 vols, Florence 1681–1728; 2nd edn, 5 vols, Florence 1845.

Barabesi 1926 — R. Barabesi, 'L'antiquario Leonardo Agostini e la sua terra di Boccheggiano', Maremma 3 (1926-7), pp. 149-89.

Barclay Lloyd 1981 — J. Barclay Lloyd, 'The medieval church of S. Maria in Portico in Rome', *Römische Quartalschrift* lxxvi, 1981, pp. 95–106.

Barclay Lloyd 1989 — J. Barclay Lloyd, *The Medieval Church and Canonry of S. Clemente in Rome*, Rome 1989.

Baretti 1798 — G. Baretti, *Dizionario delle Lingue Italiana ed Inglese*, London 1798.

Barocchi 1985 — P. Barocchi, *L'Accademia Etrusca*, Milan 1985.

Baronio e l'Arte — *Baronio e l'Arte (Atti del Convegno Internazionale di Studi, Sora, 10–13 ottobre 1984)*, R. De Maio *et al.* (eds), Sora 1985.

Baronio 1587 — C. Baronio, *Martyrologium Romanum…*, Venice 1587.

Baronio 1588 — C. Baronio, *Annales ecclesiastici*, 12 vols, Rome 1588–1607.

Barsanti/Guiglia Guidobaldi 1992 — C. Barsanti and A. Guiglia Guidobaldi, 'Gli elementi della recinzione liturgica ed altri frammenti minori nell'ambito della produzione scultorea protobizantina', in *San Clemente. La scultura del VI secolo (San Clemente Miscellany IV, 2)*, Rome 1992, pp. 67–320.

Bartoli 1994 — C. Bartoli, 'Bartolomeo Cavaceppi famoso scalpellino e i restauri per il Museo Sacro di Benedetto XIV', in *Bartolomeo Cavaceppi scultore romano (1717–1799)*, M.G. Barberini and C. Gasparri (eds), exhib. cat., Palazzo Venezia, Rome 1994, pp. 37–50.

Bartoli/Bellori *Antiche lucerne* — P.S. Bartoli and G.P. Bellori, *Le antiche lucerne sepocrali figurate*, Rome 1691.

Basile 1988 — G. Basile, M. Bianca Paris, G. Serangeli, 'Il restauro degli affreschi del portico di San Lorenzo fuori le mura a Roma', *Arte Medievale* II ser. ii/2, 1988, pp. 205–40.

Becatti 1969 — G. Becatti, *Scavi di Ostia VI: Edificio con 'opus sectile' fuori Porta Marina*, Rome 1969.

Beger *Lucernae veterum* L. Beger, *Lucernae veterum sepulchrales iconicae ex cavernis Romae subterraneis collectae, et à Petro Santi Bartoli, cum observationibus J. Petri Bellorii, ante decennium editae*, Col. Marchicae 1702.

Bellori 1664 G.P. Bellori, *Nota delli Musei, Librarie, Gallerie, & Ornamenti di Pitture ne' Palazzi, nelle Case e ne' Giardini di Roma*, Rome 1664.

Bellori 1730 P. Bellori, *Annotationes in XII priorum Caesarum numismata*, Rome 1730.

Belting 1976 H. Belting, 'I mosaici dell' aula Leonina come testimonianza della prima "renovatio" nell' arte medievale di Roma', in *Roma e l'età carolingia*, Rome 1976, pp. 167–82.

Bénézit E. Bénézit, *Dictionnaire critique et documentaire des Peintres, Sculpteurs, Dessinateurs et Graveurs...*, 8 vols, Paris 1948.

Bertaux 1903 E. Bertaux, *L'Art dans l'Italie méridionale*, Paris/Rome 1903.

Bertaux 1978 *L'Art dans l'Italie méridionale. Aggiornamento dell'opera di Emile Bertaux*, Rome 1978.

Bertelli 1970 C. Bertelli, 'Calendari', *Paragone* ccxlv, July 1970, pp. 53–60.

Bertoldi 1994 M.E. Bertoldi, *S. Lorenzo in Lucina* (Le chiese di Roma illustrate n.s. 28), Rome 1994.

Bianchini *Anastasius* *Anastasii Bibliothecarii de vitis Romanorum Pontificum a B. Petro Apostolo ad Nicolaum I. Adjectis vitis Hadriani II. et Stephani VI. autore Guillelmo Bibliothecario*, etc. (Nunc tertium proderunt, cum auctario variantum lectionum..per Lucam Holstenium, et Emmanuelem à Schelestrate, additis etiam plurimis collectis ex veteri Cod. MS. Cavensi à Francesco Penia...cum praefatione, & indice...opera et studio Francisci Blanchini) 4 vols, Rome 1718-35.

Bianchini *Demonstratio* G. Bianchini, *Demonstratio Historiae Ecclesiasticae quadripartitae comprobatae monumentis pertinentibus ad fidem Temporum et Gestorum* 1 volume in 3 parts, 1 volume of plates, Rome 1754.

Bibl. Sanct. *Bibliotheca Sanctorum*, 12 vols, Rome 1961–70.

Bignami-Odier 1973 J. Bignami-Odier, *La Bibliothèque Vaticane de Sixte IV à Pie XI: Recherches sur l'histoire des collections de manuscrits* (Studi e testi 272), Vatican City 1973.

Blunt 1945 A. Blunt, *The French Drawings...at Windsor Castle*, Oxford/London 1945.

Blunt 1965 A. Blunt, 'Poussin and his Roman patrons', in *Walter Friedlaender zum 90. Geburtstag*, Berlin 1965, pp. 58–75.

Blunt 1971 A. Blunt, 'Italian drawings: addenda and corrigenda', in E. Schilling, *The German drawings in the collection of Her Majesty the Queen at Windsor Castle*, London 1971, pp. 47–206.

Blunt/Cooke 1960 A. Blunt and H.L. Cooke, *The Roman drawings of the XVII and XVIII Centuries in the collection of Her Majesty The Queen at Windsor Castle*, London 1960.

Boldetti 1720 M.A. Boldetti, *Osservazioni sopra i cimiteri de' santi martiri ed antichi cristiani di Roma*, Rome 1720.

Bosio *Historia Caeciliae* A. Bosio, *Historia passionis B. Caeciliae Virginis, Valeriani, Tiburtii, et Maximi Martyrum necnon Urbani, et Lucii Pontificum, et Mart. vitae ...*, Rome 1600.

Bosio *Roma Sotterranea* A. Bosio, *Roma Sotterranea*, G. Severano (ed.), Rome 1632 [1635].

Bottari G.G. Bottari, *Sculture e pitture sagre estratte dai cimiterj di Roma pubblicate gia dagli autori della Roma Sotterranea ed ora nuovamente date in luce colle spiegazioni*, 3 vols, Rome 1737–54.

Bovini 1964 G. Bovini, 'Identificato il pannello dell' estremità destra della fronte d'un sarcofago romano strigilato del III secolo', *Römische Quartalschrift* lix, 1964, pp. 100–102.

Braham/Hager 1977 A. Braham and H. Hager, *Carlo Fontana: the Drawings at Windsor Castle*, London 1977.

Brenk 1975 B. Brenk, *Die frühchristlichen Mosaiken in S. Maria Maggiore zu Rom*, Wiesbaden 1975.

Brenk 1994 B. Brenk, 'Casanatense 724 (B I 13)', in *Exultet. Rotoli liturgici del Medioevo meridionale*, G. Cavallo (ed.), Rome 1994, pp. 87–100.

Bresson 1975 A. Bresson, 'Peiresc et le commerce des antiquités à Rome', *Gazette des Beaux-Arts* 6th ser., vol. 85, no. 1273 (February 1975), pp. 61-72.

Briquet C.M. Briquet, *Les filigranes: dictionnaire historique des marques du papier dès leur apparition vers 1282 jusqu'en 1600*, facsimile of the 1907 edn, Allan Stevenson (ed.), Amsterdam 1968.

Buonarroti 1716 F. Buonarroti, *Osservazioni sopra alcuni frammenti di vasi antichi di vetro ornati di figure trovati ne' cimiteri di Roma*, Florence 1716.

Busuioceanu 1924 A. Busuioceanu, 'Un ciclo di affreschi del secolo XI: S. Urbano alla Caffarella', *Ephemeris Dacoromana* ii, 1924, pp. 1–65.

Byzance cat. 1992 *Byzance: l'art byzantin dans les collections publiques françaises*, exhib. cat., Musée du Louvre, Paris 1992.

Byzantium cat.1994 *Byzantium. Treasures of Byzantine Art and Culture from British Collections*, D. Buckton (ed.), exhib. cat. British Museum, London 1994.

Caetani *Vita Gelasio II* D.C. Caetani, *Vita del pontefice Gelasio II*, Rome 1638.

Calza 1977 *Antichità di Villa Doria Pamphilj*, R. Calza (ed.), Rome 1977.

Campanella 1631 T. Campanella, *Atheismus Triumphatus Seu Reductio ad Religionem per scientiarum Veritates*, Rome 1631.

Carloni 1995 L. Carloni, 'Luoghi filippini nelle Marche. Le fondazioni più antiche', in *Regola e fama* cat. 1995, pp. 210-29.

Cassiano cat. 1993 *The Paper Museum of Cassiano dal Pozzo*, exhib. cat., British Museum, London 1993. *Quaderni puteani* 4, Milan (Olivetti) 1993.

Carteggio Puteano *Il Carteggio di Cassiano dal Pozzo*, Rome BAL, 39 vols.

Cavazzi 1908 L. Cavazzi, 'S. Passera', in *La diaconia di S. Maria in Via Lata e il monastero di S. Ciriaco*, Rome 1908, pp. 278–307.

Cecamore 1989 C. Cecamore, 'Pitture antiche nel codice Barberiniano Latino 4413 (XLIV, 22)', *Xenia* 18, 1989, pp. 77–92.

Cecchelli 1924a C. Cecchelli, 'La Madonna di S. Maria in Portico', *Roma* ii, 1924, pp. 25–35, 149–60.

Cecchelli 1924b C. Cecchelli, 'Il mosaico absidale', in C. Hülsen *et al.*, *S. Agata dei Goti*, Rome 1924, pp. 29–37.

Cecchelli 1930 C. Cecchelli, *San Clemente* (Le chiese di Roma illustrate 24–25), Rome n.d. [1930].

Cecchelli 1956 C. Cecchelli, *I mosaici della basilica di Santa Maria Maggiore*, Turin 1956.

Cecchelli 1991 M. Cecchelli, '"Valilae" o "valide"? L'iscrizione di S. Andrea all'Esquilino', *Romanobarbarica* 11, 1991, pp. 61–78.

Cervone 1983 R. Cervone, 'L'apporto umbro di Maestro Paolo da Gualdo', in *Il Quattrocento a Viterbo*, exhib. cat., Rome 1983, pp. 313–23.

Ciaconio *Historia* A. Ciaconius, *Historia utriusque belli Dacici a Traiano Cesare gesti ex simulacris quae in eiusdem columna Romae visuntur*, Rome 1576.

Ciampini *Vet. mon.* G. Ciampini, *Vetera monimenta, in quibus praecipue musiva opera sacrarum, profanarumque aedium structura, ac nonnulli antiqui ritus, dissertationibus iconibusque illustrantur*, 2 vols, Rome 1690, 1699.

Ciampini G. Ciampini, *Sacra historica disquisitio de duobus emblematibus in cimelio Em. Gasparris Carpinei osservantur*, Rome 1691.
De duobus emblematibus

Ciampini *De sacris aedificiis* G. Ciampini, *De sacris aedificiis a Constantino magno constructis*, Rome 1693.

CIL *Corpus Inscriptionum Latinarum*, Berlin 1862– (in progress).

Claussen 1980 P. Claussen, 'Der Wenzelsaltar in Alt St. Peter. Heiligenverehrung, Kunst und Politik unter Karl IV', *Zeitschrift für Kunstgeschichte* 43, 1980, pp. 280–99.

Cod. Vat. Sel. *Codices e Vaticanis Selecti phototypice expressi*, vols I– Rome 1899– (in progress).

Concina 1983 E. Concina, 'Componenti ideologiche ed istanze politiche nella cultura antiquaria del primo settecento veneto', in *Piranesi e la cultura antiquaria*, pp. 141–7.

Conze A. Conze, *Die attischen Grabreliefs*, 8 vols (in 6), Berlin 1881–1922.

Cristofani 1983 M. Cristofani, 'Le opere teoriche di G. B. Piranesi e l'etruscheria', in *Piranesi e la cultura antiquaria*, pp. 211–20.

Cropper 1988 E. Cropper, 'Pietro Testa, 1612-1650: The Exquisite Draughtsman from Lucca', in *Testa* cat. 1988, pp. xi–xxxvi.

Cropper 1992 E. Cropper, 'Vincenzo Giustiniani's "Galleria"', in *Quaderni puteani* 3, pp. 101-26.

Cropper/Dempsey 1996 E. Cropper and C. Dempsey, *Nicolas Poussin: Friendship and the Love of Painting*, Princeton 1996.

Curzi 1993 G. Curzi, 'La decorazione musiva della basilica dei SS. Nereo ed Achilleo in Roma: materiali ed ipotesi', *Arte Medievale* vii/2, 1993, pp. 21–45.

Cutler 1995 A. Cutler, 'From loot to scholarship: changing modes in the Italian response to Byzantine artifacts ca. 1200–1700', *Dumbarton Oaks Papers* 49 (1995), pp. 237–67.

D'Achille 1991 A.M. D'Achille, 'La Scultura', in *Roma nel Duecento*, pp. 145–235.

DACL *Dictionnaire d'archéologie chrétienne et de liturgie*, F. Cabrol and H. Leclercq (eds), 15 vols, Paris 1907–57.

Dal Pane 1959 L. Dal Pane, *Lo Stato pontificio e il movimento riformatore del settecento*, Milan 1959.

Dassmann 1970 E. Dassmann, 'Das Apsismosaik von S. Pudentiana in Rom', *Römische Quartalschrift* lxv, 1970, pp. 67–81.

Dati 1664 C. Dati, *Delle lodi del Commendatore Cassiano dal Pozzo*, Florence 1664.

Davis-Weyer 1965 C. Davis-Weyer, 'Das Apsismosaik Leos III. in S. Susanna', *Zeitschrift für Kunstgeschichte* 28, 1965, pp. 177–94.

Davis-Weyer/ Emerick 1984 C. Davis-Weyer and J. Emerick, 'The early sixth-century frescoes at S. Martino ai Monti in Rome', *Römisches Jahrbuch für Kunstgeschichte* 21, 1984, pp. 1–60.

DBI *Dizionario Biografico degli Italiani*, vols i– Rome 1960– (in progress).

De Angelis 1621 P. De Angelis, *Basilicae S. Mariae Maioris de urbe Descriptio et Delineatio*, Rome 1621.

Deichmann 1958 F.W. Deichmann, *Frühchristliche Bauten und Mosaiken von Ravenna*, Baden-Baden 1958.

Deichmann 1967 *Repertorium der christlich-antiken Sarkophage*, I, *Rom und Ostia*, F.W. Deichmann (ed.), Wiesbaden 1967.

Deichmann *Ravenna* F.W. Deichmann, *Ravenna. Hauptstadt des spätantiken Abendlandes*, 2 vols, Wiesbaden 1969–89.

Delbrueck 1929 R. Delbrueck, *Die Consulardiptychen und verwandte Denkmäler*, Berlin 1929.

Delehaye 1943 H. Delehaye, 'Saints de Tolentino. La "Vita S. Catervi"', *Analecta Bollandiana* lxi, 1943, pp. 5–28.

Dempsey 1989 C. Dempsey, 'Poussin's "Sacrament of Confirmation", the scholarship of "Roma Sotterranea", and dal Pozzo's Museum chartaceum', in Solinas 1989a, pp. 244–61.

De Rossi *Musaici cristiani* G.B. De Rossi, *Musaici cristiani e saggi di pavimenti delle chiese di Roma anteriori al secolo XV*, 27 fascicules, Rome 1872–99.

De Rossi *Roma Sotterranea* G.B. De Rossi, *La Roma Sotterranea Cristiana*, 3 vols, Rome 1864–77.

De Rossi 1864 G.B. De Rossi, 'Frammenti d'un vetro cemeteriale adorno delle immagini degli apostoli Pietro e Paolo', *Bullettino di Archeologia Cristiana* ii, 1864, pp. 81–7, with a chromatic plate.

De Rossi 1865 G.B. De Rossi, 'Disegni di Filippo de Winghe ritraenti monumenti sotterranei e sarcofagi cristiani di Roma', *Bullettino di Archeologia Cristiana* iii, 1865, p. 80.

De Rossi 1867 G.B. De Rossi, 'I monumenti del secolo quarto spettanti alla chiesa di s. Pudenziana', *Bullettino di Archeologia Cristiana* V (1867), pp. 49-60.

De Rossi 1870 G.B. De Rossi, 'Della singolare lucerna nella quale è effigiato il pastore con i busti del sole della luna e sette stelle sul capo', *Bullettino di Archeologia Cristiana* 2nd ser. i, 1870, pp. 85–8.

De Rossi 1871 G.B. De Rossi, 'La basilica profana di Giunio Basso sull'Esquilino', *Bullettino di Archeologia Cristiana* 2nd ser. ii, 1871, pp. 5–29, 41–64.

De Rossi 1887 G.B. De Rossi, 'Lamina di bronzo con i busti degli apostoli Pietro e Paolo', *Bullettino di Archeologia Cristiana* 4th ser. 5, 1887, pp. 130–35.

De Sepibus *Musaeum* *Romani Collegii societatis Jesu Musaeum celeberrimum cujus magnum Antiquariae rei, statuarum, imaginum, picturarumque partem...*, G. de Sepibus (ed.), Amsterdam 1678.

De Waal 1889 A. De Waal, 'Ein Christusbild aus der Zeit Leos III', *Römische Quartalschrift* iii, 1889, pp. 386–90.

DHGE *Dictionnaire d'Histoire et de Géographie Ecclesiastiques*, vols 1- Paris 1912- (in progress).

Diehl 1925 E. Diehl, *Inscriptiones Latinae Christianae Veteres*, 3 vols, Berlin 1925–31.

Ditchfield 1992 S. Ditchfield, 'How not to be a counter-reformation saint: the attempted canonization of pope Gregory X, 1622–45', *Papers of the British School at Rome* lx, 1992, pp. 379–422.

Documentary Culture *Documentary Culture in Florence and Rome from Grand-Duke Ferdinand I to Pope Alexander VII*, Papers from a colloquium held at the Villa Spelman, Florence 1990, E. Cropper, G. Perini, F. Solinas (eds), Florence 1992.

DTC *Dictionnaire de Théologie Catholique*, A. Vacant, É. Mangenot, É. Amann (eds), 15 vols, Paris 1899-1950.

Du Cange *De imp. Const.* C. du Fresne, Sieur du Cange, *De imperatorum Constantinopolitarum seu de inferioris aevi vel imperii uti vocant numismatibus dissertatio*, and glossary: *Glossarium ad scriptores mediae et infimae latinitatis*, Paris 1678.

Duchesne 1889 L. Duchesne, 'Le nom d'Anaclet II au palais de Latran', *Mélanges d'Archéologie et d'Histoire* ix, 1889, pp. 355–62.

EAA *Enciclopedia dell'Arte Antica*, 7 vols, Rome 1958–66 and supplements I (1971), II (1994).

EAM *Enciclopedia dell'Arte Medievale*, vols I– Rome 1990– (in progress).

Ehrle 1928 F. Ehrle, 'Dalle carte e dai disegni di Virgilio Spada (codd. Vaticani Lat. 11257 e 11258)', *Atti della Pontificia Accademia Romana di Archeologia. Memorie* ii, 1928, pp. 1–98.

Einaudi 1990 K. Einaudi, '"Fons Olei" e Anastasio Bibliotecario', *Rivista dell'Istituto Nazionale d'Archeologia e Storia dell'Arte* ser. 3 xiii, 1990, pp. 179–222.

Enciclopedia Cattolica *Enciclopedia Cattolica*, 12 vols, Vatican City 1948–54.

Engemann 1968 | J. Engemann, 'Bemerkungen zu spätrömischen Gläsern mit Goldfoliendekor', *Jahrbuch für Antike und Christentum* xi–xii, 1968–9, pp. 7–25.

Enking 1964 | R. Enking, *S. Andrea cata Barbara e S. Antonio abbate sull'Esquilino*, Rome 1964.

Faber 1628 | J. Faber, *Animalia Mexicana descriptionibus scholijsque exposita...*, Rome 1628.

Fabretti 1683, 1690 | R. Fabretti, *De columna Traiani*, Rome 1683; 2nd edn Rome 1690.

Fabretti *Inscript. antiq.* | R. Fabretti, *Inscriptionum antiquarum quae in aedibus paternis osservantur explicatio et additamentum*, Rome 1699.

Fea 1790 | C. Fea, *Miscellanea filologica critica e antiquaria*, 2 vols, Rome 1790.

Ferrari 1633 | G.B. Ferrari, *De Florum Cultura*, Rome 1633.

Ferrari 1646 | G.B. Ferrari, *Hesperides sive de Malorum Aureorum Cultura et Usu Libri Quatuor*, Rome 1646.

Ferretto 1942 | G. Ferretto, *Note storico-bibliografiche di archeologia cristiana*, Vatican City 1942.

Festus | *Sextus Pompeius Festus, De verborum significatione quae supersunt cum Pauli epitome*, C.O. Müller (ed.), Leipzig 1839; W.M. Lindsay (ed.), Leipzig 1913.

Feugère *et al.* 1992 | M. Feugère, M. Thauré, G. Vienne, *Les objets en fer dans les collections du musée archéologique de Saintes (Ier–XVe siècle)*, Saintes 1992

Fileri 1991 | E. Fileri, 'Disegni di "metalli" antichi del Fondo Corsini', *Xenia* 22, 1991, pp. 49–121.

Filippini 1639 | G.A. Filippini, *Ristretto di tutto quello che appartiene all' antichità e veneratione della chiesa de' santi Silvestro e Martino de' Monti di Roma*, Rome 1639.

Fillitz 1993 | H. Fillitz, 'Bemerkungen zum Freskenzyklus im Porticus von S. Lorenzo fuori le mura in Rom', *Wiener Jahrbuch für Kunstgeschichte* xlvi–xlvii, 1993–4, pp. 165–72.

Fleming 1958 | J. Fleming, 'Cardinal Albani's drawings at Windsor: their purchase by James Adam for George III', *The Connoisseur* cxlii, 1958, pp. 164–9.

Fogolari 1900 | G. Fogolari, 'Il Museo Settala. Contributo per la storia della coltura in Milano, nel secolo XVII', *Archivio Storico Lombardo* 27, 1900, pp. 58–126.

Forcella *Iscrizioni* | V. Forcella, *Iscrizioni delle chiese e d'altri edifici di Roma dal secolo XI fino ai giorni nostri*, 14 vols (in 7), Rome 1869–84.

Fragmenta picta cat. 1989 | M. Andaloro, A. Ghidoli, A. Iacobini, S. Romano, A. Tomei, *Fragmenta picta: affreschi e mosaici staccati del medioevo romano*, exhib. cat., Castel S. Angelo, Rome 1989.

Franzoni/Tempesta 1992 | C. Franzoni and A. Tempesta, 'Il Museo di Francesco Gualdi nella Roma del Seicento tra raccolta privata ed esibizione pubblica', *Bollettino d'Arte* ser. VI, no. 73, May-June 1992, pp. 1–42.

Fremiotti 1926 | P. Fremiotti, *La riforma cattolica del secolo decimosesto e gli studi di archeologia cristiana*, Rome 1926.

Gabelmann 1973 | H. Gabelmann, *Die Werkstattgruppen der oberitalischen Sarkophage*, Bonn 1973.

Gaitzsch 1980 | W. Gaitzsch, *Eiserne römische Werkzeuge: Studien zur römischen Werkzeugkunde in Italien und den nördlichen Provinzen des Imperium Romanum*, 2 vols, Oxford 1980.

Galbreath 1930 | D. Galbreath, *Papal Heraldry*, Cambridge 1930.

Galileo 1623 | G. Galilei, *Il Saggiatore...*, Rome 1623.

Galileo 1632 | G. Galilei, *Dialogo...sopra i due massimi sistemi del mondo tolemaico e copernicano*, Florence 1632.

Galli 1934 | G. Galli, 'Relazione', *Atti della Pontificia Accademia Romana di Archeologia. Rendiconti* x, 1934, pp. 68–89.

Gallo 1986	D. Gallo, *Filippo Buonarroti e la cultura antiquaria sotto gli ultimi Medici*, exhib. cat., Florence 1986.
Gardner 1992	J. Gardner, *The Tomb and the Tiara. Curial Tomb Sculpture in Rome and Avignon in the Later Middle Ages*, Oxford 1992.
Garms *et al.* 1994	J. Garms, A. Sommerlechner and W. Telesko, *Die mittelalterlichen Grabmäler in Rom und in Latium vom 13. bis zum 15. Jahrhundert. 2. Band: Die Monumentalgräber*, Vienna 1994.
Garrison 1956a	E. Garrison, 'Contributions to the history of twelfth-century Umbro-Roman painting. Part II, Materials. V. The Italian-Byzantine-Romanesque fusion in the first quarter of the twelfth century', *Studies in the History of Medieval Italian Painting* ii no. 4, Florence 1956, pp. 171–88.
Garrison 1956b	E. Garrison, 'The identity of the frescoed chamber in the Old Lateran Palace', *Studies in the History of Medieval Italian Painting* ii no. 4, Florence 1956, pp. 188–97.
Garrucci 1858	R. Garrucci, *Vetri ornati di figure in oro trovati nei cimiteri dei cristiani primitivi di Roma*, Rome 1858.
Garrucci 1864	= Garrucci 1858 but *Edizione seconda notabilmente accresciuta e corretta con atlante separato in fol. di XLII tavole incise in rame*, Rome 1864.
Garrucci *Arte Cristiana*	R. Garrucci, *Storia della Arte Cristiana nei primi otto secoli della Chiesa*, 6 vols, Prato 1872–81.
Gassendi 1641	P. Gassendi, *Viri illustris Nicolai Claudii Fabrici de Peiresc*, Paris 1641.
Gettens/Stout 1966	R.J. Gettens and G.L. Stout, *Painting Materials: a short encyclopaedia*, New York 1966.
Gigli 1975	L. Gigli, *S. Sebastiano al Palatino*, Rome 1975.
Giunta 1976	D. Giunta, 'I mosaici dell'arco absidale della basilica dei SS. Nereo e Achilleo e l'eresia adozionista del sec. VIII', in *Roma e l'età carolingia*, Rome 1976, pp. 195–200.
Goldman 1978	J. Goldman, *Aspects of Seicento patronage—Cassiano dal Pozzo and the amateur tradition*, unpublished Ph.D. thesis, University of Chicago 1978.
Goldschmidt 1934	A. Goldschmidt and K. Weitzmann, *Die byzantinische Elfenbeinskulpturen des X.–XIII. Jahrhunderts*, Berlin 1934.
Grabar 1955	A. Grabar, 'Portraits oubliés d'empereurs byzantins', *Recueil publié à l'occasion du Cent-cinquantenaire de la Société nationale des Antiquaires de France, 1804–1954*, Paris 1955, pp. 229–33.
Grabar 1968	A. Grabar, *L'Art de la fin de l'Antiquité et du Moyen Age*, 3 vols, Paris 1968.
Grafinger 1993	C.M. Grafinger, *Die Ausleihe Vatikanischer Handschriften und Druckwerke (1563–1700) (Studi e testi* 360), Vatican City.
Grierson 1973	P. Grierson, *Byzantine coins in the Dumbarton Oaks Collection*, 3, *Leo III to Nicephoros III (717–1081)*, Washington DC 1973.
Griffiths 1989	A. Griffiths, 'The Print Collection of Cassiano dal Pozzo', *Print Quarterly* vi, 1989, pp. 2–10.
Gruterus *Inscriptiones*	J. Gruterus, *Inscriptiones antiquae totius orbis Romani*, Heidelberg 1602, 1603.
Guérard 1893	L. Guérard, 'Un fragment de calendrier romain du moyen-âge', *Mélanges d'Archéologie et d'Histoire* xiii, 1893, pp. 153–75.
Guerrini 1972	L. Guerrini, 'La collezione delle sculture', in *Sculture di Palazzo Mattei* (*Studi Miscellanei* xx, Rome 1972), pp. 3–17.
Guidobaldi 1992	F. Guidobaldi, *San Clemente: gli edifici romani, la basilica paleocristiana e le fasi altomedievali* (*San Clemente Miscellany* IV, 1), Rome 1992.

Haskell 1963	F. Haskell, *Patrons and Painters: A Study in the Relations between Italian Art and Society in the Age of the Baroque*, London 1963.
Haskell 1981	F. Haskell, 'La dispersione e conservazione del patrimonio artistico', in F. Zeri (ed.), *Storia dell'arte italiana* 10, Turin 1981, pp. 5–35.
Haskell/Rinehart 1960	F. Haskell and S. Rinehart, 'The Dal Pozzo Collection. Some new Evidence', *Burlington Magazine* CII, no. 688, July 1960, pp. 318–29.
Heawood	E. Heawood, *Watermarks mainly of the 17th and 18th centuries*, Hilversum 1950.
Heres 1978	G. Heres, 'Die Sammlung Bellori: Antikenbesitz eines Archäologen im 17 Jahrhundert', *Études et Travaux* 10, 1978, pp. 5–38.
Herklotz 1985a	I. Herklotz, *"Sepulcra" e "Monumenta" del Medioevo. Studi sull'arte sepolcrale in Italia*, Rome 1985.
Herklotz 1985b	I. Herklotz, 'Historia sacra und mittelalterliche Kunst während der zweiten Hälfte des 16. Jahrhunderts in Rom', in *Baronio e l'Arte*, pp. 21–72.
Herklotz 1992a	I. Herklotz, 'Das Museo Cartaceo des Cassiano dal Pozzo und seine Stellung in der Antiquarischen Wissenschaft des 17. Jahrhunderts', in *Documentary Culture*, pp. 81–125.
Herklotz 1992b	I. Herklotz, 'Cassiano and the Christian Tradition', in *Quaderni puteani* 2, pp. 31–48.
Herklotz 1993	I. Herklotz, review of *Cassiano* cat. 1993, *Burlington Magazine* CXXXV, no. 1085, 1993, p. 573f.
Herklotz 1995	I. Herklotz, 'Francesco Barberini, Nicolò Alemanni, and the Lateran Triclinium of Leo III: an episode in restoration and seicento medieval studies', *Memoirs of the American Academy in Rome* XL (1995), pp. 175-96.
Hernandez 1651	F. Hernandez *et al.*, *Rerum Medicarum Novae Hispaniae Thesaurus, seu plantarum, animalium, mineralium Mexicanorum historia...*, Rome 1651.
Herz 1988	A. Herz, 'Cardinal Cesare Baronio's restoration of SS. Nereo ed Achilleo and S. Cesareo de' Appia', *Art Bulletin* LXX, 1988, pp. 590–620.
Hetherington 1979	P. Hetherington, *Pietro Cavallini: A Study in the Art of Late Medieval Rome*, London 1979.
Hoogewerff 1926	G. Hoogewerff, 'Le tombeau-autel du cardinal Philippe d'Alençon à Sainte-Marie du Trastevere', *Mélanges d'Archéologie et d'Histoire* xliii, 1926, pp. 43–60.
Hoogewerff 1927	G. Hoogewerff, 'Philips van Winghe', *Mededeelingen van het Nederlandsch Historisch Instituut te Rome* vii, 1927, pp. 59–82.
Hübner 1885	E. Hübner, *Scripturae epigraphicae latinae*, Berlin 1885.
Hülsen 1890	C. Hülsen, 'Il "museo ecclesiastico" di Clement XI Albani', *Bullettino della Commissione archeologica comunale di Roma* xviii, 1890, pp. 260–77.
Hülsen 1927	C. Hülsen, 'Die Basilica des Junius Bassus und die Kirche S. Andrea cata Barbara auf dem Esquilin', in *Festschrift für Julius Schlosser zum 60 Geburtstag*, A. Weixlgärtner and L. Planiscig (eds), Zurich 1927, pp. 53–67.
Hülsen *Chiese*	Ch. Hülsen, *Le Chiese di Roma nel Medio Evo*, Florence 1927.
Iacobini 1989a	A. Iacobini, 'Il mosaico absidale di San Pietro in Vaticano', in *Fragmenta picta* cat., pp. 119–29.
Iacobini 1989b	A. Iacobini, 'Il mosaico del Triclinio Lateranense', in *Fragmenta picta* cat., pp. 189–96.
Iacobini 1991	A. Iacobini, 'La pittura e le arti suntuarie: da Innocenzo III a Innocenzo IV (1198–1254)', in *Roma nel Duecento*, pp. 237–319.

ICUR G.B. De Rossi, *Inscriptiones Christianae Urbis Romae Septimo Saeculo Antiquiores*, 2 vols, Rome 1857–88.

ICUR III *Inscriptiones Christianae Urbis Romae. Septimo Saeculo Antiquiores.* New Series vol. III, A. Silvagni and A. Ferrua (eds), Vatican City 1956.

Incisa della Rocchetta 1925 G. Incisa della Rocchetta, 'Il museo di curiosità del cardinale Flavio Chigi seniore', *Roma* iii, 1925, pp. 539–44.

Incisa della Rocchetta 1959 G. Incisa della Rocchetta, 'Una relazione del padre Virgilio Spada', *Archivio della Società Romana di Storia Patria* lxxxii, 1959, pp. 25–78.

Incisa della Rocchetta 1966 G. Incisa della Rocchetta, 'Il museo di curiosità del card. Flavio I Chigi', *Archivio della Società Romana di Storia Patria* lxxxix, 1966, pp. 141–92.

Insalaco 1984 A. Insalaco, 'S. Cesareo de Appia e le terme Commodiane', *Bollettino della Unione Storia ed Arte* n.s. xxvii, 1984, pp. 82–90.

Inventory A Manuscript inventory preserved in the Print Room, Royal Library, dating from the end of the eighteenth century; drawn up by or under the direction of George III's librarian, Richard Dalton.

Ioli 1971 M. Ioli, *Il sarcofago paleocristiano di Catervio nel Duomo di Tolentino*, Bologna 1971.

Iskusstvo vizantii *Iskusstvo vizantii v sobraniiakh SSSR. Katalog vystavki*, A.V. Bank (ed.), 3 vols, Moscow 1977.

Jacks 1993 P. Jacks, *The Antiquarian and the Myth of Antiquity: The Origins of Rome in Renaissance Thought*, Cambridge 1993.

Jaffé 1988 D. Jaffé, *Rubens Self-Portrait*, exhib. cat., National Gallery of Australia, Canberra 1988.

Jaffé 1989 D. Jaffé, 'The Barberini circle: some exchanges between Peiresc, Rubens, and their contemporaries', *Journal of the History of Collections* 1, 1989, pp. 119–47.

Jenkins 1987 I. Jenkins, 'Cassiano dal Pozzo's Museo Cartaceo: new discoveries in the British Museum', *Nouvelles de la République des Lettres*, 1987 (II), pp. 29–41.

Jenkins 1989a I. Jenkins, 'Newly discovered drawings from the Museo Cartaceo in the British Museum', in Solinas 1989a, pp. 131–6, 141–75.

Jenkins 1989b I. Jenkins, 'The "Mutilated Priest" of the Capitoline Museum and a drawing from Cassiano dal Pozzo's "Museo Cartaceo"', *Burlington Magazine* CXXXI, no. 1037, 1989, pp. 543–9.

Jenkins 1992 I. Jenkins, 'Pars pro toto: a muse from the Paper Museum', *Quaderni puteani* 2, pp. 49–65.

Josi 1928 E. Josi, 'Le pitture rinvenute nel cimitero dei Giordani', *Rivista di Archeologia Cristiana* v, 1928, pp. 167–227.

Jounel 1977 P. Jounel, *Le culte des saints dans les basiliques du Latran et du Vatican au douzième siècle*, Rome 1977.

Kanzler 1903 R. Kanzler, *Gli Avori dei Musei Profano e Sacro della Biblioteca Vaticana*, Rome 1903.

Kinney 1975 D. Kinney, *S. Maria in Trastevere from its founding to 1215*, unpublished Ph.D. thesis, New York University 1975.

Kitzinger 1980 E. Kitzinger, 'A Virgin's face: antiquarianism in twelfth-century art', *Art Bulletin* LXII, 1980, pp. 6–19.

Klauser 1958 T. Klauser, 'Studien zur Entstehungsgeschichte der christlichen Kunst I', *Jahrbuch für Antike und Christentum* i, 1958, pp. 20–51.

Klauser 1964 T. Klauser, 'Studien zur Entstehungsgeschichte der christlichen Kunst VII:16. Noch einmal zur heidnischen Herkunft des Bildmotivs der Orans und des Schafträgers', *Jahrbuch für Antike und Christentum* vii, 1964, pp. 67–76.

Klauser 1965 T. Klauser, 'Studien zur Entstehungsgeschichte der christlichen Kunst VIII', *Jahrbuch für Antike und Christentum* viii-ix, 1965–6, pp. 126–70.

Klauser 1967 T. Klauser, 'Ein altchristlicher Sarkophag als Ausgangspunkt einer hagiographischen Legendenbildung', *Jahrbuch für Antike und Christentum* x, 1967, pp. 200–201.

Klauser 1968 T. Klauser, 'Noch einmal der Catervius-Sarkophag von Tolentino', *Jahrbuch für Antike und Christentum* xi-xii, 1968–9, pp. 116–23.

Krautheimer *CBCR* R. Krautheimer *et al.*, *Corpus Basilicarum Christianarum Romae*, 5 vols, Vatican City 1937–77.

Ladner 1931 G. Ladner, 'Die italienische Malerei im 11 Jahrhundert', *Jahrbuch der kunsthistorischen Sammlungen in Wien* n.f. 5, 1931, pp. 33–160.

Ladner *Papstbildnisse* G. Ladner, *Die Papstbildnisse des Altertums und des Mittelalters*, 3 vols, Vatican City 1941–84.

Lafontaine-Dosogne 1980–81 J. Lafontaine-Dosogne, 'Le "Diptychon Leodiense" du consul Anastase (Constantinople 517) et le faux des Musées royaux d'Art et d'Histoire à Bruxelles', *Revue Belge d'Archéologie et d'Histoire de l'Art* 49–50, 1980–81, pp. 5–19.

Lanciani *FUR* R. Lanciani, *Forma Urbis Romae*, Milan 1893–8, reprinted Rome 1990.

Lanciani 1895 R. Lanciani, 'Le "picturae antiquae cryptarum Romanorum"', *Bullettino della Commissione Archeologica Comunale di Roma* xxiii, 1895, pp. 165–92.

Langlois 1886 E. Langlois, 'Le Rouleau d'Exultet de la bibliothèque Casanatense', *Mélanges d'Archéologie et d'Histoire* vi, 1886, pp. 466–82.

Lattimore 1962 R. Lattimore, *Themes in Greek and Latin Epitaphs*, Urbana 1962.

Lauer 1911 P. Lauer, *Le Palais de Latran*, Paris 1911.

Le Bachelet 1930 X. Le Bachelet, 'Immaculée Conception', in *Dictionnaire de Théologie catholique*, VII, Paris 1930, cols 845–1218.

Le Grelle 1910 S. Le Grelle, 'Saggio storico delle collezioni numismatiche vaticane', in C. Serafini, *Le monete e le bolle plumbee pontificie del Medagliere Vaticano* I, Milan 1910, pp. xvi–lxxix.

Letarouilly 1840 P.M. Letarouilly, *Édifices de Rome moderne*, 6 vols, Liège 1840.

Lettere inedite *Lettere inedite di alcuni illustri Accademici della Crusca che fanno testo di lingua*, T. Cicconi (ed.), 2nd edn Florence 1837.

Lhote/Joyal 1989 *Nicolas-Claude Fabri de Peiresc. Lettres à Cassiano dal Pozzo (1626–1637)*, J.-F. Lhote and D. Joyal (eds), Clermont Ferrand 1989.

Liber Pontificalis *Liber Pontificalis*, L. Duchesne (ed.), 2 vols, Paris 1886, 1892.

Licetus *De lucernis* F. Licetus, *De lucernis antiquorum reconditis*, Venice 1621 and 1652, Udine 1653, Padua 1662.

Longhurst 1927 M.H. Longhurst, *Catalogue of carvings in ivory*, Victoria and Albert Museum, London 1927.

Lugli/Ashby 1932 G. Lugli and T. Ashby, 'La basilica di Giunio Basso sull' Esquilino', *Rivista di Archeologia Cristiana* ix, 1932, pp. 221–55.

Lumbroso 1874 G. Lumbroso, 'Notizie sulla vita di Cassiano Dal Pozzo', *Miscellanea di Storia Italiana* xv, 1874, pp. 129–388.

Lumbroso 1875 G. Lumbroso, *Notizie sulla vita di Cassiano Dal Pozzo* (offprint of Lumbroso 1874), Rome 1875.

Lutz 1971 G. Lutz, *Kardinal Giovanni Francesco Guidi di Bagno, Politik und Religion im Zeitalter Richelieus und Urbans VIII*, Tübingen 1971.

Mabillon *Annales*	J. Mabillon (ed.), *Annales Ordinis S. Benedicti Occidentalium Monachorum Patriarchae* 6 vols, Paris 1703-39.
Mabillon *Iter Italicum*	J. Mabillon and M. Germain, *Iter Italicum*, Paris 1687.
Mabillon *Musei italici*	J. Mabillon and M. Germain, *Musei italici*, Paris 1689.
Maccagni 1967	*Galileo Galilei, 1564–1964. Mostra di Documenti e Strumenti Scientifici*, C. Maccagni (ed.), Bologna 1967.
Mackie 1989	G. Mackie, 'The Zeno chapel: a prayer for salvation', *Papers of the British School at Rome* lvii, 1989, pp. 172–99.
Mancinelli 1982	F. Mancinelli, 'La chiesa di San Pellegrino in Vaticano e il suo restauro', *Bollettino dei Monumenti, Musei e Gallerie Pontificie* iii, 1982, pp. 43–62.
Mancinelli 1983	F. Mancinelli, 'Decorazione dell'arco trionfale e del catino absidale della chiesa di S. Pellegrino', *Bollettino dei Monumenti, Musei e Gallerie Pontificie* iv, 1983, pp. 77–80.
Mango 1972	C. Mango, *The Art of the Byzantine Empire, 312–1453. Sources and Documents*, Englewood Cliffs 1972.
Mann 1920	H. Mann, 'The Portraits of the Popes', *Papers of the British School at Rome* ix, 1920, pp. 159–204.
Margiotta 1988	A. Margiotta, 'L'antica decorazione absidale della basilica di San Pietro in alcuni frammenti al Museo di Roma', *Bollettino dei Musei Comunali di Roma* n.s. ii, 1988, pp. 21–33.
Marini 1884	G. Marini, *Iscrizioni antiche doliari*, G.B. De Rossi (ed.), Rome 1884, based on an original manuscript of 1798–9.
Marioni *Vita s. Catervi*	U. Marioni, *Vita gloriosi Iesu Christi martyris sancti Catervi civitatis Tolentini patroni admirabilis*, Macerata 1649.
Marriott 1868	W. Marriott, *Vestiarum Christianum: the origin and gradual development of the dress of the holy ministry in the Church*, London 1868.
Marucchi 1892	O. Marucchi, 'Conferenze di archeologia cristiana', *Bullettino di Archeologia Cristiana* 5th ser. 3, 1892, pp. 18–42.
Matthiae 1948	G. Matthiae, *SS. Cosma e Damiano e S. Teodoro* (Le chiese di Roma illustrate 59), Rome 1948.
Matthiae *S. Pietro*	G. Matthiae, *S. Pietro in Vincoli* (Le chiese di Roma illustrate 54), Rome n.d. [1960?].
Matthiae 1967	G. Matthiae, *Mosaici medioevali delle chiese di Roma*, Rome 1967.
Matthiae/Andaloro 1987	G. Matthiae, *Pittura Romana del Medioevo. I. Secoli IV–X. Aggiornamento scientifico e bibliografia di Maria Andaloro*, Rome 1987.
Matthiae/Gandolfo 1988	G. Matthiae, *Pittura Romana del Medioevo. II. Secoli XI–XIV. Aggiornamento scientifico e bibliografia di Francesco Gandolfo*, Rome 1988.
Matz/Duhn	F. Matz and F. von Duhn, *Antike Bildwerke in Rom mit Ausschluss der grösseren Sammlungen*, 3 vols, Leipzig 1881–2, reprinted Rome 1968.
Mazzoleni 1735	A. Mazzoleni, *Vita di Monsignor Francesco Bianchini Veronese*, Verona 1735.
McBurney 1989a	H. McBurney, 'History and contents of the dal Pozzo collection in the Royal Library, Windsor Castle', in Solinas 1989a, pp. 74–93.
McBurney 1989b	H. McBurney, 'A Short History of the Museo Cartaceo', in *Quaderni puteani* 1, pp. 5–9.
McBurney 1989c	H. McBurney, 'The later history of Cassiano dal Pozzo's "Museo Cartaceo"', *Burlington Magazine* CXXXI, no. 1037, 1989, pp. 549–53.

MDA	*The Dictionary of Art*, J. Turner (ed.), 34 vols, London (Macmillan) 1996.
Métraux 1979	M. Métraux, *The Iconography of San Martino ai Monti in Rome*, unpublished Ph.D. thesis, Boston University 1979.
Michaelis 1874	A. Michaelis, 'Die Privatsammlungen antiker Bildwerke in England', *Archäologische Zeitung* xxxi, 1874, pp. 1–70.
Michaelis 1882	A. Michaelis, *Ancient Marbles in Great Britain*, trans. C. Fennell, Cambridge 1882.
Minisci 1947	T. Minisci, 'L'Accademia Basiliana (1635–1640)', *Bollettino della Badia Greca di Grottaferrata* n.s. i, 1947, pp. 51–4.
Miraeus 1622	A. Miraeus, *Fasti Belgici et Burgundici*, Brussels 1622.
Montfaucon *Ant. Exp.*	B. de Montfaucon, *L'Antiquité Expliquée et Représentée en Figures*, 5 vols (in 10 parts), Paris 1719, and 5 supplementary vols, Paris 1724.
Montfaucon/Galliano 1987	B. de Montfaucon and A. Galliano, *Voyage en Italie-Diarium Italicum: un journal en miettes. Edizione critica*, Geneva 1987.
Montini 1955	R. Montini, 'L'Ordine di Malta a Roma. S. Maria del Priorato sull' Aventino', *Capitolium* xxx, 1955, pp. 103–12.
Montini 1957	R. Montini, *Le Tombe dei Papi*, Rome 1957.
Montini 1960	R. Montini, *S. Pudenziana* (Le chiese di Roma illustrate 50), Rome n.d. [1960].
Morello 1979	G. Morello, 'Il museo cristiano di Benedetto XIV nella Biblioteca Vaticana', in *Benedetto XIV. Atti del Convegno Internazionale di Studi*, 2 vols, Cento 1979, pp. 1119–59.
Morello 1981	G. Morello, 'Il museo "cristiano" di Benedetto XIV', *Bollettino dei Monumenti, Musei e Gallerie Pontificie* xi, 1981, pp. 53–89.
Morey 1915	C.R. Morey, *Lost Mosaics and Frescoes of Rome of the Mediaeval Period*, Princeton 1915.
Morey 1936	C.R. Morey, *Gli Oggetti di Avorio e di Osso del Museo Sacro Vaticano*, Vatican City 1936.
Morey 1959	C.R. Morey, *The Gold-Glass Collection of the Vatican Library*, G. Ferrari (ed.), Vatican City 1959.
Mosin 1973	V. Mosin, *Anchor watermarks*, Amsterdam 1973.
Muñoz 1914	A. Muñoz, *Il restauro della chiesa e del chiostro dei SS. Quattro Coronati*, Rome 1914.
Muñoz 1944	A. Muñoz, *La basilica di S. Lorenzo fuori le mura*, Rome 1944.
Müntz 1877	E. Müntz, 'Recherches sur l'oeuvre archéologique de Jacques Grimaldi', *Bibliothèque des Écoles Françaises d'Athènes et de Rome* i, 1877, pp. 225–69.
Müntz 1888	E. Müntz, 'Les sources de l'archéologie chrétienne dans les bibliothèques de Rome, de Florence et de Milan', *Mélanges d'Archéologie et d'Histoire* viii, 1888, pp. 81–146.
Müntz 1902	E. Müntz, 'Les premiers historiens des mosaiques romaines', in *Mélanges Paul Fabre: Études d'Histoire du Moyen Age*, Paris 1902, pp. 478–95.
NDB	*Neue Deutsche Biographie*, vols 1- Berlin 1953- (in progress).
Nestori 1975	A. Nestori, *Repertorio topografico delle pitture delle catacombe romane*, Vatican City 1975.
Nestori 1992	A. Nestori, 'Alla ricerca del mausoleo di Catervio a Tolentino', in *'Memoriam Sanctorum Venerantes': Miscellanea in onore di Monsignor Victor Saxer*, Vatican City 1992, pp. 599–611.
Nestori *et al.* 1996	A. Nestori, P. Paoloni and G. Alteri, *Il mausoleo e il sarcofago di Flavius Iulius Catervius a Tolentino*, Vatican City 1996

Nibby 1839	A. Nibby, *Roma nell'anno MDCCCXXXVIII. Moderna*. I, Rome 1839.
Niceron	J.-P. Niceron, *Memoires pour servir à l'histoire des hommes illustres dans la République des Lettres avec un catalogue de leurs Ouvrages*, 48 vols, Paris 1718-58.
Nicolò 1991	A. Nicolò, *Il Carteggio di Cassiano dal Pozzo: Catalogo*, Florence 1991.
Nicolò/Solinas 1987	A. Nicolò and F. Solinas, 'Cassiano dal Pozzo: appunti per una cronologia di documenti e disegni (1612–1630)', *Nouvelles de la République des Lettres*, 1987 (II), pp. 59–110.
Nilgen 1981	U. Nilgen, 'Maria Regina—ein politischer Kultbildtypus?', *Römisches Jahrbuch für Kunstgeschichte* 19, 1981, pp. 1–33.
Oakeshott 1967	W. Oakeshott, *The Mosaics of Rome from the Third to the Fourteenth Centuries*, London 1967.
Olina 1622	G.P. Olina, *Uccelliera overo discorso della natura, e proprietà di diversi Uccelli...*, Rome 1622.
Omont 1929	H. Omont, *Miniatures des plus anciens manuscrits grecs de la Bibliothèque Nationale du VIe au XIVe siècle*, Paris 1929.
O'Neil 1985	M.S. O'Neil, 'Stefano Maderno's Saint Cecilia: a Seventeenth-Century Roman Sculpture Remeasured', *Antologia di belle arti* n.s. 25–6, 1985, pp. 9–21.
Osborne 1991a	J. Osborne, 'Lost Roman images of pope Urban V (1362–1370)', *Zeitschrift für Kunstgeschichte* 57, 1991, pp. 20–32.
Osborne 1991b	J. Osborne, 'A drawing of a consular diptych of Anastasius (A.D. 517) in the collection of Cassiano dal Pozzo', *Échos du Monde Antique/Classical Views* xxxv, 1991, pp. 237–42.
Osborne 1993	J. Osborne, 'New evidence for a lost portrait of the family of Michael VIII Palaiologos', *Thesaurismata* xxiii, 1993, pp. 9–13.
Osborne 1994	J. Osborne, 'New evidence for the mural decorations in the apse of S. Pellegrino in Naumachia', *Bollettino dei Monumenti, Musei e Gallerie Pontificie* xiv, 1994, pp. 103–11.
Painter 1987	K. Painter, 'Gold Glasses', in D. Harden *et al.*, *Glass of the Caesars*, exhib. cat., Milan (Olivetti) 1987, pp. 262–8.
Panvinio 1570	O. Panvinio, *De praecipuis urbis Romae sanctioribusque basilicis, quas septem ecclesia vulgo vocant*, Rome 1570.
Paris 1990	R. Paris, 'Il pannello con Hylas e le Ninfe dalla Basilica di Giunio Basso', *Bollettino di Archeologia* 1–2, 1990, pp. 194–202.
Paschini 1923	P. Paschini, 'Il Cardinale d'Alençon e il suo sepolcro a S. Maria in Trastevere', *Roma* i, 1923, pp. 337–44.
Pascoli *Vite*	L. Pascoli, *Vite dei pittori perugini*, Rome 1732.
Pasquali 1904	L. Pasquali, *Santa Maria in Portico nella storia di Roma dal secolo VI al XX*, Rome 1904.
Passeri/Hess	*Die Künstlerbiographien des Giovanni Battista Passeri*, J. Hess (ed.), Leipzig and Vienna 1934.
Pastor *Papi*	L. von Pastor, *Storia dei Papi dalla fine del Medioevo*, P. Cenci (ed.), 17 vols, Rome 1923–36.
Pavan 1977	M. Pavan, *Antichità classica e pensiero moderno*, Florence 1977.
Pedroli Bertoni 1987	M. Pedroli Bertoni, *S. Maria in Campitelli* (Le chiese di Roma illustrate n.s. 21), Rome 1987.
Perret 1851	L. Perret, *Les catacombes de Rome*, 5 vols, Paris 1851.

Perini 1899	D.A. Perini, *Onofrio Panvinio e le sue opere*, Rome 1899.
Petau 1630	D. Petau, *Ad Iuliani opera praefatio in qua de Iuliani ipsius, et uniuerse de gentilium libris*, Paris 1630.
Petrucci Nardelli 1985	F. Petrucci Nardelli, 'Il card. Francesco Barberini senior e la stampa a Roma', *Archivio della Società Romana di Storia Patria* cviii, 1985, pp. 133–98.
Phillips cat. 1990	Sale catalogue Old Master Drawings, 12 December 1990, Phillips, Son & Neale, London.
Pietrangeli 1985	C. Pietrangeli, *I musei Vaticani. Cinque secoli di storia*, Rome 1985.
Pietrangeli 1989	C. Pietrangeli (ed.), *San Paolo fuori le Mura* (Le chiese monumentali d'Italia), Florence 1989
Pietrangeli 1993	C. Pietrangeli, *The Vatican Museums. Five Centuries of History*, Rome 1993.
Pillinger 1984	R. Pillinger, *Studien zu römischen Zwischengoldgläsern. 1. Geschichte der Technik und das Problem der Authentizität* (Österreichische Akademie der Wissenschaften Phil.-Hist. Kl. Denkschriften 110), Vienna 1984.
Pio *Vite*	N. Pio, *Le Vite de' pittori, scultori e architetti*, C. and R. Enggass (eds), Vatican City 1977.
Piranesi e la cultura antiquaria 1983	A. Lo Bianco (ed.), *Piranesi e la cultura antiquaria : gli antecedenti e il contesto* (*Atti del convegno internazionale, Roma 14–17 novembre 1979*), Rome 1983.
PLRE	J.R. Martindale and J. Morris, *Prosopography of the Late Roman Empire*, 3 vols, Cambridge 1971–80.
Pollak 1928	O. Pollak, *Die Kunsttätigkeit unter Urban VIII*, Vienna 1928–31.
Pomponi 1992	M. Pomponi, 'Alcune precisazioni sulla vita e la produzione artistica di Pietro Santi Bartoli', *Storia dell'arte* 27 (1992), pp. 196-225.
Poncelet	A. Poncelet, *Nécrologie de la Province Flandro-Belge*, Wetteren 1931.
Popham/Wilde 1949	A.E. Popham and J. Wilde, *The Italian Drawings of the XV and XVI centuries in the Collection of His Majesty the King at Windsor Castle*, London 1949.
Poussin Actes 1996	*Actes du Colloque Poussin*, A. Merot (ed.), Paris 1996.
Poussin cat. Paris 1994	*Nicolas Poussin (1594–1665)*, P. Rosenberg and L-A. Prat (eds), exhib. cat., Galeries Nationales du Grand Palais, Paris 1994.
Poussin cat. London 1995	*Nicolas Poussin (1594–1665)*, R. Verdi (ed.), exhib. cat., Royal Academy of Arts, London 1995.
Previtali 1964	G. Previtali, *La fortuna dei primitivi. Dal Vasari ai neoclassici*, Turin 1964.
Quaderni puteani 1	*Il museo cartaceo di Cassiano dal Pozzo, Cassiano naturalista. Quaderni puteani 1*, Milan (Olivetti) 1989.
Quaderni puteani 2	*Cassiano dal Pozzo's Paper Museum Volume I* (Proceedings of a conference held at the British Museum and Warburg Institute, London, 14–15 December 1989). *Quaderni puteani 2*, Milan (Olivetti) 1992.
Quaderni puteani 3	*Cassiano dal Pozzo's Paper Museum Volume II* (Proceedings of a conference held at the British Museum and Warburg Institute, London, 14–15 December 1989). *Quaderni puteani 3*, Milan (Olivetti) 1992.
Quaderni puteani 4	*Cassiano* cat. 1993.
Rannusio 1604, 1634	P. Rannusio, *Della guerra di Costantinopoli per la restitutione de gl'Imperatori Comneni fatta da' sig. Venetiani et Francesi, l'anno 1204*, Venice 1604, 2nd edn Venice 1634.
Rasponi *Basilica*	C. Rasponi, *De basilica et patriarchio Lateranensi*, Rome 1656.
Recio Veganzones 1968	A. Recio Veganzones, 'La "Historia descriptio Urbis Romae", obra manuscripta de Fr. Alonso Chacón O.P. (1530–1599)', *Anthológica Annua* xvi, 1968, pp. 44–102.

Recio Veganzones 1969	A. Recio Veganzones, 'Los primeros diseños de sarcófagos cristianos de Roma y el nuevo "Repertorium" de los mismos', *Antonianum* xliv, 1969, pp. 485–511.
Recio Veganzones 1974	A. Recio Veganzones, 'Alfonso Chacón, primer estudioso del mosaico cristiano de Roma y algunos diseños chaconianos poco conocidos', *Rivista di archeologia cristiana* l, 1974, pp. 295–329.
Recio Veganzones 1982	A. Recio Veganzones, 'Fragmentos de sarcófagos paleocristianos ineditos, existentes en Roma o de ella desaparecidos', *Rivista di archeologia cristiana* lviii, 1982, pp. 323–52.
Regola e fama cat. 1995	*La regola e la fama. San Filippo Neri e l'arte*, exhib. cat., Palazzo Venezia, Rome. Milan 1995.
Ridley 1992	R. Ridley, 'To protect the monuments: the papal antiquarian (1534–1870)', *Xenia Antiqua* i, 1992, pp. 117–54.
Righetti 1955a	R. Righetti, 'Opere di glittica dei Musei annessi alla Biblioteca Vaticana', *Atti della Pontificia Accademia Romana di Archeologia. Rendiconti* xxviii, 1955, pp. 279–348.
Righetti 1955b	Righetti 1955 a printed separately with different pagination as *Opere di glittica dei Musei Sacro e Profano*, Vatican City 1955.
Righini 1975	V. Righini, *I bolli laterizi romani. La collezione Di Bagno*, Bologna 1975.
Rinehart 1960	S. Rinehart, 'Poussin et la famille dal Pozzo', in *Nicolas Poussin. Actes de Colloques Internationaux*, Paris 1960, pp. 19–30.
Rinehart 1961	S. Rinehart, 'Cassiano dal Pozzo (1588–1657): some unknown letters', *Italian Studies*, 1961, pp. 35–59.
RIS	*Rerum Italicarum Scriptores ab anno aerae Christianae quingentesimo ad millesimum quingentesimum...*, L.A. Muratori (ed.), Milan 1723–54. New edn, G. Carducci and V. Fiorini (eds), Bologna 1900– (in progress).
Rizzardi 1970	C. Rizzardi, *I sarcofagi paleocristiani con rappresentazione del passaggio del Mar Rosso*, Faenza 1970.
Robert 1890	C. Robert, *Der Pasiphae-Sarkophag* (14 Hallisches Winckelmannsprogramm), Halle 1890.
Robert *ASR*	C. Robert, *Die antiken Sarkophag-reliefs*, 3 vols, Berlin 1890–1919.
Roma nel Duecento	*Roma nel Duecento. L'arte nella città dei papi da Innocenzo III a Bonifacio VIII*, A.M. Romanini (ed.), Turin 1991 [1994].
Romano 1992	S. Romano, *Eclissi di Roma: Pittura murale a Roma e nel Lazio da Bonifacio VIII a Martino V (1295–1431)*, Rome 1992.
Ross 1957	M. Ross, 'A Byzantine gold medallion at Dumbarton Oaks', *Dumbarton Oaks Papers* 11, 1957, pp. 247–61.
Rubinstein 1992	R. Rubinstein, 'A drawing of a Bacchic Sarcophagus', in *Quaderni puteani* 2, pp. 75–8.
Russo 1987	E. Russo, 'Scavi e scoperte nella chiesa di S. Agata di Ravenna', *Atti della Pontificia Accademia Romana di Archeologia. Rendiconti* lx, 1987–8, pp. 13–50.
Ruysschaert 1968	J. Ruysschaert, 'Le tableau Mariotti de la mosaique absidale de l'ancien S.-Pierre', *Atti della Pontificia Accademia Romana di Archeologia. Rendiconti* xl, 1968, pp. 295–317.
Ruysschaert 1975	J. Ruysschaert, 'La biblioteca Apostolica Vaticana', in *Il Vaticano e Roma Cristiana*, Vatican City 1975, pp. 307–33.
Sambon 1912	A. and G. Sambon, *Repertorio generale delle monete coniate in Italia e da Italiani all' estero dal secolo V al XIII (476–1266)*, Paris 1912.

Sambon 1919 — A. Sambon, *Recueil des Monnaies Médiévales du Sud de l'Italie avant la domination des Normands*, Paris 1919.

Santini 1789 — C. Santini, *Saggio di memorie ecclesiastiche e civili della città di Tolentino*, Macerata 1789.

S. Stanislao 1894 — P. Germano di S. Stanislao, *La casa celimontana dei SS. martiri Giovanni e Paolo*, Rome 1894.

Schlunk 1939 — H. Schlunk, *Kunst der Spätantike im Mittelmeerraum*, Berlin 1939.

Schramm 1928 — P.E. Schramm, *Die deutschen Kaiser und Könige in Bildern ihrer Zeit I: Bis zur Mitte des 12. Jahrhunderts*, Leipzig/Berlin 1928.

Schuddeboom 1996 — C. Schuddeboom, *Philips van Winghe (1560–1592) en het ontstaan van de christelijke archeologie* (Proefschrift Rijksuniversiteit Leiden), Groningen 1996.

Severano *Memorie sacre* — G. Severano, *Memorie sacre delle sette chiese di Roma e di altri luoghi, che si trovano per le strade di esse*, Rome 1630.

Shepherd 1984 — E. Shepherd in *L'opera ritrovata. Omaggio a Rodolfo Siviero*, exhib. cat., Palazzo Vecchio, Florence 1984.

Sinthern 1908 — P. Sinthern, 'Der römische Abbacyrus in Geschichte, Legende und Kunst', *Römische Quartalschrift* xxii, 1908, pp. 196–239.

Sirmond 1614, 1652 — J. Sirmond, *C. Sollii Apollinaris Sidonii opera*, Paris 1614, 2nd edn Paris 1652.

Skippon — P. Skippon, 'An account of a journey made thro' part of the Low-Countries, Germany, Italy and France', published in A. Churchill, *A Collection of Voyages and Travels*, London 1732, vi, pp. 359–736.

Smith 1914 — E.B. Smith, 'A lost encolpium and some notes on Early Christian iconography', *Byzantinische Zeitschrift* xxiii, 1914, pp. 217–25.

Smyth 1989 — C.H. Smyth, 'Charles Rufus Morey (1877-1955): Roma, archeologia e storia dell'arte', in *Roma, centro ideale della cultura dell'antico nei secoli XV e XVI*, S. Danesi Squarzina (ed.), Milan 1989, pp. 14–20.

Solinas 1989a — *Cassiano dal Pozzo. Atti del Seminario Internationale di Studi. Napoli, 18–19 decembre 1987*, F. Solinas (ed.), Rome 1989.

Solinas 1989b — F. Solinas, 'Percorsi puteani: note naturalistiche ed inediti appunti antiquari', in Solinas 1989a, pp. 95–129.

Solinas 1989c — F. Solinas, 'L'Erbario Miniato e altri fogli di iconografia botanica appartenuti a Cassiano dal Pozzo', in *Quaderni puteani 1*, pp. 52–76.

Solinas 1992 — F. Solinas, 'Sull'atelier di Cassiano dal Pozzo: metodi di recerca e documenti inediti', in *Quaderni puteani 3*, pp. 57–76.

Solinas/Nicolò 1988 — F. Solinas and A. Nicolò, 'Cassiano dal Pozzo and Pietro Testa: New Documents Concerning the *Museo cartaceo*', in *Testa* cat. 1988, pp. lxvi-lxxxvi.

Sparti 1990a — D. L. Sparti, 'Carlo Antonio dal Pozzo (1606–1689): an unknown collector', *Journal of the History of Collections* 2, 1990, pp. 7–19.

Sparti 1990b — D. L. Sparti, 'The Dal Pozzo Collection again: the inventories of 1689 and 1695 and the family archive', *Burlington Magazine* CXXXII, no. 1049, August 1990, pp. 551–70.

Sparti 1992 — D. L. Sparti, *Le collezioni dal Pozzo: storia di una famiglia e del suo museo nella Roma seicentesca*, Modena 1992.

Spatharakis 1976 — I. Spatharakis, *The Portrait in Byzantine Illuminated Manuscripts*, Leiden 1976.

Spon *Miscellanea* — Jacob Spon, *Miscellanea eruditae antiquitatis*, Lyons 1685.

Staatliche Museen 1966 — Staatliche Museen, Berlin-Dahlem, *Bildwerke der christlichen Epochen*, Munich 1966.

Stelluti 1638 — F. Stelluti, *Trattato del Legno Fossile Minerale Nuovamente Scoperto...*, Rome 1638.

Stirling-Maxwell 1891 — W. Stirling-Maxwell, *Miscellaneous Essays and Addresses*, London 1891.

Stroll 1991 — M. Stroll, *Symbols as Power: The Papacy following the Investiture Contest*, Leiden 1991.

Suarès *Praenestes* — J.M. Suarès, *Praenestes antiquae libri duo*, Rome 1655.

Tamizey de Larroque *Lettres* — Ph. Tamizey de Larroque, *Lettres de Peiresc*, 7 vols (Collection des documents in-édits sur l'Histoire de France), Paris 1890-99.

Tertullian — Q. Septimus Florens Tertullianus, *Opera* (Corpus Christianorum, series Latina I–II), Turnhout 1954.

Testa cat. 1988 — *Pietro Testa, 1610-1650, Prints and Drawings*, E. Cropper (ed.), exhib. cat., Philadelphia Museum of Art, Philadelphia, and Arthur M. Sackler Museum, Harvard University Art Museums, Cambridge, Mass. 1988.

Thieme-Becker — *Allgemeines Lexikon der bildenden Künstler von der Antike bis zur Gegenwart*, U. Thieme and F. Becker (eds), 37 vols, Leipzig 1907–50.

Tiberia 1991 — V. Tiberia, *Il restauro del mosaico della basilica dei Santi Cosma e Damiano a Roma*, Rome 1991.

Toesca 1960 — P. Toesca, *Pietro Cavallini*, London 1960.

Tomassetti 1910 — G. Tomassetti, *La Campagna romana. Antica, medioevale e moderna*, 4 vols, Rome 1910.

Tomassetti 1979 — G. Tomassetti, *La Campagna romana: antica, medioevale e moderna. Nuova edizione aggiornata a cura di L. Chiumenti e F. Bilancia*, II, *Via Appia, Ardeatina ed Aurelia*, Florence 1979.

Tomei 1991 — A. Tomei, 'La Pittura e le Arti Suntuarie: da Alessandro IV a Bonifacio VIII (1254–1303)', in *Roma nel Duecento*, pp. 321–403.

Torrigio 1643 — F.M. Torrigio, *Historia del martirio di s. Teodoro soldato, seguito nella città di Amasia*, Rome 1643.

Toubert 1970 — H. Toubert, 'Le renouveau paléochrétien à Rome au début du XIIe siècle', *Cahiers Archéologiques* xx, 1970, pp. 99–154.

Turner 1992 — N. Turner, 'The drawings of Pietro Testa after the Antique in Cassiano dal Pozzo's Paper Museum', in *Quaderni puteani* 3, pp. 127–44.

Turner 1993 — N. Turner, 'Some of the copyists after the Antique employed by Cassiano', in *Cassiano* cat., pp. 27–37.

Uccelli 1876 — A. Uccelli, *La chiesa di San Sebastiano M. sul colle Palatino e Urbano VIII P.M. Memoria storica con scritture inedite di Orazio Giustiniani, di Antonio Bosio, del Lorigo, di Francesco Maria Torrigio e di Antonio Riccioli*, Rome 1876.

Ughelli, *Italia sacra* — F. Ughelli, *Italia sacra sive de episcopis Italiae et insularum adiacentium*, 9 vols, Rome 1644–62.

Ugonio *Historia* — P. Ugonio, *Historia delle Stationi di Roma che si celebrano la Quadragesima*, Rome 1588.

Valery 1846 — M. Valery (ed.), *Correspondance inédite de Mabillon et de Montfaucon avec L'Italie*, Paris 1846.

Valeri 1900 — A. Valeri, *Cenni biografici di Antonio Bosio*, Rome 1900.

Valone 1994 — C. Valone, 'Women on the Quirinal hill: patronage in Rome, 1560–1630', *Art Bulletin* LXXVI, 1994, pp. 129–46.

Vatican Collections cat. 1983 — *The Vatican Collections. The Papacy and Art*, exhib. cat., Metropolitan Museum of Art, New York 1983.

Vattuone, forthcoming	L. Vattuone (ed.), *Gli inventari del Museo Sacro della Biblioteca Apostolica Vaticana redatti da Giovanni Battista de Rossi, Arch. Bibl. 66A- Arch. Bibl. 66B* (*Studi e testi* 366), Vatican City, forthcoming.
Velmans 1971	T. Velmans, 'Le portrait dans l'art des Paléologues', in *Art et Société à Byzance sous les Paléologues*, Venice 1971, pp. 91–148.
Venturi 1969	F. Venturi, *Il settecento riformatore*, Turin 1969.
Vermeule 1955	C.C. Vermeule, 'Notes on a new edition of Michaelis', *American Journal of Archaeology* 59, 1955, pp. 129–50.
Vermeule 1956	C.C. Vermeule, 'The Dal Pozzo-Albani Drawings of Classical Antiquities: Notes on their content and arrangement', *Art Bulletin* XXXVIII, 1956, pp. 31–46.
Vermeule 1958	C.C. Vermeule, 'Aspects of Scientific Archaeology in the Seventeenth Century: marble reliefs, Greek vases, and minor objects in the Dal Pozzo-Albani drawings of classical antiquity', *Proceedings of the American Philosophical Society* 102, part 11, 1958.
Vermeule 1960	C.C. Vermeule, 'The Dal Pozzo-Albani Drawings of Classical Antiquities in the British Museum', *Transactions of the American Philosophical Society* 50, part 5, 1960.
Vermeule 1966	C.C. Vermeule, 'The Dal Pozzo-Albani Drawings of Classical Antiquities in the Royal Library at Windsor Castle', *Transactions of the American Philosophical Society* 56, part 2, 1966.
Vermeule 1976	C.C. Vermeule, 'Classical Archaeology and French Painting in the Seventeenth Century', *Bulletin of the Museum of Fine Arts Boston* lxxiv, no. 370, 1976, pp. 94–109.
Vielliard 1931	R. Vielliard, *Les origines du titre de Saint-Martin aux Monts à Rome*, Rome 1931.
Villehardouin 1601	G. de Villehardouin, *L'Histoire ou Chronique du Seigneur G. de Ville Hardouin...*, Lyons 1601.
Volbach 1976	W.F. Volbach, *Elfenbeinarbeiten der Spätantike und des frühes Mittelalters*, 3rd edn Mainz 1976.
Von Matt/Bovini 1971	L. von Matt and G. Bovini, *Ravenna*, Cologne 1971.
Waetzoldt 1964	S. Waetzoldt, *Die Kopien des 17. Jahrhunderts nach Mosaiken und Wandmalereien in Rom*, Vienna/Munich 1964.
Williamson 1984	P. Williamson, *The eleventh-century frescoes in the church of Sant'Urbano alla Caffarella outside Rome*, unpublished M.Phil. thesis, University of East Anglia 1984.
Williamson 1987	P. Williamson, 'Notes on the wall-paintings in Sant'Urbano alla Caffarella, Rome', *Papers of the British School at Rome* lv, 1987, pp. 224–8.
Wilpert 1891	J. Wilpert, *Die Katakombengemälde und ihre alten Copien*, Freiburg im Breisgau 1891.
Wilpert 1903	J. Wilpert, *Die Malereien der Katakomben Roms*, Freiburg im Breisgau 1903.
Wilpert 1908	J. Wilpert, 'Malereien des Oratoriums im Kloster von S. Pudenziana', *Römische Quartalschrift* xxii, 1908, pp. 173–7.
Wilpert 1916	J. Wilpert, *Die römischen Mosaiken und Malereien der kirchlichen Bauten vom IV. bis XIII. Jahrhundert*, 4 vols, Freiburg im Breisgau 1916.
Wilpert *Sarcofagi*	J. Wilpert, *I Sarcofagi cristiani antichi*, 3 vols, Rome 1929–36.
Wilthemius 1659	A. Wilthemius, *Diptychon Leodiense*, Liège 1659.
Wisskirchen 1992	R. Wisskirchen, *Die Mosaiken der Kirche Santa Prassede in Rom*, Mainz 1992.
Woodward	D. Woodward, *Catalogue of Watermarks in Italian Printed Maps ca. 1540-1600*, Chicago 1996.

BIBLIOGRAPHY

Wrede 1989	H. Wrede, 'Die "opera de' pili" von 1542 und das Berliner Sarkophagcorpus. Zur Geschichte von Sarkophagforschung, Hermeneutik und klassischer Archäologie', *Jahrbuch des Deutschen Archäologischen Instituts* 104, 1989, pp. 373–414.
Wright 1992a	D.H. Wright, 'The study of ancient Vergil illustrations from Raphael to Cardinal Massimi', *Quaderni puteani* 2, pp. 137–53.
Wright 1992b	D.H. Wright, *Codicological Notes on the Vergilius Romanus* (*Studi e testi* 345), Vatican City 1992.
Wulff 1909	O. Wulff, *Königliche Museen zu Berlin. Altchristliche und mittelalterliche, byzantinische und italienische Bildwerke. I. Altchristliche Bildwerke*, Berlin 1909.
Zahlten 1994	J. Zahlten, 'Barocke Freskenkopien aus SS. Quattro Coronati in Rom: Der Zyklus der Sylvesterkapelle und eine verlorene Kreuzigungsdarstellung', *Römisches Jahrbuch der Bibliotheca Hertziana* 29, 1994, pp. 19–43.
Zanchi Roppo 1969	F. Zanchi Roppo, *Vetri paleocristiani a figure d'oro conservati in Italia*, Bologna 1969.
Zonghi 1953	A. and A. Zonghi and A.F. Gasparinetti, *Zonghi's Watermarks*, Hilversum 1953.
Zuccari 1981	A. Zuccari, 'La politica culturale dell'Oratorio romano nella seconda metà del cinquecento', *Storia dell'Arte* 41, 1981, pp. 77–112.
Zuccari 1995	A. Zuccari, 'Cesare Baronio, le immagini, gli artisti', in *Regola e fama* cat. 1995, pp. 80–97.

LIST OF FIGURES

TEXT FIGURES

Frontispiece, p. 8. Gasparo Morone Mola, *Portrait of Carlo Antonio dal Pozzo*, obverse of medal. Cambridge, Fitzwilliam Museum. Photo Museum

Figs 1.1–1.9. Composite folios: *Mosaici Antichi II*, fols 28, 30–31, 44–9

Figs 2.1–2.6. Composite folios: *Mosaici Antichi II*, fols 50–51, 62–3, 71, 74

Fig. 3. Vincenzo Grifoni, *Portrait of Giuseppe Bianchini*. Engraving from F. Bianchini, *Josephi Blanchini presbyter congregationis Oratorii romani. Elogium historicum*, Rome, 1765.

Fig. 4. Giuseppe Bianchini, *Design for a medal commemorating the foundation of the 'Accademia Ecclesiastica'* On the obverse is Benedict XIV pointing to a picture of the Chiesa Nuova, seat of the new Academy. On the reverse is the Academy's emblem. Pen and brown ink and watercolour.Rome, Biblioteca Vallicelliana MS U39, fol. 7. Photo Biblioteca

Fig. 5. A page from the Latin version of the Bianchini inventory (Appendix I). The inscription at fol. 97 is not transcribed in the Italian version. Rome, Biblioteca Vallicelliana, MS T9, fol. 214v. Photo Biblioteca

Fig. 6. Giuseppe Bianchini, *Various proposals for the naming and location of the Museo Cristiano*. Rome, Biblioteca Vallicelliana, MS T9, fol. 143. Photo Biblioteca

Fig. 7. Engraving, Pl. II from Antonio Giuseppe Barbazza, *Demonstratio Historiae Ecclesiasticae*, Rome 1752

COMPARATIVE FIGURES

Comp. fig. 163, 166: Anonymous, *Apse mosaic, S. Agata dei Goti*, engraving,Ciampini, *Vet. mon.* I, pl. LXXVII. London, British Library

Comp. fig. 167: Anonymous, *Three saints from apse mosaics in S. Andrea on the Esquiline and S. Venanzio*. Rome, Biblioteca Angelica, MS 1564, fol. 44 (top). Photo Biblioteca

Comp. fig. 168 (i): Anonymous, *Triclinium of Leo III*, engraving, Alemanni 1625, pl. II. Oxford, Bodleian Library

Comp. fig. 168 (ii): Anonymous, *St Peter, Pope Leo III and Charlemagne, from the Triclinium of Leo III*. BAV, Vat. lat. 5407, fol. 97. Photo BAV

Comp. fig. 169: Anonymous, *Pope Leo III from the apse mosaic of S. Susanna*. Rome, Biblioteca Angelica, MS 1564, fol. 45. Photo Biblioteca

Comp. fig. 170: Anonymous, *Emperor Charlemagne from the apse mosaic of S. Susanna*. Rome, Biblioteca Angelica, MS 1564, fol. 47. Photo Biblioteca

Comp. fig. 171: Anonymous, *Paintings and inscriptions in the Catacomb of Domitilla*. Rome, Biblioteca Vallicelliana, fols 4 and 22. Photo Biblioteca

Comp. fig. 177 (opposite): Anonymous, *Apse mosaic in Old St Peter's, Rome*. Oil painting. BAV, Museo Cristiano, inv. 973. Photo BAV

Comp. fig. 178, 179: Anonymous, *Apse mosaic in S. Andrea cata Barbara*, engraving, Ciampini, *Vet. mon.* I, pl. LXXVI. London, British Library

Comp. fig. 180: Anonymous, *Mural in S. Andrea cata Barbara*, engraving, Ciampini, *Vet. mon.* I, pl. XXV. London, British Library

Comp. fig. 182: Anonymous, *Mural in the oratory of St Thomas, S. Giovanni in Laterano*, engraving, Ciampini, *De sacris aedificiis*, pl. IV. London, British Library

Comp. fig. 183 (i): Anonymous, *Entombment of Christ, panel from a mural painting in S. Urbano alla Caffarella*. BAV, Barb. lat. 4408, fol. lx (top right). Photo BAV

Comp. fig. 183 (ii): Antonio Eclissi, *Entombment of Christ, panel from a mural painting in S. Urbano alla Caffarella*. BAV, Barb. lat. 4402, fol. 5 (top right). Photo BAV

PHOTOGRAPHIC ACKNOWLEDGEMENTS

All catalogued items in the Royal Collection are reproduced by permission of Her Majesty The Queen. We are grateful for permission to reproduce items in the following collections:

Berlin, Staatliche Museen (© Preussischer Kulturbesitz Museum 1996), inv.1: Comp. fig. 295; Cambridge, Fitzwilliam Museum: Frontispiece p.8; Florence, Istituto e Museo di Storia della Scienza: Comp. fig. 302, 303; London, British Library, shelfmark 142.f.11-12: Comp. figs. 163, 178, 180, 195, 196, shelfmark 143.f.21: Comp. fig. 182, shelfmark 195.b.2: Comp. fig. 202, shelfmark 559*.g.1: Comp. figs. 225 (i), 228(ii), shelfmark 202.f.15: Comp. fig. 241(i), shelfmark 141.f.1: Comp. fig. 280, shelfmark 985.a.1(1): Comp. fig. 281 (ii), shelfmark 604.h.6: Comp. figs. 202, 286(iii), shelfmark 603.k.11: Comp. figs 292, 293; London, Victoria and Albert Museum: Comp. fig. 241(ii); Oxford, Bodleian Library: Comp. figs.168 (i), 230,231,235(ii), 236(ii); Rome, Biblioteca Angelica: Comp.figs. 167, 169, 170, 222(i); Rome, Biblioteca Casanatense (photo Humberto N. Serra): Comp. figs. 206, 207; Rome, Biblioteca Vallicelliana: Figs. 4-6; Comp.fig.171; Rome, Deutsches Archäologisches Institut: Comp. figs. 223(i), 225(ii), 228(i), 235(i), 236(i); Rome, Istituto Centrale per il Catalogo el la Documentazione: Comp. figs. 183(iii), 185(ii); Rome, Archivio Fotografico Soprintendenza Beni Artistici e Storici di Roma: Comp. fig. 243; Vatican City, Biblioteca Apostolica Vaticana: Comp. figs. 168(ii), 177,183(i) and (ii), 184(i) and (ii), 185(i), 187, 188, 204, 205, 222(ii), 223(ii), 249, 250, 251-2, 254-258, 260, 263-269, 272, 275, 277-9, 281(i), 282, 283(i-ii), 286(i).

SUBJECTS ILLUSTRATED
IN VOLUME ONE

Catalogue numbers are in **bold** type

INDEXES

ERRATA FOR A.II. VOLUME ONE

p. 13: caption to fig. 4 should read 'Gasparo Morone Mola'

p. 37, line 41: for 'A.I.64' read 'A.I.68'

line 4: for 'A.I.43' read 'A.I.40'

for 'A.I.77' read 'A.I.81'

for 'A.I.78–123' read 'A.I.83–127'

p. 39, note 1: for 'three' read 'four' and for 'Franks I, fol. 84, no. 94 and fol.119, nos 132-3' read 'Franks I nos 14, 27-8 and 124'

p. 44, line 6: for 'Farnese's' read 'Panvinio's'

p. 47, line 40: '[Fig. 17]' is misplaced: it should be at line 37 which should read '(c. 1640, S. Maria Maggiore [Fig. 17],…)'

p. 48: year of Skippon's visit to the Paper Museum was 1665 not 1664

p. 279: Comp. fig. 125 should be on p.303, as Comp. fig. 137–8

Watermarks

p. 357: under Hills 6 for '3,6' read '36'

Bibliography

p. 368: for 'Farnese 1570' read 'Panvinio 1570' (O. Panvinio)

p.369: under Griffiths 1989, for '*Print Quarterly* 4.1' read '*Print Quarterly* VI, No.1'

p. 373: under Montini 1960 for series no. '54' read '50'

p. 377: under Stroll 1991, for '*Controversy*' read '*Contest*'

INDEX OF LIBRARIES AND MUSEUMS

References to Volume Two are prefixed by an asterisk (*). Catalogue numbers are in **bold** type

INDEX OF SUBJECTS AND ICONOGRAPHY

References to Volume Two are prefixed by an asterisk (*). Catalogue numbers are in **bold** type.

INDEX OF FORMER LOCATIONS

References to Volume Two are prefixed by an asterisk (*). Catalogue numbers are in **bold** type.

GENERAL INDEX

References to Volume Two are prefixed by an asterisk (*).